Castaways *of the* Image Planet

Also by Geoffrey O'Brien

CASTAWAYS

of the

IMAGE

PLANET

Movies,

Show Business,

Public Spectacle

Geoffrey O'Brien

COUNTERPOINT

WASHINGTON, D.C.

Grateful acknowledgment is made to the following publications in
which these essays were first published, in slightly different form:
*American Heritage; Film Comment; Filmmaker; The New Republic;
The New York Review of Books; The New York Times; Newsday; O.K. You
Mugs: Writers on Movie Actors* (Pantheon Books); *The Village Voice;* and
Voice Literary Supplement.

Library of Congress Cataloging-in-Publication Data
O'Brien, Geoffrey, 1948–
Castaways of the image planet : movies, show business, public spectacle
/ Geoffrey O'Brien.
p. cm
ISBN 1-58243-190-6 (alk. paper)
1. Motion pictures. 2. Popular culture—United States. I. Title.
PN1994 .O25 2002
791.43—dc21 2001007347

FIRST PRINTING

Jacket and text design by David Bullen

COUNTERPOINT
P.O. Box 65793
Washington, D.C. 20035-5793

Counterpoint is a member of the Perseus Books Group

10 9 8 7 6 5 4 3 2 1

This book is for my aunt
LaVerne Owens

Table *of* Contents

Introduction

THE ESSAYS IN THIS BOOK chart a series of encounters that took place during the last sixteen years, encounters dependent on the whims of what was playing, what was about to open, what refused to go away. But many of those encounters were already re-encounters: with movies seen originally in childhood, with images in new movies that sprang from someone's obsession with images in old movies, with comic books that recapitulated ancient literatures or recklessly distorted the advertising novelties of a vanished era, with movies by old men trying to reconstruct a lost world they had invented in the first place out of scraps of inherited rumor, with ongoing political dramas whose reels had been switched while no one was looking with those of a drive-in exploitation feature from the mid-fifties, with silent movies that by the end of the century had begun to look like premonitory surveillance footage.

The past of movies and TV shows is curiously unstable. The years that they end up defining for us — 1912 or 1932 or 1949 or 1965 — won't stay in one place. Those people keep being alive back there, with no visible diminution of energy; it is only we who have edged away, perhaps, from the intensity of the primal moment when our eyes first made contact with them. Musidora and Groucho and the swordsmen who went through their paces under the aegis of Sir Run Run Shaw — all of them preserve, uncannily, their own autonomous present, at least as long as the desperate efforts of film preservationists will allow them to. A century ago nobody knew what it would be like, this curious long-term connection that the sciences of reproduced image and sound have made inevitable for us. We know that we will have

Cary Grant with us for the foreseeable future—Cary Grant, whose aging we watched as it progressed in the same rhythms as our own—but cannot know in what world we will have him.

The fleeting, often random impressions captured thirty or fifty or seventy years ago become something more solid than the sensory input of a present mutating too rapidly even to create a sense of form. An effect captured on a Warner Brothers lot in 1942, subject to all the vagaries of a crowded schedule of commercial filmmaking, becomes as reliable—as necessary, finally—as the ruins of the Coliseum.

We become the creatures of fictions that were made for other eyes than ours, and when we imagine the makers of those fictions we invent fictions of our own. There is a mating dance of unmoored obsessions that happens in the darkness of screening rooms that makes all writing about film more or less shifting and unreliable. What was shown and what was seen could never be quite the same, even if the director was as calculating as a Hitchcock or a Lang. The spectator wants too much to make the movie over into something just a little bit different, something a bit closer to the dream image (the inner trailer, so to speak) that lured him into the dark in the first place. Delusion, masquerade, and confidence trick each have their part to play in this unending transaction with shadows.

These are, then, often deliberately subjective accounts of filmgoing and related pursuits. I've tended to be as precise as possible about the circumstances and presuppositions and viewing conditions that inflected my reactions, while also trying to make clear the material conditions and public expectations that shaped what those movies and performances were in the first place. The imperatives of serious business (contract negotiations, marketing revolutions, the skulduggeries of carny hustlers and the battle plans of media-empire builders) participate in the same flux as the automatic writing of skid-row visionaries, the comic inspirations of the high-school cafeteria, the dress-up games of Edwardian children. I have not yet found a theory that might alleviate the fundamental mysteriousness of what finally occurs in the interacting of those separate realities. Together we construct a history of our lives as we go, and, whether we wish to or not, turn movies and comic books, exotic postcards and billboards and television commercials into

materials for that unfinishable and never quite settled chronicle. They haunt us because they don't go away, and we do. They haunt us because they do go away, and then when they come back unexpectedly they turn out to have intruded into a world made partly in imitation of them, of the myth of them, of the rumor of them. Early and late, we find ourselves among them, made only slightly uneasy by the sensation of eavesdropping on conversations in rooms that we can never reenter.

It's a world: all the weirder because it seems almost as if it could get along without us. Does the Bing Crosby of *Going Hollywood* really need to be watched? Wouldn't he find his way to Marion Davies without benefit of our passive participation? Having already become part of our lives, the ghosts don't need to convince us that they exist. We need to convince ourselves, perhaps, that the ectoplasmic forms they write on air as they dance and intrigue are indeed a form of writing—body writing, breath writing, space writing, light writing—the unimaginable heir of Sumerian wedge forms sunk in clay. What will have been written, and who wrote it?

I have made minimal changes in the texts of these pieces, allowing myself a few small corrections, compressions, and belated nuances, but not attempting updates, postscripts, or recantations of earlier views. Most of these were written in fairly rapid response to current spectacles, and I am grateful to the editors who conceived of assignments, cleared roadblocks, checked facts, detected errors and inadvertencies, and in general helped to see these writings into the world. I am even more grateful, in an era of encroaching media monopoly and the tyranny of marketing, for their willingness to let me go my own way. To M. Mark at *VLS*, where I learned how to do this kind of thing, I owe a permanent debt for her astute judgment and constant encouragement, and to Robert Silvers and Barbara Epstein of *The New York Review of Books*, where a great deal of this material first appeared, I am grateful as always for their help and stimulus and for the opportunity to write for a publication of incomparable scope and unwavering standards.

Finally, I ought to thank everyone—from friends and family to foreign visitors and strangers at parties—with whom I've talked about movies over the years. Movie talk is one of the great open-ended pleasures we are still

permitted, making its own rules as it goes along and freely incorporating the most disparate kinds of information and insight. It was out of those conversations, always intimate, always unpredictable, so often yielding uncanny facts and even uncannier stretches of fantasy, that this writing grew. If we are to live among electronic shadows, it helps to keep on talking back to them.

Castaways *of the* Image Planet

Touch *of* Ego

THERE ARE NO UNGUARDED photographs of Orson Welles. In a childhood portrait—posing in a Fauntleroyish sailor suit alongside a dog nearly as big as he is—all traces of infantile cuteness have been burned out. Instead, his clenched fist, tight frowning lips, and dead-ahead gaze speak of a vigilant unhappiness. A glint of defiant intelligence assures us that this is one little boy who is well aware of the compositional figure he cuts. (Given his later aptitude for matching shots by eye and memory alone, and his obsession with transforming his own face through lighting, the shadows that wreathe his baby fat might be an early stylistic experiment.)

By puberty, the minimal disclosure of feeling in the childhood pictures has given way to a theatrical mask: a sculpted charm that thereafter even in moments of apparent abandon (joking on the set, living it up in a nightclub) betrays a directorial consciousness at work. Like the calculated modulations of the famous voice, the face tells us only what he wants it to tell. At best, we can detect a gesture of concealment; the thing concealed remains mysterious. A French critic has described Welles's life as "delirious exhibitionism," but we may wonder what precisely was exhibited.

Such a life creates curious traps for biographers. A subject so hyper-aware of his audience, so dedicated to controlling his image, resists being confined in someone else's interpretation—just as Welles is said often to have seized control of his own scenes when acting in other directors' movies. Welles the conjuror prefers to display without revealing, and anyone who wants a closer look must pass through a protective aura as shimmeringly disorienting as *The Lady from Shanghai*'s hall of mirrors. Instead of a coherent protagonist,

we find personae that form and dissolve at dizzying speeds — the radical populist, the silk-robed sybarite, the intellectual avant-gardist, the genial popularizer reading Twain and Stevenson to his radio audience, the brash PR whiz, the pipe-smoking scholar, the coarse practical joker, the heavy-lidded Romantic whose moodiness switches suddenly into a high-camp parody of itself.

From the outset, he defined himself through metamorphosis — as the teenaged American who played old Europeans, the stage director who transposed Shakespeare to Haiti and Fascist Italy, the radio actor who handled all the voices — and in the process invented a new profession: media manipulator. The process of transformation initiated in his own person, through accents, walks, and the arts of disguise, could be extended infinitely through the technology of radio and film. Splintering and multiplying and dispersing his image, he populated a world with himself. No one, least of all Welles, ever quite recovered from the multimedia one-man show he kept alive from his debut (at sixteen) at Dublin's Gate Theatre in 1931 to *Citizen Kane* a decade later. Just a listing of his activities in these years tends to induce breathlessness. In one typical season, he was simultaneously running the Mercury Theater, working full-time as radio actor and producer, and starring in a Broadway play. Then, inevitably, that jet of energy began to falter, and the messiness began: a succession of professional disasters that by the mid-fifties led one critic to dub him "the world's youngest has-been."

It makes a grand story — everyone likes to hear about the collapse of glory. But at the center there's a glaring blank: when we look for the hero's motives, we find only a chronicle of disconnected pageants, unaccountable retreats, obscure but violent quarrels. It's not that Welles gives us too few clues to his nature, but rather far too many. Faced with this surplus of personality, his biographers are forced to simplify what would otherwise be an unmanageable sprawl. Charles Higham (in *Orson Welles: The Rise and Fall of an American Genius*) chooses the narrowest possible characterization: a demonic figure as thunderingly melodramatic as any of Welles's radio villains, "a haunted man, driven by terrifying ancestral memories . . . fearful always that madness would strike him." While paying lip service to Welles as "a poet" and "a national treasure," Higham drives the knife in, reminding us with Iago-like persistence that Welles cheated on his wives, neglected his children,

took advantage of his friends, squandered his creditors' money. He seems morally offended that Welles has lived a life unworthy of his genius, and Higham's half-fawning, half-recriminatory subtext culminates in a classic bit of nastiness: "As his waistline grew, his career shriveled; it was almost as though eating and drinking were substitutes for creativity."

Although Barbara Leaming's portrait, in *Orson Welles: A Biography,* is far more variegated than Higham's, she diminishes Welles with kindness. Leaming works so hard to show him as a good guy, sensitive and overtrusting, that the book begins to sound like special pleading. Her efforts to mold "the sorcerer-seducer" into a plausible, sympathetic protagonist are constantly contradicted by the frantic and chameleonic activity she records. We are fed exhausting amounts of data — Orson as a boy resisting countless homosexual advances, Orson carrying on with everybody from Judy Garland to Marilyn Monroe to a "six-foot Berber girlfriend" in the mountains of Morocco, Orson as political aspirant, Orson as the object of three separate assassination attempts, Orson drunkenly throwing furniture out the window in Rio — to somewhat trivializing effect. The compulsive energies displayed are remarkable, but Welles's life begins to resemble a case study in metabolism.

Perhaps the error lies in the search for an essence behind or beyond the outward spectacle. While private life is for some a refuge, for him it appears to have been more an uneasy interlude between performances. One senses an anxiety to keep the show going at all hours and at all costs. But if Welles was the prisoner of theatricality, it was his very great achievement to turn that prison into a model of liberty. His stage is a mirror more vital than what it mirrors: a warm, enveloping parallel world full of fluidly changing vistas and gliding, intertwining movements. The same formal elements that may signify death or oppression or isolation simultaneously evoke a balletic joy. The Mercury productions were remembered above all for the depths they opened up through color and lighting and geometry, and his radio broadcasts for the subtleties of density and distance suggested by the interwoven voices. These theatrical spaces provided a home far more congenial than the oddly flat and stagy accommodations of the "real" world.

If the theater was his home, his original home was in its way a theater, animated by dramatic contradictions and a complex confusion of roles. Not only were his parents utterly disparate types — the father a rough-grained,

alcoholic manufacturer of bicycle lamps from Kenosha, Wisconsin, the mother an ethereally beautiful concert pianist and suffragist—but also, when Orson was eighteen months old, a third, equally influential character intruded. Dr. Maurice Bernstein was an orthopedist who made a more profitable career out of well-to-do married women, in whose homes he ensconced himself with great regularity. Attaching himself to Welles's mother, he also determined that baby Orson was an artistic prodigy requiring special treatment. Welles would be educated at home, with a curriculum (piano, violin, art, Shakespeare, opera) designed to turn him into a performing child. "Children could be treated as adults," Welles says of his mother's household, "as long as they were amusing. The moment you became boring, it was off to the nursery." The persona thus implied—aesthete as precocious brat—often would come back to haunt him. But the sheltering family fell apart. Welles's mother died of hepatitis when he was nine; the drunken father would die a few years later. An older brother, diagnosed as schizophrenic, was institutionalized for ten years. Orson remained in the care of Dr. Bernstein, who continued to focus obsessively on the boy's future greatness while helping himself liberally to the money he was holding in trust for him.

It seems almost as if Welles was not so much a prodigy as he was prodigized. The most extroverted performance became a form of passive compliance with the expectations of the parental audience, and his career can be seen as an attempt to re-create on a global scale the ambience of those childhood performances. His paradise, then, is one in which a child is rewarded for donning a mask, in which love is meted out according to how many false identities he can assume. In such a context, the most palpable elements are neither the performer nor his audience—ghostly, on either side—but the objects that mediate between them: props, wigs, makeup, backdrops. By mastering these, Welles masters reality: "The one thing on which I am totally without self-doubt," he tells Leaming in what amounts to a credo, "is the technical side of the theater, radio, and movies. And I never did anything that wouldn't work. I did things people didn't *like*. But any story you hear about something not working: *not true!*" Even if this sounds like an egotistical rant, he is simply defending what he sees as his home ground, his minimal definition of self. After all, if he is not "the absolute technical master of the medium," then what is he?

For Welles, technique is the only magic. "I don't think Orson *feels* any great emotion when he's acting," notes director Richard Fleischer, "but his *technique* is a master's." To an ego that shapes itself around the model of performance — with all the sense of hollowness that implies — technique offers itself as salvation, grounding, happiness. The manifold trickeries of Welles's art are not ornament but essence. The ego builds a universe of baroque accoutrements in order to have something other than itself to contemplate.

Welles's truest biography — the biography not of an exuberant glutton but of a visionary artist — can be found among his accumulated heaps of celluloid and tape and production notes. Robert L. Carringer's meticulous technical study *The Making of Citizen Kane*, by showing things like the sketches for the unfilmed *Heart of Darkness* and the storyboards for *Kane*, not only reminds us of why we want to read about Welles in the first place but comes closer to the core of the man than any biography. Even though the book's ostensible purpose is to give a fair share of credit to collaborators such as cinematographer Gregg Toland and art director Perry Ferguson, it in fact reaffirms the intensity and precision of Welles's craftsmanship. He never was more seriously engaged than when immersed in the technology of illusion, and in *Citizen Kane* he had, for the first and last time, the resources to embody his most dreamlike conceptions. Carringer also reminds us of the improvisational flair that enabled Welles to profit from a budget cut by transposing intimate scenes between Kane and Susan Alexander to the desolate vastnesses of Xanadu's main hall — just as, years later during the impoverished filming of *Othello,* a lack of costumes would inspire him to shoot Roderigo's murder in a steam bath.

Such absorption in technical invention represents perhaps the only kind of selflessness available to a performer of Welles's disposition. Whatever bluster and posturing he projects as an actor is counterbalanced by the graphic objectivity of his directorial eye. Being both star and director of his own spectacle, he creates at once a myth and a commentary on that myth. As actor, he imposes a simple presence: the insatiable, omnivorous self. As director, he stands outside that presence, interprets it, contradicts it, kills it. (He filmed his own death seven times.) From *Citizen Kane* ("I don't think any word can explain a man's life") to *Touch of Evil* ("What does it matter what you say about people?"), the text of his performance remains the same:

the isolated ego is a sealed-off desert, horribly real and horribly unknowable by anyone else.

His experience at manipulating others allows Welles to add as corollary that the more successfully the ego dominates the forces outside it, the more empty and helpless it feels. This plight of the impotent king is his special domain. He invests so much of himself in it that even an absurd figure like the reclusive plutocrat Mr. Arkadin, with his false beard and portentous glowerings, takes on archetypal intensity. Arkadin is both Welles's double and his antagonist: the incarnation of a falseness made glamorous by the deflected energies that sustain it. "I am not Arkadin," he once declared, "and I don't want to have anything to do with all the Arkadins of the world." But further on in the same interview he added: "Obviously an actor is in love with the role he plays."

His film roles enable him to dress up in the vestments of absolute power, and it's obvious how much he savors them — from Macbeth's peculiar square crown to the obscene folds of flesh (padding, we are now told) that Hank Quinlan flaunts as if they were a form of drag. But the pleasure that Welles the actor derives from these trappings reinforces rather than negates Welles the director's parable on the emptiness of power. It's his own fantasy he's taking apart. To confirm the gesture, he capped his film career — that extended symbolic autobiography — with *Chimes at Midnight,* a sweetly melancholy acceptance of mortality, enfeeblement, and the failure of ambition. The rest — the Paul Masson ads and the thousand voice-overs, lawsuits and bickerings, disappointed backers and film critics looking for a quick kill — amounts to no more than detritus. His real life can be found where he so carefully secreted it, in the sound effects and gestures and serpentine shadows of his puppet show.

The Village Voice, October 15, 1985

The Ghost
and the Machine

CRAZY HORSE, ACCORDING TO Evan S. Connell's *Son of the Morning Star,* refused to let himself be photographed. "Why should you wish to shorten my life by taking from me my shadow?" Some would argue that Crazy Horse's unseen, unseeable face is intrinsically more evocative — more fundamentally real — than the shadows Edward S. Curtis devoted his life to capturing: the forty thousand photographic images from which his twenty-volume *The North American Indian* was constructed. After all, in assembling his "comprehensive and permanent record of all the important tribes . . . that still retain to a considerable degree their primitive traditions and customs," didn't Curtis impose a mode of representation alien to the cultures he was depicting, thereby asserting an aesthetic sovereignty over the peoples he photographed?

It was easy enough for the Commissioner of Indian Affairs to declare, in 1908, that Curtis "has actually reached the heart of the Indian and has been able to look out upon the world through the Indian's own eyes"; no Indian would be asked to confirm the accuracy of the assessment. At the time, it hardly seemed to matter, since Curtis's project was based on the almost universally held premise that the Indians were a vanishing race. The work was intended not for their eyes but for the unborn generations of whites. Curtis photographed his subjects as if they were already ghosts.

The issue is complicated, of course, by the blinding, overwhelming beauty of the photographs. The two hundred or so selected to accompany Barbara

9

A. Davis's biographical essay *Edward S. Curtis: The Life and Times of a Shadow Catcher* are so dazzling that the photographer's confident assurance of his own objectivity seems a blessing. If Curtis had been prone to self-questioning doubts, he might never have embarked on an undertaking that was to consume three decades of his life, destroy his marriage, and leave him penniless. He appears to have been unperturbed by the notion of one self-educated individual setting out to compile—with camera, pen, and wax-cylinder recorder—an encyclopedic record of all the tribes in North America. Sponsored in part by J. P. Morgan and encouraged by Theodore Roosevelt, *The North American Indian* reflects the era of expansive individualism it sprang from. Curtis embodied the age: explorer, inventor, ethnographer, aesthete, he was turn-of-the-century America's version of the universal man. An artist of this type—democratic in spirit and scientific in method, his sense of beauty tempered by rugged outdoorsmanship—was not the outcast but, momentarily, the hero of his society.

For all the thoroughness of her research, Barbara Davis is unable to tell us what drove Curtis. She describes the social and aesthetic context of his career with great skill, but we learn little about his actual dealings with or feelings about the people he photographed. He was a man of surfaces; whatever self-expression was involved in his art lay far beneath a reticent, businesslike exterior. He approached his work as stoically as if volunteering for military service. Years later, hauled into court for failure to pay alimony and asked to justify the money he had squandered on his scheme, he told the judge tearfully: "Your honor, it was my job. The only thing I could do which was worth doing . . . I was duty bound to finish. Some of the subscribers had paid for the whole series in advance." By the time he did finish in 1930, after an expenditure of some $1.6 million, both he and his monumental series were entirely forgotten. At that point, with the job completed, he cracked up mentally and physically and didn't resurface until two years later. Afterward he abandoned photography and—with equally unprofitable results—devoted the rest of his long life to prospecting for gold.

The North American Indian, of which only 272 sets were printed, remains mysterious. Relatively few people have looked at the whole work, and even fewer have absorbed the voluminous text, based mostly on Curtis's own field-work. What we have instead are selections of images like those in Davis's

book, photographs displayed without context or explanation. We must invent our own imagined histories to flesh them out. Curtis invites such an approach, by constantly suggesting a narrative that remains hauntingly incomplete. What can be shown, he implies, is only a remnant of something that has passed beyond seeing. The reality on which he focuses has already disappeared. One of his pictures — a young girl standing by a pool within an encanyoned Eden — is entitled *Before the White Man Came,* and many of the others betray a similar impulse to resurrect the past. If, as some have objected, he sometimes dressed up his subjects in antiquated robes and carefully removed contemporary artifacts from camera range, he also disguised the land's changes. He wanted the landscape to masquerade as its lost self, to pretend that it had never been violated. In his viewfinder he attempted to reassemble the world as it existed before his own birth.

The idea is more than a little eerie. We peer at Curtis's images as if through them we could reenter the archaic. No matter how aware we are of his directorial manipulation of effects, the illusion persists. The scene must be real because there is a photograph of it. Stylistically Curtis might be compared with Frederic Remington (*Dancing to Restore an Eclipsed Moon*) or N. C. Wyeth (*At Nootka*), while his riders threading their way between rock walls foreshadow John Ford's vistas. In fact Curtis directed at least one feature, the remarkable *In the Land of the War Canoes* (1914), with a Kwakiutl cast reenacting — or more precisely reinventing — an already vanished era; he also worked briefly in Hollywood when he needed quick money, and the publicity stills he shot for Cecil B. DeMille and Elmo Lincoln (the original Tarzan) show the same painterly eye in a radically different context.

But he reserved his subtlest mise-en-scène for his ostensibly ethnographic work. *The Rush Gatherer* (1910), with a canoe drifting among reeds against a backdrop of fog-wreathed mountains, recalls Japanese art in the same way that Frances Densmore's renderings from Chippewa poetry (published the same year) evoked the newly discovered nuances of haiku. In *Masked Dancers — Qagyuhl,* a whole world of sacred theater surges up in Bosch-like profusion. *Story-Telling — Apache,* on the other hand, is as sedately stage-managed as any Dutch genre painting.

There is no more sculptured abstraction than *Crying to the Spirits,* a low-contrast shot in which a solitary figure almost blends with the sky behind

him, the face so softened by reflected light that it becomes an ethereal mask. Yet behind that artful play of light, we can still feel the weight and volume of the actual face. The closer Curtis gets to his subjects, the more their presence breaks through his carefully designated compositional coordinates, as in his unforgettable full-face close-ups of Geronimo, Red Cloud, the ancient Princess Angeline of Seattle. The caught shadows offer their own resistance, until we wonder just who is catching whom. Curtis seems, in effect, to have become the willing prisoner of his own work. Beginning as a confident showman, energized by the national fame his project brought him, he ended as an isolated man whose obsessive determination had led him far beyond the audience he had originally courted. So intent was he on capturing a vanishing race that it was he who vanished into his images of them.

The Village Voice, 1985

The Admiral

Back in my movie-ridden adolescence, when in company with a band of fellow obsessives I shunted from double features to late late shows, life was given shape by directorial styles. There were Mizoguchi strolls in the park and Godard afternoons in coffee shops, Howard Hawks courtships and Nicholas Ray breakups. Parties, depending on mood, might be choreographed by Welles, von Sternberg, or Vincente Minnelli; the mornings after were more frequently in the manner of Antonioni. In those days some of us spent a lot of time watching John Ford's movies. These, however, affected us in quite a different way. They provided no models for style or behavior, no glimpses of what we might become—unless, that is, we wanted to become our own ancestors. If for Wittgenstein the world consisted of everything that is the case, for Ford it amounted to everything that had just ceased to be the case. He commemorated an extinction.

Sitting in the Times Square, looking for the tenth time at *Rio Grande* or *She Wore a Yellow Ribbon,* we saw a cavalcade of lost possibilities: fellowships to which we would never be admitted and attitudes we would never share, no matter how much the seductive harmonies of Ford's movies made us want to share them. We would not be warriors, would remain shut out from both the Biblical simplicity of those marriages and the rough good humor of those fistfights. Yet across the divide we accepted Ward Bond and Ben Johnson and Harry Carey Jr. as vicarious kinfolk, with all the loyalty and tolerance that implied. After all, if you were not prepared to find Victor McLaglen lovable, then you weren't likely to be diverted by the sight of him smashing a chair over someone's head.

It might have been a family album we were looking at: not pictures of our forebears but pictures of their probable ideas about space and relationship and the weight of human actions. A curtain parted to display, in formal theatrical fashion, the world as it was meant to have been. Ford showed pictures of a home we'd never find again: a white-suited Southern judge propping his feet up on a porch rail, Abraham Lincoln and Ann Rutledge strolling along a riverbank, a man and a boy standing atop a flowery hill staring down into a Welsh valley, an empty cottage locked in pristine silence somewhere in the green depths of Ireland.

The beauty of the images lay not in their originality but in their being handed down, like a worn batch of postcards. Here was the old world, a tribal world where no person stood alone. No matter which way you turned you were part of a calendar, a genealogical grid, a system of coordinates as unyielding as the layout of a barn dance. The slightest gesture served as a wrenching emotional cue, and it was a landscape made of nothing but such gestures. The atmosphere suggested a permanent family reunion, complete with the exhaustion that it might induce. To be John Wayne was not a casual thing. In any corner of Ford's world the pressures of the whole structure could be felt. Even in the relaxed nooks where the lads drank, sang, and humorously knocked each other silly, war or the threat of war was never far off. Although the fringes were enlivened, for respite, by a procession of cowards, drunks, yokels, and comical half-wits—incarnated with Kabuki-like gusto by Stepin Fetchit, Hank Worden, Andy Devine, Ken Curtis, or Ford's brother Francis—the center of gravity still lay in the heart of an ancient and ponderous clan law.

Sexuality was not exempted from that law's jurisdiction. Betrothals and weddings were rarely more than elements of a social machinery, whose working no flight of passion could seriously threaten. Such youthful love affairs as existed in Ford's movies were lightweight stuff, amiable filler. Wives and mothers interested him a good deal more, because the definition of their precise political leverage was essential to his mapping of chains of command. A marriage might at best be an efficient working partnership, benefiting from a clear division of labor; at worst an endlessly unresolved power struggle.

The courtship comedies were variations on *The Taming of the Shrew. The*

Quiet Man (1952), for all its verdant lyricism, evolved into a quasi-mythical apology for wife-beating, and a decade later the Polynesian rhapsody *Donovan's Reef*—in which Ford for once tried to unburden himself of all codes and obligations—could still resolve its plot tangles only through a ritual spanking. It was in good fun, but one could just glimpse the protagonists of *The Quiet Man* a few decades on: Maureen O'Hara one more village harridan, John Wayne another of the louts down at the pub playing hooky from their marriages. Ford's men ultimately preferred one another's company, seeking out a paradise of male camaraderie where alcohol and warfare counted for more than any imaginable eroticism. Most of the wives put up with it; a few walked out, like Maureen O'Hara in *The Wings of Eagles* (1957)—the most emotionally naked of Ford's movies, where the icon of John Wayne was finally broken down into a snapshot of a sealed-off fighting machine, abandoned by his wife and reduced to a wheelchair, his last human link the formulaic salute of his fellow soldiers.

Where Ford stood amid all this was by no means obvious. His movies, although suffused with notions of morality, pointed no clear moral. Their ritual solemnity at times seemed to be laying the foundation for a patchwork national religion, a fusion of Christ and Lincoln and the U.S. Navy, but the range of its communicants was generous: soldiers and priests, drunken doctors and loyal manservants, noble whores and half-crazed vagabonds. The goal was always reconciliation, a gathering of as many diversities as possible under a single tent. In *The Sun Shines Bright* (1954), the hierarchies of 1905 rural Kentucky were transmuted by a sort of moral enchantment into an ideal commonwealth founded on forgiveness and cooperation. This alchemy was manifested, as was usual with Ford, in parades and music; civil hatred dissolved into the choreography of a sacramental vaudeville.

But to complicate matters, the magical resolution of disharmonies occurred within history. There could be no pure fantasies because the past always got in the way. It was Ford's self-appointed task to remake that past, in a spirit of neither exoneration nor protest but of loving placation. He would make the best peace that could be made with what had irrevocably happened. Even his war movies were singularly devoid of battle cries. Instead of the sanctimonious bellicosity that for Hollywood denoted patriotism, Ford evoked a mood of almost meditative absorption in a job of work.

Indians had their allotted task, and cavalrymen had theirs. The resulting battle was merely a necessary phase in the ironing out of contradictions, a rough form of compromise.

Ford habitually approached things from an almost godlike angle, as if he had been appointed to sort out all polarities and come up with a workable midpoint. A certain awe surrounds both his life and his work. His films were uniquely preoccupied with legend, and those who worked with Ford perceived him in similarly legendary terms. John Wayne once remarked that "many people had directed his films but that John Ford had directed his life." This hagiographic aura unfortunately tends to affect those who write about Ford as well, so that he emerges as an additional face carved out of Mount Rushmore.

Even Tag Gallagher's elaborate and carefully researched *John Ford: The Man and His Films,* easily the most reliable and informative guide to Ford's work, suffers for all its scope and wealth of detail from a tendency to set up Ford as a moral and aesthetic exemplum. From one point of view, however, the filial piety that informs Gallagher's account accurately reflects the subject at hand. The devotion Ford elicits from his commentators mirrors a type of relationship that was basic to his life. Ford was a self-made patriarch, his filmmaking the focal point of a family of workers for whom his barest nod was law. On the set he could be terrifying—"big men like Victor McLaglen or Wayne," according to Gallagher, "would break down and cry"—but it's no surprise to learn of the reverence he inspired.

Himself the sixth child in a family of pub-keepers and politicians, he clearly knew all about clans and what sustains them. His directorial activities were only one aspect of the tribal responsibilities he assumed. Having trained a corps of film technicians to work with the newly formed OSS, he oversaw them throughout the war years, afterward purchasing a twenty-acre estate as home and recuperation center for those who had served under him: "Here," writes Gallagher, "the central service of Ford's life was enacted each Memorial Day. Everyone from his unit (and most of the Ford stock company) was expected to be there. Bagpipers would march, a black choir sang 'The Battle Hymn of the Republic,' and the honor roll of the dead was read." Ford himself was the prototype of the populist rulers—Judge Priest or Abraham Lincoln—on whom his notion of democracy depended.

It was in many ways a medieval sort of democracy, built on shared family histories and deference to inherited prerogatives. Written law, for such a community, represents an intrusion, and elected politicians are little better than carpetbaggers. Not words but silent understandings hold people together, just as Ford's method of direction relied not on verbal instructions but on invisible cues: "He wouldn't tell you what to do," a Ford regular reports to Gallagher, "but you'd find yourself doing things that obviously had come from somewhere. It was some kind of thought transference that he did. And I think that's why he liked people who worked with him to be totally absorbed in him as a director, in other words, not to have too many ideas yourself. You were the vessel in which he injected what he wanted, and then it sort of flowed out of you." The final chapter devoted to Ford's working methods is far and away the most interesting part of the book; we learn more from a glimpse at how the movies were made than from any attempt to pin down final meanings. Ford mistrusted scripts and rehearsals and anything else that obstructed spontaneous response; to an amazing degree he would get what he wanted on the first take. Ford was both a peerless improviser and, as a necessary precondition for that, a technical genius with a photographic memory for detail. As one of his cinematographers described him: "Only director I ever remember walking on a set and I never see this guy open up a script. . . . He knew exactly what he was going to do. . . . He had every cut in his head." He likewise didn't need to look through the camera, because he knew where the frame's edges were. Under his guidance the film company became a utopian community where absolute freedom flowed from the benevolent dictatorship of a philosopher-king. A large part of Ford's legend came from his ability to shield this community from interference by the studio heads precisely like a chieftain protecting his tribe's autonomy within a nation-state.

The political notions underlying Ford's movies link up with his practical experience of tribal rule. The letter kills; bureaucratic politics is a kind of death, because it spells out what by nature ought to remain implicit. If you start questioning traditions, they fall apart. The radicalized sons in *How Green Was My Valley* (1941), for all their good intentions, hasten the breakup of the family. In *The Man Who Shot Liberty Valance* (1962), James Stewart with his law books kills off the heroically anarchic society in which a John

Wayne could flourish. Wayne of course aids the process, committing class suicide in order to bring about the advent of centralized government. The clan code must at length make an uneasy truce with the state. The generosities of traditional culture inevitably become implicated in the heartless mechanisms of industry and warmaking. The roistering Irish immigrant of *The Long Gray Line* (1955) incorporates himself by degrees into the rectilinear rituals of West Point, as if the military academy were an analogue of his lost village. That something is lost in the exchange Ford is first to acknowledge, but he does not allow for any alternate course of action. Gallagher resolves the conflict by making what strikes me as a purely rhetorical distinction: Ford's "moral subordination did not conflict with his clarity and honesty as a moviemaker. . . . *The Long Gray Line* pleases, on one level, militarist viewers, while yet, on another level, it is objectively a critical, damning portrait of the 'heart' of the military." How damning can a critique be if it is invisible to 99 percent of the intended audience?

Military service was as central to Ford's life as filmmaking; in fact they were nearly indistinguishable, since his wartime duties consisted mostly of filming and his films dealt so obsessively with themes of military duty. He was in effect filming his own life. His two major war movies, *They Were Expendable* (1945) and *The Wings of Eagles,* were based on the experiences of close friends, and he was always ready to take time off from commercial directing to make military training and propaganda films, ranging from the 1941 *Sex Hygiene* to the 1972 *Vietnam! Vietnam!,* a Ford-produced apologia withdrawn from circulation by the USIA because, Gallagher notes, "its interpretation of the war had become embarrassing by the time of its release." The making of the documentary *The Battle of Midway* (1942) could itself be the subject of an adventure picture: Ford filmed it himself, "standing on an exposed water tower and, according to onlookers, yelling at the attacking Zeroes to swing left or right—and cursing them out when they disobeyed directions." To him, "heroic cinema" was obviously more than a phrase.

From one angle his films might be seen as the entertainments of a contemporary warrior caste, a caste of which Ford was an honored member: his OSS activities took him as far afield as Algiers and Chungking, and he participated in the D-day landing as well as a mission in support of right-wing Yugoslav partisans that even he found dubious. Through his movies Ford

expressed a faith that the values of warriors could be incarnated in beautiful artifacts. Just as the samurai of the Momoyama era sat for hours watching Noh plays to strengthen their spirit, General Douglas MacArthur screened *She Wore a Yellow Ribbon* over and over. Of all Ford's unmade movies, the late projects ditched when he proved unbankable, I most regret the loss of OSS, a biopic that would have starred John Wayne as Ford's pal "Wild Bill" Donovan. In the contrast between the improvisational freedom of the Office of Strategic Services (a setup that allowed Ford to command virtually a private army of operatives) and the bureaucratic intelligence agency into which it hardened, he might have found his most daunting nest of contradictions. Ford would have had to bring the legend forward into the contemporary world, a task from which he always shied away. Perfection could exist only in the closed world of the past.

At their happiest, Ford's movies approach a state of pure ritual. When at the end of *Wagonmaster* (1950) the Mormons kneel down by the river to sing, or when Henry Fonda and Cathy Downs execute their chastely erotic two-step in the church-raising sequence of *My Darling Clementine* (1946), personal thought processes can be temporarily suspended. The possibility of an absolute joy in social participation is not merely suggested but enacted. There are no gunmen, no wilderness, no death, only the dance: and everybody knows how to do it. Ford, superintendent of an unwritten *Book of Rites*, doesn't just depict events, he brings them to pass. The film itself is the ritual. The geometry of the camera setups redoubles the force of the already stylized ceremonies they frame. Ford's compositional eye discards everything but the central gesture, so that no obstacles hold back the spectator from taking part in the celebration. This ability to discard personal identity in the midst of one's fellows almost defines a humane society; its loss can only lead to the whole culture gradually being driven crazy. But those great optimistic moments occur in the middle rather than at the end of Ford's career. He increasingly envisages the craziness that accompanies decay. Finally a whole movie — *The Searchers* (1956) — will be devoted to exorcising the specter of a man utterly cut off from communion. Now we see the dances and religious services through an outcast's eyes. The ceremonies that bind together can equally well exclude and oppress, and in late movies such as *Sergeant Rutledge* (1960) and *Two Rode Together* (1961) they do so more

and more. What's displayed is not so much the splendors as the limitations of ritual.

Ford's movies had always been energized by their internal conflicts; his predominant impulse toward harmony only accentuated flaws and inconsistencies. Behind every assertion of God and Mother and Country, a covert blasphemy peeps fitfully out: the suspicion that it might all be a sham. Ford plays as close as possible to the edge of that suspicion, since he is not a naïf but a bitter realist, well schooled in the lessons of war and power. His loyalty, although absolute, is not blind. In *Pilgrimage* (1933), one of the most striking of his earlier films, a tyrannical mother punishes her son's disobedience by pressuring him to enlist; he dies in the trenches. That sense of war as devourer lurks under all the parades: and what has the family done, finally, but feed its children to that maw? The rituals do not change reality, they merely make it momentarily tolerable, and Ford, as master of ceremonies, knows this better than anyone. When John Wayne, in *The Searchers,* finds the body of his murdered niece and Harry Carey Jr. asks for details, Wayne screams: "Do you want me to draw a picture?" In other words: Don't ask. The seeing of horrors should be restricted, if possible, to the elite guard fit for that duty. It's they who patrol the perimeter of the encampment while the others—the innocents—feast, dance, live as they are meant to: live, that is, in the heart of a children's book. The soldiers are voluntary outsiders, sacrificing a normal life for the sake of those in their charge.

Yet in another sense they live *more* fully, since they alone have been privileged to see past the false consolations of ritual. Ford's final hero, Anne Bancroft's atheistic cigar-smoking doctor in *Seven Women* (1966), dies to preserve a band of missionaries too foolishly innocent even to appreciate what she's doing; at the "happy" end, they go on their way, illusions intact. Leaders are condemned to loneliness because they don't dare tell their followers how bad things really are. For the good of morale, a square dance annuls nagging fears. Beyond the pratfalls and sing-alongs, Ford's mode is really paternalist tragedy—a genre for which American democracy, with its penchant for all-knowing father figures, has a peculiar affinity. According to *Liberty Valance's* celebrated formulation, "When the legend becomes fact, print the legend." This implies a class of individuals empowered to make such decisions.

In a crisis, the collectivity of village life gives way to a military command structure. The functionaries of the information class mediate between the commanders, who know what needs to be done, and the civilians, who must be persuaded of it. If, as in *Fort Apache* (1948), the commanders are fools and bring disaster, then that fact must be carefully covered up. By showing the process, Ford gives the game away. Gallagher considers that an ironic protest; I would take it as a sincere demonstration of the difficulties of command, not a questioning of the right to command.

The impression that lingers from Ford's movies is not the harshness of military discipline but the warmth of the life that discipline protects. A long-time colleague of Ford's said that "the John Ford we know is a legend, a living legend who was created by John Ford himself to protect the other John Ford, the sympathetic, sentimental, soft John Ford." This notion of a gruff and frightening exterior protecting a tenderness within translates readily into an image of the women and children inside a house protected by the men outside, or of unarmed settlers guarded by a convoy of troopers. In a similar sense, the formality and simplicity of his cinematic images seem to "guard" emotional realities that would otherwise be lost. He is not simplifying the complex but putting it into a form tough enough to survive. By mastering the system of analogues and stereotypes provided by the Hollywood feature film, Ford sought to transmit the concepts "village" or "family" or "loyalty" or "obligation" to those who might never know them firsthand. He reduced the ancient world to encodable elements so that a living picture of it could someday be played back. The rest of it—whatever his form couldn't hold—would have to die with him, leaving only a room empty of anything but mementos: a hat, a pipe, a photograph, a war medal, a pile of old books of navigation and strategy.

VLS, October 21, 1986

Close-Up
of an Eye

THE REASSESSMENT OF Michael Powell's film career has been one of the archival triumphs of the last decade, revealing Powell not just as the director of a few old favorites (*Black Narcissus, The Red Shoes*) but as a philosopher of the camera whose distinct point of view infuses all his work. Initiated by a British Film Institute retrospective in 1978 and bolstered by the enthusiasm of such admirers as Francis Coppola and Martin Scorsese, the Powell revival has done belated justice to a director who even at the height of his career (in the 1940s) experienced more than his share of critical attack, and whose films have been to an unusual degree mangled, abridged, or hidden from sight. Today he looks very much like the visionary filmmaker that England never thought it had, a formalist poet whose gaudy inventiveness was entirely at odds with the cautious traditions of the British film industry.

A few decades back, François Truffaut suggested that the terms *England* and *cinema* were incompatible, and the remark, although no longer defensible, was understandable in its context. For French critics who were uncovering a silent language of mise-en-scène in directors as varied as Max Ophuls and Nicholas Ray and Roberto Rossellini, the absence of such personal expression among the English was striking. (There was Hitchcock, of course, but the French in any event preferred his Hollywood output.) A certain box-like stiffness afflicted even the most capable craftsmen, the Asquiths and Reeds and Leans. Too often their films seemed to be illustrated sound

tracks, in which the image tamely adapted itself to an essentially literary conception. The real auteurs of English cinema were the authors it respectfully adapted: Shakespeare, Dickens, Noël Coward, Graham Greene. That respect for the primacy of the word reflected a deep cultural conservatism, a basic mistrust of what film could do. Rather than breaking into new territory, the movies were supposed to recapitulate scenes already familiar from other media. This wasn't all to the bad by any means; it accounts for the remarkably tranquilizing effect of old British movies, their sense of beloved scenes revisited and ancient rituals faithfully carried out. Seen today, even ostensibly realistic movies like Carol Reed's *The Way Ahead* and David Lean's *This Happy Breed* seem as hieratic and predictable as an Anglican service.

Against this background it becomes easier to see why Powell was never quite accepted as a mainstream director. For one thing, he was never predictable: his work presented an eccentric mix of the nationalistic, the erotic, the mystical, the whimsical, and the hyperaesthetic, an assortment of personal obsessions arranged in striking but sometimes bewildering patterns. Nor was he content to be an adaptor. He preferred to develop original scripts with the Hungarian screenwriter Emeric Pressburger, to whom he insisted on giving equal credit. Unlike so many other English films, these were not scripts that might as easily have been plays or novels; they were more like libretti, sustaining and accentuating the visual impressions rather than dominating them. The words were only one element of a seamless fusion, and Powell emphasized the fact by continually going beyond the words, asserting the powers of the eye with spinning and meandering and plummeting camera movements, oscillations between color and monochrome, glacial tableaux, barrages of masks, unexpected intrusive vistas, abrupt changes of scale.

"In my films," he writes,

> images are everything; words are used like music to distil emotion. The ballet sequence in *The Red Shoes,* the whole of *The Tales of Hoffmann,* the defusing of the bomb in *The Small Back Room,* the movement of ships at sea in the *Graf Spee* film, the whole of *The Edge of the World,* more than half of *Black Narcissus,* the trial in Heaven in *A Matter of Life and Death,* are essentially silent films.

In an industry that prized "invisible technique," Powell saturated his images with texture and movement, forcing even the dullest viewer to note that a camera was behind all this. Unorthodox narrative structures involving flash-backs, parallel worlds, and visualized reveries added to the disorientation. The resulting air of flagrant unreality was often seen by contemporary reviewers as "bad taste" and "vulgarity."

The notion that there was something not quite healthy about Powell's recurrent motifs and stylistic ostentation came to a head with the 1960 release of *Peeping Tom,* a thriller so perverse in its implications that it was universally decried as "beastly," "nasty," and "morbid," and effectively made Powell (then fifty-five) unemployable in his native land. This episode (recounted at length by Ian Christie in his useful 1978 anthology *Powell, Pressburger and Others*) has made Powell a heroic figure in British film annals, an all too uncommon embodiment of rebellious individualism. Recent dis-cussions of Powell have understandably placed special emphasis on *Peeping Tom,* a rigorous and mesmerizing film that provides a metaphoric key not only to the rest of his work but to movies in general. The screenplay (by Leo Marks rather than Pressburger) posited a horror story superficially similar to others of the period but uniquely well suited to Powell's preoccupations. A demented psychologist drives his son mad by filming him throughout his childhood, never allowing him a moment free from the camera's gaze; the son in turn grows up to be a compulsive murderer, whose weapon is the spiked tripod of the movie camera he carries with him everywhere, and who films the death of his victims with the passionate detachment of a born movie director. (Powell's preferred title was *The Filmmaker.*)

This garish premise is worked out with baroque precision, beginning with an extreme close-up of an eye and ending with a shot of a blank movie screen. Along the way Powell incorporates a profusion of variations on the acts of seeing and filming—on the glance as seduction and the glance as violence —along with an inexhaustible supply of visual rhymes, movies within movies, and somewhat sinister private jokes: the sadistic psychologist, for instance, is played by Powell himself, and the future murderer by his infant son. Rarely has a movie paraded its self-referentiality so elaborately, and to such disturbing effect. Airless and perfect, *Peeping Tom* resembles a claustropho-bic hall of mirrors, its meanings endlessly and maddeningly ricocheting off

one another. It epitomizes the kind of "esoteric masterpiece" Yukio Mishima had in mind when he spoke of works "dominated not by openness and clarity but by a strangling tightness," in which "a writer's most secret, deeply hidden themes make their appearance."

The cold-blooded efficacy with which *Peeping Tom* maps its world of fetishism and terror might well make one wonder about its director's inner life. All of Powell's films, in fact, have a dark and dreamlike afterecho, a suggestion that beneath the children's fantasy or the patriotic propaganda or the quaint Celtic romance lurks an altogether different film, guided by obscure imperatives of desire. Yet any such dark traces remain well concealed in Powell's autobiography, *A Life in Movies*. This immense book, weighing in at 705 pages, is in fact only a first installment, taking us as far as *The Red Shoes* (1948) and covering the period of Powell's greatest successes. A sequel will deal with the rockier road to *Peeping Tom* and beyond. [That volume, *Million-Dollar Movie*, was published posthumously in 1992.]

As it stands, *A Life in Movies* is as cheerful and generous a memoir as anyone could ask for, written in a vein of seasoned garrulity that conjures up an ambiance of bygone pubs and hunting lodges and county fairs. The prewar England it evokes, a web of primeval traditions and undamaged social ties, in whose innocence a cavalry charge still suggests heroic possibilities, reminds us that as a guardian of national myths Powell might be England's answer to John Ford. The book flows along like the monologue of a remarkably high-spirited old man determined to savor the full contents of his memory. Powell's air of voluptuous self-indulgence, his lingering over meticulously reconstructed childhood incidents and landscapes, bespeaks such a pleasant state of mind that one puts up with the book's inordinate length. The author is too clearly enjoying himself for anyone to want to stop him. He makes for good company.

The tales he has to tell are interesting enough: of his childhood on a Kentish hop farm, his youthful adventures along the Riviera (where his restless father, leaving the family behind him, had embarked on a second career as hotelier), his apprenticeship in movies under the guidance of the legendary silent director Rex Ingram. We follow him through the phases of British film history, the "quota quickies" of the thirties, the morale builders of the war years, the prestige pictures of the late forties, and through the episodes of a

hyperactive career crammed with extraordinary acquaintances — Alexander Korda, Fritz Lang, Ralph Richardson, Henri Matisse — and a fair share of amorous attachments. (Characteristically, Powell reserves his most passionate declarations not for friends or lovers but for the technicians with whom he worked, the cameramen and art directors and set constructors.) Yet the anecdotes wouldn't count for much without the underlying suggestion of a keen enthusiasm prolonged indefinitely and surfacing at times in rhapsodies and outbursts of hyperbole.

Powell at eighty-one manages to radiate boyish gusto. He can make a statement like "I am cinema" seem a perfectly unassuming act of self-definition. His faith in the magical quality of his own life is contagious and does much to explain how he managed to create the otherworldly atmosphere of his films. He is entirely convincing when he describes filmmaking as a process of dragging his collaborators with him into an adventure. For all their technical tricks and their toying with structure and point of view, Powell's films function primarily as conduits for an irrational and somewhat childlike excitement. They are acts of recovery, insistent attempts to reconstruct a lost world.

The opening sentences of *A Life in Movies* might be a voice-over at the beginning of a Powell film:

All my life I have loved running water. One of my passions is to follow a river downstream through pools and rapids, lakes, twists and turnings, until it reaches the sea. Today that sea lies before me, in plain view, and it is time to make a start on the story of my life, to remount it to its source, before I swim out, leaving behind the land I love so much, into the gray, limitless ocean.

As emotional statement this is unexceptionable; as rhetoric it has the charmingly old-fashioned, somewhat hollow sonority of the writers (H. Rider Haggard or Alfred Noyes) that Powell admired in childhood. Its vitality — like the vitality of his movies — lies in its sense of actual rather than symbolic water, of the tangibility and pressure of the "pools and rapids" and "twists and turnings." In Powell's work the image is more important than anything it could possibly stand for. The screenplay is an alibi providing a frame in which the images are permitted to appear. The director surrenders to a pure

fascination with the act of seeing. He wants to drown in the visible. A passage in which Powell dwells on the flour mills he knew as a child hints at that rapt absorption, as he describes in turn "the deep, calm millpond where the weeds waved and the coarse fish rose to the flies," "the iron grating to catch weeds and tree branches that might damage the millwheel, placed where the still water of the pond got sucked down into the chute," "the millrace between narrow slippery stone walls down into the pool below the mill." These images, with their suggestion of a gaze prolonged to satiety and beyond, are not simply vivid — they are haunted by depths and origins. No picture stands alone. Each arises and disappears and is mysteriously linked to every other picture. The visible is only one aspect of a secret geography, a network of currents.

The memoir becomes a map of pathways, whether they lead through the physical landscape of oasts and ricks and forges that he inhabited as a child, through the emotional territory shared with lovers and collaborators, or through the constructed spaces of the films. These contiguous worlds are charted with the same sort of restless, exploratory, spiraling forays characteristic of Powell's camera movements. If only he could have filmed it: *A Life in Movies* is the autobiography of an eye, a scenario incomplete without the visual track that ought to have accompanied it. Behind the photographic detail of the narration one senses the frustration of a filmmaker cut off too soon from the practice of his craft. He shoots as best he can with language, but clearly feels the lack of the technical resources he once commanded. Powell's most cherished unrealized project was a film version of *The Tempest,* and in his unsought retirement he calls to mind a Prospero stripped of wands and books of necromancy. He once likened himself, in an interview, to the homicidal filmmaker of *Peeping Tom:* "I felt very close to the hero, who is an 'absolute' director, someone who approaches life like a director, who is conscious of and suffers from it. . . . And I am someone who is thrilled by technique, always mentally editing the scene in front of me in the street, so I was able to share his anguish." In the autobiography, by contrast, Powell describes his life as a series of lucky breaks, of which the luckiest was his tying in with Rex Ingram's MGM unit, who happened to lunch at his father's restaurant as they scouted locations on the Mediterranean. Powell's first taste of filmmaking, on a day in 1925 at the Victorine Studios in Nice, is

recounted with the awe appropriate to a tribal initiation. As he peers through the camera, he looks into a fabricated space: "The object over the camera was a miniature ceiling, built in false perspective to fit over the top of the camera, and by careful adjustment make the set appear like a ceilinged room. . . . So my first day in movies was centred on a trick shot as, I have no doubt, my last will be."

Powell was to become one of the great tricksters, making an Arabian wilderness out of a strip of beach in Devonshire for *The Thief of Bagdad*, conjuring up a gelatin whirlpool for the climax of *I Know Where I'm Going*, and patching together, out of some painted backdrops and a Sussex garden, a Himalayan kingdom so substantial that most audiences assumed *Black Narcissus* had been shot on location. The trickery was not incidental but essential. The "Beauty of Image" on which Powell once lectured at the British Film Institute demanded total control. In *Black Narcissus* it becomes positively oppressive, as one perfectly realized image follows another, and the psychological conflicts of an isolated nunnery take second place to the visual effect of white cowls and deep shadows on a series of female faces. By the time David Farrar remarks balefully that "there's something in the atmosphere that makes everything seem exaggerated," he appears to be commenting on the art direction. That frisson of absolute fakery occurs frequently in Powell's films, as when the heavenly messenger in *A Matter of Life and Death* makes a joke about being "starved for Technicolor up there," or when Anton Walbrook—just as *The Red Shoes* reaches a peak of unlifelike melodramatics—declares "Life is so unimportant!" It's as if the illusion, so carefully built up out of props and gauzes and false perspectives, would be incomplete if it were not revealed as an illusion.

Yet the illusion is no less effective for being shown as such. The films are full of palpable presences that are not really there: the wise old man in *The Thief of Bagdad* who acknowledges that he exists only through Sabu's faith in him, the hallucinatory Heaven in *A Matter of Life and Death* that is a byproduct of David Niven's brain injury, the phantasmal thought projections that leap toward Moira Shearer in *The Red Shoes*. On the reverse side there are absences made brutally visible: the empty screen in *Peeping Tom*, the smashed mirror in *The Red Shoes*, or the spotlight standing in for the dead

ballerina at the end of the same movie. If the images have a life of their own, they also have a death. The cinema — that "box of tricks out of which to create marvels" — functions as an immortality machine, attempting to cheat death with the insouciant daring of an outnumbered RAF pilot in one of Powell's wartime pictures. The screenplay of *A Matter of Life and Death* asserts that love can triumph over death, but our eyes tell us it's film alone that does the triumphing: the freeze-frame stops time, the close-up isolates a tear on a rose petal, the three-strip color process carries the rose intact into a monochrome eternity.

The desire to see always counts for more than the particular content of what is seen. Powell's camera pokes about in space, finds openings, tries always to glimpse a bit more than seems possible or permissible. That probing movement of the eye unites the apparently disparate subject matter of his films. He is forever describing initiation or intrusion into privileged interiors, forbidden precincts. The German invaders in *49th Parallel* making their way into the Canadian interior, the materialistic girl in I *Know Where I'm Going* who becomes ever more immersed in the folkways of a remote Scottish island, the nuns ascending into the mountain retreat of *Black Narcissus,* Moira Shearer gaining entry into the hermetic ballet world of *The Red Shoes,* James Mason effecting a return to an Australian Eden in the late, underrated idyll *Age of Consent:* all participate, willingly or not, in an unveiling of mysteries.

The journey can equally be through time, as in the multiple flashbacks of *The Life and Death of Colonel Blimp,* or (as in *A Matter of Life and Death*) outside time altogether. Powell's peculiar storytelling genius lies not in making logical connections or even in making us care about his characters. It springs entirely from the arousing of fairy-tale expectations, the hope that this time, miraculously, we will be allowed to peer into the interior of Ali Baba's cave. Thus all his movies, even the horrific *Peeping Tom,* retain the aura of children's stories. While *49th Parallel* on one level goes very ably about its business of anti-Nazi propaganda, it holds us with pictures of a dream journey only tenuously related to the ostensible theme. The ideological pretext has little to do with the effect of the opening shots (in which the camera moves among clouds, rolls over mountains, glides along the frontier,

over the city, and out to sea) or of the scene in which, their stolen seaplane upended in water, the stranded Germans stagger through reeds and marsh toward an unfamiliar shore.

Powell has often been taken to task for the gratuitousness of such beauties, and it's true that his movies often encourage a split in consciousness, as if the images sought to liberate themselves from the plots and rationales that constrict their free movement. His stated ambition was to realize a "composed" film, a visual flow analogous to music; that desire for an untrammeled cascade of images (most nearly achieved in the ballet film *The Tales of Hoffman*) carries with it a potent and unsettling erotic charge. Powell lends a mythic quality to the theme of voyeurism, admitting the spectator to a world made all of eyes and glances, a world of total visibility. To William Carlos Williams's dictum "no ideas but in things," Powell might have responded: no ideas but in sheens, textures, curves, waverings, volumes, color harmonies. He stakes everything on the powers and pleasures of the image, and to a large extent so do his characters. That the image finally, inevitably, is not enough gives even his most lurid fancies an unexpected aftertaste of tragic splendor.

The New York Review of Books, August 13, 1987

Zukkaaa!
Dokitsu! Kiiiii!

AT NIGHT, IN A TWISTING side street of a Japanese city, a single bright interior gleams from among the shadows: a comic-book shop open late, its shelves crammed with thousands of compact, durably bound volumes given over to every imaginable adventure and fantasy. These are the legendary *manga,* the picture books that account for more than a fourth of Japan's publishing and that may yet make literature obsolete.

Open one at random and you might find anything—a sleek extraterrestrial landscape, an illustrated treatise on golf or fishing, an episode of torture, an elaborate reconstruction of sixteenth-century court life or twentieth-century gang warfare, a sexy or caricatural romp among high-school students —all rendered in a black-and-white so richly varied it makes color beside the point. It is difficult to tell what age group the books are aimed at, since uniformed schoolchildren and middle-aged businessmen browse along the same aisles. No matter how many customers are on hand (and at some hours the place gets as crowded as a commuter train), the shop remains weirdly silent except for the discreet rustling of pages. It's a peculiar kind of social center, warm but disconnected: a crowd of strangers, each locked in solitary communion with a carefully selected dream world.

The silence of the shop contrasts with the sound effects radiating from the pages of the comics: the ZUKKAAA of a sword slicing through a neck, the DOKITSU of a passionate kiss, the KIIIII of an airplane taking off. The panels are alive with transcribed noises whose exuberance is more than

matched by the images they punctuate. Manga come in an astonishing range of moods and tonalities: each book has its own distinctive rhythm and barometric pressure, its own sense of how a frame should function. To leaf through a baseball comic, for instance, is to fall into a hyperactive world of whizzing balls and thundering bats, an experience not unlike being physically hurled from one page to the next. The romance comics, by contrast, resemble a languorous unraveling, a slow slide into a pool of emotions. Inarticulate yearnings are manifested in the form of liquid glistening eyes and long (usually blond) hair cascading down the page. The samurai comics induce an illusion of rigor and ferocious alertness; the space adventures simulate levitation and free fall.

Whether swirling or galloping or exploding, the page layouts are designed to sustain a relentless flow of energy. One does not so much read a manga as submit to it, entering a state of total absorption in which the book seems to read itself. Manga contain far fewer words than the average American or European comic, so that the reader's eyes race from frame to frame and his hands turn the page without any awareness of conscious intent. The layouts encourage a lightning-swift reading process. As the indispensable manga historian Frederick Schodt notes, "According to an editor of Kodansha's *Shonen Magazine* . . . it takes the reader twenty minutes to finish a 320-page comic magazine. A quick calculation yields a breakdown of 16 pages a minute, or 3.75 seconds spent on each page." An efficiently executed manga should provide an interlude devoid of hindrances or perplexities, one visual cue gliding into the next faster than the speed of thought. While immersed in his comic, the reader enjoys an effortless trancelike condition; when it's finished, he tosses it aside and wonders for a moment what *that* was all about.

The medium did not attain its current ascendancy overnight, but in retrospect manga seem a logical culmination of the caricatural and narrative elements that have always figured in Japanese art — and the perfect vehicle for a country where seemingly almost any five-year-old can produce a passable cartoon. While the modern comic strip may be an Occidental invention, Japanese artists could find roots beyond Blondie in the work of Hokusai (who coined the word manga to describe his sketchbooks), Kuniyoshi (who was given to such cartoonish conceits as a classic Kabuki play performed by ghosts), and yet more anciently in the animal scrolls of the

twelfth-century Bishop Toba. In his definitive *Manga! Manga!: The World of Japanese Comics,* Schodt has lovingly traced the stages by which the modern manga found its shape. Schodt's book provides an unlikely fusion of scholarship, enthusiasm, and wit whose implications go well beyond its ostensible subject. Schodt charts a complex journey whose detours range from the stylistic fine points of wartime propaganda leaflets to the erotic symbolism of eggplants, from the bisexual subtext of girls' romance comics to the economic structure of the comic-book industry.

Serialized comic strips have existed in Japan since 1902, rising to new heights of popularity during the American occupation. A rich sampling of postwar styles can be found in the Japanese anthology *Natsukashi no hiiro manga (Nostalgic Hero Comics),* which offers a succession of swift, gag-filled adventures and endearingly roly-poly protagonists. The fluent narration and flair for comic fantasy indicates a fully established national style. Within a decade, these relatively simple stories evolved into the longer and graphically more complex strips that launched the manga boom: the metaphysical epics *Phoenix* and *Buddha* created by cartoonist and animator Osamu Tezuka, who functions somewhat as Japan's answer to Walt Disney; *The Rose of Versailles,* Riyoko Ikeda's romantic saga of androgyny and revolution in eighteenth-century France, which generated a stage play, a TV series, and a movie version (Jacques Demy's *Lady Oscar*) that although filmed in French was aimed almost exclusively at the Japanese market; and Sanpei Shirato's *Tales of the Ninja,* an ultraviolent, politically charged historical adventure, which the filmmaker Nagisa Oshima so admired that he constructed an entire feature from still photographs of its artwork.

During the sixties and seventies, manga continually took on new audiences and new subject matter, and they did so unconstrained by the censorship that has afflicted American mass-market comic books. The reputation of Japanese comic books for dismemberment, scatology, and ingenious perversions is not entirely undeserved, even though such elements are far from predominant. It's just the way they crop up unexpectedly that unnerves some foreign readers. What appears to be a children's comic suddenly turns erotic; the stalwart hero of a samurai tale abruptly commits an act of outrageous cruelty. Similar shock effects occur in visual style. Many comics subject the characters to continual oscillations of body image, so that the

inhabitants of a realistic story change, depending on their emotional state, into childish stick figures or surreal caricatures. The comic book is a waking dream, volatile and irrational.

That the dreams of the manga artists are deeply in tune with their society can be judged by the extraordinary sales figures Schodt cites. The artists and writers (who, unlike many of their American counterparts, hold the copyright on their creations) sometimes achieve the wealth and fame of rock stars. An outsider might mistake the phantasmagoric bouts of sex and violence, the unrestrained reverie and nonsense, for the manifestations of an avant-garde, but the manga do not represent a subculture. They are the mainstream, and in recent years (owing to the lamentable decline of the Japanese film industry) they have been the country's most original and wide-ranging form of cultural expression. In Japan, it should be noted, comics are not necessarily ephemeral publications. Following serialization in weekly or monthly magazines, the most popular strips come out in paperback and commonly continue for many installments; a few years back, an adaptation of the Chinese novel *The Romance of the Three Kingdoms* ran to fifty-one 200-page volumes. Enduring classics of the form, such as *Phoenix* and *The Rose of Versailles,* may be reissued in deluxe hardcover editions, to be read and reread by one generation after another. Manga in turn spill over into other media, generating live-action and animated film adaptations and TV series. The animated films are so popular that they have resulted in another hybrid form, the full-color *anime* comics created by laying out film frames in manga form.

The profusion and variety of manga make it hard to generalize about their future direction. Clearly the comic-book format—which is already being used for introductory books on history and economics—will find ever wider applications. A random sampling of books currently on the stands in Tokyo yields something for every taste, age, and level of reading ability. (The comics for younger readers spell out ideograms phonetically in the margin.) On the relatively adult side, there are the Kurosawa-like historical epic *Nobunaga,* with its stately panoramas punctuated at regular intervals by sex and violence, and the more flavorful *Nishitte Monogatari,* a picaresque, antiheroic treatment of samurai themes featuring the beautifully stylized artwork of Satomi Koe. More contemporary concerns provide the basis for *Money*

Hunter, a financial saga set against photographically meticulous renderings of banks, offices, coffee shops, and railroad stations, an eerily exact mirror image of its readers' world. This is only one of many business comics dealing with everything from stocks and bonds to the sushi trade; the trick is an artful mingling of melodrama and down-to-earth information. Notable among the always popular sports comics is the long-running, broadly humorous *Weather Permitting,* focused exclusively and obsessively on the hallowed realm of golf. (Although the dramatic possibilities of golf might seem limited, the sport has inspired a wide range of comics, from the farcical to the pornographic.)

Adolescent fare (by no means read only by adolescents) caters to a spectrum of sensibilities. At one end is *Fist of the Seven Stars,* the epitome of post-apocalyptic heavy-metal skull bashing, whose art resembles a collaboration between El Greco and the makers of *The Road Warrior,* and whose most recent issue includes a slow-motion three-page simulation of a bowie knife being driven through a forehead. For tenderer natures there is *Street of Angels,* the languid, mildly erotic adventures of a rather androgynous gigolo; on the cover of the first issue he sports a red rose and a bow tie, and (in an innovative bit of romantic imagery) presses a cold can of Budweiser against his pallid and presumably feverish cheek. *Toy,* the similarly dreamy but sexually milder chronicle of a sensitive young pop star, is notable for the chic starkness of its layouts.

Traditionally, there has been a sharp distinction between boys' and girls' comics, but a crossover of readership is now evident, most notably in teenage sex comedies like *City Hunter, Be Free!,* and the inimitably titled *New Sex Life-Style Bible.* While some of these appeal mostly to male readers, they have incorporated visual and story elements from the romance comics, and the female characters play an increasingly dominant role. These comics, with their blend of playful raunchiness, romantic tenderness, and elaborate slapstick, have no precise American equivalent. One might try to imagine what *Archie* comics would be like if they contained nudity, digressed into discussions of clitoral orgasm, and spun off now and again into perverse and sometimes violent fantasy.

American comic book artists have been studying manga for years. Their influence is flagrant in the countless ninja fantasies of the past decade,

while Frank Miller's graphic novel *Ronin* pays overt homage to the stylistic inventions of the Japanese. A number of factors, however, have prevented the originals from becoming widely available in English. First, there are technical problems: manga read from right to left, so that for an English edition the pages must be reversed or redrawn; the text runs vertically rather than horizontally; the Japanese sound effects are an essential part of the design. Even more crucial, as Schodt notes, are the profound cultural barriers, in both structure and symbolism: "What non-Japanese would guess . . . that when a huge balloon of mucus billows from a character's nose it means he is sound asleep; that when a male character suddenly has blood gush from his nostrils he is sexually excited; or that when the distance between his nose and his lips suddenly lengthens he is thinking lascivious thoughts?" While it would be fascinating to have the unadulterated manga in English, the process is prohibitively expensive without the support of a mass audience.

The existence of such an audience has until now seemed unlikely, but the growing popularity of Japanese animation (especially on the West Coast) has encouraged a few publishers to gamble. If the experiment works, it could begin a reversal of that cultural trade imbalance in which the Japanese open their markets to Madonna and Sylvester Stallone but find few American buyers for their own pop culture. So far, interest is running high among comic-book freaks; the only question is whether manga can reach the wider audience they command at home. The current contenders include *Golgo 13,* an enduringly popular serial about an international hit man; the legendary samurai series *Lone Wolf and Cub;* and, most ambitiously, a whole line of manga from the California-based Eclipse Comics: *Area 88, Mai the Psychic Girl,* and *The Legend of Kamui.*

All of these (with the partial exception of *Mai*) fit comfortably into the action genre—hardly surprising in view of the predominantly male American comic-book readership. We will probably not be seeing English versions anytime soon of the sentimental, erotic, or humorous comics that make up such a large part of the manga culture; nor, because of cultural differences, are we likely to be given a glimpse of the sports, business, or porno subdivisions (although one American publisher has promised a Japanese economics text in manga form). For the moment, Japanese comics will have to rely on swords and rocket ships for their American export business.

Of the manga currently available here, *Golgo 13* is superficially the most assimilable, since it represents a fusion of sixties espionage clichés, from *Doctor No* to *Mission Impossible*. But its protagonist, superagent Golgo (short for Golgotha), has none of the urbanity of a James Bond; this morose and relentlessly efficient killing machine is characterized only (according to an attached dossier) by "narrow, penetrating eyes" and "nearly total lack of facial expressions." Nuance has no role in *Golgo 13*: a Golgo prey to complexity or self-doubt would defeat the purpose of the strip. The writer-artist Takao Saito has spent sixteen years perfecting a single explosive encounter. To a streamlined cosmopolitan world stocked with high-tech weaponry he opposes the solitary destructive force of Golgo smashing through all complications. The backgrounds are as topical as possible—neo-Nazis in Argentina, Soviet troops in Kabul, Amal terrorists in Beirut—and the details of machines and uniforms are drawn with fetishistic precision. The more solid the setup, the bigger the jolt when Golgo barrels through and knocks everything down. The comic works by narrowing its options to a single gesture, to be repeated as often as desired.

If *Golgo 13* is a resolutely internationalized fantasy—even the hero's nationality remains ambiguous—*Lone Wolf and Cub* is something else again: an intrinsically Japanese entertainment, now virtually enshrined as a masterpiece of manga art. This revenge saga picks up from a long line of Kabuki plays and serialized novels, simplifying them down to their essence. The narrative's monotony is its point. An outlawed samurai vows vengeance on the clan that slaughtered most of his family; in the meantime, he wanders the back roads of Japan, transporting his infant son in a wooden cart and severing a certain quota of heads and hands in each episode. American audiences have already met this story in *Shogun Assassin,* the exercise in continuous mayhem that Robert Houston ingeniously stitched together from two of the six movies based on *Lone Wolf and Cub.* Those movies (most of them directed by action specialist Kenji Misumi) were cult material in themselves, and the original installments now available make it clear just how faithfully Misumi adhered to his source material, at times duplicating the layouts frame for frame. But Goseki Kojima's artwork for *Lone Wolf and Cub* is more than a storyboard for a better-than-average samurai movie. It creates, with the most minimal graphic means, a world with its own distinct

tempo and its own sense of body weight, setting a sword thrust against a distant mountain peak, a cluster of fighting men against a thick fall of snowflakes.

Kojima avoids the monumentality that can afflict period pieces. His fight scenes are executed in lightning shorthand; he registers sweeping movements rather than static tableaux. No gouts of Technicolor blood could compare with the splashes of black ink that spatter vigorously across the page, shaken from the brush in a carefully controlled variant of action painting. Kojima's graphics, in short, imitate the hero's swordsmanship; the slash and its depiction become a single gesture. That calligraphic intensity unites the whole interminable series. Whether it will be enough to sustain most American readers for six thousand pages is another question, but *Lone Wolf and Cub* can at least be recommended unconditionally to admirers of such films as *Sanjuro, Samurai Rebellion,* and *Sword of Doom.*

The Legend of Kamui, billed by Eclipse as "a genuine ninja story," was another long-running favorite, and judging by the episodes translated so far, it may prove even more appealing than *Lone Wolf and Cub.* Its creator, Sanpei Shirato, is famous for his infusion of class struggle into traditional adventure modes. His influential *Tales of the Ninja* was a fresco of peasant rebellions, and *Kamui* takes us into a world of impoverished fishing villages and nomadic mountain dwellers. Shirato's tale is slow-paced, sentimental, and dense with homely realities. The requisite displays of ninja skill and cunning are interspersed with lyrical intervals and snippets of practical lore; the scenes that show how to make a fishing lure, or that witness the preparations for a traditional feast, are more absorbing than the scenes of combat. Shirato seasons his melodrama with real places and things. That he can devote eight pages to a chaste and almost wordless love scene, and almost a whole issue to an ordinary fishing expedition, suggests his range. The other Eclipse manga are fun as well (*Area 88* is a futurist aerial adventure, *Mai* a thoroughly Japanese variation on *Firestarter* and *The Fury*). But for an introduction to the flavor of manga, *The Legend of Kamui* is the best place to turn.

The most striking characteristic of *Kamui,* as of many other manga, is its spaciousness. Incidents that would occupy a single frame in an American comic book go on for many pages. Like the cinematic long takes of Mizoguchi and Ozu, these extended scenes achieve a lifelike continuity; the

narrative is given breathing room and escapes the claustrophobia of cluttered panels and compressed plots. An ancient Japanese predilection for empty spaces and periods of silence comes into play once more, to give air and flow to the wordless literature of the space age.

<div align="right">VLS, December 1987</div>

Free Spirits

T HERE IS A SECRET history of Hollywood that must remain largely unwritten; the story not of the on-screen or off-screen careers of the movie stars, but of their phantasmal afterlives in the minds of their audiences. Manuel Puig's novel *Betrayed by Rita Hayworth,* with its vision of Hollywood gestures and plot structures seeping into the life of a movie-mad Argentinian town, represents only one of the potentially infinite possibilities. Film books these days, with their emphasis on semiotic codes and quantitative analysis, tend to reduce moviegoing to a rather impersonal experience, as if we brought nothing to our encounters with the screen and emerged from the dark imprinted with precisely identical patterns. If it were all that predictable, cinema would be as airless a business as the common run of academic studies manages to make it seem.

All too often analysis reduces movies to ghostly formulas unraveling in a void. But if the movies were canned, their audiences were not. James Harvey's marvelously comprehensive *Romantic Comedy,* which takes as its subject the string of great American comedies turned out between Ernst Lubitsch's *The Love Parade* (1929) and Preston Sturges's *Unfaithfully Yours* (1948), is useful among other things as a reminder that Hollywood's Golden Age was sustained by the unparalleled enthusiasm of its spectators. The public space created by the movies of that era grows increasingly difficult to imagine at a time when entertainments are growing ever more narrowly focused and isolated from one another. Harvey, a fervent partisan of Hollywood's "permanent occasions of amazement and delight," makes a single-

handed attempt to re-create the mass elation that once buoyed up even the flimsiest of vehicles. Uncharacteristically for a contemporary film historian, Harvey finds elements of "sanity and resistance" at the heart of the products of the studio system.

Although Harvey teaches at the State University of New York at Stony Brook, his prose is unusually free of academic jargons and methodologies. A fan's book in the best sense, *Romantic Comedy* catches the tone of real-life movie talk, all the interminable conversations wedged in between commercials while watching *The Thin Man* on New Year's Day or extended with voluptuous aimlessness on the sidewalk outside Theatre 80 St. Marks. Harvey is clearly one of those who have spent half their lives at revival houses — in his acknowledgments he pays special, now sadly outdated, tribute to New York's Thalia and Regency — and those afflicted with the same pleasant vice will recognize the way all the separate storylines end up merging into a single messily unbounded meta-narrative. An objective chronicle of screen history inevitably evolves into a self-portrait of the author as an amalgam of the movies he has seen. For such a spectator, movie actors are not remote ideological counters but long-term companions, espoused or despised for the quirkiest of reasons. When Harvey writes of Myrna Loy, Joel McCrea, or Jean Arthur, it's with that twentieth-century brand of intimacy that turns film stars into family. (The VCR completes the process by enabling the customer literally to take Cary Grant home in a box.)

Harvey's enthusiasm does threaten at moments to turn his book into a sequence of rhapsodic love letters. In the case of a few favorite stars, his adoration adopts a tone of what might be called metaphysical press-agentry: "Irene Dunne's Lola is a kind of ultimate moment in the experience of freedom that all these comedies mean to invoke. . . . Dunne is to playfulness on the screen what Garbo is to weariness: the keeper of mysteries." He is at his best when, rather than surrendering utterly to awe, he savors his pleasures by distinguishing precisely among them. The numinous aura that envelops the primary gods and goddesses gives way to the matter-of-fact bustle of character actors in constant collision and of scriptwriters working industrious variations on the two or three available plots.

Given his subject, Harvey's wonderment is entirely appropriate. A sam-

pling of titles from two years indicates the fecundity of the period. In 1934 the high thirties mode of comedy was ushered in by *It Happened One Night, The Thin Man, The Gay Divorcee,* and *Twentieth Century,* while an earlier style was epitomized by Lubitsch's brilliant but financially disastrous remake of *The Merry Widow.* By 1937 the screwball cycle was at its peak: there were Cary Grant and Irene Dunne in *The Awful Truth,* Carole Lombard in *Nothing Sacred,* Jean Arthur in *Easy Living,* Astaire and Rogers in *Shall We Dance,* and Katharine Hepburn, Ginger Rogers, and a full complement of wisecracking starlets in *Stage Door,* with the off-screen assistance of writers like Ben Hecht and Preston Sturges and directors like Leo McCarey and Gregory La Cava. Almost any scene from one of these films today seems impossibly dense and energetic, squandering enough invention to fuel a decade's worth of sitcoms.

For a few years Hollywood mastered a kind of careless perfectionism. Scene by scene, a movie like La Cava's *My Man Godfrey* (1936) is a phenomenally complex interlacing of elements: art deco sets and compositions, comic timing deriving equally from vaudeville and Cowardesque high comedy, lighting and camera movements that by themselves create an impression of psychological depth, the adrenaline rush of dialogue constantly topping itself, and beyond all that the imponderable contributions of two such iconic presences as Carole Lombard and William Powell. Yet the movie's real kick comes from the way it all appears to be tossed off on a moment's notice, as, indeed, from all accounts of La Cava's approach to filmmaking, much of it was. "Directing in this style," Harvey remarks, "was like being an action painter or a jazz musician; it was part of what people meant (whether they knew about it or not) by 'screwball.'"

These were fairy tales for grown-ups, the best ever filmed, and for those who continue to watch them they can still serve the same function. The couples around whom they are structured — Astaire and Rogers, Powell and Loy, Grant and Dunne — actually create the impression of having a good time together, a feat that grew increasingly difficult for American movies. The silents had gloried in passionate melodrama and the forties would return to it with literal vengeance. Screwball permitted a brief interval of relaxation. "The screwball couple," Harvey writes, "are committed above everything to common-sense standards. They immolate themselves like

other great lovers — but for laughs. The skeptical and reductive comic vision — the wonderful wised-up voice of the movies themselves — becomes in them something overtly romantic. . . . The life that stirs in this comic world is a passional one."

THE MARVEL IS THAT the genre was sustained for so long (in its pure form it lasted about five years) since it depended on an almost impossible balancing of contradictions. The rooms through which Grant and Astaire and Lombard move seem at once weightless and charged with tension. The white gowns and settees are the stuff of a bubble world, but the people are real enough: the fun they are clearly having testifies to that. (One need only watch Cary Grant in the long one-shot sequence in the last reel of *His Girl Friday,* just barely holding himself back from a fit of convulsive laughter.) We share the adventures of people who belong to a magical social niche that enjoys the advantages of each class and the disadvantages of none. They mix low-class slang with high-class interior decoration. They live like aristocrats yet remain free to make fun of the "real" aristocrats, those dour stuffed shirts and brainless matrons on whose rugs they spill martinis. They revel in a distinctly American air of naughtiness: they are definitely getting away with something, but to spell out what it is would spoil the party.

Nick Charles lives lavishly off his wife's inherited wealth but prefers mixing, on equally exuberant terms, with crooks and cops; Cary Grant in *The Awful Truth* is at home with strippers and heiresses. Screwball permits a wonderful blurring of social boundaries. By contrast, Ernst Lubitsch's thoroughly European *Merry Widow,* whatever the flagrant unrealities of the Lehár plot, is rooted in a clear-eyed recognition of hierarchies and power ploys. The apparently more daring American style flirts with a vaguely defined aura of insurrection, an "us against them" game made possible by the fact that neither term is ever defined. Grant and Dunne in *The Awful Truth* are outside of, and superior to, everybody they encounter, from socialites to showgirls, and what finally brings them together is that mutual superiority. They are the ultimate insiders, the only ones who will ever really get the joke. They are also prototypical middle-class Americans in the process of inventing a liberated zone for themselves. The complicity they establish with the audience against the other characters in the movie foreshadows an eventual

distinction between "hip" and "square." Square people in this instance are those who sell insurance or live in Tulsa or are played by Ralph Bellamy (or all of the above).

Screwball was a seamless hybrid of several distinct traditions. Its quotient of sophistication derived from the likes of *Private Lives* and *The Guardsman* and *Reunion in Vienna,* Broadway favorites whose movie versions today resemble waxworks, their witticisms hanging in dead air waiting for the audience reaction that doesn't come. Screwball kept the sets, the suits, and (sometimes) the classical farce structure, aerating them with the anarchic comic energy unleashed by the talkies. For a while after 1929, the movies didn't feel the need for much structure at all; pictures such as *The Big Broadcast, International House,* and *Going Hollywood* got by with a stepped-up parade of doubletalk, dialect comedy, surreal sight gags, and novelty numbers. It was the genius of screwball to tap into that craziness and revive the wan art of drawing-room comedy with vaudevillian energy. This was accomplished by replacing the comic specialists—the Marx Brothers, Mae West, Burns and Allen—with "normal" people like Cary Grant and Myrna Loy. Where the Marx Brothers inhabit an entirely grotesque world, screwball restricts the grotesque to the peripheries of its landscape. In this respect its closest predecessor was the sort of fast-talking tough comedy ushered in by *The Front Page* (1931) and extended in the early vehicles of Jean Harlow (*Red Dust, Red-Headed Woman*) and James Cagney (*Taxi!, Jimmy the Gent*).

But those tough comedies—like the tough melodramas they paralleled—had a much harsher sense of where the lines were drawn. They are still less familiar than the comedies of the late thirties, chiefly because they predate Hollywood's great era of self-censorship and consequently were rarely revived or televised until recent years. It is not altogether coincidental that 1934—the year Harvey celebrates as the watershed of American comedy—was also the year the Hays Code took effect. The startling bawdiness and generally disorderly air of pre-code comedy disappeared almost overnight. The carefree goofiness of screwball masks the systematic suppression of certain possibilities. It is doubtful, for instance, that Lubitsch's 1933 version of *Design for Living,* laundered though it is, could have been made at all a few years later. Thereafter, Grant and Dunne slipping into bed together as their

divorce becomes final is as naughty as it gets: a gag that manages to reaffirm the moral code by breaking it. Soon even that would be out of bounds. By 1943, as Harvey points out, Lubitsch was reduced to making *Heaven Can Wait*, "the story of a philanderer in which no philandering ever occurs. The film gives less a feeling of double entendre than of massive denial."

The pre-code movies, on the other hand, can still shock, as a recent retrospective at New York's Film Forum confirmed. Not that the moral code is absent in them—it weighs heavily on every scene—but the film's and the audience's reactions to it are fascinatingly unpredictable. This was the era that ennobled the gangster and the whore, so that in an underrated comedy like W. S. Van Dyke's 1933 *Penthouse* the lawyer hero could be a mouthpiece for the mob and the call-girl heroine (radiantly incarnated by Myrna Loy) could marry him and sail off happily into the fade-out. That sort of thing went out in 1934. As if in compensation, the screwball heroine emerged: a lady who might be as dizzy and madcap as she liked, but whose essential respectability was never in question. The genre's great stars, Colbert and Loy and Lombard and Dunne, excelled at conveying an impression of rule-breaking without visibly transgressing. The scene in *The Awful Truth* where Irene Dunne shocks Cary Grant's society friends with her low-life impression would hardly have the same effect if her part were played by Jean Harlow. The mere presence of Harlow would have suggested all that the movies lost in their gradual process of homogenization.

The screwball comedies were both part of that process and a protest against it. They nurtured a subversion at once exhilarating and ineffectual, a madness with no rough edges, a freedom with no consequences. Their heroes and heroines play like children; they dance on roller skates and shoot out Christmas ornaments and enjoy every minute of it, magically holding at bay anything that might let the 1930s come stealing through those white-on-white portals.

SUCH A GENRE COULD NOT survive the outbreak of war. In the wartime comedies, screwball's free spirits were gradually replaced by characters anchored in domesticity. The forties brought comedy down to earth, grounding it (like everything else) in the family, and in the process pretty much

squeezing the life out of it. Harvey notes: "It was the heroines, and the inevitably aging stars who played them, who were really trapped — in movies that seemed to embody an animus against them, against the style and wit that made them possible." The regimented laughs of these movies set the pace for the heavy-handed family comedies of the fifties, the decade when Hollywood's unified worldview finally fell gaudily apart.

The forties did permit the flowering of two talents who had been around since the twenties. Frank Capra's *Meet John Doe* (1941) and *It's a Wonderful Life* (1946) took his curious brand of ideological comedy into a new territory too emotionally draining to be called comic. Harvey gets rather worked up about Capra, whom he accuses of betraying everything represented by his earlier *It Happened One Night,* and whom he seems to equate with Ronald Reagan (the object of several ill-conceived diatribes in his final pages). It's quite true that Capra goes too far, and in the process destroys the delicate balance of classic thirties comedy. His two late masterpieces systematically ignore the division between screen and screening room; Capra lets in the sense of reality that screwball wisely excluded, thereby setting off a chain reaction in which one unresolvable situation leads into another. The spectator who thought he was getting a movie gets an emotional breakdown. The joyous conclusion of *It's a Wonderful Life* owes much of its force to one's relief that the relentless process is finally over.

That leaves us with the solitary figure of Preston Sturges, to whom Harvey devotes 150 pages offering shot-by-shot replays of *The Great McGinty, The Lady Eve, The Miracle of Morgan's Creek,* and the rest, virtually a book in itself. Blessed for a few years with the chance to create a private universe with a minimum of interference, Sturges was able to incorporate a flair for physical comedy reminiscent of Rube Goldberg and Buster Keaton with a dense, stylized sense of social hierarchies and sexual antagonisms. He was at once the most sophisticated and the most cartoonish of creators. To Sturges was left the whole cycle's swan song, the wonderful *Unfaithfully Yours* (1948), a film that failed so completely that Sturges's career never recovered. Here was a movie that combined the verbal and behavioral bubbliness of thirties comedy with the psychic splintering of forties film noir. Indeed, Sturges's charade of reality and illusion, with Rex Harrison stagemanaging his own obsessions in a series of films within the film, anticipated

Hitchcock's *Vertigo* a decade later. Yet this mirror-movie about the isolated ego somehow rose to a note of romantic affirmation: "A thousand poets dreamed a thousand years, and *you* were born . . . my love." It was an appropriately wistful sentiment to end a film marking the end of a tradition.

The New York Review of Books, July 20, 1989

Stark Raving *Mad*

W<small>E LIVE IN STRANGE DAYS</small>: within a floodlit mausoleum of show business, the hours are measured by the anniversaries of music festivals and movie premieres, by the birth of Mickey Mouse and the death of Elvis. All that was once disposable is frozen into monumentality—and in the age of mechanical reproduction that makes for more monuments than even the previous century had to contend with. One might well wonder how we got here. A significant piece of the story can be found in *The Complete Mad:* itself a monument but a welcome one, twelve pounds of budding media awareness, a guided tour of early-fifties image glut conducted in a mood far removed from today's mournful nostalgia.

Who would have imagined, when *Mad* began publication in October 1952, that thirty-seven years later we would have its first twenty-three issues preserved for us in a boxed, hardbound, full-color facsimile, annotated with Talmudic devotion? Certainly not *Mad*'s creator, Harvey Kurtzman, nor the extraordinary artists who helped realize his vision of American pop culture; it would have been an altogether different magazine if they had. "We were working by the seat of our pants," Kurtzman remarks in an interview in *The Complete Mad.* "I didn't really know what the hell I was doing. All I was doing was 'funny.' Funny. Gotta make it funny, gotta make me laugh, gotta tickle myself." The out-of-control things that happened in the pages of the early *Mad* were of the sort that occur when people are not erecting monuments. "When you're desperate to fill space, you think of outrageous things."

Mad was engaged in an elaborate practical joke at the expense of the available culture, covering billboards and movie posters and comic-strip pages

48

with graffiti that were more entertaining than what they defaced. Today's *Mad* — the black-and-white magazine that has carefully replicated the same formulas for the past thirty years — is so much a part of the landscape that it is hard to grasp the impact of Kurtzman's original color comic-book version. Without venturing into obscenity, blasphemy, or revolutionary sloganeering, it managed to anticipate all the assaults on public taste that were to follow. (Kurtzman himself left *Mad* in 1956, following a dispute over financial control, and was replaced by Al Feldstein; the magazine was never quite the same, and Kurtzman's own later ventures never achieved such popularity.)

In its boxed form *Mad* stands revealed as a perfect postmodern epic, decentered, multireferential, inextricable from the particulars of its place and time. To read it adequately we would in theory have to re-create its original circumstances, watch the same television shows, listen to the same jukeboxes (for a hundredth chorus of "How Much Is That Doggie in the Window?"), scan the same comic strips. Intertextuality can go no further. *Mad's* guiding principle was spillover: the TV programs on neighboring channels blended, the separate strips on the comics page began communicating among themselves. Everything got thrown into the soup. No figure was allowed to dominate a space for long: the foreground action was forever being upstaged by clusters of microscopic idiots grimacing or waving absurd placards, like bystanders grinning at the camera on TV news. It was an aesthetic of interruption and intrusion. *Mad's* panels retained the classicism of traditional comics only to subject it to remorseless pummeling. The four-square frame persisted, with Superduperman poised heroically in its center, but the walls and floors could be seen collapsing all around him.

In 1952 American culture was a parody waiting to happen. It was an era of oddly unconscious abeyance and dereliction. Not long before, popular art had gone through a series of more or less concurrent Golden Ages: of the movies, of jazz and the big bands, of radio, of the pulps and the comics. But a slow unraveling had begun. The forms that had seen the country through depression and world war seemed to have lost the effortless confidence that had given them the air of a national religion, a precarious unity of spirit encompassing swing records, Jack Benny, and *Terry and the Pirates*.

The postwar period's most brilliant manifestations — bebop, film noir — were already marginal. At center stage a warped stiffness seemed to have

taken over. The Red Scare generated such movies as *My Son John, I Was a Communist for the FBI,* and *Red Planet Mars,* gibbering studies in deception and religiosity whose every frame seemed grotesquely off-key. The bestseller list alternated between billowing clouds of spiritual comfort (*The Silver Chalice, The Gown of Glory, A Man Called Peter, The Power of Positive Thinking, This I Believe*) and the sustained paranoid outbursts of Mickey Spillane's *Kiss Me Deadly.* Television was exemplified by variety and quiz shows of trancelike somnolence (*The Arthur Murray Show, Arthur Godfrey's Talent Scouts, I've Got a Secret, You Asked for It*) and transplanted radio serials like *Gangbusters* and *The Lone Ranger.* As for Hollywood, it offered little beyond Martin and Lewis, Abbott and Costello, the desperate grandiosity of 3-D and Cinerama, and, for the Saturday afternoon crowd, cheapo adventure flicks like *Son of Ali Baba* and *The Battle at Apache Pass.* The comic strips, in the meantime, persisted without change, as Skeeziks, Dick Tracy, and Orphan Annie lived on in a world where nobody ever got older.

In that strange era before the dawn of media self-consciousness, evidence of mental fatigue was everywhere. Humor consisted of Jack Benny and Bob Hope recycling their old routines or Donald O'Connor locked in conversation with a talking mule. The real humor, however, was in all the places it wasn't supposed to be: in the lurid solemnity of movie posters, in the sanctimonious hucksterism of advertising, in the unquestioned formulas that governed comic-book plots. Plainly people had gotten so used to grinding the stuff out that it had been a while since anyone actually looked at it.

Mad was like the lone giggle that subverts a hitherto respectful audience into uncontrolled laughter. Well, not exactly lone. The Warner Brothers cartoonists had created a parodistic parallel world throughout the forties, and since 1950 Sid Caesar and Imogene Coca had been broadcasting *Your Show of Shows,* to be joined in 1952 by *The Ernie Kovacs Show* and Steve Allen on *Tonight.* More remotely, there was the lingering influence of the Marx Brothers and of S. J. Perelman's fantasias on the themes of pulp fiction and advertising. Before long Stan Freberg would bring another medium into the picture with recorded parodies like "St. George and the Dragonet" and an echo-ridden "Heartbreak Hotel." None of these could top *Mad's* secret weapon: its explosive visual presence. You might not find it funny, but you

couldn't take your eyes off it; its graphics changed the tone of a room just by being there.

By adopting the form of a comic book, *Mad* had the advantage of surprise, like a sniper firing from an unsuspected position. Comic books until then had fed the same material over and over to an audience limited in age and influence, rarely reaching anyone outside that audience except for crusading congressmen, psychologists, and clergymen. No comics were more targeted than those of *Mad*'s parent company, EC (it stood for Educational Comics), creators of the most morbidly explicit horror tales, the most inventively apocalyptic science fiction, and the most harrowing and socially conscious crime stories, all of them written and edited by the brilliant and astonishingly prolific Al Feldstein. When Harvey Kurtzman joined EC, he had the advantage of working with a staff that had already mastered the sharp and savage tactics of *The Vault of Horror* and *Shock Suspenstories*.

Kurtzman, a Brooklyn-born journeyman gag cartoonist in his late twenties, was unusual for his combined mastery of writing and drawing. A perfectionist in matters of detail, he habitually sketched out each story frame by frame, allowing artists small leeway in interpreting his layouts. Initially he edited a pair of war comics, *Two-Fisted Tales* and *Frontline Combat,* notable for their sober restraint and morally serious tone in contrast to EC's usual sardonic Grand Guignol. The special issues devoted to the Civil War demonstrate an eye obsessed with fusing swarms of historical detail into impeccably harmonious sequences of frames; if Kurtzman had not been a great humorist he could clearly have been a great propagandist. The distinctive styles of his artists (Wallace Wood, Will Elder, Jack Davis, John Severin) are, although still apparent, carefully held in check; Kurtzman's directorial control of his comics' overall look was unchallenged although sometimes resented.

Mad started routinely enough with farcical variations on standard comic-book plots, hit its stride with the "Superduperman" and "Shadow" features in the fourth issue, and grew steadily more experimental as long as it was under Kurtzman's editorship. In the meantime it became a success of cult-like intensity, trailed by a pack of imitations—including EC's own *Panic,* which featured the same artists as *Mad* but under the guidance of Al Feldstein. *Panic* had a rougher edge than *Mad;* the violence in its Mike Hammer

and *This Is Your Life* takeoffs is almost on a par with one of Feldstein's horror comics. There is not a trace, however, of Kurtzman's flair for fantasy and pure nonsense, or of his capacity for bending the comic-book form into unexpected shapes.

Kurtzman didn't have to invent his humor; it was already there:

> I was always surprised at how people living and working in different places around the city would be thinking the same thing. We were a product of our Jewish backgrounds in New York; we were in the same city living in different boroughs, yet we were having the same experiences. It was bizarre that at Music and Art in the lunch room we'd carry on and do our satire parodies. . . . I remember specifically sitting around in the lunch room doing the "operating scene," or better still, doing the "airplane scene," the German ace going down in the Fokker in flames. . . . You'd see a movie, and you'd make fun of it, and twenty other guys who saw the same movie, and who had the same kind of Jewish direction of thinking, would come up with the same scene.

However familiar its tone was on the streets of Manhattan or Brooklyn, for most of its readers *Mad* was a new noise: noise about noise, about the noise that had been going on in every form of public entertainment and information but had never been labeled, an encyclopedia of what had been bombarding people's eyes and ears. Reading *Mad* was like watching a documentary on how it felt to be on the receiving end of everything that had not yet been named The Media. To children growing up in the fifties, *Mad* provided the reassurance that someone else was watching, someone else had seen what it looked like. The specific content of its satire was not as important as the simple acknowledgment that we were all soaked in mass-produced words and images.

Whether parodying comic strips ("Prince Violent," "Manduck the Magician"), movies ("From Eternity Back to Here," "Under the Waterfront"), or TV shows ("The Lone Stranger," "Howdy Dooit"), Kurtzman reiterated a single point: just because this stuff was everywhere didn't mean it was real or normal. He got off on the sheer oddness of, for instance, the conventions of comic strips: that Mickey Mouse wore white gloves or that the characters in *Gasoline Alley* aged at drastically different rates. For a fifties child, who unlike Kurtzman and company had not been reading the same comics since

the thirties, the most anachronistic aspect of *Mad* was its loving assault on the funny papers. By 1954, who knew or cared about *Smilin' Jack, Gasoline Alley, Mandrake the Magician,* or even *Flash Gordon* or *Little Orphan Annie?* For *Mad's* makers, however, this was home base, the root of their aesthetic education.

Television was a more alien presence for them; it's fascinating to see how they render the actual retinal impact of the TV image, complete with wavering horizontal lines, reception problems, and the test patterns that persisted before and after the shows. *Mad's* TV parodies almost invariably ran in black-and-white, because that denoted television: TV was still visible as something other, a rackety and unsightly intrusion.

When all else failed, *Mad* relied on a repertoire of instant laugh-getters. These included a select list of words (*furshlugginer, potrzebie, haluvah, blintzes*), names (Melvin Coznowski, Alfred E. Neuman), expletives (of which *Hoo-hah!* and *Yech!* were early favorites), and a few standard syntactical ploys. Kurtzman relied heavily on the "but mainly" construction, as in: "We are giving special attention to T.V. because we believe it has become an integral part of living . . . a powerful influence in shaping the future . . . but mainly we are giving attention because we just got a new T.V. set," or "Once more I go to fight for law and order . . . for justice . . . but mainly for adding sadistic element that is such a vital part of comic books!" With slight variations the cadence was good for a thousand gags, as in Flesh Garden's declaration: "That's the trouble with us earthlings! We always assume that alien creatures are hostile! I refuse to kill said alien creature in the belief it is hostile! I will kill it just for fun!"

That this was Jewish humor was a well-kept secret; to most of *Mad's* readers, judging from the letters pages, *haluvah* and *blintzes* were nonsense words springing from nowhere. (The "boptalk" intervals and passing references to Charlie Parker must have been equally arcane to many.) As Kurtzman has noted, however, the in-jokes underwent a peculiar alchemy in their passage to the outside world: "Of course these names come out of the artist's, the author's experience. But when they turn into things like furshlugginer or potrzebie they take on an air of mystery. . . . These were personal real things to us that we were talking about, and private in a sense, and so they imparted a sense of intrigue; the audience would be touched by this

mysterious arrangement of sounds." A new in-group was forged, with *fursh-lugginer* and *potrzebie* as its shibboleths.

Kurtzman's *Mad* had only one fundamental joke: What if the hero turned out to be a jerk? All the heroes, whether Superduperman or Flesh Garden or the Lone Stranger, were the same, lecherous, avaricious cowards, betraying every ideal to stay on top and most of the time losing anyway. If they won, it was in demonic fashion: Bat Boy in "Bat Boy and Rubin" turned out to be a vampire bat, and Teddy of "Teddy and the Pirates" ended up operating an opium-smuggling ring with his fellow pirates.

Although much has been made of *Mad*'s satirical bent, its jibes tended to be quite mild; Kurtzman's takes on the hypocrisies of television, advertising, and the funny papers would not have stirred controversy if couched as essays in *The Saturday Review*. His rare forays into politics—notably the McCarthy routine in "What's My Shine?"—were significant not so much for what they said as for raising the subject at all. Kurtzman's humor was less satire than formalist delirium; much of the funniest stuff, the send-ups of such items as picture puzzles or *Ripley's Believe It or Not,* had no real point beyond a pleasure in their own gratuitousness. He loved particularly to parody print media, and through his work small children unconsciously absorbed lessons in typography and layout, and beyond that the underlying lesson that format itself is content. The range of formats he essayed is astounding: *The Daily News, The Racing Form,* movie ads, the posters for the Miss Rheingold contest, 3-D comics, fill-in-the dots and "What's Wrong with This Picture?" puzzles, the ads in the back of comic books. The tiniest visual details were significant: changes in typeface, the spacing between letters, the relative size of different elements on the page.

Mad had an air of chaos just barely held at bay. Crazed as it might appear, there was always the implication that things might get much worse. In every frame the forces of coherence fought a losing battle against entropy. The jokes stepped on each other's toes, one gag shoved another out of the way, voices drowned each other out in violently escalating shouting matches. In the final frames of the *Julius Caesar* lampoon—intended as a self-referential commentary on *Mad*'s own methods—Marlon Brando as Mark Antony and James Mason as Brutus metamorphose rapidly into Dick Tracy, Fearless Fosdick, and Rip Kirby, while Marilyn Monroe rips apart the frame itself to

reveal Donald Duck and Goofy underneath. ("Here everyone whips off rubber masks and you find out the hero really isn't the hero . . . the villain really isn't the villain . . . I'm not really your MAD writer . . . matter of fact, this MAD comic book isn't really MAD comic book.") In "3-Dimensions," a dazzling exploration of the double vision and general disorientation produced by 3-D comics leads into more basic questions of perspective and reality. Holes are ripped in the frame, one page collapses onto another, and the last page of all is an empty white space.

No two people will agree on just how funny *Mad* was, but it always hummed with energy and it always looked great. *The Complete Mad* presents the work of Elder, Wood, Davis, and company as it has never been seen before, to such effect that the humor is almost swamped by the magnificence of the drawing. (In particular, the love-it-or-hate-it all-out ugliness of Basil Wolverton's monstrous candidates for Miss Potgold take on terrifying proportions.) Wallace Wood and Jack Davis executed Kurtzman's ideas with wonderful fluency and humor, but Will Elder was *Mad*'s other guiding genius. Elder's eerie ability to appropriate the style of other cartoonists is amply displayed in his parodies of *Gasoline Alley, Bringing Up Father, The Katzenjammer Kids,* and *Archie,* but beyond mere mimicry there's a blast of wildly destructive humor. If Kurtzman was the satirist, Elder was the anarchist: "I always wanted to shock people. . . . I was the Manson of the zanies." Elder's vision of Archie and Jughead as sullen juvenile delinquents becomes genuinely ominous, while his transformation of Mickey Mouse into the vengeful, stubble-faced Mickey Rodent cut too close for the "Walt Dizzy" people, who threatened legal action.

The Kurtzman-Elder collaboration can be seen at its best in "Howdy Dooit," with its commercials for Bupgoo ("Bupgoo makes a glass of milk look exactly like a glass of beer!") and Skwushy's Sliced White Bread ("If it's good bread—it's a wonder!") and its maniacal contingent of children in the "Pee-wee Gallery," an underage mob ready to overwhelm the repellent "Buffalo Bill." When Buffalo Bill asks one sinister-looking youngster what he wants to be when he grows up—"A police chief? A fireman? A Indian? Or (hotdog), maybe a jet-fighter pilot? Huh?"—the boy replies: "Please, Buffalo Bill, don't be juvenile! . . . If one had the choice, it would probably be soundest to get into a white-collar occupation such as an investment broker or

some-such! Of course . . . advertising and entertainment are lucrative fields if one hits the top brackets . . . much like Howdy Dooit has! In other words . . . what I want to do when I grow up is to be a hustler like Howdy Dooit!" To which Bill replies: "But child . . . Howdy Dooit is no 'hustler'! . . . Howdy Dooit is a happy wooden marionette, manipulated by strings! Howdy Dooit, child, is no mercenary, money grubbing hustler. . . . I, Buffalo Bill, am the mercenary, money grubbing hustler!" Seizing a pair of scissors, the child cuts Buffalo Bill's invisible strings. As Bill falls limp and vacant-eyed to the studio floor, a raging Howdy Dooit screams for the cameras to cut.

The humor to a large degree was about the uncanny skill of the artists. Their ability to summon up the "real" figures of television, movies, and comic strips and force them to do outrageous things provoked a manic glee. It was the revenge of the cartoonists, and every reader got a jolt of subversive satisfaction from it. That Mickey Mouse and Archie were not really the targets even a child could begin to grasp. *Mad* made it clear that all the images and characters were made by people—and that what was made could equally be unmade. They took them apart before our eyes, put mustaches on them, made them speak Yiddish or pig latin.

The world *Mad* caricatured no longer exists, but the *Mad* of the fifties still seems remarkably current. After all, the Age of Parody that it helped kick off —the age that extended through Lenny Bruce, *The Realist, Zap Comix, Blazing Saddles,* and *Saturday Night Live*—ended only recently. It ended when the potential targets of parody, from Ronald Reagan on down, finally worked out how to short-circuit the process by making themselves parodies in advance: pre-caricatured, as jeans are preshrunk. Presumably some future Kurtzman is working on the problem right now.

The problem of distinguishing parodies from the real world had been broached from the beginning in the pages of *Mad.* It was another unusual, perhaps unintended dimension of that reading experience. For me, as for many of *Mad*'s youngest readers, the objects of parody were altogether unknown. Although I could follow them when it came to *Captain Video, The Lone Ranger,* and *Howdy Doody,* I was at sea on everything else; and besides, no one had ever explained what a parody was. Slowly, by a painstaking archaeological process, I divined that something other was being referred to, but it was no easy matter to reconstruct the unknown referent, to re-create,

say, *Little Orphan Annie* from "Little Orphan Melvin" or the McCarthy hearings from *Mad*'s conversion of them into the quiz show "What's My Shine?" It was a peculiar education, learning about the world from the image it cast in *Mad*'s deforming mirrors. It was also an education from which one never quite recovered, for by the time those original models were at last revealed, they had acquired in the uncovering a haunting and perpetual aura of incongruity.

VLS, October 1989

The Sturges Style

Young and fashionable crowds spilling over into the street, turned away nightly after vain attempts to gain admission to *The Lady Eve* or *Christmas in July*: such was the unanticipated spectacle provided by a recent Preston Sturges retrospective at New York's Film Forum, which ended going into overtime in order to accommodate the eager hordes. Out in the lobby, alongside copies of the newly published memoir *Preston Sturges by Preston Sturges,* a collection of memorabilia testified to Sturges's success at shaping his own legend, from his invention of a kissproof lipstick to his elopement with the Hutton heiress (an escapade that made the front page of *The New York Times*). In each of the photos on display, Sturges managed to turn himself into a perfectly judged comic icon, an amalgam of whimsical mustache and flamboyant headgear, the glittering eyes promising initiation into unimaginable realms of gnostic zaniness. It was a sweet triumph, however posthumous and belated: Sturges presented entirely on his own terms, enjoying the unconditional success he courted so energetically.

The retrospective—assembling nearly all the movies he directed, wrote, adapted, inspired, or (in one instance) wrote subtitles for—was above all a festival of language. The inclusion of films written for other directors (like *Diamond Jim* and *Remember the Night*) or adapted from his plays (like *Strictly Dishonorable* and *Child of Manhattan*) focused attention on Sturges as a literary figure, a playwright who switched to movies because they were "handy and cheap and necessary and used constantly . . . instead of being something that one sees once on a wedding trip, like Niagara Falls or Grant's Tomb." From the speakeasy of *Strictly Dishonorable*, Sturges's 1929 Broad-

way hit, to the tavern of the late and disastrous *The Sin of Harold Diddle-bock,* and most especially in the eleven features he wrote and directed between 1940 and 1949, his abstract interiors hum to the most consistently lively dialogue that any American has written for stage or screen. Who else wrote such distinctive lines? The juxtaposition (in *Remember the Night*) of yodeling, bubble dancers, corsets, Henry Wadsworth Longfellow, "My Indiana Home," hypnoleptic catalepsy, and the remark "In China they eat dogs" establishes more clearly than any screen credit what territory we are in.

It is peculiar that movies made only a few decades ago have attained an almost Elizabethan richness and strangeness — at least in comparison with the monosyllabic dialects of today's screenplays. Sturges was hardly unique in his mix of high and low diction, his keenness for the verbal peculiarities of senatorial orators and gum-chewing soda jerks, of backwoods preachers and polyglot card sharps. The talents of Ben Hecht, Jules Furthman, S. J. Perelman, George S. Kaufman, Morrie Ryskind, Clifford Odets, Robert Riskin, Charles Brackett, and countless others combined to create that vernacular palimpsest of the thirties and forties that has so often been pastiched but never improved upon. Where Sturges stands out is in his degree of self-displaying stylization. He breaks every rule of movies by putting language at the center and making the whole film swirl around it.

For all that he learned from screwball directors like Gregory La Cava and Leo McCarey, Sturges never emulated their improvisatory approach. Every line had to be delivered precisely as written. His direction of actors took place inside his head, as he wrote lines tailor-made for the people who would be reading them. His stock company of character actors became extensions of himself, as if his unconscious could bubble forth most naturally in the accents of Porter Hall or Jimmy Conlin or William Demarest. The result is a sense, rare in movies, that all the characters have been authored by a single mind: it is a universe of logomaniacs keeping themselves alive by speech, and each is some form or aspect of Preston Sturges.

The saturated texture of his movies does not come primarily from visual effects or expressive acting. Indeed, often he deliberately flattens both photographic space and vocal intonation in order to heighten the impact of what is said. Straightforward, relatively unexpressive actors like Joel McCrea and Dick Powell are ideally suited to give him the kind of line readings he wants.

Characteristically, he plunges us into the middle of an animated dialogue, as if we had walked into a room where an argument between strangers was going on. The three-way debate in the screening room in *Sullivan's Travels* (an amazingly long one-take sequence), the noisy crisscrossing banter of the marines in *Hail the Conquering Hero,* the rooftop dialogue of the lovers in *Christmas in July,* the shipboard colloquies of Fonda and Stanwyck in *The Lady Eve:* these flurries of talk knock us off balance, forcing us into a mode of breathless attention in an effort to catch up.

The back-and-forth of what he called "hooked" dialogue went well beyond the norms of movie repartee. By the time we get to the end of his first acts we've already had a movie's worth of language. The magnificence of his dialogue resides in what makes it impossible to excerpt. There are few one-liners or punch lines: the words careen off one another with manic expansiveness. In other comedies one laughs at specific gags. With Sturges, on the other hand, whole scenes and, at his best, whole films are suffused with an unbroken undercurrent of gathering hilarity, a mood that in *Christmas in July* or *Hail the Conquering Hero* is indistinguishable from the onset of an anxiety attack.

The sources of that anxiety have been raked over by a surprisingly large number of commentators. The Sturges literature already embraces two serviceable biographies (Donald Spoto's *Madcap* focuses more on emotional portraiture, while James Curtis's *Between Flops* fills in the show-business background); critical studies by James Agee, Manny Farber, André Bazin, and many others; an edition of five screenplays (with superb commentary by Brian Henderson); and now, thirty-one years after Sturges's death, a sort of autobiography. It is a curious book. Sturges did undertake to write his memoirs in 1959, generating, according to his editor Robert Lescher, "an unfortunate manuscript . . . prolix, repetitive, often distasteful—really just terrible": it only went as far as 1927. *Preston Sturges by Preston Sturges* is presumably a much-edited version of this draft (portions of which had previously shown up in the biographies by Curtis and Spoto) supplemented by material from letters, diaries, and magazine articles.

The surprisingly seamless result is certainly fun to read. On his worst day Sturges was capable of putting together absolutely amusing and satisfying

sentences. He writes of his father, whom he barely knew: "Among his possessions was a revolver, with which he often threatened to shoot himself, and my mother, who didn't like him, would urge him to go ahead." Of his mother's best friend Isadora Duncan: "Isadora met Gordon Craig and began a torturing relationship, apparently spawned in an irresistible physical attraction but nourished by their mutual adoration of the genius of Mr. Craig." On his realizing the extent of his first wife's wealth: "Much as I disliked the un-American idea of marrying a lady with a dowry, I must admit that little Mrs. Godfrey's little private income put everything in a faintly different light."

He revels in an ornate vocabulary, achieving wonderful bursts of humor by the mere deployment of such words as *contumely* or *freebooter* or *pyrogravure*. All in all it is probably quite like listening to one of the after-dinner monologues in which Sturges would endlessly spin out tales of his remarkably hectic childhood and early youth: tales of the fractured years when he was shunted between his adoptive father, the Chicago businessman Solomon Sturges, and his mother, Mary Dempsey, who crisscrossed Europe in company with the beloved Isadora while indulging in an extravagant succession of name changes (Dempsey to d'Este to Desti), marriages, liaisons, religious conversions, artistic epiphanies, and moneymaking schemes. From this childhood, which brought him into early contact with the likes of Enrico Caruso, Cosima Wagner, Elsie Janis, Theda Bara, L. Frank Baum, Evelyn Nesbit, and Lillian Russell, Sturges constructed a legend more frenetic than any of his scripts.

THAT SO LITTLE OF HIS inner life is revealed in these memoirs hardly comes as a surprise. He was by choice a man of brilliant surfaces, an ebullient figure who might have been invented by Feydeau or Lubitsch. The anecdotes intend to charm and amuse, not harp on pain or anger. Whatever suffering Sturges betrays he wraps in a wry and self-deprecating manner. But the feelings come through clearly enough, whether in a story about his shock upon learning at age eight that the adored Solomon Sturges was not his real father, or in his laconic summary of what followed: "Despite my express wish, I was not left in Chicago, but taken to Paris to live, and I did not see my father for many years."

His father, he asserts, was the person he loved most, but that is about all he has to say about him. Of his mother there is much more to tell — in fact, she manages to upstage her son in his own memoirs. She makes a marvelous character, a quintessentially Sturges character, with her mixture of scatter-brained enthusiasm and cold-blooded calculation. Keenly aware of what colorful copy she provides, Preston almost succeeds in transforming her into a lovable eccentric:

> She was . . . endowed with such a rich and powerful imagination that anything she had said three times, she believed fervently. Often, twice was enough. . . . This then is what I mean by "according to my mother." I would not care to dig too deeply in some spot where she indicated the presence of buried treasure, nor to erect a building on a plot she had surveyed.

On one level his mother's outrageousness delights Sturges; the mere fact of accompanying her on her travels has made him a man of the world, rich in exotic experience. He depicts a woman whose grandiose artistic and spiritual aspirations did not detract from her skill as a hustler. Preston is quick to detect the ruthlessness under the aestheticism, and he makes it clear that for all Mary's strenuously exercised joie de vivre, she had little interest in tending to the emotional needs of her son, who was parked with a series of random caretakers while Mary took off. The closest he comes to a direct accusation is this: "Every so often a beautiful lady in furs would arrive in a shining automobile with presents for everyone. This was Mother, of course. . . . After a little while, I would be able to talk to her haltingly in English."

It would be poor form for him to show his hurt any more bitterly, but he gets his revenge through satiric demolition of everything she took seriously. His accounts of her husbands and lovers leave an aftertaste of sullen jealousy, exploding into outright (and understandable) rage when he comes to her brief but intense involvement with the notorious self-proclaimed necromancer and Antichrist Aleister Crowley:

> Generally accepted as one of the most depraved, vicious, and revolting humbugs who ever escaped from a nightmare or a lunatic asylum . . . Mr. Crowley nevertheless was considered by my mother to be not only the

epitome of charm and good manners, but also the possessor of one of the very few genius-bathed brains she had been privileged to observe at work.

Attempting to account for this fascination, he can only surmise that "my mother was still a woman, one of that wondrous gender whose thought processes are not for male understanding."

Anger rarely shows itself so openly; but perhaps Preston was saving up his wrath in order to vent it through his comic surrogates. The real laughs in his movies come most frequently from the choleric outbursts — modulating every variation of peevishness, sarcasm, bluster, and barroom gruffness — of Raymond Walburn, Al Bridge, Franklin Pangborn, Lionel Stander, Akim Tamiroff, and most indispensably William Demarest, without whose insistent rages Sturges's comedy is hardly conceivable. The sheer satisfaction of expressing unbounded hostility and contempt finds its culmination in Rex Harrison's flight of invective in *Unfaithfully Yours,* upon discovering that his brother-in-law (the hapless Rudy Vallee) has had Harrison's wife followed by detectives:

> You stuffed moron! . . . You dare to inform me that you have had vulgar footpads in snap brim fedoras sluicing after my beautiful wife? . . . This is the sewer, the nadir of good manners! . . . Now get out of here and never speak to me again unless it's in some public place where your silence might cause comment or embarassment to our wives!

Sturges's presence is strangely muted in his account of his tumultuous childhood. He emerges at the end of it as a young man with perfect manners, an apprentice voluptuary with a fluent knowledge of French, a flair for mechanical tinkering, and no clearly defined ambition. He had been marked indelibly by the fashionable world he glimpsed at Deauville in the summer before World War I — "dukes, barons, deposed kings . . . notorious actresses, vaudeville performers, gigolos . . . playwrights, publishers, gamblers" — and subsequently strove to live up to the dandyish ideals of a vanished epoch.

It would take him until the early thirties — after two marriages to heiresses who walked out on him (two other marriages and countless affairs would follow), a long stint running his mother's cosmetics business, an abortive career as a songwriter, a hit Broadway play, and three resounding Broadway flops — to get out to Hollywood and begin his career in earnest. But the

years of his greatest success get scant treatment in *Preston Sturges by Preston Sturges*; for a continuation of the autobiography it's necessary to consult the films themselves.

THE ORGANIZED CHAOS of Sturges's movies reflects the circumstances of his life quite accurately. He slept little, went to many parties, designed a house, sailed a yacht, took out patents on all manner of not-quite-successful inventions, ran a restaurant (later expanded to include a theater) and, at least nominally, an engineering company. Yet the only matter in which he was really out of control was the spending of money—the cash he poured into the restaurant finally ran him into the ground. Otherwise the anarchic surface of his life seems to camouflage a rather successful effort to direct the behavior of those around him. Whether as filmmaker, dinner host, or raconteur, he was apparently able to mold most social gatherings into his image of the ideal party. According to Eddie Bracken, "Sturges was always on stage. Always." "He was not as good a listener as he was a talker," said William Wyler. Another friend remarked, speaking of a later and darker period, "We somehow didn't do things unless he suggested we do them."

A genius of personal publicity adept at stage-managing his interviews, treasuring every bit of memorabilia, he was a man who scripted his own life. Despite the dutiful efforts of Curtis and Spoto to include his less attractive side, the sour notes (and his emotional relationships were full of them) remain powerless to undermine the compelling charm of Sturges's self-presentation. Consider his approach to the husband of the woman who would become his third wife, as recounted by Curtis: "'Sir,' greeted Sturges, bowing deeply at the waist, 'I have the *honor* of requesting the hand of your wife in marriage.'" There can be no doubt that such moments were as carefully crafted as any of his comedies.

This exertion of personal control distinguishes the chaos of his adulthood from that of his childhood. The wild party continues, but now he is at its center rather than its periphery. After learning about the world through the medium of his mother's chaos, he successfully constructed a chaos to his own specifications. Rather than surrounding himself with the truly eccentric and overbearing personalities in his mother's circuit, he often sought out more malleable types so as to remain the focal point of most occasions. Like

the wild outbursts in his movies that were in fact scripted down to the last interjection, the impression he created of making up his life as he went along appears to have been the product of a tenacious discipline.

What lingers finally from his movies is not their wildness but their unsentimental rigor. His best scripts function like traps snapping shut. Like a poker player who does not allow his attention to be disturbed by transitory runs of good luck, he has his eye out for the main disaster. The fates that hang over his characters—Dick Powell's discovery that he hasn't really won the contest on which he's staked his whole being (*Christmas in July*), Eddie Bracken's humiliating exposure as a fraud before his family and community (*Hail the Conquering Hero*)—verge on being too painful for comedy. While Sturges does manage to throw together satisfactorily happy conclusions, there are no emotional outpourings in the manner of Capra—simply a sense of having narrowly missed going over the edge. Even *Conquering Hero*, which risks the most and therefore has the most patching up to do, cannot salve the suspicion that next time Eddie Bracken may not be so readily forgiven for his shortcomings.

No one is particularly safe in a world where everyone is out for himself. "It is probably a very good thing," writes Sturges of his school days, "for a boy to learn to live with enmity, as opposed to an atmosphere of love and affection, as it hardens him and gives him a taste of what he is going to run into later in life." Selflessness is in exceedingly short supply in Sturges's movies. (On her deathbed, Mary told Preston: "I was only trying to find happiness." He leaves unspoken the implicit rejoinder: Hers, not his.) The nice people, the innocents, are ultimately as self-seeking as the grifters and bunco artists. The priggishness of Henry Fonda's snake-collecting naïf in *The Lady Eve* proves more malevolent than the open crookedness of Barbara Stanwyck. But Sturges doesn't simply reverse the values. The witty father-and-daughter team of con artists is enchanting, but when Stanwyck falls in love with Fonda, her father (the genial Charles Coburn) reveals a more cold-blooded side. Love is real enough in Sturges's world, but its limits and conditions are carefully observed.

The penalty for breaching the rules is an aloneness without reprieve. William Demarest, who worked closely with Sturges on most of his features before a quarrel ended their relationship, commented bitterly: "He never

left you with anything. He was like a separate thing walking around by him-
self. I don't think he had any love for anybody." This may not be a fair
description of Sturges, but it certainly fits a good many of his characters.

The reverse side of his humor was an O'Neill-like despair most evident in
the 1933 screenplay *The Power and the Glory,* an experimental treatment of a
go-getting businessman whose inner emptiness leads to suicide. Another of
the more interesting thirties scripts, *Diamond Jim,* also revolves around a
successful man (Edward Arnold as Diamond Jim Brady) who opts for sui-
cide, albeit of a comically apt variety: he gorges himself to death at a solitary
banquet. Husbands, achievers, and men of power who slide from grace crop
up in *The Great McGinty, The Palm Beach Story, The Great Moment, The Sin
of Harold Diddlebock,* and in the few emotionally convincing moments of
Sturges's last and least movie, the French-made *Diary of Major Thompson.*
The most frenzied of the comedies are punctuated by dark, marginal in-
stances of an anomie elsewhere held under control by the sheer will to
liveliness.

The ever-present possibility of failure can be kept at bay, when all else
fails, only by Sturges's limitless verbal imagination. Until the very end of his
career—when a decade of rejections and false starts began to chip away
even at *his* boundless self-confidence—Sturges retained the sense that he
could retrieve his career at any time by sitting down at the roadside and com-
ing up with a story. His faith in his own creative hunches, fortified by a belief
in lucky streaks and magic coincidences, enabled him to live a life on the
edge, ready to stake everything on the next story idea.

IMAGINATION BECOMES A FORM of currency, negotiable as houses,
yachts, and restaurants. Sturges can control the world with words. His films
depict an arena where politicians, con artists, salesmen, attorneys, inven-
tors, and seducers make a place for themselves through language alone.
Barroom eloquence, gutter invective, patriotic hyperbole, the effusions of
courtship: all invent instant plenitude, an all-American gratification that
redeems an otherwise squalid existence.

"I'm not a failure," intones the office manager in *Christmas in July,* "I'm a
success. . . . No system could be right where only half of one percent were
successes and all the rest were failures." But neither Dick Powell, Sturges,

nor the audience believes him for a minute. Success must be had at any price, even at the price of faking it. Sturges's main characters are mostly frauds: Woodrow in *Conquering Hero* assuming the trappings of a battle-scarred Marine, the card sharps in *The Lady Eve* reveling in aliases and fictitious origins, the director in *Sullivan's Travels* even adopting a fraudulent poverty. The writer's advantage is that he can admit to what everyone else conceals: that he operates under a set of false pretenses.

A combination of unfortunate circumstances prevented Sturges from exercising his talents in his final years. The memoirs, fragmentary as they are, must stand in for all the movies that didn't get made. One final passage might be the narration for the last one of all. One can easily imagine Joel McCrea doing the voice-over with his inimitably flat delivery:

> A man of sixty, however healthy, makes me think of an air passenger waiting in the terminal, but one whose transportation has not yet been arranged. He doesn't know just when he's leaving. He thinks back on his life and to him it seems to have been a Mardi Gras, a street parade of masked, drunken, hysterical, laughing, disguised, travestied, carnal, innocent, and perspiring humanity of all sexes, wandering aimlessly, but always in circles, in search of that of which it is a part: life.

It was somehow in keeping with Sturges's destiny to have the rare privilege of scripting his own death scene. After this he adds:

> These ruminations, and the beer and coleslaw that I washed down while dictating them, are giving me a bad case of indigestion. . . . I am well versed in the remedy: ingest a little Maalox, lie down, stretch out, and hope to God I don't croak.

He died twenty minutes later.

Tales *of*
Two Chinas

I
N A COINCIDENCE OF programming in New York
City, a selection of the commercially most successful Hong Kong movies of
the 1980s ran at the same time as a retrospective of work (some of it only
marginally released in its country of origin) by director and cinematographer
Zhang Yimou, who lives in the People's Republic, and whose recent film
Raise the Red Lantern was showing independently in New York. The contrast
could hardly have been more extreme. While confirming that both China
and Hong Kong produced some of the most exciting films of the 1980s, the
two series seemed to differentiate not so much two regions or political
systems as two universes, universes nonetheless scheduled to merge seam-
lessly in five years, when Britain's 150-year rule over the Crown Colony
finally ends.

Zhang Yimou is by now the best known of China's "Fifth Generation"
directors. (The "five generations" are the successive classes of filmmaking
students who graduated from the Beijing Film Academy, founded in 1956.
The fifth, the class of 1982, were the first to graduate after the long suspen-
sion of instruction resulting from the Cultural Revolution and its after-
math.) Their movies, such as Zhang's *Red Sorghum* (1987), Chen Kaige's *Yel-
low Earth* (1984), and Tian Zhuangzhuang's *Horse Thief* (1986), were the first
to break decisively with the rigid dictates of Maoist "cultural work." Out of
imposed muteness came a film language consisting of splendid images in
isolation — an empty sky, a river basin, a weather-roughened face, a ceremo-

nial procession—hemmed in by a strained terseness suggesting multiple layers of historical, political, and social meanings that could not be stated. Nothing, it appeared, could be more challenging in the wake of the Cultural Revolution than sharply defined pictures devoid of any obvious didactic purpose, surrounded by silence and open to multiple interpretations. (An analogous strategy can be observed in the work of contemporary Chinese poets such as Bei Dao and Duo-Duo.)

The actions that constitute the narrative of *Red Sorghum*—a bride jostled by the peasants carrying her to her wedding, the same bride raped in a field of sorghum, a rite of purification by burning, a punitive beating, celebratory orgies of drunkenness, a worker rebelliously pissing into a vat of newly made wine, a protracted final scene of wartime torture and massacre—are virtually undifferentiated occasions for the deployment of exquisitely modulated textures, compositions, and color combinations. The movie comes to resemble an aesthetic ritual dedicated to the proposition that fire, blood, and wine are merely different aspects of the color red. Likewise in Zhang's most recent film, *Raise the Red Lantern* (1991), the meticulously cataloged horrors suffered by a rich Shanghai merchant's concubine during the 1920s run parallel with the contemplation of architectural harmonics and the symmetrical grace of even the most oppressive of domestic ceremonies. An ostensible study of deprivation becomes at the same time a celebration of visual pleasures.

Not far offscreen, both before and after Tiananmen Square, are pressures from a bureaucracy without whose approval the movie cannot be made or distributed, acting in the name of a largely voiceless mass audience on whose level of understanding bureaucratic approval ostensibly hinges. In the absence of a clearly measurable financial bottom line, the more experimental directors have been reined in by a putative popular discontent with the "foreign-influenced" artiness and obscurantism of their work. As the older filmmaker Wu Yigong argued in a widely disseminated attack on the Fifth Generation,

> All the outstanding artists in history sincerely had a warm love for life and a warm love for the people. However, some of our artists now are fixated on salon art, which only a few people appreciate. . . . I want to be a Chinese artist, and not a foreign artist or an artist enslaved to foreigners.

What is most striking about the Fifth Generation filmmakers is indeed their almost defiant ambiguity. Tian Zhuangzhuang, in *Horse Thief,* makes a point of not explaining the Tibetan religious rites with which he intercuts an already cryptic narrative about a tribal outcast: he forces the viewer to gaze at bare appearances, without benefit of a tour guide's commentary. Tian and his contemporaries cultivate a style at once lush and laconic, guarded in its statements while insistent on the right to linger over compositions as gorgeous as they are elusive in meaning: the surface of the river in which a girl is drowning off camera, an event we glean only from the sudden interruption of the revolutionary song she is singing *(Yellow Earth),* tribesmen in demon masks circling endlessly around a fire *(Horse Thief).*

Purposely "empty" images and gestures clearly have a liberating significance when they follow such oppressively legible productions as *The Detachment of Red Women* and *Flowers of Friendship Blossom in Table Tennis Tournament.* The most radical goal Tian Zhuangzhuang could assert in a 1986 interview (in tones that to hardline ideologues must have sounded as maddeningly self-assured as the aphorisms of Oscar Wilde) was a self-indulgent hermeticism indifferent to audience comprehension:

> I shot *Horse Thief* for audiences of the next century to watch. . . . There are economic losses at the moment, but they're necessary. . . . If I had to depend on explanation, I couldn't have made the film.

The result can be a work like Chen Kaige's *The Big Parade* (1985), a formally alluring, almost plotless fiction film about soldiers in training for the annual military parade in Tiananmen Square, into which can be read almost any political undertone the viewer—at any rate the Western viewer—cares to find there. When an officer declares that "only good drill will bring us honor," one hardly knows with what degree of irony, if any, to take it. Is *The Big Parade* most akin to *Full Metal Jacket? Olympia? Sands of Iwo Jima?* A television spot for the army reserve? Should one take it as an individualistic protest, an imposed piece of militarist propaganda, a humanistic examination of teamwork, a subversively homoerotic evocation of male cameraderie? Or is it none of these, but rather an exercise in the kind of gratuitous abstraction that was for so long an ideological misdemeanor in China? Seen at a distance from its Chinese context, the movie seems a decorative object

from whose textures and patternings—the zigzagging geometrics of troops on maneuvers, the sweat glistening on rows of anonymous faces, the shimmering haze in which the recruits stand at attention for hours, a soldier's tears falling on his rifle as he cleans it for the last time—the pressures brought to bear on it must be dimly extrapolated.

THE PRESSURES AT WORK in the commercial cinema of Hong Kong (which in the 1980s produced more than two thousand films) are of a more familiar nature, revolving around market share, profit margins, and the need to keep one step ahead of television, video games, and the encroachments of global entertainment cartels. Compression and competition give the industry a particularly ferocious quality, as its controlling companies fight to keep both employees and rivals in line. As the director Allen Fong has described it, "It's extremely condensed capitalism—a type you can't find anywhere in the world. We're more capitalistic and cut-throat than the United States. If you survive Hong Kong society, you can survive anywhere."

Hong Kong has the distinction of being one of the few places left whose population, given a choice, prefers its own movies to the American product; the global hits of Spielberg, Stallone, and company are regularly outgrossed by locally made comedies, sex movies, ghost movies, gangster movies, gambler movies, and hybrids of all these genres and more. Taken together, Hong Kong movies constitute a single metanarrative incorporating every known variant of sentimental, melodramatic, and horrific plotting, set to the beat of nonstop synthesized pop music. The hundreds of movies—hardly any of them more than a few years old—on display in the video outlets of New York's Chinatown suggest that Hong Kong is one of the last outposts of the kind of efficaciously formulaic medium-to-low-budget filmmaking that in America faded along with the studios. To watch Tsui Hark's *Shanghai Blues* (1984) or John Woo's *A Better Tomorrow* (1986) or Ricky Lau's *Mr. Vampire* (1985) is to sense the presence of an audience to whose response the cadences of pratfall, shock effect, and streetwise banter have been expertly calibrated.

Nothing could be farther from the meditative languors of the Fifth Generation. The images are not lingered over: they tumble one into the next with careless abandon, surrounded not by silence but by noise. Hong Kong at

present makes the most raucous and least contemplative movies on the planet, movies that by turns recall the spirit of Abbott and Costello, George Raft, Bela Lugosi, Gene Kelly, and Cyd Charisse. Hopping ghouls, cartwheeling comedians, heroines who sing and fire machine guns with equal flair, vampires kept at bay by chicken blood and sticky rice, passionate gangsters caught up in ruthless dynastic struggles, martial-arts masters who set off cascades of special effects at the least flourish of their fingers: the hyperactive characters who inhabit Hong Kong cinema make the energy level of Hollywood types like Kevin Costner and Bruce Willis seem torpid by comparison.

Hong Kong movie production historically has owed everything to events on the mainland. Influxes of filmmakers from Shanghai—in response to the Japanese invasion in 1937, to political pressures from the Kuomintang government (which, for example, banned ghost and martial-arts movies), and finally to the Communist victory in 1949—expanded what had been a relatively small-scale local film industry into the worldwide center of Chinese-language filmmaking, selling to a market that includes Taiwan, Southeast Asia, the Western diaspora, and—only in recent years, and fitfully—China. The paradox of such a small place becoming one of the key communications centers on the planet may account for much of the peculiar intensity of Hong Kong movies.

The dominant genre for most of the postwar period—as it had been (along with operas and ghost stories) from the earliest days of filmmaking in China—was the martial-arts film, a term that covers everything from traditional swordplay epics to contemporary thrillers about back-alley gang wars. The assembly-line efficiency with which Hong Kong turned out such films in their heyday can be gleaned from the series of movies about Huang Fei Hong, a revered martial-arts master of the Manchu period, described by the French film historians François and Max Armanet as "an 85-film cycle made between 1949 and 1969. . . . In 1956, the record year, 28 Huang Fei Hong movies were made." Geared as they were to an audience that knew all the plots and all the codes of behavior, with the same stories being told over and over, these films might have seemed the epitome of localized moviemaking with no wider international future.

The 1960s were dominated by the richly colored historical adventures

that were the specialty of Shaw Brothers Ltd., the Hollywood-style production company directed by Sir Run Run Shaw. Shaw, the extraordinary Shanghai-born mogul who parlayed his family's string of movie theaters in Singapore and Malaysia into a near-monopolistic control of the Hong Kong film industry, had no major competition until his longtime associate Raymond Chow broke away to found Golden Harvest in the early seventies. It was Chow, not Shaw, who had the prescience to sign Bruce Lee to a contract.

The Shaw productions were steeped in a nostalgia for imperial China and still bore stylistic traces of the gaudy, stylized, and acrobatic traditions of Chinese opera. Drawing on the enormous resources of the Shaws' Movie Town, a forty-six-acre complex (shut down since 1987) encompassing sound stages, permanent sets, labs, and dormitories, these movies seemed intent on preserving a lost China, re-creating it with a limitless inventory of brocades and lacquerware and a timelessly unreal palette of red, gold, and blue. The films of this era are difficult to see nowadays, but some sense of their robust elegance can be derived—despite atrociously dubbed dialogue and the loss of the original Shawscope proportions—from the video version of Chang Cheh's *Seven Blows of the Dragon,* a tale of heroic outlaws derived from the fourteenth-century novel *Water Margin.*

The finest flowering of the traditional martial-arts film was the work of the director King Hu, who turned historical epics into flamboyant exercises in near-abstraction. In *The Fate of Lee Khan* (1973), *Raining in the Mountain* (1979), and above all the three-hour *A Touch of Zen* (1969), he integrated lighter-than-air combat sequences (often featuring the irresistible female star Hsu Feng) and tautly orchestrated palace intrigues with a richly imagined landscape of mountain gorges and hidden monasteries, spiderwebs and sun glare, bamboo groves and jagged wastelands. *A Touch of Zen* remains an unsurpassed masterpiece of Chinese filmmaking; but commercially King Hu's poetic adventures received only marginal international distribution by comparison with the cheaper, more rough-edged kung fu movies that by the mid-1970s had proliferated beyond what anyone could have predicted.

The revolution that transformed Hong Kong moviemaking will deserve a chapter when the media history of the 1970s is sorted out: the Kung Fu Moment in which Bruce Lee abruptly became (with the possible exception

of Muhammad Ali) the most recognizable human being in the world. It was the moment when spaghetti westerns went kung fu (*The Stranger and the Gunfighter*), Hammer horror movies went kung fu (*The Legend of the Seven Golden Vampires*), porno went kung fu (*Sexual Kung Fu in Hong Kong*), Sam Peckinpah went kung fu (*The Killer Elite*), and even reggae and disco went kung fu to the strains of "Fu Man Version" and "Everybody Was Kung Fu Fighting."

The kung fu genre erupted into the burnt-out end of the sixties somewhat like Bruce Lee injecting himself into the middle of somebody else's brawl. Lee—born, as it happens, in San Francisco, where his father's Cantonese Opera troupe was appearing—was a child star in Hong Kong movies of the fifties, and returned to the United States to work as a martial-arts instructor, stunt supervisor, and actor (he played the Oriental houseboy Kato on the television series *The Green Hornet*). His first starring vehicle for Golden Harvest, *Fists of Fury*, made in Thailand in 1971 for something like fifty thousand dollars, tells the bare-bones story of a Chinese worker seeking vengeance for a murdered relative and in the process uncovering a drug ring. The direction (by veteran Lo Wei), devoid of effects or style, left it up to Bruce Lee to carry the movie with nothing but the mesmerizing self-assurance of his kicks, leaps, and lunges, punctuated by ominous vocal effects and hand gestures. *Fists of Fury* outgrossed *The Godfather* in many locations, and gave America its first Asian superstar since Sessue Hayakawa.

Lee's fight scenes restored a sense of real combat to Western audiences accustomed to movies in which stuntmen and stand-ins did most of the difficult stuff. With Bruce Lee, the stuntman became the hero. If the musical died, it was in order to be reborn as the martial-arts movie. Lee's genius lay not in extraordinary martial-arts mastery but in his Astaire-like sensitivity to spatial relations and camera placement. The climactic bare-handed duels in *Fists of Fury* and *The Chinese Connection* retain a choreographic delight transcending the rudimentary narrative.

Indeed, from the standpoint of Western viewers unfamiliar with earlier Hong Kong productions, *Fists of Fury* (or *The Big Boss*, as it was also known) seemed remarkable for the way it pared away superfluities of characterization and dramatic development to yield the purest possible action movie, predicated on the slow burn leading to a climactic convulsion of rage. The virtuous Bruce Lee, determined to refrain from violence, determined to

remain loyal to his industrialist employer, maintains his self-control in the face of increasingly gross provocations until — finally aware that his employer is a drug dealer and the murderer of Lee's friends and loved ones — he makes up for lost time by single-handedly overturning an entire power structure. He take on an army of bodyguards before confronting the Boss himself (who, in keeping with the rules of genre, is not merely ruthless and powerful but a martial-arts master as accomplished as Lee) in a lovingly protracted duel on the manicured lawn of the Big Boss's Western-style mansion.

THE TRANSITION FROM STATELY, tradition-bound costume dramas to the violent directness of the kung fu movie owed much to the influence of Japanese *chambara* movies (the term is onomatopoeia for the clashing of swords). The traditional samurai genre had been revitalized in the early 1960s by a string of violent, starkly stylized films including Akira Kurosawa's *Yojimbo* and *Sanjuro*, Masaki Kobayashi's *Harakiri* and *Samurai Rebellion*, Kihachi Okamoto's *Sword of Doom*, and Hideo Gosha's *Tenchu* (in which Yukio Mishima was given the chance to enact a dress rehearsal for his imminent suicide). Most enduringly successful was the long-running series detailing the peregrinations through feudal Japan of the blind masseur and master swordsman Zatoichi, whose hypersensitive hearing enabled him to fend off twenty or more ambushers at a time as easily as he killed a fly in midair with a pair of chopsticks. (The masseur's popularity throughout East Asia is indicated by *Zatoichi Meets His Equal,* in which he encounters his comparably handicapped Chinese opposite number, the One-Armed Swordsman; two endings were shot so that the local favorite would always come out on top.)

The *chambara* movies' mix of gritty, often gory realism, soaringly lyrical camera work, and the nastiest of black comedy culminated in such characteristically excruciating passages as the scene in *Harakiri* in which a masterless samurai, maneuvering for a handout by declaring his intention to commit ritual suicide, has his bluff called and is forced to disembowel himself with a blunt bamboo sword. They were among the great unacknowledged influences of the 1960s, leading directly to Sergio Leone's *A Fistful of Dollars* (which went so far as to lift *Yojimbo*'s scenario outright) and the slow-motion blood geysers of Sam Peckinpah's *The Wild Bunch.*

Yet the Japanese movies did not enjoy the same kind of global success as

the kung fu cycle; and whatever stylistic devices the Hong Kong filmmakers may have appropriated, the tone of their films remained entirely different from the Japanese, eschewing the strain of pessimism and ritual cruelty that informs movies like *Lightning Swords of Death* or *Trail of Blood*. The Japanese *Sword of Doom* and Bruce Lee's *Chinese Connection* have similar endings — the fatally wounded hero, in violent motion to the end, is caught in freeze-frame as he manages one final burst of energy — but there is a world of difference between the demonic killing mania of Tatsuya Nakadai's psychotic swordsman, hacking at shadows as the world around him goes up in flames, and the radiant enthusiasm of Bruce Lee's avenging hero, triumphant even in death. The kung fu movies were about feeling strong, while the Japanese sword movies were often about feeling annihilated.

The stylistic elaboration of the Japanese *chambara* would in any event have been out of place in the kung fu movies, which preferred a head-on approach, with no frills to impede the performers' moves. Beyond matters of tempo and mise en scène, the Japanese films were restricted in their range of influence by being so uncompromisingly Japanese, their tortuous plotting relentlessly inflected by the labyrinthine configurations of Japanese feudalism. Caught up in a series of obscure political conspiracies, clan vendettas, and endlessly splintering intrafactional conflicts, the uninitiated viewer rarely found it easy to determine which side the lethal contenders were on.

Kung fu movies, by contrast, moved through fine cultural distinctions with the force of a sandblaster. A fight was a fight. The vision of a freelance army of Third World street fighters kickboxing their way through all obstacles proposed an apocalyptic self-sufficiency just right for a moment when governments and revolutions alike seemed to be foundering. An unarmed fighter smashing through the complexities of technology by a combination of physical training, spiritual discipline, and simple enthusiasm was powerful enough to override any competing imagery. The martial-arts notion of the body as deadly weapon had hitherto provided sight gags for Peter Sellers comedies — Bruce Lee himself had served mainly as comic relief when he tried his karate moves on a hard-boiled and unimpressed James Garner in the 1969 Raymond Chandler update *Marlowe*. Now it became the occasion for a sacrament of violence, an invigorating equation of destruction and moral justification.

The mythology of kung fu was deepened and expanded in the desperate

days that followed Bruce Lee's death at the age of thirty-two after making only four films. In an effort to stave off the catastrophe threatened by the disappearance of the genre's only worldwide star, Hong Kong filmmakers reverted to the historical trappings that Lee had rejected. The Buddhist Shaolin Temple, legendary center of martial-arts studies, founded in the sixth century and destroyed by the Manchu dynasty in the eighteenth, represented a perfect fusion of wisdom and power, spiritual grace and physical force. The longing for a virtuous, hermetic task force dedicated to the secret righting of all wrongs proved an equally seductive motif in American ghettos, Andean provincial outposts, and Parisian cinematheques, providing an all-purpose metaphor for rebellion and resistance. (As an indication of the enduring significance of these movies, a *New York Times* report on insurgency in Burma from March 22, 1992, notes in a description of a rebel camp: "On one morning not long ago in Manerplaw . . . the loudest sound was the dubbed English soundtrack of an old Hong Kong–made Kung Fu movie. The movie was being shown on video to several dozen young Karen soldiers as part of a wake for a dead comrade. . . . His body, set on a platform a few feet from the video screen, was covered by a thin white shroud, awaiting burial.")

At one extreme, the cycle produced increasingly sadistic scenes of bone-cracking, eye-gouging physical punishment; at the other, a more homogenized international version was achieved with the American television series *Kung Fu* (1972–75), starring David Carradine, in which the lineaments of the tough fighter were softened with the more benign characteristics of the vision-seeking hippie as Carradine's displaced Shaolin monk wandered in road-movie fashion through nineteenth-century America. (Thereafter, the martial-arts film lost its Oriental connotation at the hands of Chuck Norris [*Forced Vengeance*], Jean-Claude Van Damme [*Lionheart*], Steven Seagal [*Marked for Death*], and other martial-arts masters turned box-office champs; today a karate movie is as likely to be produced in South Africa as in Hong Kong.) In the best examples of the genre, however, the grace and flexibility of the performers — augmented by razor-fast editing, slow-motion trampoline leaps, and the guttural and percussive punctuations of the soundtrack — created unmediated cinematic pleasure. The movie did not represent anything at all; it presented.

———————

THE SAME DIRECTNESS INFORMS the hits that roll off the Hong Kong assembly line nowadays. The martial-arts component is no longer the main attraction, but it is still there, taken for granted: an essential ingredient of the repertoire of such Peking Opera–trained stars as Jackie Chan and Sammo Hung. Thanks in part to that theatrical tradition of bravura acrobatics and onstage combat, the Hong Kong cinema retains an athleticism that Hollywood, with a few fleeting exceptions, lost after the era of Douglas Fairbanks and Buster Keaton. These days, however, kung fu often figures as an occasion for comedy, as in the energetically staged leaps, chases, and brawls of Jackie Chan's *Project A* (1983) and the supernatural shenanigans of *Mr. Vampire* and its hundred spin-offs. (The potential for physical comedy in the horror genre—dimly sketched in such American productions as *Abbott and Costello Meet Frankenstein* and the Martin-Lewis *Scared Stiff*—has been developed in Hong Kong into a sprawling subgenre pitting whole armies of ghosts, monsters, and the living dead against an assortment of resourceful clowns. Ghastly special effects bring to life a rich tradition of Chinese horror quite different in tone from the seductions of Gothic Romanticism. These vampires and ghouls—leechlike, ravenous, preternaturally strong, and apt to travel in packs—are quite inhuman creatures, with the odor of the grave and decaying subterranean organisms about them.)

In the kung fu era, relentless dubbing (into cartoonish "Oriental" voices) made the soundtrack something to be endured rather than enjoyed. Dubbing could certainly never do justice to the verbal tones and speech rhythms essential to the charm of movies like *Peking Opera Blues, Project A,* or *God of Gamblers,* in which characters spend considerable time hurling rapid-fire insults and complaints at one another. The actors in these films are able to uncover infinite variations in the art of yelling. For all their special effects and jazzy editing, recent Hong Kong movies are primarily driven by their actors. Star performers like Anita Mui, Leslie Cheung, and Sylvia Chang combine comic flair, toughness, and glamor in ways that recall Hollywood in the 1930s.

In this respect Chow Yun-fat, the star of *A Better Tomorrow, The Killer,* and *God of Gamblers,* is the exemplary performer, with a vocal range permitting him to range from lachrymose pathos to hard-boiled repartee; at moments he recalls James Cagney, and the persona he incarnates has much

in common with Cagney's agile and unrelenting working-class heroes. He lends an unfailing air of conviction to the outrageous plot twists in which his characters have a tendency to become enmeshed — twists that would themselves have been perfectly at home in the early 1930s: in *God of Gamblers,* a blow on the head turns him from a James Bond–like cosmopolite into a near-infantile naïf, while in *The Killer* he plays a professional assassin who undertakes one last killing in order to pay for a cornea transplant for a woman he blinded inadvertently during a previous shootout.

Hong Kong movies are more notable for their storytelling than for their stories. The narrative tradition out of which they have evolved, which values the force of the episode and the flow of moment-to-moment continuity over large-scale schemata and tidy resolutions, might be traced all the way back to the marketplace story reciters of ancient China, the enormous classical novels like *The Romance of the Three Kingdoms, The Journey to the West,* and *Water Margin,* the endlessly recycled stock types and situations of the Chinese opera. This is not to imply a lack of shape, quite the contrary: but the shape develops out of gradual accretion and adaptation rather than from following the strict lines of a blueprint. The uncannily lifelike quality of ancient Chinese fiction has a great deal to do with the way new characters and elements keep entering the situation, the way events move too fast to tie up all loose ends. In a comparable fashion, the improvisatory messiness of Hong Kong movies — with their lurches of mood and their digressions that unaccountably become the main story line — gives them, despite their fantastic premises, a sense of underlying gritty reality.

That sense of reality is played off against a luxurious surface sheen. At first viewing, the spectator may feel that the historical and spiritual themes that informed earlier visions of imperial swordsmen and Shaolin monks have been peeled away to disclose a cynical art of survival in an implacably material world well stocked with consumer goods. The "newness" of the new generation is signaled by a consistently bright and shiny look, and an optimistic energy no matter how tragic a turn the scenario takes. A critic has written reproachfully of Tsui Hark's *Shanghai Blues* (1984) that it "looks and sounds like a ninety-minute commercial"; that may be the point. The movie declares itself unencumbered by the past, part of a worldwide marketing universe in which only the freshest and most eye-popping packages survive.

Yet Tsui Hark — a Vietnamese-born filmmaker who came to Hong Kong at age fifteen and subsequently spent eight years studying in Texas and New York — speaks in interviews of roots and heritage, and is influenced as much by traditional Chinese storytelling as by the special-effects technology and disjunctive editing that are his trademarks. It is his particular genius to combine the flavor of very ancient narrative with a jarringly futuristic tone: folktale as video game. (His newest film, the two-part *Once Upon a Time in China*, goes so far as to revive the 1950s martial-arts hero Huang Fei Hong with an exuberant inventiveness that may rejuvenate the kung fu genre.) As director (*Peking Opera Blues, Zu: Warriors from the Magic Mountain*) and producer (*A Chinese Ghost Story, The Killer, Swordsman*), Hark has emerged as the most influential figure of the past decade, a virtuoso of high-speed narration and optical panache whose films sometimes resemble a music video codirected by Jean-Luc Godard and Steven Spielberg.

At his best, as in the period comedy *Peking Opera Blues* (1986), his interlocking machinery of cues and responses induces a euphoria in which one is happy to mistake the screen's leaps and convolutions for a semblance of reality. The movie, set in a fantasy world that purports to be China in 1913, mixes together an assortment of warlords, government spies, assassins, student revolutionaries, and the representatives of a mysterious entity identified in the subtitles as "the Ticketing Office" and drops them into the midst of a theatrical company with all its machinery of deception. The result is a constantly evolving game of concealment, evasion, and disguise, in which trysts, cabals, masquerades, and police raids become inextricably entangled with theatrical illusion, culminating in a finale in which the disguised heroes make their escape through the roof of the theater. The cutting throughout is so rapid that one actually needs to see the film twice, once to watch the images and once to read the subtitles. Hark cultivates giddiness as a deliberate style, and even the occasionally lethal violence is not permitted to dampen the festive atmosphere: indeed, one of the best gags involves a resourceful heroine extricating herself from a difficult situation by pretending to make love with the general she has just murdered.

A characteristic Hark production evokes the experience of watching several different movies at once. He raises to its highest pitch the tendency of Hong Kong films to mix genres with abandon, allowing for radical shifts in

emotional tone from scene to scene. The grimmest of melodramas will explode unexpectedly into farce, and a horror movie will interrupt its exorcisms and eviscerations for a romantic musical interlude. *A Chinese Ghost Story* (1987), for instance, oscillates continually between the comic and the horrific, while remaining grounded in a poignant love story on the traditional theme of a naive young man infatuated with a beautiful ghost, a melange held together by an up-to-the-minute electronic soundtrack in which a Taoist monk's mantric patter is made to sound uncannily like an archaic anticipation of rap.

Hark's supernatural extravaganzas—*Zu: Warriors from the Magic Mountain, Swordsman, A Chinese Ghost Story*—restore something of the fantastic quality of the silent films of Georges Méliès; their transparently fake special effects are to be savored for decorative value rather than any quality of realism. The supernatural movies hurtle through a space whose coordinates alter from shot to shot, as protagonists catapult themselves from one dimension to another, plunge into microscopic nether regions, or go into free fall through etheric spirit zones, emitting luminous tendrils and changing shape at will. (Here again the link with traditional fiction is strong, for example with the contests of magic in *The Journey to the West.*) The screen becomes an arena from which everything not flagrantly unreal has been rigorously excluded, a condition exhilaratingly close to the landscape of dreams.

THE SENSE OF GAUDY UNREALITY persists even in movies ostensibly set in the contemporary world, like the gangster trilogy *A Better Tomorrow* (1986–89), directed by John Woo and Tsui Hark, in which swords and thunder kicks are replaced by calligraphic cascades of automatic-weapons fire. The psychic space elsewhere commandeered by monks and demons becomes a geopolitical hyperspace linking Hong Kong, New York, and Saigon. The characters shuttle from point to point, executing a complicated dance of conspiracy and betrayal redeemed by periodic arias of fraternal loyalty. Questions of motivation and story logic have about as much relevance as in Italian opera: the question is only what will make for the most rousing scene.

From *A Better Tomorrow*'s opening image of Chow Yun-fat, in dark glasses and tailored suit, lighting a cigarette with a counterfeit hundred-dollar bill, a sleek and ruthless tone is cultivated: this is the universe of power, of high-

rises and cellular phones. But it has the same dreamlike instability as the magic mountains and ghost-haunted villas, an instability that mirrors the uncertain loyalties of the gangsters who spend their lives conspiring to wrest power from one another. There are no secure bastions. No interior, no matter how expensively decorated, is safe from sudden incursions of explosive violence.

Like every other place in Hong Kong movies, the city of the successful is a malleable space that can be transformed or swept away by the force of desire, in this case the desire for revenge. The premise of movies like *A Better Tomorrow* and *The Killer* is that deep and sincere feeling has the volcanic power to overwhelm the world around it. Their fundamental story is that of the loser who triumphs, the wronged man who comes back. The triumph remains complete even if the avenger also has to die, as is frequently the case — a small price to pay for the emotional satisfaction of bringing the world down with him. The image of Chow Yun-fat, in *A Better Tomorrow*, riding in a speedboat toward the harbor where his enemies are all gathered together, his machine gun blazing and his face erupting in a victorious grin, evokes not death and destruction (the bloody results of all that gunfire are barely indicated) but a blissful erasure of the world and its encroachments.

This is not to say that history is successfully bypassed. By necessity it is everywhere, in everybody's family story and in the oppressive contingencies of geography. The heroes assert a freedom whose impossibility is tacitly acknowledged by their frequent failure to survive the last reel. They do not so much participate in historical events as try to find a way to live in their shadow. In *A Better Tomorrow III*, the fall of Saigon is simply the catalyst for a private melodrama involving the loves and power struggles of glamorous black marketeers.

Even the military heroics of Sammo Hung's *Eastern Condors* (1986) is given an aura of cartoonish fantasy. The American withdrawal from Vietnam opens the way for a Hong Kong paratrooper team to pick up where the Green Berets left off; the setup provides for more or less broad parodies of *The Dirty Dozen, Rambo,* and *The Deer Hunter,* not to mention *Stagecoach,* reenacted with an ox-drawn cart galloping madly to evade Vietcong sniper fire. Nothing suggests that a serious political point is being made when one of the team kicks away the butt of a machine gun with kung fu footwork —

beyond the proposition that if the cut-and-run science of street fighting were carried into the jungle, hooligans from Hong Kong could outfight the Vietcong any day. They have no real reason for being there anyway, and the film's final recriminatory line puts the blame where it is perceived to lie: "Fucking America! Goddamn America!"

Of modern-day Hong Kong itself not all that much can be seen; there is little of the travelogue footage so conspicuous in the grandiose miniseries adapted from James Clavell's *Noble House* or in Mitsuo Yanagimachi's multinational thriller *Shadow of China* (1990). As the last great producer of studio films, Hong Kong specializes in making fantasies visible. A few of the more realistic crime films (*The Long Arm of the Law, Gangs*) offer glimpses of battered backstreets and brief vistas of neon, but this mode of filmmaking suggests a world in which real estate is at a premium. The intensity of the confrontations has a great deal to do with the sense of the characters being crammed together in a confined area.

For instance, in Lawrence Ah Mon's *Gangs* (1988)—an unusually glum juvenile-delinquency saga whose teenage protagonists smoke heroin and play video games in between gang rapes and turf battles—no one is ever alone. There is nowhere anyone can walk without running into some of the other characters. In such a tight little world, questions of turf are clearly paramount, and among the refugees and illegals of Hong Kong there are scapegoats to spare, outlanders like the hopelessly rural and inept mainland criminals whose schemes come to a bloody end in *The Long Arm of the Law* or the Vietnamese-born villain of *God of Gamblers*. As the racketeer tells his hit men in *Gangs*: "Any more screw-ups and it's back to China for you."

A FEARFUL UNDERTONE OF GEOGRAPHICAL precariousness hovers around these movies, although it rarely surfaces with such painful explicitness as in the last shot of Ann Hui's anti-Communist polemic *Boat People* (1982): the heroine and her surviving family, after passing through the tortures of the damned in their efforts to escape from Vietnam, are abandoned in a freeze-frame to the emptiness of the open sea. The movie's uncharacteristic documentary style (at the time of its release it was taken as the harbinger of a new realism, which failed to take hold) further erodes the security zone established by the brilliant artifice of the studio films.

Themes of separation and homelessness impinge even on the most commercial projects. In *A Better Tomorrow II,* a couple of displaced Chinese racketeers stand in a Long Island field staring across at the Manhattan skyline and exchange a melancholy dialogue:

"This is after all not our place."
 "Many try to leave at all costs. Many want to go home. Many cannot even find a temporary place to live."
 "One's home is always better."

Or, as a character in *Peking Opera Blues* chimes in: "The world is so big. Where can I run? Everyone is running away." Dispersals, farewells, reunions, memorials: between the comings and goings there are few moments of durability and stillness. The restless energetic movement that gives the movies their vitality implies that to stop moving is to become a sitting target.

Tsui Hark's *Shanghai Blues* plays on a nostalgia for the Shanghai of the 1930s, which is also a nostalgia for the sort of coincidence-ridden plotting in which the Astaire-Rogers musicals reveled: identities are mistaken, long-separated lovers live next door to each other without knowing it, an aspiring songwriter finds sudden fame, an unemployed young woman accidentally wins a beauty contest. The predominantly farcical tone is sweetened by a constant sentimental undertone that bursts out in images of the hero playing his violin on a tenement rooftop at night, against a backdrop of neon signs, or a young woman fighting her way across a crowded railroad platform just as the last train to Hong Kong is carrying her friends away. The escapism, so carefully crafted and self-aware that it becomes an analysis of escapism, has a cruel aftertaste: even the most unreal of movies is finally forced to accept an inevitable cataclysm.

No movie evokes separation across abysses of time and space more movingly than Stanley Kwan's *Rouge* (1987), in which a 1930s courtesan who committed suicide for love returns to modern-day Hong Kong in search of her lover, who somehow survived their suicide pact. Moving back and forth between past and present, the film alternates between the voluptuous slowness of a vanished culture symbolized by the color schemes and rhythms of Peking opera—a culture lending all its aura to a luxuriously extended love-suicide—and the more drab, antiheroic, wistfully comic present, whose

grayness is barely offset by omnipresent consumer goods and by the pyro-technic effects of the supernatural adventure movie whose filming provides the background for the climactic sequence. Only a Hong Kong movie would dare to be so divided against itself, oscillating between two altogether con-tradictory moods as if to deflate its own nostalgia in acknowledgment of an unavoidable and unbridgeable gulf.

In terms of film production, however, the pre–1997 tactics seem to center on bridge-building between Hong Kong and the mainland. Signs of immi-nent convergence are apparent in the increasing number of international coproductions and Chinese–Taiwanese–Hong Kong–Japanese–American hybrids. (Zhang Yimou's *Raise the Red Lantern,* for instance, while filmed in the People's Republic, is in fact a Taiwanese–Hong Kong coproduction.) This process can result in a clunky curiosity like *Code Name Cougar* (1989, codirected by Zhang Yimou and Yang Fenliang), a would-be edge-of-the-seat hijacking thriller whose Maoist-style rhetorical devices (a huge close-up of clasped hands to signify Chinese-Taiwanese cooperation) alternate uneasily with awkwardly timed bouts of bloodletting.

But at least in this competition over cultural fusion Hong Kong appears to be winning the style wars. Kung fu movies (although now only one genre among many) have remained viable by expanding their scope, with the whole of China to play with instead of just the Shaw Brothers back lot, mak-ing possible the dazzling vistas and cavalcades of Ann Hui's *Romance of Book and Sword* (1987), an epic of dynastic struggle between Han Chinese and Manchu overlords. The archaeological treasures of Xian—not to mention several thousand more extras than one expects to see in a Hong Kong movie —give an unaccustomed solidity to the fantasy comedy *A Terra-Cotta War-rior* (1989), in which Zhang Yimou and his star Gong Li, under the direction of Hong Kong special-effects expert Ching Siu-tung (*A Chinese Ghost Story*), display an unexpected gift for comic turns and romantic silliness. The solemn pageantry of the first half gives way to noisy slapstick as the terra-cotta warrior of the title comes to life in the twentieth century in order to unite with his reincarnated lover. The resulting clash of moods, in which an august archaeological monument is enlisted in the service of frivolous sight gags, is no doubt an indicator of a coming era of unpredictable fusions.

If anything, the new grandeur of scale runs the risk of detracting from the

reckless, catch-as-catch-can improvisation and picaresque flexibility that characterize Hong Kong's recent movies: but that is one among the many pitfalls lurking for an industry that has until now been strengthened by its isolated independence. Already some directors and actors are being lured away to Hollywood; many of the money men behind the Hong Kong industry are likely to be among those who take the escape route to North America in 1997; and the continued dominance of conservative forces in Beijing has led to a momentary resurgence of old-style, big-budget, thoroughly unpopular propaganda movies, while work with less official approval continues to circulate more or less freely in the samizdat of videotape. The permutations and compromises to come can only be guessed at in a situation that changes daily. It is only one of the ironies of the situation that the potential dangers of 1997 can make a frankly commercial, assembly-line cinema—dedicated to nothing more than the fleeting pleasures of spectacle and narration— look somewhat like an endangered ecosystem.

The New York Review of Books, September 24, 1992

Endless Present

THE FUTURE WAS THE airbrushed billboard that under pressure of rain and glare gradually peeled away to show the past that had been at work underneath all along, the archaic realities alive and well as always: witchcraft delusions in New Jersey and Oregon, collapsing dynasties and wars of religion all along the ancient trade routes, erosions and syncretisms of mutually exotic knowledge systems in the brusque decentered global downtown. All it took was a single displacement—a brick from the Berlin Wall, say, or footage of the Spanish Civil War broadcast live from the Dalmatian coast—to burst that charmed state of suspension within which the Cold War world constructed its fantastic future. The world it feared—of mechanistic precision, of a countdown beyond human control—gives way to an unanticipated randomness, a profusion of rapidly mutating pathways precluding the curiously comforting (because so easily grasped) paranoia of the age of nuclear showdown. The illusion of long-term visibility—the highway to the stars, the liberal horizons of the open society—yields to thickets where what crops up is precisely what was thought to have been abandoned in an earlier lifetime, left for dead at the turn of the last century or the last millennium. In that instant of collision with the alien fact of eventuality— when a monolithic Future half a century in the making falls apart as if the Krazy Glue holding it together had abruptly dried out—recent decades conflate in frequently comic fashion (*Woodstock,* for instance, revealing itself as the ultimate summer-stock production of *Oklahoma!,* just another of the discarded futures fit for nothing more than recycling on cable kiddie channels). Instead of the Future, that heaven-or-hell promise of ultimate clarity,

we have the limited prospect of just more history all the time, a continuous present as stubbornly uncommunicable as the seventh century (B.C. or A.D., take your pick). If the future must be sought for—or just enough of a peek to constitute a coming attraction—we are not likely to be better off than the ancient diviners reading sheep's entrails, and must settle like them for gazing into the innards of the present moment.

<div align="right">VLS, September 1993</div>

Quentin Tarantino's
Pulp Fantastic

THE TWO DICTIONARY DEFINITIONS of "pulp" that Quentin Tarantino posts at the beginning of *Pulp Fiction* both have a direct bearing on what follows. The first, "a soft, moist, shapeless mass of matter," recalling as it does the phrase "beaten to a pulp," invokes from the outset those catastrophes of the flesh that are never far away at any moment in the film's two-and-a-half-hour running time.

Physical risk, the possibility of being damaged severely (perhaps irrevocably) by gun, fist, sword, chain, or hypodermic needle, by falling off a roof or crashing a car: these are not so much plot elements as the medium in which *Pulp Fiction*'s inhabitants draw their breath, the background — so omnipresent as to be taken for granted — against which they pursue their endless jags of more or less amiable small talk. This first definition serves almost as a warning of some of the material dangers that await, an appropriate gesture for a movie that ultimately gets comic mileage out of the removal of bits of brain and bone, remnants of an exploded head, from the backseat of a car.

Through all the blood and injured body parts, Tarantino suggests that everything is going to be all right, even if he says it somewhat in the manner of a holdup man pointing a gun at someone's head. That trope — the man of violence as the voice of reason urging calm — becomes literal in the final sequence, in which the principle of "nobody moves, nobody gets hurt" is carried to its logical extreme in a tableau-like standoff, with a gun aimed at every head, that out-Woos John Woo himself. "What is Fonzie?" asks the gunman (Samuel L. Jackson) of Amanda Plummer, who is dangerously close

to a lethal tantrum, in order to break her concentration by eliciting the rote response: cool, Fonzie was cool.

They are all cool: Tarantino may set up a demonic universe, but not for him are the demonic emotions that might be expected to suffuse it. There are two states of being, fear when danger threatens, affectless relaxation at other times: more or less the contrast between adrenaline and heroin (both of which play a role in the movie's most indelible sequence, Uma Thurman's overdose and its comic-horrific aftermath). The old-time noir passions, the brooding melancholy and operatic death scenes, would be altogether out of place in the crisp and brightly lit wonderland that Tarantino conjures up. Neither neo-noir nor a parody of noir, *Pulp Fiction* is more a guided tour of an infernal theme park decorated with cultural detritus, Buddy Holly and Mamie Van Doren, fragments of blaxploitation and Roger Corman and *Shogun Assassin,* music out of a twenty-four-hour oldies station for which all the decades since the fifties exist simultaneously.

The second definition — "a publication, such as a magazine or book, containing lurid subject matter" — appears to announce some kind of homage or pastiche, and Tarantino has remarked that his original intention was "to do a *Black Mask* movie — like that old detective story magazine." But, as he acknowledges, "it kind of went somewhere else." Each of the movie's curiously linked episodes, in fact, kind of goes somewhere else. If *Reservoir Dogs* could to a certain degree be seen as a reshuffling of previously existing movie bits, *Pulp Fiction* enlists its recognizable elements in a superstructure of considerable originality: the order of difference between the two is roughly that between *A Fistful of Dollars* and *Once Upon a Time in the West.*

The end result is indeed far from the hard-boiled detective stories of Dashiell Hammett, Raymond Chandler, or Paul Cain (the stars of *Black Mask's* lineup). It does, however, connect rather powerfully to a parallel pulp tradition: the tales of terror and the uncanny practiced by such writers as Cornell Woolrich, Fredric Brown, Robert Bloch, Charles Beaumont, and Richard Matheson, with their diabolical tricks of fate and wrenching twist endings, a tradition that led (via Beaumont and Matheson) into the cheap but enduring thrills of *The Twilight Zone* (whose theme music as interpeted by the Marketts is very aptly interpolated into *Pulp Fiction's* time-warp soundtrack alongside Link Wray, Dick Dale, Al Green, and Dusty Springfield).

Cornell Woolrich and Fredric Brown were writers who mined the gray

zone between supernatural or (in Brown's case) extraterrestrial horror on the one hand and criminal violence and madness on the other, Woolrich with the humorless intensity of the true paranoid, Brown with a sort of spaced-out whimsy that might have sprung from the brain of an alcoholic reporter steeped in chess and Lewis Carroll. Both dealt heavily in the realm of improbable coincidences and cruel cosmic jokes, a realm that *Pulp Fiction* makes its own.

Just how deeply Woolrich's I-can't-believe-this-is-happening-to-me vision has permeated noir mythology is evident from a partial list of the films based on his work, including *Rear Window, The Leopard Man, The Bride Wore Black, Mississippi Mermaid, The Night Has a Thousand Eyes, Phantom Lady, I Married a Shadow,* and Maxwell Shane's potent quickie *Fear in the Night.* Brown's work has not been so fortunate — only Gerd Oswald's inimitably sleazy Anita Ekberg vehicle *Screaming Mimi* springs to mind — but the diabolically engineered plot twists of his novels *The Far Cry* (1951), *The Wench Is Dead* (1955), *The Murderers* (1961), and his masterpiece *Knock Three-One-Two* (1959) show a clear affinity with the crisscrossing and recursive narrative lines of *Pulp Fiction.*

Tarantino does not exactly dabble in the supernatural, but he bends space and time in ingenious ways and goes so far as to broach the possibility of divine intervention. Horror movies provide a constant reference point — Uma Thurman's eleventh-hour resurrection might have been lifted from *The Evil Dead,* and the sadists into whose clutches Bruce Willis falls have in their arsenal a chainsaw that would have done Tobe Hooper proud. In any event, we are clued early on that we have entered a fantastic world when — in a visual gimmick worthy of Frank Tashlin — the hand gesture by which Uma Thurman signs the squareness she hopes John Travolta will avoid is transformed momentarily into a literal glittering square.

The twist endings of Woolrich and Brown tended to have the effect of a trap snapping shut: the door slams and there's no way out, the nightmare turns out to be real, the hope of rescue is revealed as an optical illusion. The irony of Tarantino's creation is that its twist endings are all upbeat, in each case rerouting a descent into living hell toward an unexpectedly happy ending. If *Pulp Fiction* is not quite "the feel-good movie of the year," it nonetheless imparts a kind of sweet relief, the relief a hostage might feel at being permitted to live another day.

The comedy—and for most of its length the movie consists of little *but* comedy—is charged with the sense that "it didn't hurt as much as I thought it would," or alternatively, "we've still got time to joke around before it starts hurting." It's the banter of, precisely, two hit men killing time between hits with a free-floating dialogue involving Samoans, foot massage, and the French term for "Quarter Pounder with cheese."

Tarantino's vein of chat is steeped in all the speech that came before, in the words of Jim Thompson's schizoid con artists, Charles Willeford's blandly reassuring sociopaths, the laconic schemers in the Parker novels of Richard Stark (aka Donald Westlake), David Mamet's hustlers, in the poker-faced give-and-take of Budd Boetticher's Randolph Scott westerns and Don Siegel movies like *The Lineup* and *The Killers,* and above all in the free-associating riffs of Elmore Leonard's assorted misfits and bandits, the variously wily and demented thieves and assassins who populate *Fifty-Two Pickup, Swag, The Switch,* or *City Primeval.*

Like Leonard, Tarantino works by ear, letting the narrative shape itself around speech rhythms, as if there were all the time in the world for the circular, repetitive exchanges to play themselves out, as if the flow of talk could by itself keep annihilation at bay. Or as John Travolta interjects with exquisitely modulated blankness: "Personality goes a long way." At *Pulp Fiction's* most violently menacing moments, words prove more effective than hardware, from the rapid deal that Bruce Willis cuts with the gangster he has rescued to Samuel L. Jackson's protracted monologue during the final holdup.

It becomes music, the music of storytelling that was what pulp fiction was always about in the first place. From Hammett to Woolrich, from Fredric Brown to Elmore Leonard, the old hands worked to set lengths and obligatory climaxes, with the plot twists falling into place as emphatically as background music scored by Miklos Rozsa or Alex North. Tarantino has absorbed all that, but he takes it into a new moment in which different constraints operate, where spaces feel more wide-open and payoffs are less assured. But it's still just as dangerous: it's always dangerous out there.

Filmmaker, Summer 1994

Emperor *of* Ink *and* Air

Ernest Hemingway once called Walter Winchell "the greatest newspaper man that ever lived"; a long-term employee described him as "almost godlike. . . . He was the king of the world and I was one of the assistant kings." Yet Winchell — the inventor of gossip as a form of mass-market entertainment, the broadcaster whose machine-gun delivery was part of the sound track of his time, the columnist who held court at Table 50 of the Stork Club and made press agents tremble in fear of landing on his "Drop Dead List" — has left little to mark his passage.

Some rasping voice-overs on cable-TV reruns of *The Untouchables,* a few scattered citations in slang dictionaries as the popularizer of "phffft" or "blessed event": not much to show for a career in which for the better part of three decades Winchell effortlessly dominated radio and print journalism and, as Neal Gabler suggests in his richly detailed biography, presided over the birth of the tabloid culture of infotainment and fifteen-minute fame. But after contemplating Winchell's trajectory, few readers will wonder at his almost total disappearance from public memory. By the time Winchell finally left the stage in the late sixties, he had long since worn out his welcome; the go-getting vaudevillian and impish purveyor of showbiz patois and spicy tidbits had mutated over the years into a vitriolic avenger of imagined slights, hurling political and personal smears in the manner of Lear raging at the elements.

The spectacle of Winchell's spectacular decline would have more tragic

resonance if he had more substance to begin with. Watching him in action in Gabler's pages is like studying a mass of adrenaline hurtling blindly forward. To the public, Winchell seemed like a dynamo at the heart of twentieth-century American life, but he remained untouched by the nuances of the society he was helping to mold. Although his acquaintances ranged from Franklin D. Roosevelt to the gangster Owney Madden, from nightclub queen Texas Guinan to FBI director J. Edgar Hoover, the breadth of his associations seems not to have made a dent in Winchell's unbelievably narrow frame of reference. Directing his energy strictly toward staying on top, keeping his journalistic rivals at bay, and maintaining the preeminence of "The Column," he passed through extremes of self-absorption into the outer limits of paranoid vindictiveness.

Gabler's biography, which is admirable for its thorough research and carefully measured assessments, has an underlying grimness at odds with the raffish and exuberant Broadway scene that Winchell converted into part of the national mythology. The superficially colorful elements of that milieu — vaudeville, speakeasies, racketeers, hordes of fast-talking "gintellectuals" and "illiterati" — may add some spice, but Gabler is not especially interested in nostalgic evocation. He is more concerned with how Winchell found a way to package strictly local shtick, the private banter of mostly small-time operators, and turn it into coast-to-coast media fodder.

HIS USE OF LANGUAGE — or, in Winchellese, "slanguage" — was crucial. As Gabler observes, "to know which words were in vogue, to know what 'scram' meant and 'palooka' and 'belly laughs' and 'lotta baloney' and 'pushover,' was like being part of a secret society." Thanks to Winchell, anybody with a nickel to plunk down for the *Mirror* could enjoy the illusion of eavesdropping on the insiders of the Main Stem. The Stork Club was a magic space inhabited vicariously by every reader of The Column. His outmoded critics called it "prodding impudent fingers into intimacies which any gentleman would consider deserving of privacy," but Winchell's millions of fans felt privileged to be admitted as equals to the inner circle.

In the long run, the insiders needed Winchell more than he needed them, and it was through the ruthless dispensing or withholding of plugs that he maintained his power. A Stork Club habitué recalled the protocol of Table 50:

"If he deigned to wave or something, you'd go over to shake his hand. If he ignored you, you wouldn't go near him because he'd be very rude." It was this Winchell, fawned on by celebrities and hungry press agents, who provided the model for what may be his most enduring monument: the unforgettable megalomaniac gossip columnist played by Burt Lancaster in the 1956 movie *Sweet Smell of Success.*

Show business could hardly provide him a wide enough arena for the exercise of power. Franklin D. Roosevelt thought so, too, and successfully steered the columnist in the 1930s into a new role as an unofficial cheerleader for government policy initiatives. Winchell's deep admiration for Roosevelt was clearly one of the strongest emotional bonds of his life, and it was in acting on behalf of FDR that Winchell was to play an unexpectedly heroic part. Taking on congressional isolationists (some of them virtual Nazi sympathizers), Winchell found himself under attack from the anti-Roosevelt right, the target of ferocious anti-Semitic invective and trumped-up legal investigations. (Gabler's account of this episode offers an astonishing gallery of political monsters, from Mississippi senator John Rankin, who publicly described Winchell as "that little communistic kike," to Michigan representative Clare Hoffman, who sought legislation making membership in the B'nai B'rith Anti-Defamation League a federal crime.) His vigorous self-defense won him admiration, however briefly, as a champion of democratic ideals.

There is no doubt that Winchell liked a good fight, but in the long run it was an open question how much he cared what the fight was about. He applauded the excesses of McCarthyism with as much energy as he had resisted the onslaughts of the right-wingers of the war era. He took pride in claiming to have introduced Roy Cohn to Joe McCarthy, and played the "pinko" card with increasing abandon in his attacks on a rapidly multiplying list of enemies, from singer Josephine Baker to *New York Post* editor Joseph Wechsler. The 1950s marked Winchell's painfully slow fall from grace, as his vendettas took on a punch-drunk quality and his family was racked by madness, suicide, and physical collapse. The embittered isolation of his final years makes painful reading.

The final impression is of a man whose energy as performer and scuffler was matched only by his utter lack of self-knowledge. Dorothy Parker's famous description — "He's afraid he'll wake up one day and discover he's

not Walter Winchell"—was borne out only too precisely in the hollow awakening of his last days. A reviewer wrote admiringly of Winchell in his heyday that he was "as vivid as a nerve, and he is all nerves"; when advised to calm down, Winchell's reply was: "Dead people stay calm." In a culture that worshiped "verve" and "zip," he was the perfect leader of the dance, but his life turned into a parable of momentum without direction as he became, in Gabler's words, "another name on the ash heap of celebrity."

Newsday, October 1994

A Kinder,
Gentler Perversity

F EW BIOGRAPHICAL MOVIES can afford to take as their
title the bare name of their subject, without further adornment or explica-
tion. *Napoleon, Cleopatra, Abraham Lincoln, Al Capone, Gandhi* — and now,
Tim Burton's *Ed Wood.* The inevitable response — Who was Ed Wood, and
why are they making a movie about him? — is part of the strategy. Nor does
Burton stand alone in his enshrinement of the mysterious Mr. Wood. In
addition to Burton's film, Wood's career has been celebrated in two docu-
mentaries (Ted Newsom's *Look Back in Angora* and Brett Thompson's *The
Haunted World of Ed Wood*). There have also been a biography (Rudolph
Grey's *Nightmare of Ecstasy*), critical essays, and a succession of retrospec-
tives: all this for a man who died in utter obscurity only sixteen years ago
under the most squalid circumstances.

Edward D. Wood Jr., ex-marine and veteran of Tarawa, onetime carnival
geek, sometime professional female impersonator, collapsed and died on
December 10, 1978, at the age of fifty-four, three days after being evicted from
his Hollywood apartment. He was by then well past what must be called the
glory days of his never very visible career: the brief period in which he
directed a series of extremely-low-budget features including *Glen or Glenda*
(1953), *Bride of the Monster* (1955), *Plan 9 from Outer Space* (1956), and *The
Sinister Urge* (1960), movies so marginally released as to be virtually unseen
outside the circuit of rural drive-ins and urban "grind houses" devoted to the
cheapest of exploitation filmmaking. In his latter decades, wracked by alco-

holism and unable to get financing for such film projects as *I Awoke Early the Day I Died* and *The Day the Mummies Danced,* Wood kept himself alive by writing or directing porno (including a series of super-8 shorts for the Sex Education Correspondence School), contributing short fiction to magazines like *Bi-Sex, Hot Fun,* and *Young Beaver,* and churning out an extravagant number of paperback novels including *Black Lace Drag* (1963), *It Takes One To Know One* (1967), *Hell Chicks* (1968), and *Death of a Transvestite Hooker* (1974).

That such a career, or at least a portion of it, would be the theme of what used to be called a major motion picture is a destiny that Wood himself could hardly have imagined in the wildest delusions of his delirious final years. His posthumous canonization was spurred by his having been pronounced the worst movie director of all time in Harry and Michael Medved's 1980 book *The Golden Turkey Awards,* a heavy-handedly ironic tribute to "the worst achievements in Hollywood history." In the age of instant celebrity, an indelible formula like "worst director of all time" has the value of currency. It is a unique badge, the very definition of "high concept," so irresistible that it must be dutifully repeated every time Wood's name is mentioned in print.

Wood's dubious claim to celebrity was clinched by the revelation that he was a transvestite obsessed with angora sweaters, who frequently directed in drag. In *Nightmare of Ecstasy,* an actor in one of Wood's porno films reminisces: "He was very gentle, very patient. I hate to say this, but for him to direct in the pink baby doll outfit, it just seemed normal!" The angora was just the right fetish to add a personal touch, colorful, unusual, but unthreatening: a kinder, gentler perversity.

TIM BURTON'S MOVIE REPRESENTS the culmination of a sophisticated and highly self-conscious process, by which an unworthy figure has been elevated to an emblematic fame. The Wood phenomenon might be seen as a subversive experiment in manipulating the machinery by which people become famous in America, a collective act of cultural vandalism comparable to dropping LSD in the water supply or voting for a farm animal as a write-in candidate.

The Wood cult (if it deserves the name) began as a satiric response to the solemnities of academic film criticism, complete with mock reassessment,

mock retrospectives, and mock awards. The joke was simple reversal: the most blatantly amateurish elements of Wood's films — their robotic acting, incoherent dialogue, and flimsy sets, their overall atmosphere of desperate and impoverished improvisation — would be singled out for exaggerated praise. The Medveds' tribute, for instance, was a none too subtle pastiche of the kind of orthodox auteurism that might argue, for instance, that the unconvincing process shots in Hitchcock's late films are a deliberate distancing effect: "[Wood's] *mise-en-scène* is particularly intriguing in *Plan Nine* when he shows studio floodlights above his haunted cemetery set. It is also pure genius to instruct an actor to trip over a tombstone, causing the cardboard replica to bend notably."

In the spirit of a collegiate prank, Wood's partisans enacted a revenge on the solemnities of aesthetic veneration, on the very notion of greatness. Call it mass-market camp, terminal irony, or the ultimate triumph of *The Gong Show,* that televised amateur contest of the late 1970s where honors accrued to the freakiest, tackiest, and most singularly ungifted contestants. Camp, which implied a rarefied appreciation of the poetry of fakeness, was succeeded by a delight in stupidity for its own sake, as something to which even the densest spectator could feel superior. The witless, elbow-in-the-ribs narration of *Look Back in Angora* unintentionally emphasizes the point: watching Ed Wood movies makes anybody at all feel like some kind of genius.

The notion of badness as consolation, of the transparently witless and contemptible as an object of sincere affection, isn't to be confused with the discovery of unperceived beauties in ignoble places. It's a style of response that seems to spring from the entrenched but largely unsung ritual of prepubescent children, mostly boys, sitting around in the fifties and sixties and seventies watching bad movies on television and cracking each other up with their sarcastic comments. The lingering traces of that ambience seem to be everywhere these days, from Quentin Tarantino's *Reservoir Dogs* and *Pulp Fiction,* with their casts of gangsters and lowlifes taking time out for endless dissections of old TV shows and pop songs, to the popular cable television series *Mystery Science Theater,* which supplies not only clips from terrible movies but suitably sarcastic running comments, as if today's viewers were too passive to concoct their own wisecracks.

But even a one-joke affair such as "the Ed Wood resurgence" (as it is

sometimes portentously described) doesn't remain simple for long. Once Ed Wood is placed on a pedestal, people start to look at him differently. His apotheosis may have been intended as a mockery of fame, but pseudo-celebrity turns out to be indistinguishable from any other kind of celebrity.

Tim Burton's *Ed Wood* confirms Wood's ersatz legend by adapting it to the most ersatz of classic Hollywood forms, the biopic. By giving Wood's existence the same kind of glamorously fake treatment once allotted to George M. Cohan, George Gershwin, Thomas Edison, and Alexander Graham Bell, by turning Wood's miserably unsuccessful life into a journey through adversity toward triumph, Burton creates a benign parallel world where the last are the first and the insulted and injured are the recipients of all-star tributes. In his pitch-perfect parody, the awe and exhilaration appropriate to the invention of the light bulb or the birth of jazz are lavished on the completion of *Bride of the Monster* or on Wood's heroic decision to wear drag on the set. To cap the effect, the most risible scenes from Wood's movies are reenacted as if they were Jenny Lind's American debut or the world premiere of *Rhapsody in Blue*.

The most remarkable thing about Burton's film, aside from its getting made at all, is its preciosity and arcane allusiveness; the nuances, from the opening tombstone credits (lifted from *Plan 9*) to the flawless impersonations of every last woebegone member of the Wood stock company, are designed to be fully accessible only to those happy few who have memorized every frame of *Glen or Glenda* and *Plan 9 from Outer Space*. An air of self-reflexive decadence hangs over this meditation on some of the most deeply buried episodes of film history. Forget the angora: *Ed Wood* is its own fetish, sleekly stylized, obsessively detailed, and delighting in its own gratuitousness. Yet perhaps it won't matter to the uninitiated, who will find themselves watching a thoroughly engaging comedy, exquisitely shot in black and white, about a band of amusing misfits played with great exuberance by a cast including Bill Murray, Sarah Jessica Parker, and Jeffrey Jones. Wood himself is incarnated by Johnny Depp in an appealing if one-note performance in which boyish enthusiasm predominates.

The New York Film Festival's program notes describe Tim Burton as "champion of the eccentric outcast." In *Ed Wood* he recasts his protagonist as a lovable eccentric, a category of being with which American culture has

historic difficulties, since reclusive or deviant types tend to be imagined as dangerous maniacs. Burton's solution is to evoke the humorous madcaps of screwball comedy; Wood and his cronies (many of whom, if not dangerous, were certainly maniacs) might be descendants of the good-hearted drunkards of Preston Sturges's Ale and Quail Club. The one somber note is struck, magnificently, by Martin Landau in his uncanny impersonation of Bela Lugosi, a performance that begins in campy mimicry and deepens into unsettling intimations of madness and mortality. By putting Lugosi's decline and death at the center of his film, Burton is able to discreetly foreshadow the fate awaiting Ed Wood without having to put it on screen and spoil the festive mood. He also pays the price of having Ed Wood look like a supporting character in his own movie.

The predominantly feel-good tone of *Ed Wood* is summed up by one of its screenwriters, Larry Karaszewski, in an interview in the magazine *Film Threat*:

> Ed is really symbolic of the American dream in a sense that sure he's
> a freak, but he did it his way. He fought for what he believed in. . . . If
> you can get an audience to root for a guy who is sitting there in an angora
> sweater, directing an aging heroin addict, and get the audience to realize
> that these people are lovable, that they're not really freaks, they're nor-
> mal people, then you've done your job.

The implication is that to be lovable one must be normal, and since it is unthinkable that Ed Wood should go unloved, he must be relieved of his demons and reconstructed as a clean-spoken, smiling go-getter with a heart of gold, a figure out of a Horatio Alger novel or a Harold Lloyd movie. A journey into the lower depths becomes yet another recovery of lost innocence. What matters in the end is not what Ed Wood does but the spirit in which he does it: he's the artist as "special" child, the humiliated and despised martyr for art who follows his vision against all odds. As long as the heart is pure, ineptitude and stupidity become badges of honor, and Ed can become an icon, a Prince Myshkin of the exploitation racket.

Burton's movie is far removed from the dark and finally depressing tone of its source material, Rudolph Grey's oral biography *Nightmare of Ecstasy*. If *Ed Wood* exudes good-natured whimsy, the book is something altogether

opposite. It's a bit like sitting around at a wake on Skid Row, awash in maudlin and self-contradictory afterthoughts. Much of it is quite funny if you don't think too hard, such as this bit of directorial analysis by another one of Wood's porn actors: "Eddie let you improvise a lot. A lot. Because he was not stuck to any one particular concept or idea." Or even better, these descriptions of Wood the writer at work: "It all came out of his head just like a machine gun. Real fast. He would sit down and do a whole book in something like four hours. He wouldn't rewrite or proofread or anything." "When he wrote, drinking seemed to help. We used to sit and talk, and it was such a nice progression of drinking and talking, and talking and drinking, and he'd wake up in the middle of the night and he'd think of something, and thank God he wrote most of it on paper. The drinking helped. He was always close to a pencil."

The much-despised genre of oral biography is actually appropriate here, because we don't often get this level of barely articulate dialogue in print:

> My pancreas is shot to hell—I had major surgery for it—and Ed Wood was a contributor! Ha ha ha! I really started drinking when I got with Eddie. Jesus Christ! Everything was Imperial whiskey. Big ones. Two a day. . . . He switched to vodka because Ralph's on Highland and Fountain, which was his source of Imperial, went out of business! Ha ha ha ha! So he switched to vodka!

Grey's book evokes a fallen world where there is no one to shed light, no one to interrupt the relentlessly self-deluding monologues. At moments we seem to be among the real-life models of the Threshold People of whom Wood wrote in the prologue to *Night of the Ghouls:* "This is a story of those in the twilight time—Once human—Now monsters—In a void between the living and the dead—Monsters to be pitied—Monsters to be despised."

As the book traces Wood's final descent, the mood gets downright scary. "It was the kind of place," an acquaintance says of his last apartment on Yucca Street, "when you walked in, you just had the feeling, this creeping feeling all over, that you might not even survive this walk down this hallway." The reader who may have been looking for some good laughs is forced to contemplate, in slow motion, an all-too-real disintegration.

At one point in Grey's book, someone recalls Wood, frustrated at a wrong

turn in the production of *Night of the Ghouls,* crying in the rain somewhere in Westwood: "I love this movie so much, it's almost like part of me. And they're not going to do it to me this time. This movie is my baby—they're not going to take it away from me." There is a congruence between the disproportionate affection Wood lavished on his brainchildren and the deep bonding between the television children and the junk they grew up on. To make a cult of Ed Wood is to establish a human provenance for an otherwise despised object like *Plan 9 from Outer Space.* It's like a reinvention of home and family in a context of maximum alienation and isolation, so that in the end Wood ends up eliciting this sort of testimonial from his fans: "In a curious way, he's an inspiration for everyone who has ever been ridiculed, has ever been maligned, has ever been criticized, has ever failed." (The speaker is John Wooley, the artist responsible for a painstakingly faithful re-creation of *Plan 9* in the form of a graphic novel.)

The notion of an "Ed Wood resurgence" suggests some sort of resurrection from the symbolic swamp of pop culture's lowest depths, a submerged culture of exploitation movies, comic books, and pulp magazines, a culture created by people who lacked whatever skills might have enabled them to graduate to the mainstream of major studio releases, glossy magazines, and best-selling fiction, people who will never be in *People.* Ed Wood is appointed to stand for that culture precisely because he is imagined to possess an unexpectedly otherworldly aura, a faint touch of the visionary surviving in a world of schlock and porno.

SO MUCH FOR THE MYTH. What about Wood's movies themselves? They are only intermittently as bad as has been claimed, without quite being good enough to qualify him as the film poet he clearly aspired to be. *Glen or Glenda,* his most personal film, a plea for tolerance for tranvestites, stands out—for 1953, and for a twenty-nine-year-old filmmaker working on an almost nonexistent budget—as a fairly radical and ambitious effort, no poorer in technical quality than a thousand other bottom-of-the-bill featurettes. With its crazy quilt of styles—mixing narration in the manner of an army orientation film with naturalistically lit scenes of the director, in drag, studying the window of a woman's clothing store, or veering from stock footage of a stampeding buffalo herd into fantasy sequences that might be from

a pseudo-Expressionist crime thriller of the early sound period—it does at least offer constant visual surprise. The later films are more static—varying the camera angle would have made things too expensive—and the visual pleasures tend to be more accidental. Things were evidently moving too fast for him by then, and anything that couldn't be pulled off in the first take wasn't going to make it onto the screen.

Plan 9 from Outer Space is rightly regarded as the most interesting of his later features; it has the charm of a truly infantile schema transferred without mediation onto the screen. Movie scripts are often described as childish, but it is rare to find one that might really have been written by an eight-year-old, a dreamy and rather morbid eight-year-old. Far from being the worst movie ever made, *Plan 9* is a work of startling if inadvertent originality. Its flagrantly cheap and artificial look is indistinguishable in the end from a deliberately chosen style, and who can say it is not? It isn't exactly Jean Cocteau, but those images of Vampira and the Swedish wrestler Tor Johnson wandering endlessly with glazed expressions through a landscape of fake fog and fake tombstones do linger in the mind; they even return in dreams.

And there is Wood's famous dialogue, with its grammar always just enough off-kilter to induce a sudden disorientation: "We've developed a language computer, a machine that breaks down any language to our own." "Ah yes, Plan Nine deals with the resurrection of the dead, long-distance electrodes shot into the pineal and pituitary glands of the recent dead." Then again, if you listen closely you might start to wrest some kind of sense from what is being intoned. For instance, the notion of "solaranite," reiterated at endless length by one of the movie's worried extraterrestrials, according to which the explosion of a single particle of sunlight will destroy both the light's source (i.e., the sun) and everything illuminated by that source (i.e., the universe): a lucid exposition of a truly schizoid concept.

Wood's artifacts serve as seismographs to register a very real disturbance, a permanent discomfort that he translates into the impoverished pulp vocabulary available to him. The line that links him to Poe or Lovecraft is decidedly attenuated, but he is indeed a late and enfeebled emanation of the gothic tradition, lamentably lacking the skill or intelligence to produce much more than rough sketches of his nightmares. Seen close up, he's anything but a joke; we may wonder legitimately why we should care, but it's

hard to look away from the portrait that emerges from *Nightmare of Ecstasy.* Once you've begun to seriously sift through a life, it's too late to ask why, and in Wood's case the sifting begins to feel like a journey among the damned.

It's only too appropriate that the eulogies he elicits sound like dialogue from a low-grade horror film: "There's nights when he just can't sleep. Nights upon nights. He's like a lost being on this earth. He doesn't belong here." The laughter that his work inevitably provokes is in part a way of warding off that chill. We may be laughing in sheer thankfulness that it was someone else's destiny, and not our own, to be Edward D. Wood Jr.

The New York Review of Books, November 17, 1994

Brando:
Pro *and* Con Man

As I DRIVE DOWN Sunset Boulevard, Marlon Brando's face looms up on a billboard, an advertisement for Peter Manso's 1,100-page biography. Or rather it's half his face from one portrait laid side by side with half from another, the cover designer's instantly readable ideogram for a fractured personality. The apparition is incongruous enough to provoke spontaneous laughter, a slightly unsettled laughter paying tribute to a lingering iconic force: whatever one expected to see hovering over the Los Angeles streetscape, it wasn't *that* face.

If the billboard is from one perspective a workaday artifact of 'nineties America — the Disney Corporation angling for a return on a substantial publishing investment — it's also jarring. If Brando has been part of the cultural geography of the whole postwar period, he has been a part that always seemed out of place: initially an icon of instability and intrusion, later of implosion and withdrawal. As an advertisement, a brand name, up there with Guess? jeans and Obsession for Men, he makes for a bizarre product, ill at ease on any shelf. It seems like the latest peculiar transmutation of an element that was never at rest.

An early colleague of Brando's commented, "You could write a whole chapter on the ways he could make people feel uncomfortable," and indeed his art of acting could be read above all as an art of inducing unease. From the start he was an object lesson in the smashing of polite distinctions, the invasion of social space. For anyone growing up in the fifties, his name was

a part of the language learned relatively early: not so much the name of an individual as a mysterious ideogram bound up with all the elusive connotations of bongos, motorcycles, the Method, girls in black lace stockings, torn T-shirts, mumbling, and a defiance taking the form of sullen withdrawal.

Beyond all else he was a teacher of behavior. In Anthony Quinn's words, "Everybody started behaving like Brando," including of course a generation of actors — Ralph Meeker, Vic Morrow, and a hundred other "Brando types." *A Streetcar Named Desire* and *The Wild One* and *On the Waterfront* were a lexicon of slur and overspill, a catalogue of slouches, drawls, nudges, grins, enraged outbursts, totterings, groans, soul-piercing glances. He proposed a different way for men to be. Talking was a small part of it, although his line readings were savored and endlessly recycled. Adolescent boys vied endlessly for the best replication of Brando's reading of "Have you ever heard of the Napoleonic code?" (*Streetcar*) or "What do I get? A one-way ticket to Palookaville" (*Waterfront*) or "You scum-sucking pig!" (*One-Eyed Jacks*).

But here the tensing of eyebrows, the slackening of lips, the flexing of muscles, even the pouring of sweat were indispensable components of the performance. It was acting in which the whole body was implicated. Several generations of moviegoers internalized the way he turned his face into a mask of suffering, spoke with eyes averted or closed, laughed as if it was a form of intimate communication with himself, dragged his battered body toward the gate in *On the Waterfront,* sagged under the whip in *One-Eyed Jacks.*

That he was, in those performances, so often on the receiving end of violence could not conceal the far greater capacity for inflicting violence coiled inside him. It is still possible to be shocked by the moment in *A Streetcar Named Desire* when, as Vivien Leigh's Blanche DuBois spins out a line of evasive chatter, he shouts: "Now how about cuttin' the rebop!" People sat in the dark waiting for Marlon Brando to erupt. What differentiated him from other actors was that unpredictable suddenness. Rapid lunges came out of nowhere, cut people off, seemed to threaten actual harm to the actors, and to the fiction that this was only a scene in a movie. (It worked again years later in *The Godfather* when, as Al Martino's whining crooner asked what he should do, Brando's Don Corleone leapt with amazing speed out of a courtly repose, collared Martino, and shouted: "You could act like a man!") In one of

the few revealing passages of his sort-of-autobiography, *Songs My Mother Taught Me*, Brando writes: "I had—and still have—an intense hatred of loud, sudden noises and of being startled, and these could cause me to explode." He who has been hurt by being startled startles everybody else in retaliation.

The crucial outbursts were over almost as soon as they began, all the more precious for the fact that if you blinked you missed them. On video, such moments can be watched again and again, and it is almost irresistible to indulge in that once inconceivable luxury; but the magic in the movie theater was the wait for the moment to arrive, knowing it would be over in an instant. It was worth waiting ninety minutes for a single grimace, a sudden isolated cry. That tyranny of duration, instilling a sense of anticipation tinged with a sense of dread, was in a sense what movies were about: the power of a performance lay in its absolute control of timing, a power inevitably undercut by the ability to rewind or fast-forward. To that extent the full effect of Brando's art may be lost even as his performances are preserved.

Growing up with Brando as a fifties star was growing up with the aftermath of a shock. The overwhelming impact of Brando's first stage performances in the late forties can be gauged from the words of his teacher Stella Adler: "He's the most keenly aware, the most empathetical human being alive." A prodigy of sensitivity, his antennae frighteningly alert, he was like someone who had escaped being molded by society. Marlene Dietrich saw him in *Streetcar* and declared him "the most natural boy she'd seen." A Kaspar Hauser, a wild child intuitively demolishing the strictures of what passed for classical acting to lay bare raw feeling: this was the myth of Brando as the man born to redeem acting, a myth consonant with the more or less contemporary myths adhering to jazz and action painting and modern dance and coffeehouse poetry.

In the overall scheme of fifties culture, however, the connotations were also inescapably comedic. "Doing Brando" was every comic's last resort, good for a laugh when all else failed. He was all over the place, lovingly delineated in caricature in *Mad*; incarnated by a mimic on TV in the requisite torn T-shirt yelling "Stel-la!"; alluded to in an MGM musical (Dolores Gray in *It's Always Fair Weather* boasting that she has a man who's "Clifton Webb and Marlon Brando combined"). A little later, Frank Gorshin would do the ulti-

mate Brando burlesque as the mumbling, self-absorbed hipster screen idol Blake Barton in *Bells Are Ringing*.

His mere existence seemed to call for an explanation. That already made him different from other movie stars; people didn't need to find reasons for Van Heflin or Jimmy Stewart. Brando was treated as a portentous figure, a kind of incarnate message. The French critic Edgar Morin, who compared him to John the Baptist (a John the Baptist announcing, in suitably hyperbolic fashion, the coming of James Dean as Christ), was by no means singular in his rhetorical excess. Hyperbolic phrases like "indisputably the greatest living actor" have clung to him like a birthright: an unwanted birthright, by his own account. On the evidence of his memoir, postwar America was a place where everybody but Brando wanted to be Brando. It's hard enough being an actor, even if you believe (as he once told an interviewer) that "actors get paid for doing nothing and it all adds up to nothing"; being an ideogram must be considerably tougher. Small wonder that he showed early signs of wanting out.

Explanations of his talent were succeeded by explanations of the waste or collapse or deliberate destruction of his talent. By the mid-sixties, Brando's career was becoming the kind of public disaster guaranteed to provoke voyeuristic pleasure coupled with appropriate expressions of moral disapproval. A decade's worth of commercial and critical failures, stretching from *Mutiny on the Bounty* to *Candy,* cast Brando as self-absorbed diva perversely indifferent to the debacles he provoked. I recall from that era the affronted tone taken by so many critics, as if Brando had personally offended them by failing to live up their assessments of his potential.

What was so widely perceived as betrayal or dereliction could also be seen as a further revelation, the peeling away of another layer in order to demonstrate that what passed in the fifties for unmediated emotional truth came from a consummate trickster's bag of wiles and ruses. He was using the same methods, but to almost campy effect, distancing himself from character and movie in a way that was as fascinating as it was destructive. Increasingly quirky, self-parodying, clownish, or grotesque, Brando seemed to be in the throes of creating a Kabuki theater of one out of the wreckage of such otherwise unwatchable movies as *The Ugly American, Bedtime Story,* or *The Night of the Following Day.*

His career lay under such a curse at that point that when he achieved possibly his most inventive and concentrated single performance, as the repressed homosexual army officer in John Huston's *Reflections in a Golden Eye*, both performance and movie sank virtually unnoticed. Instead it was the reassuring hamminess of his Don Corleone in *The Godfather* that would, however transiently, restore his standing.

I DON'T KNOW WHY it should be thought necessary to sit in judgment on this career—as if the seventy-year-old Brando were to be called into the dock to justify his existence—but we are invited to such a judgment by the simultaneous publication of his own memoir, *Songs My Mother Taught Me*, and *Brando: The Biography*, Peter Manso's doorstop of a book. Neither work has anything like the weight of their combined advertising and promotion budgets.

Songs My Mother Taught Me reads like the transcript of an extensive but none too probing interview, threading a frequently evasive path among the minefields and reminding us that when it comes to self-explanation Brando has always been his own worst enemy. Truman Capote's 1956 *New Yorker* profile, "The Duke in His Domain," was devastating precisely because Capote needed only Brando's own words to skewer him:

> "Anyway, I have friends. No. No, I don't," he said, verbally shadowboxing. "Oh, sure I do," he decided, smoothing the sweat on his upper lip. "I have a great many friends. Some I don't hold out on. I let them know what's happening. You have to trust somebody. Well, not all the way . . . "

With Brando one never knows if it is a case of self-knowledge masquerading as bewilderment or bewilderment masquerading as self-knowledge. "I have spent almost seven decades examining every aspect of my life trying to understand the forces that made me what I am," he writes, and his major conclusion seems to be that nothing is his fault because "everything we do is a product of . . . biochemical reactions."

Whatever the nature of those reactions, their causes evidently lie far back in Brando's middle-class childhood in Nebraska and Illinois, in the theatrically gifted mother who "preferred getting drunk to caring for us" but whose alcoholized breath had "a sweetness I lack the vocabulary to describe" and

the salesman father he describes as "emotionally destructive . . . a frighten-ing, silent, brooding, angry, hard-drinking, rude man, a bully who loved to give orders and issue ultimatums"—not to mention the housekeeper he slept with naked as a child ("I sat there looking at her body and fondling her breasts, and arranged myself on her and crawled all over her"), to whose abrupt departure to get married he attributes a lifelong sense of abandon-ment: "From that day forward, I became estranged from this world." Brando's descriptions of his childhood have a sense of the power of human relation-ships oddly lacking from his account of his adult years.

The two books are positioned almost too neatly as the defense and the prosecution, with Brando's plea of good intentions struggling with emotional damage coming up against Manso's relentless array of anecdotes designed to illustrate a life of deception and manipulation. More dossier than biography, *Brando* comes across, despite its elaborate scholarly apparatus, as an ex-tended exercise in gossip-mongering. With an ear cocked for every abject story ever told about the actor, Manso's tone alternates between perfunctory psychologizing and clucking disapproval. However accurate his delineation of Brando as sexual predator, exploitative friend, derelict parent, and reck-lessly unprofessional performer, a biography on this scale demanded more empathy for its subject, however monstrous. The monstrosity can hardly be doubted. Still, to have accepted the fact and gone on from there would have yielded more interesting conclusions than Manso's method of proceeding, which is to register perpetual astonishment as the excesses pile up.

When the judge reaches his verdict, it has a familiar ring:

> The icon of our generation, the larger-than-life symbol of rebellion, antiestablishment values, and artistic commitment—in a sense, he owed us more. At least the question had to be asked: Isn't a genius who has pushed the boundaries and probed the depths of our psyche obligated to the culture to continue the quest?

The notion that icons owe some kind of debt to the culture that packages and fetishizes them is dubious enough to elicit strong sympathy for Brando's voluntary withdrawal. There is something more than a little hypocritical about Manso raising the banner of "rebellion" and "antiestablishment values" when he has just compiled a volume of scurrilous and prurient anecdotes

designed to make Brando look as bad as possible. The tone of high moral critique is as inappropriate as the opening epigraph from Primo Levi, as if Brando's misdoings were comparable to the crimes of Auschwitz.

How much does it matter, in the end, whether Brando is to be conceptualized as victim or victimizer, whether his troubles are attributed to being the child of alcoholic parents who didn't give him enough attention, to an unbreachable narcissism, to a paranoid need to control everyone around him, or to the vagaries of his biochemical reactions? It might be more appropriate to file him under the notion of taboo, a force at once numinous and destructive, worthy of respect and best kept at a distance. It might be more precise to say not that Brando dissipated his energies but that they dissipated him, and to find it remarkable that a creature of such prodigious compulsions, who evidently has spent a great deal of time not knowing what to do with himself, should have managed nonetheless to accomplish as much as he has.

WHAT MANSO FAILS to address—and what Brando, with his unveiled contempt for the vocation of acting, finds it hard to articulate—is the connection between the art and all the rest of the mess. If he has been a con man ("one of the best con artists in the world," according to director Arthur Penn), a manipulator, a seducer, a vengeful schemer, these were not aberrations but alternate aspects of the same freakish talent that won applause in front of the camera, the talent of which Stella Adler gave such a chilling and evidently accurate description: "He's absolutely aware of everything that's going on in a person. If you left the room, he could be you."

"I think I'd have made a good con man," Brando writes, with the disarming air of coming clean that in itself feels like a con. "I'm good at telling lies smoothly, giving an impression of things as they are not and making people think I'm sincere. A good con man can fool anybody, but the first person he fools is himself." There is of course no way to gauge the sincerity of this passage, which gives it a kind of elegance. The con, like all cons, is bottomless and boundless. In the same way, there is no discernible difference between the sincere self-deprecation of Brando's character in *Sayonara* paying court to a Japanese woman of aristocratic mien ("Maybe my American manners are embarrassing") and the deceitful self-deprecation of his character in

One-Eyed Jacks preparing to defraud a Mexican woman of aristocratic mien ("I never did have much upbringing . . . never had a chance to be around fine ladies like yourself").

Brando's contempt for acting is the con man's contempt for the suckers: "As Hitler demonstrated, one of the basic characteristics of the human psyche is that it is easily swayed by suggestion. . . . It is the job of the actor to manipulate this suggestibility." As anyone knows who has ever been taken by one, con men are among the scariest of people precisely because conning themselves is an essential part of their technique: to doubt them is to threaten them. A con man has to preserve the reality of the con—a reality that is like a play or movie—because to shatter it would be to reveal him to himself as well as to the intended mark.

The contempt for acting slides all too easily into a contempt for film-making in general, and Brando doesn't disguise his penchant for dominating directors he perceives as indecisive. ("In a close-up or a shot taken over the shoulder—anything close—give him nine bad takes, blow your lines, give a weak performance and wear him down. Then, finally, when you know he's tired and frustrated, you give him the one take in which you do it the way it should be done.") Brando's filmography, with its high percentage of medi-ocre films by mediocre directors, makes one wonder whether he drifted into working with directors he knew he could manipulate—even though he did his best work when the forcefulness of the director (Kazan, Mankiewicz, and Huston, and in their different ways Coppola and Bertolucci) challenged his own.

The most characteristic Brando expression may be the broad grin that offers itself as an expression of an impossibly guileless, "aw shucks" friend-liness. It really does bear an uncanny resemblance to a guileless smile, until its demon-mask afterimage reveals it as a mesmerizing technique of the con-fidence trickster at his most assured. Brando never resembles a Kabuki mask more than when grinning.

The grin is the diametric opposite of the sorrowful mask of inner pain worn by Terry Malloy among his pigeons, or the Air Force pilot in *Sayonara* as he walks meditatively on a Japanese bridge, or the hero of *One-Eyed Jacks* sitting in soulful Heathcliff fashion by the sea as the Hugo Friedhofer music swells up. This was the Brando whose heartfelt, little-boy-lost style of

wooing—"Well, that's my sad tale, and when it's over I was hopin' you'd come away with me"—was studied with great care by teenage boys who could sense its effectiveness.

That the obverse of that mask of sensitivity was a cunning cruelty was not so easy to make out, given how successfully Brando evaded any actorly representation of that cruelty. The characters he played might be sick, hurt, misguided, confused, repressed, but rarely seemed to take pleasure in cruelty even if they inflicted it: it hurt them as much as the victim. Yet in *A Streetcar Named Desire,* as Manso points out, Brando succeeded in altering the dynamics of Tennessee Williams's play by building the audience's sympathy for Stanley Kowalski to such an extent that it became implicated in the destruction of Blanche, relishing and even laughing at every psychological blow.

The one movie in which this covert sadism becomes open is under the guise of comedy in *Bedtime Story,* an incredibly mean-spirited farce made more so by the inappropriate brutality of Brando's portrayal of a professional seducer and despoiler of women. He recalls the filming of it as his most enjoyable filmmaking experience, perhaps not surprisingly, seeing how closely its mood dovetails with another disarmingly blunt passage in *Songs My Mother Taught Me:*

> I have always been lucky with women. There have been many of them
> in my life, though I hardly ever spent more than a couple of minutes with
> any of them. I've had far too many affairs to think of myself as a normal,
> rational man. . . . With women, I've had what you might call a Rolodex
> life. I enjoy identifying and pushing the right emotional buttons of
> women—which usually means making them feel that they are of value
> to me and offering them security for themselves and their children.

If nothing else, the biographical material in these books makes it possible to look again at Brando's screen work, in terms not of acting method but of narrative. It is a story that he has been telling, a story about sex and violence whose pivotal motive is revenge. Brando, again, lays out the dynamics baldly, although without offering much in the way of details: "If I met a man who had a certain kind of overt masculinity, he became my enemy. I would find his weakness, then exploit it. I adopted his manner until I made a fool of

him, which often took the form of sleeping with his wife. I used to be very vengeful."

In that light *One-Eyed Jacks,* the only film he directed, becomes the clearest statement of what he is, and a profoundly antiheroic one despite the vistas, the cavalcades, and the Hugo Friedhofer music. It's basically a movie about the pleasures of seducing a colleague's daughter and then shooting him in the back when he gets mad about it. Although the emotional harshness of the drama is blurred by an imposed ending, *One-Eyed Jacks* looks today like a surprisingly honest self-portrait. The gratuitousness of its violence, widely noted at the time of its release, has certainly aged better than the world-saving pretensions of some of his later efforts. The man who announced in an interview that "I've spent ten years on the couch and I still don't know what to do with the urge to kill" was clearly entitled to make a movie about violence.

After all, what has dated most badly in Brando's classic performances is the heart-choking sincerity of the love scenes in *The Wild One* or *On the Waterfront.* His miming of tenderness now seems like a sentimental diversion from his primary concern with the dynamics of power. If it isn't always possible to detect much self-knowledge in Brando's political pronouncements or schemes for world salvation, his acting at its best is as precise and analytical as anyone could want: never more so than in *Reflections in a Golden Eye,* where he worms his way into the figure of the oppressed commander, the army officer who embodies outwardly that "certain kind of overt masculinity" that he has signaled as his cue for revenge.

One can only guess how much it owes to Brando's unhappy experience at military school: "I wanted to destroy the place. I hated authority and did everything I could to defeat it by resisting, subverting it, tricking it and outmaneuvering it." In the character of the major, obsessed with leadership and destroyed by desire, he achieves his surest defeat of authority by the curious tactic of identifying with it. It is a performance not only mesmerizing but mesmerized: Brando seems to subside into the part, finding his truest role in the guise of a haunted automaton, from the silent episode in which he stands in front of a mirror practicing his full range of facial expressions (including, devastating, the grin) to the lecture-room sequence in which, while droning on about Patton and the nature of leadership, he sinks gradually into bemuse-

ment, eyes closed, rubbing his chin with his clasped hands, smiling oblivi-
ously and madly to himself.

The man of power withdrawing into himself: nothing could fit his talents
better. If Manso's biography is, as its publisher claims, "an epic American
saga," it's a saga with little sense of place and only one character, culminat-
ing with Brando on his private atoll. What better metaphor for the soli-
tude within which he has secured himself, a solitude broken by middle-of-
the-night pseudonymous conversations with fellow ham radio enthusiasts
around the world?

His singularity as an actor finally made him an actor who seems always
out of place, separated from the rest of the cast in the same way that the cen-
tral masked figure in Noh drama is set apart from the other performers. If he
did not quite invent a new ritual, he managed to alter the way the old ritual
is performed. His own stubborn refusal to recognize the rite as anything but
an easy way to make a buck, a ticket for sex, food, and real estate, is some-
how appropriate for such a wild talent.

The "element of wild, irrational violence" that Bernardo Bertolucci dis-
cerned in Brando, and managed to bring into the open in *Last Tango in Paris,*
is balanced by the caginess that decided that "I wasn't ever going to destroy
myself emotionally to make a movie." Indeed, *Last Tango* is not so much a
fiction film starring Brando as a documentary about Brando padded out with
some singularly unconvincing tableaux by other actors. Whatever Brando
is doing in the movie, it would be hard to call it acting, and his having
felt "depleted and exhausted" after the filming is entirely understandable.
Watching it now, there is a sense that he has been lured into the open, in his
most vulnerable aspect: invited to make a display of his power so success-
fully that that power shores up the whole movie. He is at once the secret
author of *Last Tango in Paris* and its prisoner.

Sighted on *Larry King Live,* dutifully fulfilling (as he was careful to
explain) his contractual obligation to promote his book and still managing to
get in a fair share of psychic fencing with his interviewer, he made a perfect
portrait of a sacred monster at leisure, androgynous and ambivalent, a
plump-bellied sage dispensing a sort of indolent cruelty along with copies of
Zen in the Art of Archery, a Dionysus who leads the orgies but doesn't act as
if he's having much fun.

In iconic terms—and if anything is sincere about Brando, his contempt for being an icon seems to be—he had the misfortune to survive, as Montgomery Clift and James Dean and Marilyn Monroe did not. To the indelible frozen moments of *Streetcar* and *The Wild One* must be added all the indignities of his latter years, right up to the sight of him valiantly harmonizing with Larry King on "Got a Date with an Angel." Because Brando survived, he doesn't get to be eulogized in song like Montgomery Clift by The Clash, James Dean by The Beach Boys, or Marilyn Monroe by Elton John. (We will have to settle for the evocative old Shorty Rogers side "Blues for Brando"— a period piece.)

Being a survivor is also what gives him his somewhat bloated charm. He will not commit suicide, he will not surrender to self-erasure, but will on the contrary use every wile, every disguise, every confidence trick to stay ahead of the dissolution that he wasn't really courting all those years. His story finally is too much about life in all its scrounging tenacity to suit the taste for self-immolating rebels. Give him the benefit of the final word: "There isn't any end to this story. . . . I continue to be an enigma to myself in a world that still bewilders me." To the last it will have been his peculiar mission to hold certainty and safety at bay, to persist uneasily in a hungry bewilderment.

The New Republic, December 5, 1994

The Birthday Party

A HUNDRED YEARS AGO — to be precise, on March 22, 1895 — the Lumière brothers, Louis and Auguste, scientific entrepreneurs in their early thirties, made the first public demonstration of their invention the cinematograph, a combination camera, projector, and film printer. The occasion was a lecture at the Society for the Encouragement of National Industry in Paris, and the cinematograph figured as only one among a number of exhibits designed to show the latest developments in "the photographic sciences." The Lumières appear not to have anticipated the audience's astonished response.

It did not take long for the Lumières' invention to move beyond the domain of scientific discussion. By December they were giving their first commercial exhibitions in the basement of the Grand Café on the Boulevard des Capucines, and by June of the following year their films — each consisting of a single shot, a single chunk of reality captured by an immobile camera — were being shown in America, billed as "the greatest attraction of the century . . . the original, the greatest and the only perfect scientific projection of animated photographs in the world": from technical curiosity to global industry in fifteen months.

There are of course alternate and equally plausible versions of the genesis of movies. It is not so much a single trail as a profusion of strands, converging somewhere around 1895: the long trail that leads from the Renaissance camera obscura and seventeenth-century magic lantern through the variety of nineteenth-century toys and gadgets simulating animation (zoetrope, stereopticon, choreutoscope, phasmatrope, zoopraxiscope) to the inventions

of half a dozen other pioneers — Marey, Demeny, Reynaud, and above all Thomas Edison and W. K. L. Dickson, who by April 1894 were exhibiting, at New York's Kinetoscope Parlor, films that lacked only one element of movies as we know them: they were viewed in peep-show form rather than projected on a screen.

The question of who invented movies has been contentious from the outset, because so many were working toward essentially the same end. It was not by accident that researchers stumbled on a machine for annihilating the constraints of space and time and making dreams visible. As André Bazin observed in his 1946 essay "The Myth of Total Cinema," the cinema was a fully formed Platonic ideal long before it existed materially.

According to legend, the first Lumière screenings at the Grand Café elicited cries of terror as the first train in movie history steamed into view. It was an incomparable and unrepeatable shock effect, one that filmmakers have perennially, and with ever more difficulty, tried to emulate: the roller-coaster dynamics of *Die Hard* or *Speed* deploy a century's worth of technological advances toward achieving the same visceral surprise that the Lumières accomplished less strenuously by planting a camera on the platform of La Ciotat station as a train was arriving.

Something of that shock can be experienced again thanks to a remarkable five-cassette compilation released by Kino Video, *The Movies Begin,* a survey of the earliest cinema encompassing 122 films made between 1894 and 1914. It actually begins even further back, with the "simultaneous photography" developed by Eadweard Muybridge in the 1880s. Muybridge's sequential exposures are here projected at film speed and brought uncannily to life: seeing still photographs set so convincingly in motion is a little like watching a mummy come back to life. But then, reversing time is one of the primal powers of film, a fact grasped early on by the exhibitors who, after showing the Lumières's *Demolition of a Wall,* liked to project it a second time backward so that audiences could marvel at the demolished wall springing back out of smoke and debris into perfect order.

The collection radiates rough vitality, a powerful sense of life existing beyond the edges of the frame and spilling into it in exuberant and disorderly fashion. What a range of life is on display here, either caught on the sly or acted out with boisterous enthusiasm: cockfights, boxing matches, horse

races, a fracas in a barbershop, a pillow fight in a girls' dormitory, New York skyscrapers and the San Francisco earthquake, holdups and executions, reenactments of the Boxer Rebellion and the Russian Revolution of 1905, flirts and Peeping Toms and practical jokers, countless horses and dogs and babies, a coal mine and a biscuit factory, Ali Baba and Little Nemo, Nero and President McKinley, not to mention an unforgettable 1897 advertisement for Dewar's Scotch in which four mustached men in kilts perform a madly energetic reel with evident indifference to how very silly they look.

For every more or less realistic vignette, equal space is accorded to fantastic jokes and flights of absurd invention. Imps pop out of ovens and pots to bedevil a hapless kitchen staff; planets and posters and playing cards come to life; time is speeded up so that everyone ages in a matter of seconds; a city is destroyed by sneezing. As the filmmakers feel out the possible uses of screen space, they undermine the viewer's sense of stability in ways that are still surprising. In *The Big Swallow,* a British film of 1901, an elegantly dressed man on the street, apparently angry at being filmed, advances toward the camera remonstrating furiously: as he moves into extreme close-up, his mouth fills the screen, which goes black. Cut to the cameraman, tumbling headfirst into a dark abyss, after which we return to the mouth in close-up, chewing vigorously, as the offended gentleman smiles with satisfaction. The image takes revenge on those who look at it. As the irate subject munches his victim, the spectator might well feel that he himself has been swallowed.

In effect the package makes available a whole archive of early film, ranging from the earliest one-shot films of Edison and Lumière, through a cassette's worth of Georges Méliès's fantasy films, to a 1912 D. W. Griffith melodrama, *The Girl and Her Trust,* an early enough film in most contexts but figuring here as the highly evolved culmination of two decades of work. Throughout there is blessedly little obtrusive commentary to get between the viewer and the films themselves; the snippets of voice-over explication on two of the cassettes could have been spared, but for the most part comments are restricted to a set of excellent printed notes by Charles Musser, the historian of early cinema best known for his indispensable study *The Emergence of Cinema: The American Screen to 1907.*

So successfully does *The Movies Begin* make its case for the rich variety of early filmmaking that one might conceivably begin to question how much

more is to be gained from watching movies made *after* 1914. Dialogue aside, most of what came later is already here, in exhilaratingly compact form. Indeed, a whole canon of future films surfaces in embryo. How much does Ford's *How Green Was My Valley* add to the authenticity of the mining scenes in *A Day in the Life of a Coalminer* (1910), or Eisenstein's *Battleship Potemkin* to the reenactment of the Odessa mutiny and massacre in the 1905 *Revolution in Russia?* The languid Italian spectacle *Nero, or The Fall of Rome* (1909) offers all the essential ingredients of Mervyn Le Roy's *Quo Vadis* or Anthony Mann's *The Fall of the Roman Empire* in roughly a thirty-sixth of the running time.

The earliest movies still induce a sense of wonder, even if it is attenuated by the fact that with a VCR we can control the images that once overwhelmed their viewers. Even freezing the frame or reversing the action cannot annul the recalcitrant power of these movies. It's like watching one form of life collide with another. New beginnings in art—paleolithic cave painting or Sumerian epic—are also points of breakage. By initiating new forms of knowledge, they have the effect of plunging what came before them into the realm of the unknowable. In that sense our era begins in 1895: the era of playback. Everything previous eludes our newfound capability for resurrection.

The henceforth increasingly unimaginable pre-filmic world persists in the casual demeanor of these performers, mountebanks, and bystanders pressed into service. They become, by accident, mythic figures, carrying with them the air of a different world; they seem still to confront a live audience and to be unaware of the implications and aftereffects of capturing living motion on film. Less self-conscious than any future movie actors would be, they act as if the images had no tomorrow, as if they were as evanescent as a circus turn or a slice of street theater. The future was an empty screen next week that needed to be filled.

MOST OF THE IMAGES, of course, had no tomorrow, and it is just luck that these ones survived. Movies weren't made to last. A print was shown until it wore out; if a film's popularity warranted, it could always be shot again. Cecil Hepworth's beautifully concise *Rescued by Rover* (1905), one of the most entertaining movies in the set, was made in at least three different versions. (Musser neglects to note whether the same gifted dog played

Rover in each version; the vigor with which he shakes the water off, after crossing a stream on his way to rescue an abducted child, marks him as the most charismatic performer in the whole series, the very embodiment of animate movement.) A film could equally be remade by competing filmmakers. Here, a favorite gag—the old man flirting with a vivacious young woman wakes up to find himself embracing his hag of a wife—shows up in two different but essentially indistinguishable incarnations, English and French.

To satisfy curiosity and to provide a good laugh were the chief ends of most early movies, although graver ambitions (or at any rate, more complex forms of exploitation) are evident as early as Ferdinand Zecca's 1901 tableau of murder, remorse, and punishment, *The Story of a Crime*. Beauty for its own sake may not have been a major drawing card, but it crops up everywhere, whether by design or by accident. Knockabout farces and industrial documentaries become the inadvertent repositories of city streets, unrehearsed facial reactions, animal movement, shifts of light. Nowhere are such beauties more abundant than in the Lumière films. My only complaint about *The Movies Begin* is that it doesn't contain even more Lumière; there can never be too much. These endlessly fascinating remnants are both a point of origin for movies as we know them and a haunting suggestion of what they might have become.

They might, for one thing, have remained that short. The pleasures of the one-shot movie elicit a keen regret that they aren't made anymore; it's ironic that the simplest possible cinematic form should be out of bounds to filmmakers, that brevity should be the most forbidden of virtues. A movie consisting of a single shot focuses the attention wonderfully. If it is amusing to imagine a Lumière "view" as the establishing shot for an imaginary movie—the adventures, say, of one of the passengers disembarking from that train at La Ciotat station—that is only because we have almost forgotten how to consider a filmed moment in isolation rather than as part of a sequence. If narrative has been our unavoidable destiny—so much so that we find ourselves living in terms framed by the stories movies have chosen to tell—the Lumière films offer, even at this late date, a momentary reprieve from the fixed orders of storytelling.

When the Lumières filed for their first patent, their invention was described as "an apparatus for obtaining and showing chronophotographic

prints." It is indeed as photographs of time that they exert their fascina-
tion, the purest possible distillation of a single moment. Those tiny pieces
of duration — perhaps forty-five seconds — are nonetheless extraordinarily
dense with human activity. To describe everything that goes on in *Workers
Leaving the Lumière Factory* or *The Arrival of a Train at La Ciotat Station* —
every fugitive movement and sudden glance, a dog scampering into the
frame, a worker tugging at another worker's wrist, a man grinning as he sets
his bicycle in motion, a child adjusting her hat as she descends from the
train — could take many pages. The more one watches them the more they
contain.

Movies have learned to leave out most of that detail, pruning the scene of
distractions so that we look only at what is significant; here, everything is of
equal significance. Within their little compass the unwitting subjects bustle,
their existences narrowed to the length of a railroad-station platform and
some forty-five seconds of duration, bounded on either side by abrupt dark-
ness. The return of the black screen has the shock of life truncated without
warning, a reminder of how much art has been lavished subsequently on
gently easing viewers out of movies.

Clearly the Lumières were not trying to emulate the art of haiku — the
idea was to produce something like an animated postcard — but they did
make art of a profoundly contemplative order. I use the name "Lumière" in
the emblematic sense of "Homer." The brothers took joint credit for their
work, although Louis was principally responsible for the invention and at
first almost solely responsible for the actual filming. Yet the bulk of the
Lumière canon — consisting of more than a thousand films — is made up
largely of work by other cinematographers (trained by Louis), who brought
back views from all over the world. What the Lumières established in their
first films was a standard of visual acuity at once technological and aesthetic.
It was out of technical necessity that they planted the camera in one place
and let the world happen in front of it.

Whatever the motive, the results suggest how much of the real movie
magic is a passive phenomenon, a matter of standing back and letting things
take place. I cannot otherwise account for the power of *Boat Leaving the
Harbor,* in which some women stand on a jetty watching some men set off
into a fairly rough sea in a small boat. It's really nothing more than a home

movie; the women are relatives, the waters are in the Mediterranean off La Ciotat. Yet the image—balancing the women's waves of farewell with the rolling of the choppy waters, the firmness of rock against the fragility of the boat—is indelible, its ramifications unending: it might be a compression of whole epochs of European history, a somber ideogram encapsulating the exhilaration and terror of departure.

Movies at their beginning promised an ultimate and unconditional satisfaction of the desire to see: to see everything everywhere, to roam over the earth and through the heavens like God's eye, and all without even budging from one's seat. The audience had an infinite curiosity, and there was an apparently infinite supply of objects for that curiosity to batten on. It was as if they had seen nothing. Every subject became exotic by virtue of being filmed. The world was to be made over for their benefit, brick by brick and dog by dog.

We, on the other hand, begin to feel that we have seen everything. Life imitates movies, and movies themselves imitate other movies. Has a hundred years really been long enough to exhaust that promise? Have we seen enough parades, coronations, beauty pageants, earthquakes, invasions? Have enough murderers been hauled off to justice, enough lovers found contentment on the other side of the hedge? As the stop-motion tricks of Méliès give way to the newest morphing techniques, are there any magical transformations we have not already imagined?

As the medium branches out into new shapes—with screens as big as living-room walls or small enough to fit in the palm of the hand, with the promise of more images than ever before, available at the slightest whim, endlessly replayable, malleable at the viewer's command—it is hard to avoid a nostalgia for cinema's roots, which is the same as saying a nostalgia for the world on which it has fed almost to satiety. We would like to go back, and the irony is that through the machinery of movies we can enjoy the illusion of doing so. That world isn't gone; the train continues to arrive, the porters continue to bustle importantly along the platform, the little girl persists in straightening her hat. It isn't lost, it's merely lost to us, condemned to inhabit the other side of the screen. The hundred-year-old moving images nag at us as if to suggest that perhaps we missed the train at La Ciotat after all.

The New Republic, June 12, 1995

Spymaster Lang:
The Legacy of *Spione*

THE MASTERMIND IS PLAYING cat's cradle with a string of pearls and the beautiful spy crosses her legs, just as the diplomat (in another part of the city) is completing his ritual suicide. Soon the sliding panels in the wall will open, the mastermind will roll forward in his wheelchair, the express train will begin its fatal journey into the tunnel, the dance band will strike up its last tune before disaster strikes, the clown will prepare to blow his brains out. It's the same movie again — Fritz Lang's *Spies* — and it feels as if I've been watching it all my life, a prolonged viewing occasionally interrupted by bouts of exposure to the external world.

No matter which episode is up, I'm at home, a familiarity that may have something to do with *Spies* having served as matrix for at least half the movies ever made. Around each of Lang's meticulous images hover the wispy presences of movies yet unmade: there's the bullet-in-the-book motif from *The Thirty-Nine Steps*, there are the gangsters in gas masks from *Armored Car Robbery*, there's Shanghai Lily, there's Mysterious Dr. Satan, there's James Bond's comically irascible supervisor M, all of them traveling the network of corridors and rails and superhighways that stretches from Alphaville to Gotham City. Indeed, you could imaginably take *Spies*, colorize it, dub in a dialogue track, add suitably cheesy synthesizer music, and sell it direct to cable as *Terror Agents* or something of the sort, perfectly at ease in a future it more or less invented.

The inexorable rhythm of the opening montage retains its power to hook

the eye into a chain of images. Made in 1927, *Spies* was Lang's first independent production, and in this stunning prelude he allows himself a bravura flourish to demonstrate his mastery. An intertitle flashes: *"The same sort of thing was happening all over the world."* Hands open a safe. Hands slide a sealed document into a plain envelope. A goggled motorcycle driver drives madly away. Radio waves emanate from gigantic pylons. A headline flashes news of a theft. A diplomat riding in the back of a car is shot from a passing car; as he collapses, his briefcase is deftly lifted by the assassin. Bureaucrats surrounded by disorderly heaps of documents shout desperately into telephones. A uniformed agent strides into headquarters, salutes his superior, starts to speak: *"I KNOW WHO—"* A bullet pierces the window; the agent falls dead to the floor. His interlocutor looks toward the camera in horror: *"My God, what can be the power behind all this?"* Close-up of a bearded man with hypnotic eyes, his face wreathed in cigarette smoke: *I!* It's a perfect demonstration of what movies do so dangerously well: create an inexorable visual logic out of images devoid of context or ultimate cause. You don't need to be told how or why the man with the cigarette brought about these disasters, since you already believe it.

It takes about three minutes; if the movie stopped there it would feel complete. Video makes it possible to prolong those three minutes voluptuously, to meditate more calmly on indelible images projected only for a fraction of a second. That spy on the motorcycle, for instance: an incredible shot that resonates disturbance, perhaps because of the rider's fixed demonic grin, perhaps because it is shot from under the wheels of the escaping vehicle (it was created, according to Lotte Eisner, by suspending the motorcycle in midair and creating clouds of dust with a wind machine). Or that animated image of radio towers with shimmering coils of sound radiating from them, sleek monoliths of modern communication carrying the same mythic charge as the Tower of Babel in *Metropolis:* impossible not to admire a filmmaker who can afford to toss away such an effect.

With that first glimpse of Rudolf Klein-Rogge (Dr. Mabuse himself) as Haghi, master criminal, international banker, and probable Soviet agent — Haghi with his gleaming skull and neatly trimmed beard, his stylishly tailored jacket and dark turtleneck, who according to Lang was supposed to look like Trotsky but who looks a good deal more like Lenin — we have been brought right to the heart of the movie. It doesn't get any deeper. Once we've

seen him, chain-smoking in his wheelchair, attended by his tough unsmiling nurse, manipulating the world from behind his desk, we've gone as far as this particular system of signs can take us. The rest is elaboration and complication swirling around that empty and alluring mask. He is the unmoving source of all intrigue, a totem to which the intrigue continually recurs in order to renew itself.

As for what it might all be about, the banality of the first intertitle — *"The same sort of thing was happening all over the world"* — encapsulates the spy genre's banal essence: the conviction that apparently random and widespread acts of disruption form a pattern and are centrally directed, an ever-popular doctrine that appears to flourish with renewed vigor as Lang's century approaches its end.

As always with Lang, each shot insists on being a separate compartment, a space with distinct coordinates and laws; a series of such shots could be strung together in almost any order to form an outwardly coherent narrative. The American release print of *Spies* is less than half as long (eighty-eight minutes) as the nearly three-hour German original (recently reconstructed by the Munich Film Archive); it sloughs off a major subplot, based on the incident that is also the subject of István Szabó's *Colonel Redl,* and also pares away any number of striking and clarifying details, such as the snapshot, brandished for purposes of blackmail, of a society woman lounging in an opium den; it reverses the order of scenes and uses one important sequence to convey an entirely different plot point; yet in all major respects it's the same movie. If there were a lost six-hour version kicking around somewhere, that too would undoubtedly be the same movie, only with more branches, more street scenes to place under surveillance, more locked premises to be entered covertly, more seductive or intimidating glances to be launched.

PARANOIA IS THE CLASSICISM of the twentieth century. The conspiratorial traps shut with a rationality that lends the world a semblance of order and balance. Within its welter of apparently bewildering surfaces — systematic malevolence, secret surveillance, betrayal, masquerade, infiltration — the melodrama of espionage offers the paradoxical reassurance that all things really are interconnected. The details converge on a central and symmetrical anxiety with streamlined serenity of form. More terrifying than any con-

spiracy theory would be the absence of conspiracy. The alternative is vacancy and drift: the paranoid patriots of America, for instance, find it preferable to believe that black helicopters are being sent to control them rather than confront the government's actual indifference to their fate.

Spies soothes like music. The spy genre it virtually inaugurates has remained a primary vehicle for transmuting the most unsettling of emotions — dread of entrapment, suspicion of appearances, universal mistrust — into an orderly, not to say mechanical, exhilaration. Chaos is repackaged as quadrille. However much *Spies* may purport to be about anxiety and social disturbance, its pleasures are those of equipoise and sharp focus and crisp action, and its suicidal finale is neatly capped by the descent of a music-hall curtain, like the punch line of a joke.

What indeed do spies do but play tricks on people? Their activities constitute little more than a more sophisticated variant on the tricks that the earliest movies loved to demonstrate, like the boy stepping on the garden hose in *L'Arroseur arrosé,* the diabolical substitutions and transformations in the films of Georges Méliès, the pranks of Louis Feuillade's mischievous street urchin Bout-de-Zan. Spy movies — like their cousins the wartime commando movie and the caper movie — are elaborately engineered practical jokes, ranging in complexity from the almost ineffably abstract scams of Le Carré's people to the explosive gimmickry of 007's arsenal.

It's a peculiar genre, capable of carrying its pleasures to unusually attenuated and cerebral limits. In musicals people sing and dance; in Westerns they ride horses and shoot six-guns; in spy movies they conduct discussions in offices, examine pieces of paper, sit immobile in nightclubs in order to study the faces of other patrons, go for long walks or drives through city streets, go regularly in and out of buildings like some species of municipal inspector: like the urban bureaucrats they are or pretend to be.

Instead of chasing outlaws through the canyon, the spies chase misfiled documents, improperly issued authorizations, glitches in accounting procedure. *"Information was the thing for which they fought,"* announces an intertitle in *Spies,* and the movie's climactic revelation stems from a pedantic clerk's noticing a discrepancy in a financial statement. Spy stories are a century-long graphing of our psychic relation to an ineluctable bureaucracy conceived alternately as protector and oppressor, invader and home team.

Bureaucracy is everywhere and nowhere; like the Chinese poet trying to describe the mountain, we can hardly conceptualize it because we're inside it.

In *Spies* Lang constructs a model kit of modernity, complete with rail systems and bank vaults and wired for communication in all its rooms. To the newspapers, the radios, the telegrams sent "via Transradio," the ingenious spies add their tiny secret cameras, duplicate keys, disappearing ink, microphones hidden in vases, carbon paper hidden under blotting pads in post offices, and the marvelous teleprompter-like device built into the wall that keeps Haghi abreast of every fresh development.

Above all there is paper, still central in this world: notes, slips, clippings. Disasters (like the wreck of car 33133) begin as marks on paper. In a toy world defined by an interlocking system of delivery routes, the secret pirates make it their business to divert things from their proper destination: messages, treaties, trains, even a murderer en route to his execution. The game is to intercept the interceptors: when contact is made, explosive devices go off.

None of it is in any more danger of running out of control than an electric train. Within this loop we are at leisure to contemplate, ecstatically, the internal rhymes of pulp fantasy, the multiple resonances and replications from a century of mirror images: the rhymes of Haghi with Mabuse and Dr. No, of Gerda Maurus's exotic spy Sonia with Dietrich's Agent x–27 in *Dishonored,* of Willy Fritsch's resourceful hero with James Bond and Matt Helm, of the lethal gas in Haghi's bank vault with the psychedelic gas sprayed in Mario Bava's *Danger: Diabolik,* of the death of the clown Nemo at the circus with the death of Mr. Memory at the music hall in *The Thirty-Nine Steps.*

It slides by again, a flurry of beautiful old postcards: Fritz Rasp as the traitorous Russian colonel with his extravagant mustache and his cigarette holder, Lien Dyers curled up in her kimono as she prepares to seduce the Japanese ambassador, black limousines hurtling along country roads. The images were already old. Lang saw to it that nothing was left out — dramatic tableaux from Louis Feuillade serials, moments of high tension frozen on the covers of paperback thrillers by Edgar Wallace or E. Phillips Oppenheim, posters of actresses dressed up as exotic adventuresses — all the ingredients for a universe of pleasurable expectations.

Shuffled among the cards are the faded real-world ingredients that can almost masquerade as nostalgia, the barely disguised portraits of Colonel

Redl and Zinoviev and Mata Hari, lifelike snapshots of assassination and public disorder in the streets of Europe, the trucks of the riot police and the jackboots of Haghi's private corps of security guards. No way to avoid the more troubling rhymes of pulp fantasy with its double: the world beyond the walls of the crystal dollhouse, the zone scarred and burned repeatedly through the efforts of agents seemingly steeped, precisely, in the clichés of pulp fantasy. So that by now the collapsing walls of Haghi's Götterdämmerung inevitably evoke the collapse of the federal building in Oklahoma City (whose accused perpetrator had previously rented *Blown Away*), and the poison gas triggered by Haghi's last command is redolent of the actual nerve gas manufactured by Japan's Aum Shinrikyo cult, whose leader Asahara could have been played convincingly by Rudolf Klein-Rogge (himself, to complete the rhyme scheme, an ardent Nazi — and the former husband of Thea von Harbou, subsequently Frau Lang, who wrote the novel on which *Spies* is based).

We are not going to be left undisturbed any more than the Berlin audience of 1928. Our pleasure in the movie's delirious unreality is going to be interrupted by someone for whom its premises are altogether believable. If not Asahara or Mark from Michigan, then Pol Pot or Chairman Gonzalo of the Shining Path: Haghis upon Haghis, creatures of tailoring and cigarette smoke. And so, between the frames, I catch glimpses of other episodes — scenes from the other movie, the external one — that could slot effortlessly into Lang's scheme. As I pass through East Berlin by train some years before the fall, my passport is examined with grim thoroughness by a blond young border cop who might have been one of Haghi's perfectly accoutred thugs. On every wall of every street radiating from the center of a Third World capital, The Leader stares out from identical posters. Standing in front of the World Trade Center in 1993, I watch the crushed hulks of sports cars being carted away from the bombed-out parking garage like detritus from the wreck of Train 33133. Along Second Avenue, silent and unannounced on a midwinter evening, phalanxes of police cars and ambulances carry out a dry run for apocalyptic disaster, quite as if they were making a movie: assembling, perhaps, for yet another retake of the last reel of *Spies*.

Film Comment, July–August 1995

The Art
of Obsession

ALFRED HITCHCOCK'S *Vertigo* is no less strange and singular now than on its original appearance in 1958. Visible for years mostly in a cramped, splotchy, and faded video transfer, it has now been rereleased in wide-screen proportions, brilliantly restored colors, and almost too brilliantly restored sound (each passing thud and squeak carries almost as much sonic weight as Bernard Herrmann's incomparable score). If *Vertigo* at first aroused at best muted and scattered appreciation, the response to its reemergence apparently has been enthusiastic consensus that the film is indeed not only Hitchcock's summing up but one of the defining masterpieces of the last half-century of movies.

Yet what a peculiar sort of masterpiece it is. Centrality is an uneasy position for a film so wedded to off-centeredness. As a cultural monument, *Vertigo* resembles a Hollywood spectacle seen through the wrong end of the telescope, marshaling vast and spacious resources toward an ineluctably inward and downward spiral. In the heart of the expansive 1950s, Hitchcock succeeded in making a movie of epic scale (the city of San Francisco is enlisted as a character in the drama) about the narrowing and finally the elimination of human possibilities. It is something like an amusement-park ride that, after beguiling its passengers with an intricately linked series of illusions, for its final flourish ejects them into free fall.

What has become clearest over the decades is the extent to which this uncanny machine instills permanent fascination in a certain portion of all

who see it. Such devotees seem fated to reenact *Vertigo*'s central gesture — the meticulous but fruitless attempt to re-create a lost love object — with regard to the movie itself. The painter David Reed, who has used a still of Kim Novak in her hotel room as the basis for several installation pieces, is according to Arthur C. Danto "enough obsessed with *Vertigo* that he once made a pilgrimage to all the remaining sites in San Francisco that appear in Hitchcock's film." The filmmaker Chris Marker has similarly revisited the stations of James Stewart's obsessive wanderings — Ernie's restaurant where he first catches sight of Kim Novak, the florist's where he spies on her from behind the door, the spot where she throws herself into San Francisco Bay — and the record of this journey forms a crucial portion of his cinematic essay *Sans Soleil* (1982).

The examples continue to multiply. Terry Gilliam in his film *Twelve Monkeys* (itself an adaptation of another Chris Marker work, *La Jetée*, which elaborates ingeniously on *Vertigo*'s recursive narrative spirals) incorporates a scene from *Vertigo* so that his doomed lovers can share their last hours of freedom with Hitchcock's doomed lovers. Victor Burgin in his photographic essay *Some Cities* repeatedly invokes *Vertigo*'s story line and inserts a still from the film — Barbara Bel Geddes walking down the corridor of the mental hospital — into his collage of urban spaces. Louise DeSalvo in her memoir entitled simply *Vertigo* describes her compulsive repeated viewing of the film on its first release and relates it to her discovery of her own undiagnosed vertigo.

Beyond these explicit citations, more movies than could be listed have by now adapted *Vertigo*'s narrative strategies, from Brian De Palma's *Obsession* (a near-remake, complete with Bernard Herrmann score) to Paul Verhoeven's *Basic Instinct* (whose cinematographic textures and musical motifs pay elaborate tribute to the Hitchcock film even as the movie itself raunchily explodes *Vertigo*'s mood of mystical romantic devotion). Indeed, that most reliable stock figure of contemporary made-for-television melodrama, the obsessional stalker, might be seen as the degraded descendant of James Stewart's Scottie Ferguson.

Yet *Vertigo* is not one of those movies, like *Casablanca, Singin' in the Rain,* or Hitchcock's own *North by Northwest,* that evoke the warm glow of collective enjoyment. It tends rather to turn the members of the audience in upon

themselves, to remind them precisely of what they cannot share with their fellow spectators. I can speak with some experience in this matter, having seen *Vertigo* at least thirty times over the years.

In the case of most movies, a spectator's personal obsession may seem the result of accident, a matter of circumstance and timing. With *Vertigo* the obsession feels to an unusual degree predetermined. Hitchcock was after all the director who beyond all others took a virtually scientific interest in anticipating and shaping the spectator's response ("I feel it's tremendously satisfying for us to be able to use the cinematic art to achieve something of a mass emotion"); he would later famously remark that he didn't have to go into the theater to hear the audience screaming in *Psycho*. Would it be too far-fetched to surmise that, having long since mastered the arts of instilling excitement and anxiety, he might have undertaken the more challenging task of inducing obsession in the spectator, if only for the duration of a movie? Or that he could even have foreseen that such an obsession, once rooted, might well last a lifetime? The multiple-repeat viewer of *Vertigo* has the impression sometimes of submitting to a process prepared long in advance. He submits, perhaps, in the hope of getting closer to the film's real subject—when that subject is nothing other than his own carefully programmed response, his state of entranced alertness.

ONE OF THE CURIOSITIES of *Vertigo* is its capacity to generate emotional power from a plot that lacks the most elementary believability. We are required to accept not an isolated implausibility but a continuous stream of them. For the benefit of viewers unacquainted with *Vertigo* (if there still are any), the following is a summary of the plot:

> San Francisco police detective Scottie Ferguson (James Stewart) resigns from the force when his acrophobia leads accidentally to the death of a fellow officer. Midge (Barbara Bel Geddes), an old girlfriend, seems to be his only close friend. An acquaintance from college, the shipping magnate Gavin Elster (Tom Helmore), hires Scottie to follow his wife Madeleine (Kim Novak); she appears to be dangerously obsessed with her ancestor Carlotta Valdez, who went mad and committed suicide. As Scottie follows Madeleine through places associated with Carlotta (a museum containing a portrait of her, a graveyard, an old hotel where she

once lived), he falls in love with her. She attempts suicide by jumping into San Francisco Bay; he rescues her and they meet, ultimately acknowledging their mutual love.

Madeleine is haunted by nightmares of impending death, but Scottie is convinced he can save her by finding a rational explanation; believing that her most vivid dream refers to the old mission at San Juan Batista, he takes her there. She runs up the tower; unable to follow her because of his acrophobia, he watches helplessly as her body falls from the top.

After the inquest at which the death is declared a suicide, Scottie succumbs to depression and catatonia; Midge, unable to help him, walks out of his life. Partly cured, he wanders the city disconsolately until one day he meets Judy Barton, a woman who strongly resembles Madeleine although different in obvious respects (a brunette, not a blonde; a shop-girl, not a socialite). In a flashback from Judy's point of view, it is revealed that she and Madeleine are one and the same; she played the role to assist Elster in his plot to murder his wife, who was already dead when her body was thrown from the tower.

Judy decides not to flee because she loves Scottie and hopes he will come to love her for herself rather than because she looks like Madeleine. He sets about trying to make her over through changes in clothing and hair color, finally achieving an exact resemblance. When he sees her wearing a piece of Carlotta's jewelry, he realizes he has been duped and leads her back to the tower, dragging her to the top and extorting a con-fession. A nun appears out of the darkness and Judy, terrified by the shadowy apparition, falls to her death.

Far from undermining the movie, these implausibilities make it stronger, more exhilarating, as if their proliferation confirmed that we are in the coun-try of desire, where anything can happen. The fairy-tale atmosphere makes Scottie's instant eternal passion for the beautiful sleepwalker Madeleine not only acceptable but inevitable.

By taking as his source the novel *D'entre les morts* by Pierre Boileau and Thomas Narcejac (the team responsible for *Diabolique*), Hitchcock plugged into a long-established French tradition of fantastic crime fiction that encompasses the novels of Maurice Leblanc, Marcel Allain and Pierre Sou-vestre, Gustave Lerouge, Jean Ray, and more recently Sebastien Japrisot and Delacorta. It is a tradition that prizes the outré incident, the eruption of

dream material into the fabric of the everyday, far more than any patient building up of circumstantial verisimilitude: so much so that by the light of Arsène Lupin and Fantômas, Surrealism can begin to look like little more than an extended gloss on French popular culture.

Not that the novel has anything of the film's romantic tinge; its tone is rather glum and sordid, set against the catastrophe of the fall of France and with the detective a cringing and self-lacerating character who ends by strangling the woman who has betrayed him. Hitchcock takes only the bones of the story. If he had filmed it straight, it might have come out like one of those unexpectedly grim little B movies that cropped up along the fringes of Hollywood filmmaking in the 1940s, tales of garish crimes and last-minute reckonings like *My Name Is Julia Ross* or *So Dark the Night* or *They Won't Believe Me.*

Instead he adopted a tone reminiscent of a more upscale forties cycle, the string of lushly romanticized supernatural fantasies like *Portrait of Jennie* and *The Uninvited.* The first half of *Vertigo* seems almost a throwback to that short-lived genre, an impression to which Bernard Herrmann's music, echoing his earlier score for *The Ghost and Mrs. Muir,* contributes powerfully. This is the closest Hitchcock came to the realm of supernatural fantasy, a mode that appealed to him strongly enough that for decades he sought to film James M. Barrie's 1920 ghost play *Mary Rose,* with its time warps and its ageless woman inhabiting a magical isle. (*Vertigo's* poignant harping on the theme of love reaching out from beyond the grave probably owes more to such sources than to the Orpheus myth, Asian ghost stories like the one that inspired Kenji Mizoguchi's 1953 film *Ugetsu,* or even — despite the Wagnerian tonalities that inform Herrmann's score — *Tristan and Isolde.*)

In Barrie's work, dream worlds like Mary Rose's island retain an eternal if tenuous existence; for Hitchcock, there was no opportunity to sustain such a fantasy even for the length of a movie, however much he may have wanted to. *Vertigo* wouldn't feel so much like a tragedy if its first half, its fantasy half, weren't put together with such evident love. You can almost believe that the director wants things to turn out differently, wants the film to culminate in the fulfillment of Scottie and Madeleine's cosmic passion. Instead he is obliged to reverse Hollywood formula, which traditionally wraps up a sequence of vicissitudes with an embrace at the fade-out by saving the

ultimate vicissitude for after the last kiss. If the traditional Hollywood three-act plot structure can be diagrammed as love/loss/love, Hitchcock's expanded five-act structure becomes loss/love/loss/love/loss, or more specifically, fatal fall/orgasmic embrace/fatal fall/orgasmic embrace/fatal fall.

HITCHCOCK HAD BEEN INCREASINGLY concerned with embraces, considered as a formal problem. The emotional poles of most of the films ever made are only two: fear of Movie Death and desire for Movie Love. Hitchcock had been typed as a specialist in murder, but from *Rebecca* on he clearly wanted to appropriate the power of Movie Love. It was, after all, the cheapest yet most indispensable commodity, an alchemical brew slapped together with soft-focus close-ups, swelling theme music, and slow fade-outs: the ultimate Hollywood cliché, something that anyone could do with full confidence in its effectiveness no matter how shoddily they did it. As with chases and murders, Hitchcock seems to have been fascinated with the idea of taking the most obvious device and doing something different with it.

Throughout the 1940s Hitchcock worked at managing something as distinctly original in the romantic line as he had already accomplished in the suspense and adventure lines. It was this shift toward the woman's picture, the most important area of filmmaking in forties Hollywood, that led critics to denounce his American movies as soppily unworthy of the maker of *The Thirty-Nine Steps* and *The Lady Vanishes*. It wasn't that the English movies lacked a romantic component, but that its archetypes — bright young ingenues like Madeleine Carroll and Nova Pilbeam, roguishly witty leading men like Robert Donat and Michael Redgrave — were more acceptable to American critics than the glossy likes of Gregory Peck and Ingrid Bergman in *Spellbound.*

In fact, *Spellbound,* an uneasy depiction of true love (denoted by violins) cutting through the entanglements of Freudian trauma (denoted by solo theremin), stands as something of an aesthetic disaster, at least by comparison with its magnificent successor. In *Notorious,* Hitchcock's most achieved love story, the troughs and crescendos of the troubled affair between Cary Grant and Ingrid Bergman (troubled especially and understandably by her forced marriage to Nazi agent Claude Rains) are made to dovetail seamlessly with the rhythms of the suspense mechanism, so that the lovers' final

embrace seems in the same instant to destroy the Nazi conspiracy and to resolve all romantic confusion.

In *Notorious* the glamour machinery of Hollywood is exploited to its fullest. Every element, from Edith Head's costumes to Ted Tetzlaff's sinuous tracking shots through ornate "Brazilian" interiors, suggests a world suffused with exotic sexuality. On that level *Notorious* resembles a sleek and slinky piece of forties pop music like Artie Shaw's recording of "Innuendo." Within those shiny trappings, Hitchcock is free to choreograph an intricate and quite merciless dance of desire and contempt and desperate last-minute retrieval, almost without anyone noticing.

Hitchcock was never more in tune with the stylistic currents of his day; nor was he ever again to suggest such a healthy glow of erotic feeling. In the films that followed *Notorious* (*The Paradine Case, Rope, Under Capricorn*), he strayed increasingly from what was expected of him, with commercially disastrous results. Of these the most interesting was the biggest failure of all, *Under Capricorn*. The nineteenth-century backdrop of this exercise in Australian Gothic provided a suitably remote and spacious frame for virtual arias of camera movement, extravagantly protracted takes in which the characters were closely stalked as they passed through the stages of self-destructive remorse, hopeless infatuation, jealous rage, and liberating confession. Here Hitchcock made it clearest where he really wanted to go — into a rigorous yet operatic playing out of emotional roles — only to discover that audiences had little desire to follow him there. He would find his way back to favor with more tart and emotionally restrained entertainments along the lines of *Strangers on a Train* and *Rear Window*: in other words, to the pointed, ironic mode with which he will remain primarily identified. Grand romantic passions would drop altogether out of sight until *Vertigo* provided him with the opportunity to pull the stops out one last time.

IF THE DIRECTOR WANTS grand opera, the audience prefers crossword puzzles, the sort of thing he has been doing effortlessly since the days of *The Lodger* and *Blackmail*. He had developed early on those tricks of cognitive shorthand, of rapid wordless exposition that became the trademark of the "master of suspense." His method mimics the process of thinking, so that each shot seems to follow logically from the one before. Wary of ellipses and

interludes, he strenuously avoids the lyrical patches and intermittent sight-seeing with which commercial movies customarily fill out their running time. The spectator is made to feel that every shot counts, that every bit of business is moving the intrigue directly forward.

Any situation can be broken down into a series of unmistakable messages, almost in the fashion of an educational movie on how salmon is canned. Along the way there are the equivalent of review tests, as if Hitchcock the conscientious pedagogue will not go on to the next lesson unless assured that the whole class is with him. His approach at its most elementary can be found in the sequence in *Notorious* that tells us, in three shots, that the wine bottle next to Cary Grant (1) is being nudged out of position, (2) is getting dangerously close to the edge, and (3) has crashed to the ground. Narrative proceeds by such small and precisely measured units of exposition: three shots, neither more nor less, are called for to keep the audience up to date on the state of affairs. Hitchcock's declaration in a 1940 interview that "my slogan is 'keep them awake at the movies'" pretty well sums up his primary concern with regulating the spectator's attention span.

The filmmaking problem that concerns Hitchcock above all is how to transmit information—information, that is, about what is going on in the movie. His films are for the most part closed systems, and the spectator needs to know almost nothing of the outside world to follow his narratives. From the whole body of his work one could deduce that World War II had occurred but very little else about twentieth-century history; as late as the 1950s his films of intrigue like *The Man Who Knew Too Much* and *North by Northwest* still involved unnamed foreign powers and mysteriously unde-fined state secrets. (The Cold War figures belatedly in *Torn Curtain* and *Topaz,* but these are far from typical.)

Children delight in Hitchcock's clarity; they gravitate to his films because they can understand what is going on. They find immense satisfaction in a game whose rules are so plainly established. Any ten-year-old can analyze the point of every glance, every gesture. The movie is entertaining because every element has a legible function and no part is merely to be endured while waiting for the real business to begin: in Hitchcock's often repeated phrase, it is "life with the dull bits left out." As for content, that amounts to little more than an afterthought.

Hitchcock could have continued to elaborate endlessly on the formulas of *The Thirty-Nine Steps* and *Foreign Correspondent* in a string of elegant variations on the chase movie; clearly, many people hoped he would do so. Instead he looked for material that would push the limits of his established methods. *Vertigo* was undoubtedly the extreme instance of such experimentation. The methods themselves don't change; he trusts them too much to monkey with those cogs and pulleys.

He wants to find out just how far he can push his style — a style that at its most basic is all about flash cards, quick cues, attention-getting gags. Will it see him through a region of fluidity, ominous depths, reverie, inchoate yearning? Faced with a novel problem of exposition — to show, in pictures, how an emotional complex forms — he proceeds as methodically as when working out a chase or a murder scene. Applying the same kind of storyboard logic, he breaks down the gradations of an emotional trajectory into elements that can be laid neatly side by side like painted tiles, just like those shots of the falling wine bottle.

That is precisely where the strangeness comes in: the diagrammatic qualities of Hitchcock's art are enlisted in the service of what cannot be diagrammed. *Vertigo* charts an emotional progression almost outlandishly gorgeous in the unfolding of each of its stages — gorgeous like some bright guidebook to magic hotels and highways — concealing until the end that it can only terminate abruptly and cruelly. The perfect equilibrium that marks each phase makes all the more brutal the imbalance in which the process unavoidably culminates.

He has designed a beautiful trap. The weird poetry of it resides in the Spanish filigree, the tombs and castanets and ancestral portraits, the ritualistic moves suggesting a Calderón drama or some odd baroque poem secreted in a Californian monastery, at once florid and elaborately logical.

To allow yourself to be alienated from this spectacle is to see a mechanical contraption of arranged flowers, curled hair, carefully directed lighting: like nothing so much as a funeral home. The lovers look like cutouts (to harmonize with the out-and-out animation of the nightmare scene) or like the figures on cheap tin paintings of saintly miracles or deathbed conversions: waxen, painted, mummified dolls.

But the toys are set in motion. Everything is swirling, tilting, swinging like

the hypnotist's pendulum, teetering as in the middle of a small earthquake. The spirals multiply as if in a toy shop full of mirrors and kaleidoscopes, from the whirling of Gavin Elster's swivel chair to the wave in Madeleine's hair to the corkscrewing sideways motion of Stewart as he moves in back of Novak toward the circular lampshade. People are perpetually crouched or perched on the edge of imbalance.

Vertigo epitomizes, even as it surpasses, the sensual pleasures of fifties movies: wide screen and color allied to deep focus, monumental boom shots, smoothly gliding camera movements. We are guided through a hall of glamorous surfaces. Scottie's bachelor den, with its fireplace and coffee, its comfortable furniture and companionable television set, provides the perfect setting for The Man Who Reads *Playboy* to realize his ultimate fantasy, finding Kim Novak as Madeleine deposited magically in his bed. The implied cheap thrill — Scottie's undressing of the unconscious Madeleine, indicated by her nylons hanging in the kitchen to dry — still gets a titter from audiences, as does his subsequent sheepish admission that he's enjoyed himself. It's the only point at which this ethereal romance gets down to earth at all. As Scottie and Madeleine are flirting outside his apartment, there's a moment when they behave almost like normal Hollywood stars undergoing a plot turn in a romantic comedy. At that instant they radiate an unattainable desirability denoted by the utterly unreal colors of Robert Burks's cinematography: the otherworldly cosmetic sheen of Movie Love.

That was the moment when, at age fifteen, I decided that it mattered a great deal to me whether Scottie and Madeleine succeeded in establishing a full and satisfying union. Not to care is to remain immune to the lure of *Vertigo*. Hitchcock's gamble is that the spectator will take the bait and allow the movie to tease out his intimate concern for the fate of these beings.

RIGHT FROM THE START of Saul Bass's titles — the woman's face in darkness, the eyeball, the spinning geometric shapes, the revolving phrases of Bernard Herrmann's theme — the effect is deliberately hypnotic. The tonal control exercised by Hitchcock in all his films here attains a new degree of thoroughness. We enter a world from which all superfluous detail has been removed as if surgically, with none of the intrusions of spontaneous movement.

Controls are exerted at every level. Tone of voice, for instance: the line

readings establish a languorous, not to say somnolent hum. That the voices are never raised in emotion until the final scene (except for the outburst of poor discarded Midge, alone in her room) contributes to an air of hermetic intimacy.

Almost all actions in *Vertigo* are commonplace: sitting at a bar, driving a car, drinking coffee at home, walking, talking in low civilized tones, looking intently but with no melodramatic staring. If not for the strategically timed falling of bodies (the cop from the roof, Novak into the bay and again from the tower), these could be scenes from anyone's life, the very antithesis of Hitchcockian adventure.

The multiple play of glances in the socially complex situations of movies like *Notorious, The Paradine Case,* and *Strangers on a Train* is simplified here: there are no nuanced interactions among groups of characters because there are no groups of characters. Indeed, beyond Stewart and his wraithlike love there are in effect no characters except for Barbara Bel Geddes as Scottie's long-suffering former girlfriend, without whom there wouldn't even be anyone to witness the drama. Most scenes involve only two people. In effect there is no society: no children, no parents, no parties. Each person follows a solitary track.

Minor characters exist only to irritate, to intrude on Scottie's solitary contemplation of his dream lady. Especially the women: the hotel clerk who questions Scottie's authority, the neighbor who asks prying questions about Madeleine's suicide, the saleswoman and the hairdresser who seem to take intuitive pleasure in frustrating Scottie's impatient desire to remake Judy as Madeleine. For that matter, Midge herself is the ultimate intrusion as she tries to hold him back from plunging into the vortex. (Stewart superbly suggests the resentment with which he withdraws from her attempts at companionship, as if to say, "Leave me alone, I'm only trying to destroy myself.") Of all these subsidiary ushers and go-betweens, the only one who exists with any vividness is Henry Jones as the presiding judge who at the postmortem inquest skewers Scottie for his alleged irresponsibility in letting Madeleine die; Jones's brilliant monologue, almost too calculating in its cruelty to qualify as comic relief, marks the division between parts somewhat like the porter's speech in *Macbeth.*

There is San Francisco, of course, but the city seems to exist behind glass or under water. Hitchcock favors stuffy interiors like Gavin Elster's overfur-

nished office and terminally muffled club room, with their expanses of dark leather and paneled wood, shelves of glassware, framed hunting prints. San Francisco appears to be a city of the dead, or at any rate a city in suspended animation. There is no action on the street, no trace of spontaneity to offset the funeral march of Stewart's obsessional progress: just a ghostly procession of cars and bodies set to mournful music. It's like being in church, a church in whose dank precincts all desire is somehow entombed. The only moment when strangers are endowed with any independent life is in a fleeting shot of lovers embracing on the grass in Golden Gate Park as Stewart and Novak (in her second incarnation) walk by. Those anonymous lovers seem to be the only ones having fun in the whole bewitched city.

THE PRODIGAL RICHNESS of *Vertigo* — the system of visual rhymes and musical leitmotifs, the bold chromatic range from misty green to strident purple, the incredible variety of locations providing each shade of feeling with its own distinct habitat — is matched by a poverty at its core, a resolute slamming shut of anything that would provide an exit or an opening. The spiral is sealed off within its coiling.

Two utterly schematic figures stand guard to ensure that the melodrama cannot be evaded. First of all the villain of the piece, Gavin Elster, an absurd stick figure with a mustache and a fake accent, the sole author of the crime around which the movie revolves, and a personage of so little account that we don't even learn his fate. He's a flat silhouette standing in for all those seductive and malevolent men — jovial spies, homosexual doubles, psychopathic shadows — delineated elsewhere more fully, indeed with something like compulsive precision, most particularly by Joseph Cotten in *Shadow of a Doubt*.

Likewise the nun who rises out of the dark stairwell to accidentally cause Kim Novak's second death is the shorthand encapsulation of that band of females who poison the atmosphere of countless Hitchcock films (the scheming housekeepers like Mrs. Danvers in *Rebecca* and Millie in *Under Capricorn*, the domineering mothers of Claude Rains in *Notorious* and Anthony Perkins in *Psycho* and Tippi Hedren in *Marnie*). This one doesn't even need a name: all she has to do is emerge to precipitate disaster.

They stand, as it were, at the exits. All the rest of space and time belongs to Scottie and his bisected love object Madeleine/Judy, the socialite and the

shopgirl, neither of whom seems able to make the hero altogether happy. His love will lure him to destruction, the oldest story: except that here it's told differently from all the other movie versions. It isn't the professor and the floozy, the barrister and the fallen woman, the sailor and the jungle princess.

The mysterious woman in *Vertigo* is not a femme fatale because, with the exception of the unseen Rebecca, there are no femmes fatales in Hitchcock. Barely a single manipulative beauty or scheming temptress, in genres (the spy film, the murder mystery) unthinkable without them. With Hitchcock the figure of the femme fatale appears only obliquely. Ingrid Bergman in *Notorious,* like Eva Marie Saint in *North by Northwest,* is merely mistaken for one, while Marlene Dietrich in *Stage Fright,* Laura Elliot in *Strangers on a Train,* and Brigitte Auber in *To Catch a Thief* are respectively theatrical, provincial, and adolescent imitations of the type. Even Alida Valli as the beautiful murderess in *The Paradine Case* doesn't really qualify: she's too emotionally honest, too genuinely repulsed by Gregory Peck's obsession with her.

This in a way is Hitchcock's problem; everything would be simpler if he could settle for Maria Montez as the evil twin in *Cobra Woman* or Jane Greer cold-bloodedly committing murder in *Out of the Past.* But perhaps that is why he doesn't make the same movie that all the others do. He has other obligations, to a trim, well-groomed society woman, the sort who dines at Ernie's and shops at Ransohoff's and is a regular client of the most expensive florist in San Francisco. Madeleine's conversation is hardly imaginable; if it weren't for her nightmares and suicidal impulses, she would have nothing to talk about. She's barely there apart from her wardrobe.

If he cannot explain coherently why she means so much to him, the director will do better: he will put the spectator in a position where he cannot help identifying with the director's feeling. Was it finally only for this that the whole mechanism was set in motion, that we might be brought to share Hitchcock's deep concern for these particular shoes, this particular hairdo, this particular elegantly tailored gray suit? So that he might not be altogether alone in a desire that will accept no substitutes?

No one watching *Vertigo* ever doubts that the director is in love with Madeleine. He makes his feelings sufficiently clear. The cinematic device Hitchcock invented for the film — the simultaneous tracking back and

zooming in which he denotes the flare-up of Scottie's vertigo—is the filmic equivalent of a neologism coined because one feels that no existing word can adequately express one's feelings. It's that desperate and flailing a gesture: a calligraphic representation of energy collapsed on itself and banging back and forth within its confines.

It may be that *Vertigo* is a movie best appreciated by the young and virginal; certainly it is the most chaste movie ever made about erotic obsession. The famous 360-degree pan around the embrace of Scottie and the resurrected Madeleine, amid the crescendoing of Bernard Herrmann's indelible "Scène d'Amour" theme, manages to turn lovemaking into an altogether abstract notion. A fifteen-year-old can still experience the movie as a sublime romantic dance on the edge of nothingness, while with age it more and more suggests dissatisfaction, blocked yearning, a systematic and most unhappy discomfort. In her memoir, Louise DeSalvo writes of herself at sixteen: "I know I don't want to wind up like Scottie, in love with death. . . . Each time I see *Vertigo,* I move closer to learning that loving someone the way Scottie loves Madeleine is dangerous."

So dangerous that when he does meet her double he doesn't have much steam left for fresh experience. Here is the point where the movie starts from the beginning again, this time not as tragedy but as compulsive routine. The romantic project of rescuing the doomed maiden from death gives way to the fetishist's laundry list of required elements: shoes, check; fabric, check; wave in hair, check. The film's sustained adagio suddenly snaps into a different rhythm as the hero finally assumes the role of overt control freak, fetishist *metteur-en-scène* energetically commanding resources of light and color and shape. Stewart's veneer of sensitive caring for his precious object cracks whenever she makes the slightest objection to his make-over, revealing a brusque impatience. This is the most remarkable aspect of a performance extraordinary for its shifts of tone; consider the rough way he passes Judy a slug of whiskey when she starts to complain, and how casually it undercuts the mood of ostensible tenderness.

As for Judy Barton from Salina, Kansas, the real woman, there just isn't enough time to develop any real concern for her. (She has one of the great reductive lines of dialogue: "My name is Judy Barton, I come from Salina, Kansas, I work at Magnin's, and I live here.") That would be another movie,

another life. We are left with the unforgettable awkwardness of Scottie and Judy dancing close at the start of what promises to be an uncommunicative but nonetheless down-to-earth relationship, unlike all that nonsense with the lady in gray.

It is a movie from which one yearns in the end to be delivered, as from an incubus or an ancestral curse, precisely because such deliverance is not an option within the closed circle of *Vertigo*. It took all Hitchcock's skill at neat resolutions to create so artfully a setup without a resolution. Where in *Foreign Correspondent* or *North by Northwest* the audience is led along by the question "How will they ever get out of this?" the course of *Vertigo* encourages rather a growing sense of dread at the insurmountable difficulty, and eventually the impossibility, of finding any way out. Not merely is there no happy ending, there could never have been one; she who could have brought it about no longer exists; never in fact existed.

Hitchcock has here made a diagram of chronic corrosive sadness. Only at the end is it clarified that the film has been in mourning from the first, has been grieving from before the start for the ending which was already a foregone conclusion. The only consolation his art affords him is to have bodied forth, without compromise or false alleviation, the figure of James Stewart staring downward (after his beloved's second and irrevocable death) into emptiness, unconsoled in eternity.

The New York Review of Books, December 19, 1996

The Ghost
at the Feast

To UNRAVEL MY FIRST associations with Shakespeare is like trying to clamber back into the core of childhood. My parents worked in the theater — my mother as actress, my father as director and theater owner — and stages figured early on as places of magical transformation. Seeing the process from backstage did not make it any less magical: quite the contrary. The stage was a place where people became other than what they were, in a fully real alternate world. The most highly developed aspect of that other world was called Shakespeare, conceived not as an individual but as an inventory of places, costumes, roles, phrases, songs.

Countless artifacts served as windows into it: a book of cutout figures for a toy theater, based on stills from Olivier's *Hamlet; Classic Comics* versions of *Hamlet, Macbeth,* and *A Midsummer Night's Dream;* recordings of John Barrymore as Hamlet and Olivier as Henry V and (most memorably) an Old Vic *Macbeth* whose bubbling-cauldron sound effects and echo-chambered witches' voices haunted me for years; splendidly melodramatic nineteenth-century engravings of Hamlet in pursuit of his father's ghost, Romeo running Tybalt through, Caliban and the drunken sailors carousing on the beach; prints of Sarah Siddons and Edmund Kean in their most famous roles; a whole world of Victorian bric-a-brac and accretions out of Charles and Mary Lamb; Victor Mature as Doc Holliday in John Ford's *My Darling Clementine,* reciting "To be or not to be" in a Dodge City saloon. There were productions, too, of which I remember none better than John Gielgud standing

alone in modern dress on the stage of a school auditorium on Long Island enacting the abdication of Richard II; and there were Olivier's three Shakespeare movies, the most recent of which, *Richard III*, had its American premiere on television in 1956.

It was a world that came into focus very gradually, little pieces clinging to memory out of a whole at first immense and vague. Probably the first details absorbed were of props and clothing—a crown, a dagger, a robe—augmented gradually by gestures, phrases, half-understood speeches. I can just about recall the uncanniness, on first encounter, of such an exclamation as "Angels and ministers of grace defend us!" Even more peculiar in their fascination were those words not understood at all: *aroint, incarnadine, oxlips, roundel, promontory*. No subsequent encounter with lyrical poetry ever exercised the initial hypnotic power of such a phrase as "Those are pearls that were his eyes."

This Shakespeare existed outside of history, like Halloween or the circus. He was the supreme embodiment of the Other Time before cars or toasters, the time of thrones and spells and madrigals, imagined not as a dead past but as an ongoing parallel domain. So it was that I came to participate in a sort of religion of secular imagination: a charmed world whose key was to be found in the plays themselves, in all those passages where Shakespeare, through the mouth of Puck or Jaques or Hamlet or Prospero, appeared to give away the secret of a mystical theatricality, a show illusory even where it was most palpable.

The plays were just there, a species of climate: a net of interconnections extending into the world and generating an unforeseeable number of further interconnections. Why this should be so did not seem particularly important. Having managed to bypass the didactic initiation into Shakespeare favored in most schoolrooms—where every aesthetic pleasure must be justified in the name of some more or less hollow generality about will, or fate, or human relations—I didn't need to look for reasons for the endless fascination. Certainly the sociology of the sixteenth century, or the development of the English theater, or the mechanisms of religious and political thought in early modern Europe seemed to have little to do with it. Any piece of writing, after all, came with such local meanings attached; every Elizabethan and Jacobean play was loaded to the brim with comparable social revelation.

Something else had motivated a culture to adopt this vocabulary of situations, roles, and locations as the materials for its collective dreaming: something less susceptible to quantitative analysis than scope or invention. What but some mysterious generosity in the author could make possible such an infinitely flexible repertory for the theater of the mind?

If any era could call that flexibility into question it is a post-postmodern moment skeptical by now even about its own skepticism, and unable to refrain from an anxious cataloging of inherited knowledge it can neither quite forget nor celebrate altogether without qualms. Shakespeare is the past, and the past is something we don't know quite what to do with; we toy uncertainly with a millennial sense of impending drastic rupture, as if preparing to say good-bye to everything, even Shakespeare. With or without regrets; on one side there is the conviction (to quote from a notice posted recently at the MLA) that "the current explosion of the uses of Shakespeare often consolidate elite and dominant culture" (the notice, soliciting submissions for an anthology titled *Shakespeare Without Class: Dissidence, Intervention, Countertradition,* goes on to speak disparagingly of "Shakespeare's status as high cultural capital"). On another side there is the gloomy suggestion that in our present debased condition we are barely worthy of Shakespeare at all.

Nonetheless a sort of boom has been announced, and by virtue of being announced has gained official media recognition as a phenomenon; the Globe is at last reconstructed in South London (the culmination of a long and loving process that involved, among other things, a rediscovery of Elizabethan construction techniques); new editions and CD-ROMs proliferate; a humorous compilation entitled *Shakespeare's Insults* becomes a best-seller, with accompanying magnetic Wit Kit; and in the wake of last year's films of *Othello* and *Richard III* we have been given in short order a *Hamlet,* a *Twelfth Night,* a sort-of *Romeo and Juliet,* some large chunks of *Richard III* interspersed in Al Pacino's entertaining filmic essay *Looking for Richard,* and a *Midsummer Night's Dream* (directed by Adrian Noble) still to come. It isn't exactly the Revival of Learning, and it is unlikely (although I would be glad to be told the contrary) that wide-screen versions of *Measure for Measure, Coriolanus,* or *The Winter's Tale* will be coming any time soon to a theater near you, but it beats another movie about helicopters blowing up.

Doubtless there are thoroughly prosaic reasons for the momentary surge,

having more to do with the random convergence of financing and marketing possibilities than with some cultural moment of reckoning. In a marketplace hungry for any pretested public-domain property with instant name recognition, Shakespeare clearly has not altogether lost his clout, although his near-term bankability will certainly depend a great deal on the box-office receipts of Kenneth Branagh's textually uncompromising four-hour *Hamlet*. In the meantime, singular opportunities have been created, not to recapitulate but to reinvent.

Reinvention has always been the function of Shakespeare in performance. It could have turned out otherwise: if the English Civil War had not disrupted the line of transmission, or if the post-Restoration theater had not rejected the plays except in heavily revised form, we might have something more in the nature of Kabuki or Peking opera, a fixed tradition of gestures and voicings, with ritual drumbeats and trumpet flourishes marking the exits and entrances. Of course there have always been productions — more a few decades back than now, perhaps — that inadvertently produced just that effect, of watching an ancient play in a foreign language as it moved through its foreordained paces.

In the face of such displays, audiences often tended to shut down. A brilliant Shakespearean parody in the 1960 English revue *Beyond the Fringe* hilariously summed up everything that has ever made Shakespeare in performance more burden than delight: the mellifluous rote readings gliding incomprehensibly over gnarled syntax and thickets of argument, the versified rosters of the history plays sounding like nothing so much as medieval shopping lists ("Oh saucy Worcester!"), the bawdy uproariousness and farcical mugging designed to disguise the fact that even the actors didn't get the jokes.

THAT PARODY, WITH ITS evocation of a lost era of complacent pageantry, came to mind while watching the recent production by Jonathan Miller (as it happens, one of the creators of *Beyond the Fringe*) of *A Midsummer Night's Dream* at London's Almeida Theatre. Here was the driest possible reimagining of a play capable of being smothered in ornate fancies: a *Dream* without fairies or fairy bowers, without even a hint of woodland magic or, indeed, of woodland. Miller recasts the play as a thirties comedy of precise class

distinctions, where the mortals—Theseus as lord of the manor, Hermia and Helena as bright debs pursued by young fashion plates of inspired fatuousness, Bottom and company as working men recruited from the local pub—are indistinguishable from Oberon as a somewhat tattered aristocrat, Titania as a sleek hostess out of a Noel Coward play, Puck and the other fairies as reluctant butlers inclined to be surly in their off-hours. Mendelssohnian echoes are displaced by "Underneath the Arches" and some snatches of ready-made dance music. In place of palatial pomp and natural wonderland, there is an unchanging set (designed by the animation specialists the Quay Brothers) consisting of rows of receding glass fronts, like an abandoned arcade, and permitting constant variations on the entrances and exits in which the play abounds.

Although some English critics felt that Miller had cut the heart out of the play by his policy of deliberate disenchantment, he seems rather to have demonstrated that the enchantment lies elsewhere than in light shows or acrobatics. Instead of magic, he gives us the accoutrements of 1930s drawing-room comedy, appropriately enough in a retrospective culture for which thirties comedy, whether *Private Lives* or *Bringing Up Baby,* serves as a gossamer substitute for more substantial magic. By a similar process of analogy, Shakespeare's hierarchies of courtiers and mechanicals and nature spirits are mimicked by the gently graduated hierarchies of the English class system in a later phase, the great chain of being linking landed gentry to their groundskeepers and socialites to their chauffeurs. The pastoral sublime of *Dream* is transmuted into the terms of a more recent version of pastoral, the weekend country-house party as imagined by P. G. Wodehouse or Agatha Christie.

The net effect is not to do violence to the play but to give it another text to play against, a visual and behavioral text compounded of fragments of thirties movies, plays, popular songs, magazine covers, a hundred tiny rituals and breaches of etiquette. It is a way of measuring distances: Shakespeare's distance from the Athens of Theseus, the distance of the 1930s from the 1590s, and our distance from all of those times. To put *Dream* through this particular wringer—reimagining every line precisely as if someone else (W. Somerset Maugham? Terence Rattigan?) had written them, so that Theseus's prettiest set pieces become exercises in obligatory speechmaking and

Oberon's evocations of herbs and flowers are delivered with a cosmopolite's distaste for mucking about outdoors — turns out to be a way of forcing out some of its bitterer aftertastes.

The celebration already anticipates the incipient hangover; as soon as the play ends, Theseus and Hippolyta will settle into a loveless marriage and the young lovers will begin to realize that their lives will not improve on the mysteries of the vision they have just woken from. The hilarity of a good feast with Pyramus and Thisby for entertainment may in fact be as good as it is ever going to get. The play needs only itself to confirm that the magic is real; the production adds the somewhat waspish acknowledgment that it is also unattainable outside the theatrical moment.

"Shakespeare, more than anyone else," writes Miller of this production, "recognized that the stage is a place in which blatant pretense is a perfectly satisfactory alternative to miraculous illusion." By eliminating decoration, by favoring the matter-of-fact social function of the language over its poetry, Miller lets us see *Dream* in skeletal form. Nothing essential is lost because the play turns out not to be about fairies any more than it is about weekend country-house parties in the 1930s. If it is about anything it is about the music of thought, which is why William Hazlitt considered the play intrinsically unstageable. Indeed, it may well have been unstageable in 1816 when, at Covent Garden, Hazlitt saw it "converted from a delightful fiction into a dull pantomime. . . . Fairies are not incredible, but fairies six feet high are so." Perhaps — and wouldn't it be odd if it were so — the art of performing these plays to their fullest advantage is only now being invented.

BUT WHERE, AND FOR HOW MANY, they will be performed remains a question. It is a long way from the familial intimacy of the Almeida — with its audience and actors exquisitely attuned to one another, and a seating capacity one-tenth of Shakespeare's own playhouse (three hundred against the Globe's three thousand) — to the wider and colder world of multiplexes and cable television and the megastores in which the shiny video boxes containing *Hamlet* and *Twelfth Night* will have to compete on equal terms with *Mars Attacks!* and *Beavis and Butt-Head Do America*. It's a world that's hard on old material, even as it pays lip service to what is "vintage" or "immortal"; here the earlier Shakespeare films are apt to turn up under rubrics such as Nostalgia

or Classic Hollywood, and a phrase like "timeless classic" is just as likely to be applied to *Abbott and Costello Meet the Mummy* as to *Henry V.*

Shakespeare movies have never exactly been a genre in the same sense as cowboy pictures or musicals. There have never been enough of them, for one thing; although the record books cite astonishing numbers of adaptations, most turn out to have been made in the silent era. As for the filmmakers who have seriously explored the stylistic possibilities of Shakespeare adaptations, the list is very small: Olivier, Welles, Kurosawa, Polanski, and a few others. In any event it's something of a genre apart; there are regular movies, and then there are Shakespeare movies.

Kenneth Branagh, who kicked off this particular cycle of Shakespearean revival with his 1989 *Henry V,* challenged the distinction. With a defiance worthy of the victor of Agincourt, he demonstrated that Laurence Olivier's Shakespeare films of the forties and fifties, and the performance style they embodied, could no longer be regarded as definitive. He also undertook to a make a genuinely popular movie, against odds stiffer than those Olivier faced, at a moment when more than ever before Shakespearean language had to fight for a hearing. *Henry V* played at the local multiplex alongside *Honey, I Shrunk the Kids* and *Indiana Jones and the Last Crusade,* and it was obvious that Branagh was prepared to meet that competition on its own ground.

Yet for all its superficial indications of pop refurbishing—Derek Jacobi's modern-dress Chorus wandering among the trappings of a movie studio, or Branagh's Henry striding, to the accompaniment of ponderous electronic wheezing, into a medieval council chamber framed to look as much as possible like the inner precincts of *Star Wars*' Darth Vader—the new *Henry V* gave signs of an almost purist agenda. To a degree unusual in Shakespeare movies, one had the impression of having actually sat through a production of the play. Branagh restored many scenes—Henry's entrapment of the traitorous English lords, his threats of massacre at Harfleur, the hanging of his old companion Bardolph—that would have detracted from Olivier's single-minded depiction of heroic national effort (although even Branagh could not bring himself to include the English king's injunction to "cut the throats of those we have").

What was most strikingly different was the level of intimacy at which

Branagh's film was pitched. The Olivier version of 1944 clearly occupied a niche quite separate from the other films of its moment, delivering in clarion tones a classical language inspiring but remote. For Branagh this was no longer an available choice. The continued viability of *Henry V* was not to be taken for granted; what for Olivier had been a universally recognized (if far from universally enjoyed) cultural monument now had to defend itself.

The chief end of Branagh's direction was to keep the language in front of the audience at all times, with Derek Jacobi's clipped, almost haranguing delivery leading the way. The job of the actor was to clarify, line by line and word by word, not just the general purport of what the character was feeling but the exact function of every remark, as if some kind of match were being scored. Abrupt changes of vocal register, startling grimaces and seductive smiles, every actorly device served to maintain awareness that absolutely every moment had its singular thrust and thereby to keep the audience from being lulled into an iambic doze. The result was a more pointed, even jabbing style, a tendency to deflate sonority in favor of exact meaning, while at the same time giving the meter of the verse a musician's respect and the rhetorical substructure a lawyer's questioning eye.

As I first listened, in that same multiplex, to the accents of *Henry V* — "But pardon, gentles all, / The flat unraisèd spirits that hath dared / On this unworthy scaffold to bring forth / So great an object" — transmitted in Dolby Stereo, an unanticipated excitement took hold. It didn't matter that I could read those words any time or pop a video of the Olivier film in the VCR. The thrill was to hear them in the multiplex, in that public space from which the possibility of such language had been essentially barred. Here was real home-baked bread, water from the source. It was possible to imagine that the strangers around me shared a similar unarticulated longing for a strain of expression that the culture seemed programmed to withhold.

EVERYONE WHO SUBSCRIBES TO cable television has had the experience of switching rapidly from channel to channel and hearing at every stop the same tones and inflections, the same vocabulary, the same messages: a language flattened and reduced to a shifting but never very large repertoire of catchphrases and slogans, a language into which advertisers have so successfully insinuated their strategies that the consumers themselves turn into

walking commercials. It is a dialect of dead ends and perpetual arbitrary switch-overs, intended always to sell but more fundamentally to fill time: a necessary substitute for dead air. Whether in movies or television dramas, talk shows or political speeches or "infomercials" hawking hair dyes and exercise machines, the homogenization of speech, the exclusion of anything resembling figurative language or rhetorical complexity or any remotely extravagant eloquence or wordplay or (it goes without saying) historical or literary allusions of any kind whatever, becomes so self-evident that the only defense is that winking tone of faux inanity of which the ineffable "whatever" seems to be an ironic acknowledgment. By contrast, the dialogue in the old Hollywood movies unreeling randomly night and day—*The Road to Rio* or *The Falcon in San Francisco* or *The File on Thelma Jordon*—seems already to partake of some quite vanished classical age: how soon before it needs footnotes?

Nothing leads from or to anything. The show rolls on because it isn't time for the next show yet. It is talk without any but the most short-term memory, as if language were not to be permitted its own past, a state of affairs that makes language in some sense impossible. In this context Shakespeare assumes an ever stranger role as he becomes the voice of a past increasingly less accessible and less tractable, the ghost at the fast-food feast. If in translation Shakespeare can remain our contemporary, in English he carries his language with him, a language by now almost accusatory in its richness when compared with the weirdly rootless and impoverished speech of Medialand. "I learn immediately from any speaker," wrote Emerson thinking of Shakespeare, "how much he has already lived, through the poverty or the splendor of his speech." But there is no telling what a four-hundred-year-old man will be saying; the older he gets, the more it changes, and we no longer know if we really want to hear everything. It is like peering into a flowerpot full of twisted vines and lichen surviving improbably from some ancient plot.

It is absurd that Shakespeare alone should have to bear this burden, as if the whole of the European past rested solely in him, but that's only because nearly everyone else has already been consigned to the oblivion of the archives. We aren't likely to get (speaking only of the English-language tradition) the Geoffrey Chaucer movie, the Edmund Spenser movie, the John Webster movie, the John Milton movie, the William Congreve movie, the

Laurence Sterne movie, or even the Herman Melville movie; and the Bible movies, when they appear, owe more these days to the cadences of *Xena: Warrior Princess* than to those of King James. (One of Orson Welles's last and most quixotic film projects was a movie of *Moby-Dick* consisting of himself, in close-up, reading the novel against an empty blue background.) Shakespeare has to stand, all by himself, for centuries of expressive language erased by common consent from the audiovisual universe that is our theater and library and public square.

If Shakespeare movies are to be worth making at all, they can hardly duck the language. It isn't simply that the language cannot be handled gingerly or parceled out in acceptably telegraphic excerpts; the words must be entered, explored, reveled in. Syntax must be part of screen space. (The new sensitivity of recording technology, with its potential for communicating an awareness of depth and distance, serves admirably toward that end.) How refreshing it proves occasionally to reverse the primacy (not to say tyranny) of the visual, that fundamental tenet of filmmaking textbooks.

Disregard this problem of language and the upshot can be something like Baz Luhrmann's high-speed, high-concept *Romeo and Juliet*. There is no real reason why Luhrmann's updating could not have worked; the whole mix, complete with automatic weapons, hip-hop cadences, religious kitsch, and teen sex, could have added up to the kaleidoscopic excitement obviously intended. As it is, the compulsive cleverness of the postmodernization — Friar Lawrence sending his message to Romeo by Federal Express, members of the Capulet and Montague gangs sporting CAP and MON license plates — keeps undercutting the teen pathos to the point of parodying it. However amusing Luhrmann's conceits of characterization (Lady Capulet as blowsy Lana Turner wannabe, Mercutio as drag queen), they seem to have strayed in from his more charming debut feature *Strictly Ballroom*.

It's the skittish handling of the language, though, that reduces his film to little more than a stunt. While Luhrmann gets a bit of mileage from the accidental intersections of Elizabethan with contemporary usage (as when his gang members call each other "coz" and "man"), any speech longer than a few lines just gets in the way, and the effect all too often is of sitting in on the tryouts at a high-school drama club. The Shakespearean text begins to seem like an embarrassment that everybody is trying to avoid facing up to;

Luhrmann would have been better off dropping the dialogue altogether and hiring Quentin Tarantino to do a fresh job. There are many ways to get Shakespeare's language across, but trying to slip it past the audience as if it might pass for something else isn't one of them.

OF COURSE IT'S POSSIBLE to think of Shakespeare outside of language altogether (especially if you're Russian or Japanese): as inventor (or repackager) of endlessly serviceable fables, a choreographer of bodies on a stage, a visual storyteller whose most celebrated moments (Hamlet leaping into Ophelia's grave, Macbeth confronting Banquo's ghost at the feast) can be reduced to dumb show. It would be perfectly possible to stage the plays in pantomime without losing their structural force. This is the Shakespeare who is the inexhaustible font of ballets and engravings, musicals and comic books.

A remark by Grigori Kozintsev, the director of Russian versions of *Hamlet* and *King Lear,* pretty well sums up the orthodox "cinematic" view on filming Shakespeare:

> The problem is not one of finding means to speak the verse in front of the camera, in realistic circumstances ranging from long-shot to close-up. The aural has to be made visual. The poetic texture has itself to be transformed into a visual poetry, into the dynamic organization of film imagery.

This is an unexceptionable precept for a director working in a language other than English, and one need only turn to Kurosawa's *Throne of Blood* or *Ran,* or Aki Kaurismaki's *Hamlet Goes Business* (filmed on location in a succession of unbelievably sterile Helsinki office suites), to see it put sublimely into practice. But when a Shakespeare film is made in the English language, the unavoidable problem is precisely one of finding means to speak the verse in front of the camera. No way to sidestep the embarrassment of poetry, even if it is a term by now so fraught with difficulties that some contemporary academics in their discussions of Shakespeare prefer to enclose it in quotes, an awkward relic of superannuated discourse.

The Kozintsev doctrine has been carried through by one English-language director, of course. The Shakespeare films of Orson Welles triumph over the

sheer inaudibility of much of their dialogue through an idiosyncratic vocabulary of spaces and masks. *Othello* is more like a symphonic poem inspired by the play than the play itself: but what a poem. Welles proceeds by analogies. Shakespeare's language is like the waves dashing against the walls, is like the cage in which Iago is hauled laboriously to the ramparts, is like the glimmers and shadows with which the frame is so splendidly irrigated. Even the few brief surviving scenes of Welles's unfinished TV film of *The Merchant of Venice* (shown in Vassili Silovic's documentary *Orson Welles: The One-Man Band*) instantly create a distinct universe, as Shylock, making his way into the Venetian night, is hounded by silent ominous bands of white-masked revelers, a commedia dell'arte lynch mob.

The long-deferred restoration of the currently unseeable *Chimes at Midnight* — a film whose visual magnificence is matched only by the inadequacy of its soundtrack—would surely confirm it as the best (and most freely adapted) of Welles's Shakespeare films. When it came out in the late sixties, its elegiac note was drowned out by the more belligerent noises of the moment. Welles described it as a lament for the death of Merrie England — "a season of innocence, a dew-bright morning of the world" — as personified by Falstaff, but it could as easily be seen as a lament for Welles, for the kind of movies he wanted to make and no longer could, and beyond that for Shakespeare as he receded however gradually into an unknowable past.

In lieu of lament, Al Pacino's *Looking for Richard* proffers jokes and exhortations, back talk and man-on-the-street interviews and off-the-cuff commentaries. Pacino intervenes in his own partial production of *Richard III* to question and elaborate, almost in the same way a puzzled member of the audience might be tempted to: What's going on? Who is this Margaret? The *Richard III* scenes themselves — including some strong work by Kevin Spacey, Winona Ryder, and others — are so effective that it seems a pity not to have done the whole play; Pacino looks as if he could give us yet another kind of Shakespeare movie. His Richard is far scarier than Olivier's or Ian McKellen's (in Richard Loncraine's recent film version): a real killer, especially when he's suffering verbal assaults in silence. It's all the more jarring to revert to the present and the jovial sparring of actors among actors; but that back-and-forth movement makes this one of the best movies about the

acting life. Actors here are the true scholars, the ones who mediate between the text and the world, a secret order of preservationists keeping alive what elsewhere is only mummified. We are left with the implication that the players know things the scholars have forgotten, and that they are joyful in that knowledge.

It is not precisely joyfulness, and certainly nothing like glee, that is exuded by Trevor Nunn's melancholic adaptation of *Twelfth Night;* or if so it is a joy sufficiently muted to accord with prevailing moods that range from Chekhovian-autumnal to Beckettian-wintry. The tone is set by Ben Kingsley's Feste, conceived rather scarily as prophetic beggar lurking in the background and seeing all, a figure whose intimations of latent violence and mad wisdom suggest that Lear's fool has been grafted onto Olivia's. The revels of Sir Toby and Sir Andrew are played with excellent flair while at the same time suggesting a downbeat *Last Tango in Illyria.* At every turn we are given to see how the comedy is about to slip into the realm of the tragedies, the shipwreck into that of Pericles, the duel into that of Hamlet, the wronged Malvolio into a figure of vengeance capable of destroying the whole household.

That said, Nunn's film succeeds in its chosen course. It is for the most part well played, although Helena Bonham Carter is somewhat lacking in the haughty disdainfulness required of Olivia; her surrender to love isn't enough of a humiliation, and so fails to echo the far harsher humiliation of her steward. Imogen Stubbs, by contrast, is a tough and wary Viola who keeps the film focused on the real risks and terrors of someone cast up in hostile territory. The sadistic tormenting of Malvolio, always the trickiest passage to negotiate, is here allowed to play itself out into the exhaustion, moral and physical, of the tormentors. Seeing *Twelfth Night* back to back with *Hamlet* (as it may well have been written), it is hard not to think of the plays as mirror images, a comedy that just barely avoids being tragedy and a tragedy that tries against all odds to be a comedy.

This *Twelfth Night,* like Branagh's *Hamlet,* is set in a mythical nineteenth century that seems to stand vaguely for the whole European past, as if that were as far back as we could go without suffering hopeless disorientation. Despite the clothes and the furniture, neither film has a particularly nineteenth-century feel; it's more a question of meeting the seventeenth century halfway, settling on a space that is neither quite our own world nor quite

Shakespeare's, inventing a historical era that—like the period in which cowboy movies take place—never quite happened. We want urgently to step outside of history but have perhaps forgotten how.

FINALLY—SPEAKING OF RISKS—there is Kenneth Branagh's *Hamlet,* a move on which he appears to have gambled his whole career. If this one doesn't fly, who knows when we shall see another of his Shakespeare films. On one level, the film pertains to the universe of high-concept marketing: a 70-millimeter epic (the first such in Britain for twenty-five years) with sumptuous sets, an all-star cast with cameo appearances in the manner of *Around the World in Eighty Days* (Jack Lemmon, Robin Williams, Billy Crystal, and Charlton Heston, not to mention the Duke of Marlborough, all assume minor roles), and a four-hour running time complete with an intermission to bring back memories of the early-sixties heyday of blockbuster filmmaking, the days of *Spartacus* and *Lawrence of Arabia.*

Branagh has another agenda, however: his desire to respect against all odds the integrity of Shakespeare's text, and this puts his movie paradoxically closer to such resolutely marginal projects as Eric Rohmer's *Perceval le Gallois* (1978), in which Chrétien de Troyes's twelfth-century courtly romance is recited to the accompaniment of quasi-medieval stage effects, and Jacques Rivette's *Jeanne la Pucelle* (1994), which in recounting the career of Joan of Arc restricts itself to the language of the earliest chronicles. (Branagh's version actually is completer than complete, since it conflates the First Folio text with the extensive passages that appear only in the Second Quarto, thus producing something longer than any known version of the play.) The word—or more precisely Shakespeare's words—is the life of this film, to which everything else (Blenheim Palace, Billy Crystal, FX, Surround-Sound) is incidental.

The result might be pedantic except that Branagh isn't a pedant, although his passion has its pedagogical side. In order to resolve the contradictions of his approach, he has to resort to a kind of aesthetic violence that can easily be misread as vulgarization: the horror-movie visuals (the blade piercing Claudius's head, the ground splitting open), the sometimes schmaltzy musical underscoring. The resort to such tactics has rather the effect of restoring a necessary vulgarity that other films have tended to polish. As in his previ-

ous adaptations, but even more deliberately, Branagh undertakes to clarify the literal meaning by any means necessary. The silent movies he has concocted featuring the career of Fortinbras and the death of Priam function as footnotes, supplying a visualization that in a stage production would be left to the audience. This is the first *Hamlet* in which Old Norway (not to mention Hecuba, Priam, and Yorick) actually figures as a participant.

Branagh's decision to present the play uncut was a brilliant one, however one may differ with one detail or another of his execution. The differences are of more than scholarly concern; the narrative rhythm is transformed, and Hamlet himself, while no less central, concedes a good deal more ground to those around him. The sententious digressions, contests of wit, and theatrical recitations — the repetitions, the circuitous approaches toward a point of negotiation, the interruptions and side chatter and discussions of urgent diplomatic affairs — these are what give the flavor of the milieu, without which *Hamlet* appears to take place in an abstract void. The full *Hamlet* has a different specific gravity, a density that makes it seem like the first great English novel, a Renaissance novel like such roughly contemporaneous Spanish works as the *Celestina* of Fernando de Rojas or the *Dorotea* of Lope de Vega, unplayably long narratives in dialogue form, interspersed at times with songs and poems. It works with time in a more expansive and open-ended way, sharing the endless discursiveness and purposeful sprawl of Rabelais or Montaigne.

With all the rests restored, it becomes possible to look beyond the intrusive shocks of the plot and get a feeling for the life they have interrupted. In general, modern productions, and most especially modern film productions, cut to the plot line, as if the rest of it were bothersome persiflage. We pare Shakespeare down to streamline him, bring out "meanings" that we have planted there. Driven by an obsession to bring things into sharp focus, we simplify. *Hamlet* is a much more interesting and surprising work — and, with its roundabout strategies and gradual buildups and contradictions of tone, a more realistic one — when all of it is allowed to be heard, and it is bold of Branagh to have gambled on this more ambitious dramatic arc.

Olivier's Hamlet, steeped in that marriage of Romanticism and Freud that is film noir, threads a lone path among expressionistic shadows and wreaths of mists before returning to confront the Others. In Branagh's inter-

pretation, Hamlet is one among a crowd of powerfully differentiated figures who play against one another as much as against him. He is a disturbing element in the midst of a very busy and brightly lit Renaissance court. Even "To be or not to be" is staged here as a two-character scene (or, more exactly, a three-character scene): while Branagh faces himself in a mirror (it is the mirror image who is seen speaking), we see him also from the viewpoint of the hidden Claudius. This is a Hamlet in which Rosencrantz and Guildenstern function for once as central characters. The convergence of that pair and Polonius with the simultaneous arrival of the players and the recitation of the Hecuba speech (superbly done by Charlton Heston's First Player, with just enough restrained hokum to identify him as an actor) is allowed all its complexity.

Branagh can be forgiven every failed touch — even the 360-degree pans (presumably intended to prevent visual stasis) that sometimes make it look as if the inhabitants of Elsinore are all on rollerblades, even Hamlet's absurd final swing from the chandelier into the lap of the dying Claudius — for having maintained an essential lightness, the verbal quicksilver at the heart of it. For all the sometimes athletic action, this Hamlet is strung on its language. The words *are* the play, unfolding in a space open enough to give scope to its unruly energies.

The New York Review of Books, February 6, 1997

The Republic
of *Seinfeld*

IT IS JUST ANOTHER DAY in the Republic of Enter-
tainment, and as always a major story is taking shape. DANGER SEIN, reads the
headline of the New York *Daily News* for May 9, 1997, over a photograph of
the stars of NBC's phenomenally popular sitcom *Seinfeld:* Jerry Seinfeld,
Julia Louis-Dreyfus, Jason Alexander, and Michael Richards. They are clearly
out of character, huddling cozily together and beaming with an appearance
of warm feeling entirely inappropriate to the needling and conniving per-
sonae they embody on TV. The issue in the story is money, specifically the one
million dollars per episode that each of Jerry Seinfeld's costars is demanding
for the impending ninth season of what the *News* reporter describes as "tele-
vision's first billion-dollar sitcom." THREE STARS HOLD OUT IN HIGH-STAKES
BATTLE OVER NBC MEGAHIT: only the language of hostage-taking and terrorist
attack (the actors "imperil" the series with their "hard-line demands" and "it
is essential that the impasse be resolved soon") can do justice to the drama
of the event. (The impasse was resolved a few days later for roughly
$600,000 per episode.)

A few days later, a counterattack of sorts takes place, in the form of a *New
York Times* op-ed piece in which Maureen Dowd professes shock at the
"breathtaking" salaries demanded by the "surreally greedy" actors and pro-
ceeds to a ringing denunciation of the "ever more self-referential and self-
regarding" *Seinfeld:* "The show is our Dorian Gray portrait, a reflection of
the what's-in-it-for-me times that allowed Dick Morris and Bill Clinton to

triumph." For backup she cites Leon Wieseltier of *The New Republic,* who describes the show as "the worst, last gasp of Reaganite, grasping, material- istic, narcissistic, banal self-absorption." (Neither addresses the question of why it is greedy for veteran actors who are indispensable to the most suc- cessful show on television—and who cannot reasonably expect another comparable windfall—to insist on a fair chunk of the money that would oth- erwise flow into the NBC kitty.)

In any event the diatribe scarcely registers, crowded out by celebratory cover stories in *TV Guide* ("Michael Richards: Still Kramer After All These Years . . . Seinfeld's slapstick sidekick strikes it rich!"), *Business Week* ("*Sein- feld:* The Economics of a TV Supershow, and What It Means for NBC and the Industry"), and an encyclopedic special issue of *Entertainment Weekly*— "The Ultimate *Seinfeld* Viewer's Guide"—including a plot summary of the series' 148 episodes to date (an admirably meticulous piece of scholarship, by the way).

The ramifications extend: a franchising company will turn a soup com- pany called Soup Nutsy (inspired by the *Seinfeld* episode about the Soup Nazi, itself inspired by the allegedly intimidating proprietor of Soup Kitchen International on West Fifty-fifth Street) into a name-brand chain, that is if it is not outflanked by another chain, Soup Man Enterprises, which (accord- ing to another story) has struck a deal with the man from Soup Kitchen International (although the latter is duly appalled by "'the hateful name' . . . he had been given on *Seinfeld*"); the *New York Times* interviews Cana- dian comic Mike Myers about Seinfeld as emblem of American comedic values ("That observational comedy—observing the everyday minutiae and creating a glossary of terms"); the *New York Post* reports that a Miller Brew- ing manager has been fired for talking in the office about a *Seinfeld* episode (the one about the woman whose name rhymes with a female body part)— "SEINFELD RHYME IS REASON BEER EXEC GOT CANNED"—and the ensuing trial is covered by Court TV; in *Vanity Fair, The New Yorker,* and elsewhere, Jerry Seinfeld himself poses with shoe polisher, goldfish bowl, and boxes of cereal as an advertising representative for the American Express Card; a discussion in *New York* about the erosion of Jewish identity cites *Seinfeld* as a supreme and troubling example of the assimilation of Jewish cultural style into the mainstream; and *TV Guide* enshrines two *Seinfeld* episodes in its special

issue of the 100 Greatest Episodes of All Time (an issue produced in conjunction with the cable channel Nickelodeon in order to promote a "Greatest Episodes of All Time Week" that will in turn promote a spinoff channel called TV Land, which is lobbying to be added to the roster of Time Warner's Manhattan Cable).

In exposure it doesn't get any better in this republic, all to make people even more conscious of a show they would probably have been watching anyway, since, quite aside from the hype, it happens to be inventive and suggestive and consistently funny in ways that television rarely permits. How weirdly, in fact, the speed and rigor of the show contrast with the elephantine and intrinsically humorless mechanisms of publicity and subsidiary marketing that accrue around it. My feelings about *Seinfeld*—a show I had long since gotten into the habit of watching in reruns, as a welcome respite from the execrable local news at eleven—might have been different had I known I was watching (in the words of a spokesman for what *Business Week* calls a "top media buyer") not merely a funny show but "one of the most important shows in history."

ONCE THERE WASN'T ANYTHING that seemed quite so overpoweringly important, at least not anything short of World War II or space travel. I can remember, barely, what it was like when television was still a distinctive and somewhat raggedy presence in a world to which it was foreign. The memories have a pastoral quality, mixing in bushes from the other side of window, perhaps, or a vase of flowers adjacent to the TV cabinet. Into that world of rich colors and complex textures emanated—from the squat monolithic box in the corner—a vague and grayish mass of moving figures, characters in a story line that often (given the vagaries of reception, the inadequacy of early TV amplification, and the clatter of household interruptions that people had not yet learned to tune out) had to be deduced from partial evidence.

The memories are imbued as well with a flavor of voluptuous indolence—an indolence associated with sofas, pillows, bowls of candy or popcorn, and apparently endless stretches of disposable time—which only at later ages would come to seem more like the flavor of weakness or compulsion or simple lack of anything better to do. (It took about a generation for the culture to acquire that absolute sense of the TV watcher's ennui which pro-

vides a major subtext for *Seinfeld,* whose episodes often end as the characters are just clicking the set on as if in resignation to their fate.)

It didn't seem to matter particularly what programs were on. Between the ages of five and ten, for instance, I absorbed any number of installments of a stream of television comedies, including *The Abbott and Costello Show, Amos 'n' Andy, You Bet Your Life, The Jack Benny Show, Private Secretary, Mr. Peepers, The George Burns and Gracie Allen Show, Make Room for Daddy, My Little Margie, The Adventures of Ozzie and Harriet, The Life of Riley, Ethel and Albert, Father Knows Best, December Bride, Mama, The Bob Cummings Show,* and *Bachelor Father.* Of all these, barely a single specific episode has engraved itself in memory, although each left behind a vivid impression of its essential nature, a sort of Platonic episode embodying all possible variants. The plots, as I recall, tended to revolve around failed practical jokes, embarrassing household mishaps, doomed get-rich-quick-schemes, ceaseless unsuccessful attempts to get the better of one's next door neighbor, misinterpreted telephone calls, misdirected packages. A well-meaning husband would sell his wife's heirloom to the junk man by mistake or invest his nest egg in a con man's Florida real-estate scam; a household pet would knock Aunt Flora's elderberry wine into the punchbowl; Junior would go to elaborate lengths to lie about the window he knocked out playing softball; a secretary would mix up the dunning letters and the party invitations, or uproariously blow off her boss's toupee by turning up the air conditioner full blast.

There were also other and better comedies — *The Phil Silvers Show, The Honeymooners, I Love Lucy* — of which, with the reinforcement of endless reruns, I retain a much sharper recollection. But the overall effect was of an ill-defined continually shifting flow not altogether unlike the movement of fishes in an aquarium, soothing, diverting, and (with the exception of certain programs — such as *The Web* or *Danger* — given over to tales of the eerie and uncanny) incapable of causing upset. It was stuff that danced before one's eyes and then never came back; that was its charm and its limitation.

The sheer quantity of programming was already impressive in the fifties. In retrospect — scanning complete schedules of network shows and realizing just how many of them I watched — it seems unaccountable that there was ever time for other important cultural activities like going to the movies, reading comic books, listening to LPs of Broadway show tunes, collecting

bubble-gum cards, or studying with the utmost seriousness each new issue of *Life* and *Children's Digest* and, of course, *TV Guide*. Yet the evidence is inescapable as my eye runs down the listings and recognizes one forgotten companion after another, *The Court of Last Resort, The Millionaire, Mark Saber of London, Sergeant Preston of the Yukon, Name That Tune, To Tell the Truth,* not to mention *Schlitz Playhouse* and *The Gisele MacKenzie Show*.

Of course nothing was ever as unconscious as early television programming appears in hindsight. In fact, we thought television was a big deal then, too; we just didn't have any idea what "big deal" really meant. Only by comparison with the present day do those foundational efforts take on the improvisational air of a reign of accident, where words and images washed up—anything to fill ten minutes here, twenty minutes there—as if their purveyors had given only the faintest glimmer of a thought to the overall design they formed.

THE BIG DEAL THAT IS *Seinfeld* is also just a quick little thing, a concentrated dose of farcical invention that seems to be watched by just about everybody. They watch it for reasons as varied as its uncannily precise analysis of miserable but inescapable relationships, its evocation of the bizarre randomness of urban life, its pratfalls and grimaces, its original contributions to the language (the "glossary of terms" to which Mike Myers refers, evolving out of an almost Elizabethan fondness for protracted quibbles), its affinity with the fantastically mutating formalism of Edmund Spenser, or the platform it provides for the fantastically mutating eyes and eyebrows and mouth of Julia Louis-Dreyfus. It is a brief and reliable pleasure.

The most obvious source for this pleasure is a cast capable of unusual refinements of ensemble playing. Seinfeld himself (originally a stand-up comic whose routines revolved around rather mild evocations of life's minor absurdities) is the indispensable straight man, the perfect stand-in for anybody, just a guy in sneakers who lives alone, watches television, hangs out with his friends, and only gradually reveals himself as the *homme moyen obsessionel* whose mania for neatness keeps incipient panic at bay. Seinfeld's manner, so understated as to make his lines seem thrown away, works beautifully against the relentlessly goading, operatically whining style of Jason Alexander's George (a character apparently modeled on the series' co-

creator, Larry David), in whom the classic Woody Allen neurotic persona is cranked to a far more grating level of cringing self-abasement and equally monstrous self-serving. Alexander is the real workhorse of the series and inhabits the role so thoroughly that he can get away, for instance, with an episode in which he knocks over small children in an effort to escape from a smoke-filled building.

The blank zone inhabited by Jerry and George — their trademark ennui punctuated by ricocheting gags — is made richer and stranger by Julia Louis-Dreyfus as Jerry's ex-girlfriend Elaine and Michael Richards as the perpetually mooching across-the-hall neighbor Kramer. Less striking in the earliest episodes, Louis-Dreyfus's brand of facial comedy has evolved into a distinct art form. Analyzed in slow motion, her shifts of expression are revealed as a complex ballet in which eyes, nose, mouth, neck, and shoulder negotiate hairpin turns or spiral into free fall. The smirk, the self-satisfied grin, the effusion of faked warmth, the grimace of barely concealed revulsion: each is delineated with razor precision before it slides into a slightly different shading.

As for Richards's Kramer, it seems hardly necessary at this point to praise what has become probably the most familiar comic turn in recent memory. Kramer as a character embodies all the expansive and ecstatic impulses that are severely curtailed in the others, creating an opportunity for the mercurial transformations in which Richards adopts by rapid turns the masks of Machiavellian intrigue, righteous anger, infant rapture, jaded worldliness, Buddhistic detachment, down-home bonhomie. Richards practices a refinement of the school of manic role-shifting of which Robin Williams and the Michael Keaton of *Beetlejuice* were earlier exemplars, and he seals his performance with pratfalls that by now are legendary.

Seinfeld's singular intensity has everything to do with its brevity, the twenty-two minutes of programming paid for by eight minutes of commercials. (In this case the eight minutes work out to more than a million dollars a minute.) By straining at the limits of what can fit into a twenty-two-minute slot (rather than visibly struggling to fill it, like most shows), *Seinfeld* distends time. The best episodes feel like feature films, and indeed have busier narratives than most features. (The periodic one-hour episodes, by contrast, sometimes go weirdly slack.) There is no padding; plot exposition is relayed

in telegraphic jolts. An episode normally encompasses three separate plots that must converge in some fashion at the end, and the management of these crisscrossing story lines, the elisions and internal rhymes and abrupt interlacements, is one of the show's delights.

The sheer quantity of matter to be wrapped up enforces an exhilarating narrative shorthand. Comic opportunities that most shows would milk are tossed off in a line or two. The tension and density of working against the time constraint is a reminder of how fruitful such constraints can be. If Count Basie had not been limited to the duration of a 78 rpm record, would we have the astonishing compression of "Every Tub" (three minutes, fourteen seconds) or "Jumpin' at the Woodside" (three minutes, eight seconds)?

The enormous budget, of course, makes possible frequent and elaborate scene changes that would be prohibitive for most shows. (It also makes possible a brilliant and constantly shifting supporting cast of taxi drivers, doormen, liquor-store owners, television executives, German tourists, midwestern neo-Nazis, and hundreds more.) We are far from the primal simplicity of *The Honeymooners,* whose aura owed much to the rudimentary and unchanging space of Ralph and Alice Kramden's impoverished kitchen. *Seinfeld*—despite the recurrent settings of Jerry's apartment and Monk's Cafe—is not about space in the same way, only about the psychic space of the characters and the catchphrases and body language that translate it. They carry their world with them into elevators and waiting rooms, gyms and airplanes and Chinese restaurants.

IT IS A WORLD IN SHARP FOCUS (rendered with an obsessive concern for surface realism of speech and clothing and furniture) in which everyone, friend and stranger alike, undergoes permanent uncomfortable scrutiny. The prevailing mood of *Seinfeld*'s protagonists is hypercritical irritation. Deeply annoyed by others most of the time, the four leads are only erratically conscious of how much annoyance they generate in turn. The spectrum of self-awareness ranges from George's abject self-loathing ("People like me shouldn't be allowed to live!") to the blissed-out self-approbation of Kramer, with a special place reserved for the scene where subtitles translate the comments of the Korean manicurists on whom Elaine is bestowing what she imagines to be a friendly smile while she waits impatiently to have her nails done: "Princess wants a manicure. . . . Mustn't keep Princess waiting."

The mutual kvetching of Jerry and George — of which we're given just enough to know how unbearable continuous exposure would be — serves as the ground bass over which Kramer, Elaine, and the expanding circle of subsidiary characters weave endless comic variations. The relationship of Jerry and George is much like that of talk-show host and sidekick, marked by constant obligatory banter indistinguishable from nagging. In short, a comfortable level of hostility and mistrust is maintained, upheld by everyone's fundamental desire not to get too closely involved with other people.

Seinfeld is defined by a series of refusals. Romantic love is not even a possibility, although deceptive or obsessive forms of it occasionally surface. Sex figures merely as a relentless necessity and an endless source of complications, and the intrigues that surround it have a detached, businesslike tone. *Seinfeld* succeeds in making a joke not only out of sex but, more scandalously, out of sexual attractiveness, the "telegenic" currency of the medium. Nor does the show succumb to the "feel-good" impulses that are the last resort of American movies and TV shows. It remains blessedly free of that simulation of human warmth evident in everything from weather reports to commercials for investment banking. There is a tacit contract that at no point will Seinfeld and friends break down and testify to how much they really like one another. It's clear that each thinks he really could have done better in the way of friends but happens to be stuck with these ones and can't imagine how to survive without them.

The emotional tone is a throwback to the frank mutual aggressiveness of Laurel and Hardy or Abbott and Costello (the latter frequently acknowledged by Seinfeld as a prime influence), who never made the error of thinking their characters lovable. *Seinfeld* likewise keeps in sight the comic importance of subjecting its characters to cruelty and humiliation, of forcing them constantly to squirm and lie and accept disgrace before disappearing into the ether until next week. The humiliations in question are often physical; the show has tirelessly enlisted body parts, bodily fluids, disgusting personal habits, diseases, and medical operations into its scenarios, as if the comedy of the lower body were necessary to keep in balance all that disembodied verbal riffing.

What relief to encounter comedy that does not mistake itself for anything else. Its characters are free to start from zero each time, free to indulge the marvelous shallowness that is the privilege of the creatures of farce. Noth-

ing counts here, nothing has consequences; as one of the show's writers (Larry Charles, in *Entertainment Weekly*) has observed, the crucial guideline is that the characters do not learn from experience and never move beyond what they intrinsically and eternally are.

They cannot better themselves: a condition with positively subversive implications in a culture of self-help and self-aggrandizement where has-beens no longer attempt comebacks but rather "reinvent themselves" and where a manual for would-be best-selling autobiographers advises how to "turn your memories into memoirs." There is a wonderful moment when Kramer, swelling with indignation at some petty trespass of Jerry's, asks him, "What kind of person *are* you?" and he replies in squeaky desperation, "I don't know!" The characters can only play at self-knowledge; any real consciousness of who they are—unless in some alternate world, along the lines of the celebrated "Bizarro Jerry" episode—would be like the cartoon moment when Bugs Bunny looks down and realizes he's walking on air.

Although they cannot evolve, they do change form ceaselessly. Their not really being people gives them an ideal flexibility. If Kramer is convinced in one episode that Jerry has really been a secret Nazi all along, or if sexual abstinence enables George to become an absurd polymath effortlessly soaking up Portuguese and advanced physics, it will leave no aftertaste the next time around.

If *Seinfeld* is indeed, in the words of *Entertainment Weekly,* "the defining sitcom of our age" (one wonders how many such ages, each defined by its own sitcom, have already elapsed), the question remains what exactly it defines. Deliberate satire is alien to the spirit of the enterprise. *Seinfeld* has perfected a form in which anything can be invoked—masturbation, Jon Voight, death, kasha, deafness, faked orgasms, Salman Rushdie, Pez dispensers—without assuming the burden of saying anything about it (thereby avoiding the "social message" trap of programs like Norman Lear's *All in the Family* or *Maude*).

The show does not comment on anything except, famously, itself, in the series of episodes where Jerry and George create a pilot for a sitcom "about nothing," a sitcom identical to the one we are watching. This ploy—which ultimately necessitates a whole set of look-alikes to impersonate the cast of *Jerry,* the show-within-a-show—ties in with the recursive, alternate-universe

mode of such comedies as *The Purple Rose of Cairo* and *Groundhog Day,* while holding back just this side of the paranormal. If conspiracy theories surface from time to time, it is purely for amusement value, as in the episode where a spitting incident at the ballpark becomes the occasion for an elaborate parody—complete with Zapruder-like home movie—of the Single Bullet Theory (figuring in this context as the ultimate joke on the idea of explanation).

The result is a profoundly entertaining mosaic of observed bits and traits and frames. Imagine some future researcher trying to annotate any one of these episodes, like a Shakespearean scholar dutifully noting that "tapsters were proverbially poor at arithmetic." It would not merely be a matter of explaining jokes and cultural references and curt showbiz locutions—"he does fifteen minutes on Ovaltine" or "they canceled Rick James"—but of explicating (always assuming that they were detected in the first place) each shrug and curtailed expostulation and deftly averted glance.

WHERE IT MIGHT ONCE have been asked if *Seinfeld* was a commentary on society, the question now should probably be whether society has not been reconfigured as a milieu for commenting on *Seinfeld.* If the craziness enacted on the show is nothing more than the usual business of comedy, the craziness that swirls around it in the outside world is of a less hilarious order. Comedy and money have always been around, but not always in such intimate linkage, and certainly not on so grandiose a scale. In the fifteenth century, the fate of Tudor commerce was not perceived to hinge on the traveling English players who wowed foreign audiences as far afield as Denmark.

The information-age money culture for which *Seinfeld* is only another, fatter bargaining chip clearly lost its sense of humor a long time ago, a fact that becomes ever more apparent as we move into an economy where sitcoms replace iron and steel as principal products, and where fun is not merely big business but seemingly the only business. The once-endearing razzmatazz of showbiz hype mutates into a perceptible desperation that registers all too plainly how much is at stake for the merchandisers. One becomes uncomfortably aware of them looming behind the audience, running electronic analyses of the giggles and nervously watching for the dreaded moment when the laughter begins to dry up. It all begins to seem

too much like work even for the audience, who may well begin to wonder why they should be expected to care about precisely how much their amusement is worth to the ticket sellers.

As for the actual creators of the fun, I would imagine that—allowing for difference of scale and pressure—they go about their work pretty much the same way regardless of the going price for a good laugh. Some years ago, in a dusty corner of Languedoc, I watched a dented circus truck pull up unannounced along the roadside. The family of performers who clambered out proceeded to set up a makeshift stage that in a few hours' time was ready for their show: a display of tumbling and magic that could have been presented without significant difference in the fifteenth century. After two hours of sublime entertainment, they passed the hat around and drove away toward the next bend in the road. It is strange to think of the fate of empires, even entertainment empires, hinging on such things.

The New York Review of Books, August 14, 1997

Show Trial

Public response to the Clinton grand-jury testimony may hinge on a question of film grammar. Does an audience empathize more readily with an offscreen prosecutorial voice or a witness sweating it out in tight close-up? If the dynamics of *Les Misérables* and *The Fugitive* are relevant, then the President may yet have a chance against the Javerts and Lieutenant Gerards of the Special Prosecutor's office and the House Judiciary Committee. The Starr report already resembled the surveillance records of a private detective; the grand-jury deposition puts us — aesthetically speaking — in the position of watching a backroom police interrogation. Many who watch this spectacle will surely imagine themselves in the same chair and wonder just how gracefully or forthrightly they would react to similar grilling on similar issues.

But to comment on the televised deposition as a form of theater, just another episode in the global triumph of showbiz as ultimate reality, is in itself to concede defeat. By being forced to submit to these conditions, Clinton has already lost. By accepting the legitimacy of the spectacle as simply (to quote Representative James Rogan) the Judiciary Committee's way of "bringing the American people into our confidence," the public will ensure many more such shows. The round-the-clock broadcasting of the President's four hours of testimony looks like nothing but a new version of the old-fashioned show trial, a carefully calculated public humiliation that achieves its effect regardless of how the witness actually testifies. Once the question "Did Monica Lewinsky perform oral sex on you?" has been asked,

face-to-face and on camera, the mischief has been done, even if the appropriate answer might be that it is not any Special Prosecutor's business.

Ironically enough, at the same time that television channels were monopolized by questions of why the President wore a particular tie or exactly which phone numbers he dialed from a Williamsburg motel, President Clinton, at the United Nations, was evoking "chilling prospects of vulnerability . . . bringing each of us into the category of potential victim." His theme was international terrorism, but he might as well have been talking about the question-and-answer session to which viewers were being treated. As a patron in a midtown bar remarked to a television crew, "If they can do this to the President, what could they do to me?"

Outrage may be hard to summon up in a matter so fraught with unintentional comedy, what with dialogue such as "I did not wear a tie she gave me on August the sixth" or "Is this the chicken-soup conversation, Mr. President?"—not to mention unprecedented advisories such as the one posted by CBS: "Viewers Are Cautioned That This Broadcast Contains Strong Language and Sexual Content." Even the earlier stages of this matter, however, were insufficient preparation for the queasy spectacle of the President clamped in front of the video camera as securely and relentlessly as a seventeenth-century miscreant in the stocks. Clinton's opponents will focus on his own performance, the legalistic evasions and ingratiating mannerisms by which he attempted to deflect the Starr team's invasive questioning. Far more troubling, however, is the framework within which that performance took place. Both the proceedings themselves, and even more so their indiscriminate downloading to the known universe, suggest the kind of political theater in which a public figure is deliberately stripped of authority. The point of the exercise was not to make Clinton's testimony public (a transcript would have served just as well) but to demonstrate his subservience to Congress.

Granted, this is not the trial of the Knights Templar in fourteenth-century France or the Moscow Trials of the 1930s. Unlike Jacques de Molay or Nikolay Bukharin, Clinton will physically survive this process, but the intent to destroy him—at least symbolically, and with any luck politically—is no less evident. Republican voices are now heard opining that if Clinton had simply told the truth when the Lewinsky affair was revealed in January 1998, this

whole matter would amount to nothing. If that is true, it speaks volumes about the Starr investigation and the Republican leadership that has assisted it at every turn. Starr's triumph — with the indispensable assistance of Linda Tripp — is to have finessed a bit of garden-variety sexual drifting into the realm of possible impeachment. Congress may well lack the stomach to go that far, particularly if the bullying of Clinton backfires with the public. In any event, in the culture of instant replay, it may not really matter.

The New York Times, September 22, 1998

The Movie *of the* Century:
The Searchers

THE MOVIE OF THE CENTURY: it is a phrase so high-concept it ought to be the title of a movie, or at least the slogan for a marketing campaign, the ultimate coming attraction. Never mind *Intolerance* or *Citizen Kane,* the real Movie of the Century would be just such a will-o'-the-wisp, always just about to be revealed, a hundred years in the making, cast of millions, coming soon to a theater near you. What drove movies in the past was anticipation of what the future held. In the years when Hollywood was actually producing a fairly steady flow of good-to-great movies, there was scarcely time or inclination for a backward glance.

Or else — for this impossible honor — one might take any representative slice of the old Hollywood's product, from the twenties or the thirties or the forties according to preference. Profusion was, after all, the point. At the height of the American public's romance with moviegoing, a night at the Orpheum was as fundamental and recurrent an activity as having dinner or going to bed; a reliable flow of cinematic pleasures was more important than any particular presentation. Tonight a double bill of a pirate adventure and a murder mystery; starting Wednesday the screen version of a best-selling love story and a college musical. All the movies were somehow interrelated, so that even the humblest Mr. Moto thriller or Gene Autry western had its part in the mix that likewise encompassed *Gone with the Wind.* Movies were not meant to live alone any more than people.

Pushed, however, to propose a single movie for such unnatural solitary

eminence, I'd have to pick the one I've ended up watching oftenest: John Ford's *The Searchers*. Released in 1956, it's a product of just that moment when—with the breakup of its distribution monopolies and the erosion of its audience by television—the studio machine finally began to come apart. It looks both ways in time, embodying all the traditional virtues of story-telling and technical command yet expanding established limits to suggest a world of possibility beyond what Hollywood had permitted itself to explore. It's an extraordinarily generous and exploratory work, made by a director who had just turned sixty-one. *The Searchers* might be taken as the outer-most extension of everything that John Ford—and who else but John Ford could have made the American Movie of the Century?—had learned in the forty years of filmmaking that preceded it, from the time he made what was probably his acting debut playing a character named Dopey in his brother Francis Ford's two-reeler *The Mysterious Rose*, filmed just as World War I was breaking out.

A career like Ford's was only conceivable in the old Hollywood. Born in 1894, he had already directed more than fifty films (most of them two-reel cowboy pictures along the lines of *Bare Fists* and *Desperate Trails*) when he achieved his first major success at age thirty with the epic western *The Iron Horse*. He went on to turn out seventy-two more, not counting a range of shorts and documentaries undertaken for the U.S. government. Laden with honors for such prestige pictures as *The Informer, The Grapes of Wrath,* and *How Green Was My Valley,* Ford expended more of his creative energy on quirkier personal projects, westerns like *My Darling Clementine, Fort Apache,* and *Wagonmaster.* Outwardly straightforward entertainments noted for their splendid landscapes and the vigorous presence of Ford's stock com-pany of character actors, these were films that undermined conventional movie structure in favor of a looser, more generically mixed form in which slapstick could adjoin tragedy and plot development might be suspended at any moment for a dance or a brawl or a serene stroll.

The Searchers was in many ways an atypical project for Ford. Derived from an excellent novel by Alan LeMay, it had all the earmarks of the newer "adult" westerns that were Hollywood's answer to the onslaught of TV gun-slingers: a psychologically conflicted hero, adulterous (if repressed) passion, rape, massacre, interracial sex. The dramatic action was far more violent and

overt than in Ford's previous westerns, and he rose to the challenge by forg-
ing a style unique to this film. All the amplitude and laid-back atmospherics
of his earlier masterpieces are put under a pressure that takes Ford beyond
himself; the garrulous impulse that often led to extended bouts of knock-
about comedy and ceremonial pageantry is reined in, although hardly absent.
It's as if two contradictory approaches to filmmaking operated simultane-
ously. The characteristic Fordian desire to open things up, to slow down the
story to allow the margins and backgrounds to be fully felt — his capacity for
letting minor characters become momentarily central — works together here
with a contradictory impulse toward ruthless concision and relentless for-
ward impetus. For all its seven-year time span and sprawling geographic
range, *The Searchers* works like a suspense movie. One might almost believe
that Ford had been studying the work of Hitchcock; in no other film of his
are the characters ridden so hard by the demands of narrative. (If there is an
exception, it is the 1961 film *Two Rode Together,* which amounts to an even
more radically compressed footnote to *The Searchers.*)

WHEN THE MOVIE CAME OUT in 1956, I was a little too young to be
exposed to its elements of rape and massacre, but by reputation it extended
a whiff of the forbidden. This was a movie, the word went, with a profound
violation at its core, and implacable rage stemming from that violation. It
took me a few years to catch up with it; this was before the era when direc-
tors like Martin Scorsese and Wim Wenders helped elevate *The Searchers* to
the canonical status it currently enjoys. Only on Times Square — at the
eponymous Times Square theater, devoted exclusively to old westerns — did
it surface periodically.

What was most immediately striking about *The Searchers* was what it
didn't have in common with other westerns, the westerns on which fifties
kids became experts by dint of being exposed to them Saturday after Satur-
day. It wasn't about the deed to the mine, or the coming of the railroad, or
the first great cattle drive, or a hotheaded young gunslinger out to a make a
name for himself; the standard-issue one-street cowboy-picture town didn't
come into it at all. No recourse was had to the comforting rituals of the
genre, those depredations and confrontations that recur with a lulling pre-
dictability made all the more cozy by the assortment of wonderfully familiar

character actors who recirculate endlessly as sheriffs, bankers, outlaws, barmaids, schoolmarms, and ranch hands.

In the course of the fifties the western became increasingly preoccupied with Indians, a trend that gave the genre fresh energy and fresh complications. Some Indian westerns, such as *Devil's Doorway* and *Broken Arrow,* were notably liberal in their stance, determined to expose past injustices; some, like Raoul Walsh's *Distant Drums,* a remake of the war movie *Objective, Burma!* that simply substituted Seminoles for Japanese, were rooted in implacable hostility; a few odd ones, like Allan Dwan's *Cattle Queen of Montana,* were almost *Hiawatha*-like in their evocation of a serenely utopian vision of Native American life. Here again *The Searchers* managed to avoid stock situations; there were to be none of the tiresome conflicts between sympathetic "friendlies" and fanatical "hostiles," no scenes of besieged cavalrymen sweating it out in the stockade while waiting for a dawn attack.

Nor was there any of the usual dialogue about learning to live in peace together, or the earnest speeches decrying broken treaties. Curiously, considering that its story revolved entirely around Indians, the film didn't seem to have anything particular to say about them. It pursued a course of omission and elision, as if to admit that there were places it was not capable of entering. There were no attempts at realistic vignettes of Comanche life; everything was overtly filtered through white perception and white imagination, the viewpoint of isolated settlers "out on a limb somewhere, maybe this year, maybe next," enraged at their own vulnerability. The issue was not civilization versus savagery but how to protect life and property under makeshift circumstances, and how to react after it's too late for protection.

THE LONG OPENING SCENE manages, without a superfluous touch, to introduce seven characters (four of whom do not have long to live), to sketch in the history of the Edwards family, including their adoption of young Martin Pawley (Jeffrey Hunter), himself part Cherokee, after his parents were killed in an Indian raid, and to begin elaborating the characterization of John Wayne as the embittered Confederate veteran Ethan Edwards, a performance all the more vivid for its intractable contradictions. The plot, as far as we can grasp it at the outset, has to do with Ethan's return to his brother's Texas homestead after years of mysterious postwar drifting during which he

acquired, by whatever means, a sackful of fresh-minted Yankee dollars. Some scattered remarks and furtive glances suffice to establish that Ethan's arrival is a source of unease; there is mistrust between the brothers; Ethan and his sister-in-law love each other, may even have been lovers. (This possibility is never put in words, rests entirely on a couple of reaction shots, yet subtly informs Wayne's whole portrayal.) Despite its relative brevity, the scene accomplishes a necessary job of misleading the audience into thinking that the movie is going to be about the individuals whom it has just met. On repeated viewings, nothing is more powerful than Ford's grouping of the unwittingly doomed Edwards family in a single splendid composition, as if to frame them for all time before they vanish.

The next morning, before any suggestion of daily routine is allowed, we are off with Ethan, Martin, and a posse of neighbors on a chase after stolen cattle. This breathless interruption is the first in a long chain: we are to have an interrupted funeral, an interrupted meal, an interrupted wedding, countless interrupted conversations. It becomes apparent that the cattle theft was a ruse to give a band of Comanche the opportunity to massacre those left behind; we spend the moments before the massacre with its victims. The close-up of the Comanche war chief Scar blowing his buffalo horn signals the film's most important event, which we are not allowed to witness. That the massacre must remain unseen is essential to Ford's sense of decorum. It goes without saying that this offscreen event is far more powerful than any overt depiction could be. A contemporary remake would be likely to revel in the details, with the help of half a century of prosthetic technology: how could the temptation be resisted?

In a shot famously copied by George Lucas in *Star Wars* — Jeffrey Hunter staring in horror at the smoky ruins — we intrude on the aftermath. All are dead except for the two girls, who have been carried off by the Comanche; we cut abruptly to the funeral, which is cut short angrily by Ethan: "Put an amen to it. There's no more time for praying. Amen!" In this atmosphere of indecent haste, Ford is able to rapidly fill out another indispensable family grouping, the neighboring Jorgensens, whose son Brad has been courting the older Edwards girl, and whose farm becomes the film's image of home now that the primal home has been burned. Ethan and Martin, initially with a party of others, then on their own, set out to find the girls. The elder is

found raped and killed; the younger, Debbie, becomes the sole object of the quest. Seasons pass; years pass. A secondary plot line emerges: Ethan doesn't want to rescue Debbie; he wants to kill her because by now she will have been married off to a Comanche and "ain't white anymore." In a sense it is the most linear of films, although its flashbacks, time lapses, and frequent changes of scene make it feel uncannily protracted and complex. They search; they find; Ethan has a sudden change of heart and doesn't kill Debbie when he gets the chance; Debbie comes home; Ethan goes away by himself.

Much has been made of Ethan's abrupt turnaround, encapsulated in a single image of John Wayne lifting the rescued Debbie (Natalie Wood) into his arms. But, moving though it is, it is also the most Hollywoodish moment in the film. In LeMay's novel, Ethan has no such change of heart and is killed before he can carry out his murderous intentions; he's clearly the villain of the piece. In order for Wayne to play the part, things had to come out differently, but Ford and his screenwriter Frank Nugent wisely resisted the impulse to offer any explanation for Ethan's conversion. At the same time one can't make too much of it; it's a sudden and silent reversal of everything else we know about the character, perhaps even a momentary weakening of purpose he might come to regret. This is, after all, the same person who shoots out the eyes of a dead Comanche because "by what that Comanch believes, ain't got no eyes he can't enter the spirit land, has to wander forever between the winds." Ethan Edwards stands with James Stewart's Scottie Ferguson in *Vertigo* as one of the great inscrutable obsessives of American film. Just as we don't know where Ethan has been before the movie began, we have no real sense of what kind of person he will become. The only certainty is that he will be essentially alone.

Ethan's change of heart, although it neatly resolves the situation, is no more the point of the movie than any of the other things that happen in *The Searchers.* It is a movie in which things change irrevocably between the beginning and the end, in which a world is created only to be wrecked. After the first few scenes, the worst has already happened, and the only remaining dramatic action can be an attempt to retrieve a remnant. Finding Debbie will not restore the family that has been destroyed or erase the memory of devastation.

The primary power of *The Searchers* derives from the vast stretches of space and time that it strings together on a single thread. I don't mean the mere bigness that money can buy, the splendid scenery, sweeping music, and sheer duration of, say, William Wyler's otherwise empty *The Big Country*. *The Searchers*, magnificently shot by Winton C. Hoch, is an object of incomparable beauty, a fact never more evident than when New York's Public Theater a few years ago unveiled an immaculate print and projected it under optimum conditions on a properly vast screen. If I return to *The Searchers* repeatedly, it is beyond anything else in order to see certain images again: Ethan and Martin crossing an icy plain at night, or riding downhill through deep snow, or silhouetted against a red sky as they travel along a ridge; the Seventh Cavalry, fresh from slaughtering a Comanche encampment, crossing a newly thawed stream; the camera moving down a narrow crevasse until the whole VistaVision image is given over to a singular slice of rocky abstraction. Not one shot feels like an interpolation or interlude. The visual life of the film is a continuous balancing of immensity and intimacy. Movement through space, whether of a hand in close-up or a brigade in long shot, is always in the center of the drama.

The operatic dimension of the movie exists not so much in the dialogue or in Ford's masterful deployment of onscreen singing (the hymn "Shall We Gather at the River" is heard twice, at a funeral and a wedding) — and certainly not in Max Steiner's overemphatic score (of which Ford remarked, "With that music they should have been Cossacks instead of Indians") — as it does in that succession of expansive light-paintings. The film's center and culmination is the famous shot in which, while Ethan and Martin converse in the foreground, the newly found Debbie emerges as a tiny speck at the ridge of a sand dune, running downhill toward the two men, Ethan oblivious, Martin suddenly aware of her presence and standing frozen in astonishment just as she reaches the edge of the creek by which they are standing. The coordination of movement and timing within this composition is a species of music that can be attended to an infinite number of times.

The visuals do tend to focus attention unfairly away from Frank Nugent's script, the most cunning of screenplays, with its telegraphed subplots, reiterated phrases (Wayne's famous "That'll be the day," the inspiration for

Buddy Holly's rock-and-roll anthem), and recurring actions. The structure suggests a world of cyclical rhythms and irrevocable losses; the return to the point of departure is never a true recurrence, since it always registers a fundamental change. The superbly laconic dialogue—discreetly flecked with archaisms and folksy locutions—is a major component of the film's feeling of density. There is so much to be covered that there is scarcely time for verbal elaboration, so that relatively brief speeches have the effect of lengthy soliloquies. Ethan's character is built up out of a few one-liners: "I still got my saber. Didn't turn it into no plowshare neither." "You speak pretty good English for a Comanch, somebody teach you?" The movie's single piece of inflated rhetoric—Mrs. Jorgensen's "It just so happens we be Texicans" speech—is framed by her husband's clarifying remark that she used to be a schoolteacher. Nobody else has time for speech-making. The emotional burden of Martin's final confrontation with Ethan is reduced to four words: "I hope you die."

The Searchers GIVES THE IMPRESSION of expending the material for a whole film in a single scene. Ethan and Martin's trajectory is a passage through various spheres—the world of the Comanche, of the Seventh Cavalry, of old Hispanic aristocracy and new European immigrants—lingering just long enough in each to let us know that there is much more that cannot be shown. The restless forward movement permits unresolved mysteries. We are never to be told where Ethan got those fresh-minted Yankee dollars, or what was the secret mission of Martin's accidentally acquired Indian wife. There isn't time. Most of everything gets lost, and the little that is left at the end—the small band of survivors facing who knows what difficulties of communication and readjustment—is swallowed up in blackness by a closing door.

Most of the important events around which the film revolves occur elsewhere: the years of Ethan's wanderings before the movie begins, the Army's massacre of Indians on whose aftermath Ethan and Martin intrude, Debbie's years of captivity. Of the heroes' seven years of searching we see only a few representative moments, vaulting in Shakespearean fashion over intervals of many years. The holes and absences and elisions are put to superb use

throughout. Because so much is left blank, the characters retain their mystery. In a fundamental way, the movie does not deign to explain itself.

Mystery, here, is not a matter of erasing distinctions. Ford was at bottom a profoundly antiromantic filmmaker, and his appeals to old loyalties always involve a precise calculation of the costs and trade-offs of such allegiances. Some have found the flirtatious byplay between Jeffrey Hunter and Vera Miles (as the long-suffering Laurie Jorgensen) a concession to the Hollywood demand for "love interest," but essentially it reinforces the film's disconsolate view of things. Laurie's anger at Martin is designed to force an acknowledgment that an understanding exists between them; love, or the possibility of love, has something to do with it, but mostly the theme is contractual agreement, just as the crucial flare-up between Ethan and Martin revolves around division of property. If the settlers are inordinately concerned with nailing things down, it is because they live in a territory not wholly theirs, among those already dispossessed (the old Spanish ruling class) or in the process of being dispossessed (the Comanche), and under the monitoring eye of an army serving the interests of a distant national government.

But in the interstices of all that cold-eyed pragmatism and latent rage, sheer human oddity has a way of tilting the balance. Ford's neatest trick in *The Searchers* is his enlisting of an apparently insignificant character—the alternately canny and half-witted drifter Mose Harper—to serve as messenger, chorus, and comic relief. Mose seems like extra flavoring, with his goofy outbursts (hollering "I've been baptized, Reverend, I've been baptized" in the middle of a skirmish with the Comanche) and his yearning for "a roof over old Mose's head and a rocking chair by the fire"; only in retrospect does he emerge as the engine of the story, the true discoverer, not once but twice, of the lost girl. In Hank Worden's magical interpretation, Mose becomes the secret hero of the film, the man who can cross all boundaries and who intuits or randomly picks up the information that counts. The others search without finding; he finds without searching.

American Heritage, November 1998

The Mysteries
of Irma Vep

THE UNCANNINESS OF THE WAY film preserves living moments never registered so sharply as on a July night in the mid-1960s when I was initiated into the work of Louis Feuillade. The occasion was an uninterrupted screening of his seven-hour masterpiece *Les Vampires* at the Cinémathèque Française in Paris. This was the old Cinémathèque, not the comfortable carpeted shrine in the Palais de Chaillot but the more rudimentary screening room that preceded it; no refreshments were served, the chairs were uncomfortable, the ventilation barely supportable, and, in keeping with an iron law of the Cinémathèque, no music accompanied the film. The distinctly unhistorical silence (silent movie theaters, even when they were not music palaces, almost always provided some sort of live soundtrack) was doubtless intended to focus attention rigorously and unwaveringly on the image. No arbitrary glissandi were permitted to interpolate emotional shadings or mar the purity of the visual rhythm. The hall was reasonably crowded, and for the whole seven hours neither laughter nor whispering nor so much as a restless shuffle was to be heard.

This mood of cinephilic awe could hardly have found a more appropriate object. An adventure serial about the elaborate misdeeds of a mysterious band of outlaws, filmed in Paris and environs between the fall of 1915 and the spring of 1916, *Les Vampires* had from its first appearance acquired an aura of fascination and danger. The Parisian prefect of police suspended screenings for two months on grounds of an alleged glamorizing of crime, while André

Breton and his associates discerned traces of "the great reality of this century, beyond fashion, beyond taste." (The phrase occurs in *The Treasure of the Jesuits,* an unproduced play by Breton and Louis Aragon.) The film's antiquity and rarity, its long absence from most film histories, its legendary importance first to the Surrealists and later to filmmakers such as Alain Resnais and Georges Franju, its sheer length: all these certainly helped to create an air of mystery around Feuillade's work, but if there was ever a film with no need for special pleading it was *Les Vampires.*

Without buildup or the slightest hint of back story, it unleashed a succession of perturbing images and inescapable situations that neither had nor required any justification beyond their own intensity. Severed heads turned up in hatboxes; householders were lassoed out of windows and then rolled down stairways in baskets; motorcars raced on dark errands along deserted country roads; conspirators caroused in low dives; masked assassins slipped across the roofs of Paris; a tack treated with a stupefying drug was hidden in a suede glove so as to overpower an enemy by means of a handshake; chambermaids submitted to hypnosis; top hats exploded when hurled to the ground. And beyond all that, beyond comparison, there was Irma Vep: the villainous heroine, or heroic villainess, not so much portrayed as embodied by Musidora, the actress whom Louis Aragon called—with what seems to me justifiable hyperbole—"the Tenth Muse."

It was at the moment in the third episode when Musidora made her appearance as a kohl-lidded chanteuse in the Howling Cat Café, staring directly into the camera with an expression inextricably mingling glee and rage as she howled what must be the most powerful unheard melody in film history, that the impression of strangeness became overpowering. This was not, it turned out, the sixties at all; this was the secret Paris of 1915, and we reverential viewers were to be overrun by Musidora and her Vampires as defenselessly as any of the film's anxious bourgeois investigators. For a few hours all the life energy seemed to emanate from the other side of the screen.

There is a kind of cinematic justice in making this film widely available for the first time just at the end of the century: so much of twentieth-century film is already present in Feuillade. He stands at the font of that Great Melodrama in which at least half the films ever made—whether packaged as Saturday matinee serials or Pop Art exercises in style—figure as episodes. With

its undercover agents, mad scientists, and murderous temptresses, car chases and intricately planned heists, high-society balls and séances and dance parties in underworld cabarets, *Les Vampires* makes an early comprehensive survey of that landscape of crime and paranoia that will eventually encompass the doctors Caligari and Mabuse, wartime commando adventures and late forties film noir and sixties caper pictures, *Goldfinger* and *Batman Returns* and *Die Hard II*, *Mr. Arkadin* and *Point Blank* and *The Usual Suspects*—and does so with a crazy invention and robust humor to which Feuillade's heirs have rarely measured up.

Louis Feuillade was hardly the originator of the crime film—a genre that can be traced back through vigorous if structurally protozoan efforts like the British *Daring Daylight Burglary* (1903) or the American *Automobile Thieves* (1906)—or the serial, a form that was pioneered in the United States beginning with *What Happened to Mary?* (1912) and soon found imitators everywhere. He simply sounded the potential of what had been handed to him, accomplishing in melodrama work that can be compared only to what Buster Keaton did in comedy—and by means not so dissimilar. Like Keaton, Feuillade uses sight gags, trick sets, and a choreographic sense of blocking and gesture to make a world in which the impossible becomes visible, and suites of shockingly unexpected actions unfold like demented cadenzas. *Les Vampires* also shares with Keaton's films a plastic beauty owing nothing to artistic flourishes: we merely have the impression of seeing the world for the first time.

Video, as might have been surmised, is the perfect format for a film that because of its inordinate length has been seen all too rarely, chiefly at festivals and museums. In any mode of life, it is rarely convenient to watch a seven-hour movie, and such marathons of wakefulness distort the effect in any case. *Les Vampires* was designed to be watched not in a single grueling sitting but in sessions separated by a week or more. A serial works on the viewer not only while being watched but in between times; it piles up suggestions and leaves them suspended so they can filter through days of recollection and anticipation, through dreams haunted by its personae, through moments of reverie in which the mind involuntarily rearranges the half-remembered fragments.

THE FILM'S ORIGINAL POSTER bore a repeated image of a woman's face in a black mask, her neck wreathed by a hooklike question mark, and underneath the questions: "Who? What? When? Where?" We are given no answers, only further questions. Of the origins, numbers, and ultimate aims of the Vampires we are told nothing; they simply exist, masters of all forms of dissimulation and intrusion, an underground society whose agents are everywhere, disguised according to circumstance as priests and telephone operators, clairvoyants and caterers. They peer through skylights and flee across rooftops. Shape-shifting nomads of the modern urban underworld, they change clothes and mustaches and ancestries with casual fluidity. Despite their predilection for stealing jewels and bank certificates, some motive deeper than greed is implied; but it is left (mercifully) to the imagination. Their name although not their deeds evokes the supernatural; with their black hoods and hidden lineage of Grand Vampires, they resemble an occult sect; their mastery of sabotage and their arsenal of artillery hint that they might be foreign agents; their targeting of the rich and powerful suggests an anarchist band. The decision to leave their precise mission unspecified makes the Vampires the most potently open-ended of metaphors.

Feuillade himself was no revolutionary, but rather an impeccable Catholic and monarchist, a Provençal wine merchant's son who drifted into the film industry as early as 1905 after a brief but prolific career in journalism. He claimed to have directed some seven hundred films, ranging from brief gags (the early ones have titles like *Papa Takes the Purge* and *Don't Go Out with Nothing On*), through scores of tear-jerking melodramas, historical vignettes, vaudeville routines, religious and patriotic tableaux, to the multi-episode dramas in which he ultimately specialized. A glimpse at some of his earlier shorts—a *Heliogabalus* condensing the matter and manner of a three-hour costume epic into ten minutes or so, or an account of a practical joke played by the hugely popular street urchin Bout-de-Zan—is enough to suggest that a full-scale Feuillade retrospective would be something to wonder at.

He embarked on his cycle of crime serials in 1913 with the epoch-making *Fantômas*, a sublime visualization of the pulp hero created by the prolific hack novelists Allain and Souvestre, a masked, quite heartless, apparently indestructible criminal. This he followed with *Les Vampires*, which had no

literary antecedent and evidently not so much as a scenario. The improvisational leaps and makeshift devices gave it the wild freedom of a dream that lives from one gesture to the next, never knowing where it will end up. Its seamless mix of realistic urban settings and explosively unlikely events might have stemmed from a collaboration between Eugène Atget and Max Ernst. In the ten years remaining to him, he would make further masterpieces in the crime genre — *Judex, Barabbas,* and *Tih Minh* (a sequel to *Les Vampires* that is just about as good) — before shifting to more sentimental material.

Some of the oddness of *Les Vampires* has been compounded by the passage of time, and there is a temptation to perceive some of its more bizarrely amusing moments as inadvertent. Would one really have expected to find a pair of kilted Scottish dancers providing the entertainment for a gang of murderous South American gangsters? Would the chief of these gangsters, whiling the time between crimes, lazily browse in a volume from his library? The deliberateness should not, however, be underestimated. Feuillade's earlier specialization was farce; one of his two overworked heroes here is the broadly comic vaudevillian Marcel Lévesque (a marvelous performance once one gets used to its Opéra-Comique stylization), and when not sowing terror he generally fills the interval with bits of humorous business. The aura of madness and obsession that hangs over silent German melodramas like *The Cabinet of Dr. Caligari* or the Mabuse films of Lang is rather different from Feuillade's frank and casual acceptance of shock as entertainment, his extension of the aesthetic of music hall and Grand Guignol. We will not again find such a knowing, and sometimes downright cheerful, manipulation of the frightful until the advent of Hitchcock.

IN THE SAME YEAR that *Les Vampires* was filmed, D. W. Griffith (who had gotten into the picture business some three years after Feuillade) released *The Birth of a Nation,* recounting the exploits of a quite distinct band of hooded marauders. The technical complexity of Griffith's film, with its intricate crosscutting and fluid changes of angle and distance, the sheer busyness of its mechanisms, was calculated to make movies like Feuillade's look primitive overnight. In *Les Vampires* the camera scarcely budges, and some of the most eventful scenes are enacted in a single theatrically staged long shot. Nonetheless, Feuillade's use of the medium is arguably subtler than

Griffith's; he just goes at it differently. The apparent archaism of his style looked half a century later like purposeful starkness. When a corpse under a sheet comes to life, there are no special effects, no shifts of vantage point, no shadows, just place and action. Things are shown head-on, as if there were only one way to photograph anything: the way it happens.

Feuillade was never to renounce this aesthetic position, bitterly denouncing the fanciful visual experiments of the twenties as decadent and calculated to alienate the audience. In *Les Vampires* he has his vindication. Every shot is not just a composition but an event. (Luis Buñuel, an early admirer, achieved something of the same effect in his 1952 film *The Adventures of Robinson Crusoe*, whose simplified style—a series of calm shocks—might almost be an homage to Feuillade.) Where he triumphs above all is in his pacing, which has the somnambulistic force of a train wreck in slow motion. We watch as traps are elaborately set and then recoil as they shut. When a captive Irma is hypnotized into shooting the Grand Vampire, the scene is over literally in a flash. The abruptness gives, more truly than any symphonic buildup, the effect of a traumatic event: "Did that really happen?" One of the film's most memorable episodes—the gassing and despoliation of a whole houseful of bejeweled aristocrats—is almost haiku-like in its brevity.

Feuillade's solutions to technical problems are sometimes stunningly basic (actors miming their meaning as in charades) or just peculiar: when his heroes watch a newsreel about a murder case, the supposed movie (for want of any more convincing special effect) is staged as a tableau vivant. Sound and language are made part of this mute world in interesting ways. When Irma Vep is bound and gagged by the hero and left in the front seat of his elegant automobile (one of many stately vehicles that decorate the film), she signals her confederate by repeatedly banging her head on the car horn. The visible raucousness of the participants in the various cabaret and party scenes achieves a sort of "silent scream" effect, above all when Irma (in the shot that has become the film's most familiar icon) launches into her song with a fright mask of a grimace.

Written language constantly intrudes in the form of visiting cards, telegrams, newspaper articles, posters, secret messages of all kinds. The titles of the episodes themselves have a compelling pulp poetry: "The Gem That Kills," "The Eyes That Fascinate," "The Master of the Thunder," "The

Bloody Wedding." Punctuating the film at crucial moments are two marvelous bits involving animated lettering. When we first encounter the name Irma Vep on a cabaret poster, the letters rearrange themselves into *Vampire*. The same gag recurs in more elaborate form when Irma is about to be shipped with other female prisoners to a penal colony in Algeria. The Grand Vampire, who in his disguise as a bearded missionary has been given permission to distribute religious tracts among the felons, winks knowingly as he hands Irma her copy. The title *La Vérité Sera à Nu [Truth Shall Be Naked]* transmutes merrily into an anagram worthy of Raymond Queneau or Georges Perec: *Le Navire Sautera [The Ship Will Explode]*.

In Feuillade's world the idea of criminals communicating by means of anagrams seems not altogether out of place. The society he catalogs brims with a sense of its own formality; we are given a series of trim animate lithographs of hotels, theaters, cafés, police bureaus, country manors. The characters bring their luggage with them, and their hats, their parasols, their pocket handkerchiefs. There are stiffly splendid genre scenes — The Engagement Party, The Society Ball, Arriving at the Hotel — that for the film's purposes exist only to be disrupted but, to our latecoming eyes, are irresistible in their overdecorated stolidity. Merely to observe the body language in *Les Vampires* is to become privy to the ancient history of European ceremonial forms. Even Irma Vep pauses to straighten her hair before proceeding with a mission of terror. While Feuillade was filming, the battle of Verdun was taking place; the battle of the Somme began a month after the last episode played. The waistcoats and touring cars and wallpaper and potted plants, the rides along deserted roads by car or bicycle or horse, already have the air of belonging to a lost world.

Will it be lost because of the Vampires? The anxiety that attaches to those masked and ruthless opponents is genuine — yet it is matched by Feuillade's obvious enthusiasm for their resourcefulness. If they come close to triumphing, it is through their chameleonic genius for assuming all the traits of the society they are undermining. In a world of perfect manners, they are the most mannerly. The film resembles at various moments a demonstration of techniques of hypnotism, a field guide to heavy artillery, a sadomasochistic erotic manual, an illustrated history of nineteenth-century theater with special attention to ropes and trapdoors, an antique hotel brochure with a

map of secret passageways: so many pedagogical supplements whose lessons have been absorbed and perfected by the Vampires. They have come, it might be supposed, to guide these gowned and top-hatted ladies and gentlemen into the twentieth century: a task that in itself, certainly from the perspective of France in 1915, would be enough to make demons of them.

The film's conflicting impulses converge in the figure of Irma Vep, a character who escapes from whatever designs the narrative may at some point have had on her, and who so successfully entraps the entrapper that it becomes plausible that Musidora may be the secret author of *Les Vampires*. The actress, whose real name was Jeanne Roques, did in fact go on to write poems, screenplays (some of which she directed), magazine articles, and a number of novels (one of them bore the promising title *Paroxysms*). Her embodiment of Irma Vep carries an authorial weight; the result is a character who even without words seems part of the literature of modern Europe, as endlessly fascinating as her spiritual cousin, Brecht's Pirate Jenny.

Her legend has been carried on by Olivier Assayas's 1997 film *Irma Vep*, which very appropriately casts the Hong Kong star Maggie Cheung as Musidora's stand-in in fragments of a latter-day remake (the iconic black bodysuit, suitable for roaming in the corridors of large hotels, has not lost its erotic charge). We see her between scenes of offscreen intrigue and footage from both Feuillade's original and the Feuilladesque Hong Kong action fantasy *The Heroic Trio*. Earlier in the nineties, Charles Ludlam had paid tribute with his two-character play *The Mystery of Irma Vep*. Ludlam's play, strictly speaking, has no connection with Feuillade's film other than the name of its protagonist, and what passes for its story line owes more to *Rebecca, The Mummy,* and *The Wolf Man* than to *Les Vampires*. In a deeper sense, however, the two works are linked by a common flair for humor and improvisation, a similar cavalier delight in the arbitrariness of their narratives, an air of having fed the history of melodrama into a shredder and then picked out the gaudiest bits, and above all their exultant faith in theatricality as an end in itself. In Feuillade as in Ludlam, there is no point in looking forward to a resolution or narrative afterlife that will somehow justify or tie together the events we witness. The events don't stand for anything; they impart no moral or didactic purpose: they merely dazzle and amaze.

At century's end, the fascination of the original Irma Vep is undiminished,

a fascination compounded by incessant changes of identity and constant suggestions that if only Irma could speak the audience might be inducted into an alternate reality: the world in which the Vampires come out on top. She is nothing less than protean in her transformations. Like bystanders helpless to intervene, we catch sight of her multiple infiltrations: Irma Vep as chanteuse, Irma Vep in black leotard and hood, Irma Vep as substitute telephone operator, Irma Vep in male drag in a Fontainebleau hotel, Irma Vep in jeweled headband and string of pearls, Irma Vep in thick glasses and ill-fitting coat trying desperately to look frumpy, Irma Vep as perkily professional sales rep of a phonograph company, Irma Vep in bacchanalian frenzy dancing at her own wedding. Irma Vep as fashion plate: she stands in a long tight-waisted skirt and trimly cut jacket, the very model of a Gibson Girl, until she sours the impression by putting on a rakish oversized cap — classic burglar's gear — and stands with hand defiantly on hip while talking to a criminal confederate on the telephone.

She is by turns contemptuous, vulnerable, entranced, sullenly vengeful, wild with the excitement of planning further crimes. In the end, the whole seven hours of *Les Vampires* turns into a movie about her gaze, as she emerges from a trunk or crawls out from under the tarpaulin where she has hidden, caught in the frame with her nervous alert glance of caution, of suspicion, of dawning realization, of triumphant knowledge. Her victory is so complete that, when she is finally obliged to die, Feuillade handles the scene in a single frustratingly perfunctory shot, as if for once he couldn't bear to look.

The New York Review of Books, December 17, 1998

Dana Andrews,
or The Male Mask

IN ONE OF MY NOTEBOOKS from the late 1960s, among disordered notations of dreams and sexual fantasies and barely articulated gothic plot lines, I come upon this passage:

> A man stands in a neon hallway at five in the morning. It is Dana Andrews, in a white trench coat, looking at the stairs. He lights a cigarette and thinks the thoughts that make his face that way. A vacant cop whose words are lines of dialogue. An empty trenchcoat — the eyes dead, the body inert — caught in the frame until the reel ends. Vincent Price and Ida Lupino are no longer there to keep him company. He has even lost the photograph of Gene Tierney's eyes.

There is a hiatus, and then the reverie resumes:

> The end of the cigarette. The detective fizzles. Between the office and the alley he becomes a dot. They rip the trench coat from his shoulders. The blonde in silk in the warm room back there flashes an instant against the empty background and then never comes back. He looks down and is already ceasing to exist . . .

Vacant, empty, empty, lost, ceasing to exist. Are the words an attempt to ward off the insistent materiality of the apparition, to take some of the weight off that implacable cop sprung from darkness, that hitchhiker adrift among the worlds, unable either to escape from himself or to stop existing?

194

How did he get in here, anyway, into a psychic space that elsewhere seems to partake of a late-sixties pipe dream, a bunch of scattered notes toward an album cover for some late-blooming Bay Area band just around the time the psychedelic thing went sour, a spun-sugar paradise of lotus pads and faux bonsai, Krishna framed among vintage matchbox-cover art, a lamaistic abode drawn for Marvel Comics by a scroll painter of the late Ming? Brushing past the wind chimes and coughing slightly at his first whiff of the incense, this incongruous guy barges in with his midnight shadow — a case of seriously bad karma — sleep-deprived, off-kilter, in no mood for discussion.

BUT THAT IMAGINARY SETTING — the sybaritic landscape of an equally imaginary satori — hadn't I seen that somewhere before? Was it not an adaptation, after all, of Clifton Webb's luxurious Manhattan apartment in *Laura*, the paradise of chinoiserie and discreetly eclectic interior decoration appropriate to America's most literate and acid-tongued columnist, Waldo Lydecker? Indeed, so much began with *Laura*. I shall never forget the day I first heard Clifton Webb intoning, in voice-over, as the camera glides stealthily through an initially disorienting patch of mirrors and curios: "I shall never forget the weekend Laura died." Otto Preminger's 1944 suspense film was capable of marking a spectator almost as profoundly as the title character marked everybody around her.

It played often during the 1960s on a double bill with Joseph Mankiewicz's *All About Eve*, thus bringing together, with a kind of inevitability, two great, nearly twin character roles: Clifton Webb as corrosively witty, ultimately loveless columnist Waldo Lydecker, and George Sanders as corrosively witty, ultimately loveless theater critic Addison de Witt. Just as Dana Andrews in Laura becomes obsessed — through the medium of a pop tune, endlessly repeated, and an oil portrait, endlessly stared at — with someone irretrievably lost, I was drawn through *Laura*'s tangible elements — voice-over, flashback, title theme, tracking shots, lighting (captured with the brilliant hard-edged focus that distinguished Twentieth Century–Fox movies of that era), sofas, hats, mirrors, clocks, radios, cocktails — into a disturbingly poignant relationship with the vanished 1940s: a time beyond recapture and yet still there to be immersed in, over and over, by means of this very movie.

That opening, with its implication that everything we see is somehow part of the memory of Clifton Webb, becomes even more disorienting with the belated realization that *Laura* does not in fact turn out to be narrated by Webb — indeed could not possibly have been, since he does not outlive its final frame. His voice guides us just far enough to admit Dana Andrews, as police lieutenant Mark McPherson, into the apartment: "Another of those detectives came to see me. . . . I could see him through the half-open door."

Dana Andrews is at the outset a figure in Clifton Webb's gaze, or more exactly a stooge for Webb's monologue: opaque where Webb is transparent, heavy where Webb is delicate, blunt where Webb is serpentine. The wonder was that this was to be a Hollywood movie filtered through the consciousness of a man who would sit typing in the bathtub and say, to a hard-bitten homicide cop, "Hand me my robe, please," or, witheringly, when interrogated about a factual contradiction in one of his columns: "Are the processes of the creative mind now under the jurisdiction of the police?"

As Andrews plays with one of those tiny puzzles whose object is to roll ball bearings into little holes, Webb asks: "Something you confiscated in a raid on a kindergarten?" To which Andrews rejoins, in a first indication of where the real advantage lies: "It takes a lot of control. Would you like to try it?"

Andrews has walked into a den of civilized predators, the realm of bitchy sophistication where Clifton Webb and Judith Anderson and Vincent Price, united by their style of sexual ambivalence and vengeful competitiveness, snarl over the elegant spoils: vases, armoires, classical concerts, tiny Italian restaurants in the Village, and above all the vivacious young girl, Gene Tierney's Laura Hunt — a natural, a diamond in the rough — whose blood might have kept them alive if only she had not been dead since before the movie began.

In this context Dana Andrews exists so that there might be one person who is not one of these exquisite vampires, a working-class guy who chews gum, speaks his lines with a cigarette jammed in the middle of his mouth, and says things like: "A dame in Washington Heights got a fox fur out of me once." An intruder in the realm of nuance, he submits to mockery only to emerge more effectively in the final *règlement de compte*.

Yet of course he's no different from anyone else, a point underscored visually when Webb, Price, and Andrews walk in single file into Laura's apart-

ment; they look as if they are about to go into a soft-shoe number, "The Three Guys Shuffle" or something of the kind. He has entered this world to investigate her death, and what he learns of in flashback after flashback (each triggered by an upsurge of that diabolically haunting title theme) is her mesmerizing effect on everybody whose path she crossed. It is the narrative itself, its elegant windings and recursions, that takes him over.

He falls in love with the murdered Laura. The emotion must have been gathering force while he sat there listening to all the anecdotes about her singularly penetrating charm, hearing David Raksin's title theme over and over. Soon he's taken up residence in the apartment, living with her things, listening to her records (or rather record, since she evidently has only that one melody in her collection), virtually becoming the person whose absence it's his job to resolve.

In the dead center of the movie, at its witching hour, he sits up all night looking at her picture, smoking cigarettes, pouring himself one drink after another. *Amour fou,* from a beefy cop yet. This necrophiliac plot turn gives Andrews an aura of perversity that no amount of subsequent narrative back-pedaling (the fact, for instance, that she really has been alive all along) can ever quite remove. It is what everyone remembers from *Laura,* and *Laura* is what everyone remembers from Dana Andrews's career. Unless they remember *The Best Years of Our Lives;* but there Dana Andrews is only a part—a perfectly attuned and fitting part—of something vastly larger: America, the war, small-town life, marriage and suffering and class difference. *Laura* by contrast sets up house at point zero: it gives us an enactment of the birth of an obsession rare for its tact and understatement. No histrionics, just immo-bility and silent invasion.

Later—and here the movie starts to become just another movie—he will win Laura away from them, take her back to her roots. He will show them how fatally, from the beginning, they have mistaken his stiffness for lack of perception. Likewise they misread the slow burn, the apparently inexpres-sive eyes taking it all in, registering every shade of contempt: that torpor, somehow reptilian, in his reaction time. A Mississippian drawl pulled up short to yield his characteristic clipped yet somnolent tone, a sound that threatens to spill over but doesn't, and that in later years—in his ravaged performances in Fritz Lang's *While the City Sleeps* and Jacques Tourneur's

Curse of the Demon and Allan Dwan's *Enchanted Island*—merges with the drinker's ill-disguised slur. By the end of the sixties, Andrews would resurface in public-service spots about the dangers of alcoholism. All these figures—the trim young detective of *Laura,* the up-all-night journalist of *While the City Sleeps,* the painfully serious actor As Himself—existed simultaneously, multiple incarnations of a self whose prime characteristic was the eerie suggestion of a lack of self.

HE EXISTS INITIALLY as object: coat and hat as essence. He cuts a figure —not the most graceful of figures perhaps, but one that directors find ways to use. And what directors: a parade of auteurs find in him a fetish ideal for their purposes: Otto Preminger (five times), Fritz Lang (twice), Jacques Tourneur (three times), Jean Renoir, Elia Kazan, William Wyler, William Wellman, Mark Robson (three times), Lewis Milestone (four times), and finally even the old pioneer Allan Dwan, in the Mexican shambles of *Enchanted Island.* What do they see in him?

First of all, a certain solidity of stance. He is a center of gravity. The face stirs slowly if at all. And shadows fall well on him: he was made to star in some heavy forties drama: *The Uninflected,* with suitably Central European lighting and a score by Miklos Rozsa. One of the actors who came to the fore while the older male stars (Stewart, Gable) were sidelined by World War II, Andrews never quite achieves the kind of magical screen personality—the transfigured ordinary—that evokes a loving response from fans. He manages briefly, however, to stand in for something like The Average Guy, never more seamlessly than in *The Best Years of Our Lives.* A no-nonsense lack of theatricality, coupled with a hint of emotional pain repressed through long practice, shows up when seen from the right angle as flawed but reliable — reliable precisely because he is just as flawed as anybody else. (The most idealized version of Dana Andrews is the philosophical, pipe-smoking, oddly pacifistic hero of the Jacques Tourneur western *Canyon Passage.*) Seen from the wrong angle, he is a little too real for comfort: evasive, self-doubting, resentful, capable of irrational bursts of anger and long grudges.

Most of the time he is out of place, sometimes (as in *The Ox-Bow Incident*) fatally so. If he's in a place he wants to get away from it, if he's on the road he wants to stop traveling. He can't seem to manage it either way: he is

his own context. Stuck with his mere presence in the world—his irre-
deemable materiality—he almost chokes on it. If he drinks, it is not for
champagne highs or bubbly merriment; not even for any rowdy, roustabout
venting of beer-hall energy; he takes the whiskey straight down to core level,
where he's permanently grounded anyway. This is what smoking and drink-
ing look like when they aren't fun anymore. In later days, hung over, irritable,
ill at ease in his body, it's as if he had finally become the characters he had
merely mimed at first. He is now, in eternity, that drifter getting off the bus
in *Fallen Angel,* the late-night traveler whose air of terminal weariness is
accented by what would be a sneer of discontent if only he was motivated
enough to let it rip.

THIS IS POST-HEROIC MAN, no matter how convincingly he may have
played warriors in *Crash Dive, The North Star, The Purple Heart, A Wing and
a Prayer,* and *A Walk in the Sun.* Those roles prepared audiences to see him
as the returning GI, the unwanted war hero subsiding into a dead-end soda-
jerking job and a failed quickie marriage in *The Best Years of Our Lives;* pre-
pared them to confront all the discomfort of the Korean War as it intruded
into a prematurely complacent postwar existence in *I Want You.* "I have no
appetite for power," he says in *While the City Sleeps,* and you believe him.

His haplessness lends an air of eerie believability to *The Fearmakers,* a very
odd anti-Communist programmer directed by Jacques Tourneur. Andrews's
chronically punchy demeanor—here the result of Red brainwashing—gives
him a sympathetic fragility as he tries to make sense of a world in which a
slick public-relations firm (run by such unlikely types as Dick Foran and Mel
Tormé) is really a front for a Moscow-directed campaign for unilateral
nuclear disarmament.

He constantly risks being mistaken for some other male actor: he could
almost have been Glenn Ford; might have dreamed of being Robert
Mitchum; at moments, under sufficiently noirish lighting, could pass for
John Payne or Zachary Scott (though lacking the Machiavellian guile of
either) or his own kid brother, Steve Forrest. Average guy, average bully, aver-
age two-bit grifter, who can crack wise as well as the next guy even though
he essentially lacks humor, who has little more to offer in the way of worldly
wisdom than the resigned grimace of a tough egg: someone fated for an

unglamorous unhappiness, with something like a whine at the edge of his tough-guy delivery, for all the good it does him: "Aw, what's the use." He's smarter than he looks or acts, but why would he bother giving a demonstration? He talks as if it took a little too much effort, every word forced reluctantly beyond the perimeter of a bitter silence. Knowing the score has never given him any advantage. An object lesson: *Quitters never win.* "A guy might as well give up." Born to sit up disconsolate in an all-night diner — "Why was I born?" — or simply change the radio when that song begins to play, turn to gum jingles, light another cigarette. Defeated but not conned. Don't try any of that preacher stuff on him. He'll be the first to catch on that the cop is really the killer.

He is neither good guy nor bad guy, just guy. The Man Without Qualities, in fact, or at any rate with no distinguishing characteristic but a maleness of which he seems weary as well. This thing of being a man that he has to drag around, the ponderous accoutrements of male being: this body that must carry the weight of Dana Andrews through the world, and his coat and his hat too, and the extra pack of cigarettes for later.

When he surrenders to passion, it will be with the rough futility of the thwarted date rape in Preminger's underrated noir soap opera *Daisy Kenyon.* This is one of Andrews's most fascinating performances: equal measures of suaveness and shamefacedness add up to a corporate lawyer suppressing his nobler instincts, aggressive and lovelorn, an amazingly jagged and unresolved portrait of someone who lives along the seam lines, comfortable on neither side.

When the bitterness shows through, it is acrid and unforgettable, as in another performance for Preminger: the violent detective of *Where the Sidewalk Ends,* a characterization that elaborates on the violence that could be glimpsed in embryonic form in *Laura*'s Mark McPherson. In late films like *Hot Rods to Hell* and *Crack in the World,* the bitterness will become almost unbearable, the rage of an impotent aging man — ineffectual commander, overprotective father, cuckolded husband — who wants simply to annihilate the youthful competition. Or is it the bitterness of finding himself in such wretched films? Does he rage at the dialogue, the scenario, the wooden direction that cannot lend his presence the noble dimensions that a Preminger or Tourneur could create with a mere trick of light, a shift of angle?

We see him now—a final cruelty to which age condemns him—in the washed-out, head-on immobility of low-budget TV-style framing.

The paradox of the movie actor is that in some sense he is part of the decor. "Dana Andrews": a shape intended to provide evidence of a certain angle and intensity of light, a weight for bearing up clothes, a gait whose function is to give the camera something to track, a voice for making audible the lines of dialogue: mass in movement, acted on by equipment.

We have not really seen him, only what registers. Where in all these frames is the preacher's son from Don't, Mississippi, one of thirteen children, who was dragged from place to place in Texas in the wake of his father's roving career as an evangelist, the usher who took his vocational inspiration from Douglas Fairbanks and from H. B. Warner as Christ in *King of Kings,* who figured he could do it just as well as those movie actors, and who by the time he became a leading actor had already suffered the early death of his first wife? As for his own voice speaking of himself, we have only a few scattered observations. "You can't get rid of your own personality," he told an interviewer. "It's going to come through, no matter what you're doing." And again, in passing: "It's not difficult for me to hide emotion, since I've always hidden it in my personal life."

O.K. You Mugs: Writers on Movie Actors,
edited by Luc Sante and Melissa Holbrook Pierson;
New York: Pantheon Books, 1999

Stompin' *at* *the* Savoy

IN THE WAKE OF DIRECTING what is likely to remain the best imaginable Gilbert and Sullivan movie — *Topsy-Turvy,* a fantastically detailed and wonderfully leisurely account of the genesis of *The Mikado* — Mike Leigh has taken to making statements like this: "I'm not interested in proselytizing Gilbert and Sullivan. At the end of the day they were minor artists. They did suffer, but they suffered in a bourgeois way." Leaving aside any possible arguments about the implied connection between nonbourgeois suffering and the making of major art, it's understandable that Leigh needs to put some distance between himself and the body of work he has so cunningly restored to cultural prominence. He knows, after all, that many will go to see *Topsy-Turvy* for reasons that have nothing to with Leigh's impressive earlier films (*Life Is Sweet, Naked, Secrets and Lies*) and everything to do with a lingering, if decidedly attenuated popular enthusiasm for the Savoy operas.

They will go looking for lost comforts associated with the ideas of operetta and of Victorian theater, as well as the familiar pictorial satisfactions to which this era of filmmaking — with its endless and eye-pleasing adaptations of Austen, James, Forster, and other chroniclers of bourgeois pastimes — has long since accustomed them: in short, for a Christmas treat appropriate to that imaginary nineteenth-century childhood that will endure well past the end of the twentieth. Leigh's triumph is to have provided something that can pass for exactly such a package, while delivering a movie almost as abrasive

in its way as *Naked.* The abrasiveness admittedly takes different forms: instead of apocalyptic rants, violent sex, and life on the street, we have the unobtrusive permeation of Victorian sitting rooms and dressing rooms by a full range of mental and corporeal miseries, from kidney stones and morphine addiction to raging paranoia and sexual denial. From our first glimpse of Arthur Sullivan waking in pain and panic to drag himself to the opening night of *Princess Ida,* it's clear that this is to be a period film in which the costumes and furnishings do not protect the characters from physical vulnerability. Even the gnarled and protuberant facial hair of so many of the men adds to the sense of inescapable materiality.

The premise is simply: What if Gilbert and Sullivan had actually existed as something other than the lovably eccentric caricatures that crop up on old theatrical posters or reissues of early recordings of *The Sorcerer* or *Patience,* and what if the world in which they moved did not altogether resemble one of their own operettas? It may come to seem typical of the late twentieth century, this need to look for an ultimate grittiness in even the smoothest confections, this reluctance to let trivial pleasures exist on their own terms. It is not a matter of exposing anything particularly sensational, although the film's advertising speaks enticingly of "The Women. The Scandals." On the contrary, it puts under the microscope a group of people who, whatever their personal neuroses and professional disagreements, have their lives fairly well in hand.

Sullivan may run off to Parisian brothels, and Gilbert may look on in inarticulate discomfort as his frustrated wife free-associates a fantasy about strangled babies, but the real story here is that they and their colleagues manage to keep their world running quite competently. What a lot of work that takes, on the part of all from high to low, is the almost exclusive subject of *Topsy-Turvy's* three full and not in the least enervating hours of screen time. (In one of the few lines betraying a hint of explicit authorial message, Mrs. Gilbert remarks: "Wouldn't it be wondrous if perfectly commonplace people gave each other a round of applause at the end of the day? 'Well done, Kitty. Well done!'") Leigh's film thrives on the very real conflict between the theatrical magic of *The Mikado* (even as presented here, as a deliberately rough and out-of-sequence work in progress) and the distinctly unmagical world it rose from.

THE MAGIC WILL OF COURSE not necessarily be apparent to all viewers. Many will come to *Topsy-Turvy* with scarcely a clue to what *The Mikado* might once have meant, and for them it may well resemble some strange species of vanished pop art. It's hard for me to imagine coming to Gilbert and Sullivan cold, in the middle of life, having been born into the latter phases of a world where they were part of the decor. From *Mikado* and *Pirates* and *Pinafore*—just then, around 1950, being made available on LP for the first time—I got my first taste of such things as melody, orchestration, plot, and the farther reaches of the English language. The Savoy operas formed a kind of universal lexicon: a musical range embracing sonorities out of Handel or Verdi or Offenbach, arias, marches, madrigals, chanteys, tarantellas, English country dances; story lines employing every variety of melodramatic contrivance and farcical misunderstanding; a procession, seeming to encompass all mortal possibilities, of pirates, fairies, constables, poets, schoolgirls, ghosts, jesters, jailers, lovesick maidens, impoverished Spanish grandees, and jolly sailors.

Beyond all else there was the initiation into Gilbert's linguistic realm, where words existed not so much to express meaning as to provide a gratuitous and extravagant pleasure. An inexhaustible vocabulary of recondite, often downright useless terms and phrases was absorbed long before meaning became an issue: "breach of promise," "trepanning," "scholastic trammels," "pirate caravanserai," "grace of an Odalisque on a divan"—along with endless names (Spohr, Guizot, Heliogabalus) and the endless nonsense that somehow made sense of it all, from "Tarantara" to "tiny tiddle-toddle." It would take the better part of a lifetime to untangle all the information embedded in Gilbert's arcana; at any moment a newly acquired bit of information might suddenly illuminate a lyric long since internalized. When all the elements of his art came together, in the nightmare song from *Iolanthe* or the ghost's song ("When the night wind howls") in *Ruddigore*, he seemed to embody the mystery of creative power like a second Shakespeare. With Sullivan he had brought into existence what to a child seemed something like a perfect world, in which absurd entanglements were resolved by equally absurd equivocations, to the accompaniment of melodies alternately gorgeous and sprightly.

It was only gradually that a childish listener detected, beneath the ludicrous crises of Gilbertian dramaturgy—the babies switched at birth, the lives hanging on preposterous points of imaginary legal doctrine—and his tendency to find humor in images of torture and disfigurement, a more troubling mood mixing anger, cruelty, and inconsolable depression. One phase of childhood ended with an awakening to the authentic grotesquerie and misanthropic animus in Gilbert's libretti. Now one could begin to savor the mordant variations on themes of vanity and avarice, self-serving unctuousness and moral cowardice, to take in the harshness of Ko-Ko's great renunciation in Act I of *The Mikado*:

> Now I adore that girl with passion tender,
> And could not yield her with a ready will,
>> Or her allot,
>> If I did not
> Adore myself with passion tenderer still!

The parade of cynics, toadies, grasping senescent father figures, gleefully duplicitous bureaucrats, and self-infatuated romantic leads continuously undercut any tendency toward mawkishness in what had once seemed tender love stories.

The possibility of anything like charitable impulse was remote in Gilbert's world; his characters essentially tried to get what they could for themselves while desperately trying to evade the strictures of irrational legal codes, whether the law was that of Japan or Barataria or the realm of the fairies. At the bottom of everything was cold calculation, no matter how sweet Sullivan's music, as in the glee from *The Mikado*:

> If I were Fortune—which I'm not—
> B should enjoy A's happy lot,
> And A should die in misery—
> That is, assuming I am B.

Even in a world of pure fancy, such considerations could not be put aside: that iron rule shored up the operas just as much as the metrical rigor and argumentative brilliance of Gilbert's lyrics.

This was where Sullivan came in, to suggest with his music a world of

emotional realities beyond Gilbert's reach, whether it was the exhilarating buoyancy of the trios in *Pinafore* and *Iolanthe* or the note of tender melancholy that creeps in — in the sestet in the first-act finale of *Patience* or in *The Mikado*'s madrigal — as if to elicit a compassion otherwise alien to Gilbert's creatures. Appreciation of the operas became an exercise in appreciation of temperament, of judging precisely the abyss that separated the two and thereby coming to appreciate not the infiniteness but the limits of creativity. Gilbert and Sullivan respectively reached different parts of one's being, Sullivan offering emotion and worldly color, Gilbert a brilliance spinning in the void, withering to any notion of sincere feeling: the oddity of their collaboration was that they did both in the same instant. Yum-Yum's great song in the second act of *The Mikado* (with which Leigh ends his film) was the supreme example of the disparity between them: the lyrics presented a heartless, utterly vain creature who was transformed by Sullivan's music (worthy, in this instance, of Puccini) into a mysteriously beautiful presence. Yet it was a presence that existed outside the world of *The Mikado,* a presence that world could hardly support.

The poignance of the operas resided in their precise mapping of their own limits; these worlds were so sharply defined that they also made one aware of areas of feeling and perception that could never be expressed within them. Neither eroticism nor death could be acknowledged here, and so they were a little bit everywhere, just past the edge of the jolliness. The most interesting byproduct of the Savoy operas was the residual impression of emotional depth that lingered from works that were objectively as frivolous and paper-thin as entertainment could be.

PART OF THE EMOTIONAL WEIGHT came simply from the accretion of all the people who made the operas part of their lives, who had founded a subculture of amateur Gilbert and Sullivan productions that still survives although in diminished numbers, or on a more intimate substratum in the form of family theatricals or holiday sings around the piano. The operas elicited participation; they could be sung, approximately, by anyone, and to get close to them was to end up enacting them and in the process to end up feeling that one had somehow helped to create them. It was a last lingering remnant of what had once been a culture of homemade entertainment, in

which people availed themselves of scripts and sheet music and masks and props to shape a theatrical world of their own.

A sense of that culture is very much present in an earlier film on the same subject. *The Story of Gilbert and Sullivan* (1953), a lavish Technicolor film directed by Sidney Gilliat and starring Robert Morley and Maurice Evans, embodies a tradition of historical pageantry in British filmmaking that film historians have tended to dismiss as static, wooden, and word-bound. Such films have become hard to see, even though in the 1950s they cropped up on American television with great frequency; in those days, when Hollywood studios were still loath to license their films to the rival medium, the gap was often filled with ornate English period films such as *Saraband for Dead Lovers, The Queen of Spades,* and *The Magic Box.* Like many of these films, *The Story of Gilbert and Sullivan* looks better now than anyone might have expected. The very traits once characterized as Stiff Upper Lip Cinema — the absence of high emotion or flamboyant gesture, the dry and carefully researched presentation of historical background, the tone balanced between blithe good humor and unflinching decorum in the face of life crises — have receded sufficiently into the past as to seem rather bracing.

The respect for detail, the sense that the story being told is actually important, carries real force in a film whose underlying subject is the world of expectations within which Gilbert and Sullivan shaped their work, a world of which it is in some sense still part, or at least wants to believe it is still part. With its exquisite design and photography (Vincent Korda and Christopher Challis were among the collaborators) it feels like something of an homage to the Michael Powell of *The Red Shoes* and *The Tales of Hoffmann,* an intimate celebration of a specifically British tradition of theatricality. The biographical narrative is periodically interrupted by bursts of pageantry: an abridged version of *Trial by Jury; The Gondoliers* staged for a toy theater; a musical boating party on the Thames; and, in the most impressive sequence, a montage illustrating the dissemination of Gilbert and Sullivan's songs into English society via pub piano, whistling bicyclers, seaside dance pavilion orchestras, hurdy gurdy, carousel, and military parade. Inevitably, as one form of pageantry converges on another, the film culminates in a command performance for Queen Victoria at Windsor.

In its depiction of the contrasting temperaments of the two men, *The*

Story of Gilbert and Sullivan covers much of the same ground as *Topsy-Turvy,* although far more discreetly; Sullivan here is sexually frustrated (his sweetheart rejects him because he won't focus on oratorios) rather than debauched, Gilbert (beautifully played by Robert Morley) blusteringly dyspeptic rather than anguished. The tone of the film, finally, is celebratory: we are to marvel at the happy chemistry that enabled Gilbert and Sullivan, through whatever accidental mix of whimsy, choler, deflected artistic goals, and practical ambition, to end up almost in spite of themselves contributing a new variety of unalloyed pleasure to English culture. Tradition here represents the careful preservation of what at its origin was lucky accident.

LEIGH'S MOVIE CAN COUNT on no such sense of tradition. If for the earlier film the Savoy operas represent a supreme flowering, for Leigh they are perhaps no more than a random instance. He might just as well have chosen to make a movie about the creation of *The Third Man* or *The Goon Show* or *Rubber Soul,* except that by his own account he wanted to do a costume picture "pretty much for the sheer hell of it" and was taken with the "perversity and naughtiness of subverting this chocolate-box subject, dealing with it in a serious way." In undertaking to make a period piece without nostalgia, a theatrical film unencumbered by wish-fulfilling fantasy, he has achieved a historical film that really interrogates the genre. Leigh is renowned for the extended preparation of his films, involving months of improvisational work by the actors out of which the script evolves. It is a process that in the past has made possible a pleasingly lifelike off-the-cuff looseness, even as it provided space for actors as expansive as David Thewlis and Brenda Blethyn to build multilayered characters from the inside out. Indeed, Thewlis's nomadic, ceaselessly verbalizing Johnny in *Naked* may turn out to be one of the more enduring British literary creations of this period.

The apparent realism of Leigh's previous films was not without its histrionic component: it amounted to a constant demonstration of the theatricality of everyday life, at every moment threatening to spill over into overt clowning or melodramatics. Both that actorly exuberance and the directorial restraint required to keep it within bounds prove most useful in *Topsy-Turvy.* Most history films fail to convince — either because the actors, subdued by their costumes and the unaccustomed wordiness of their dialogue, do not

seem entirely physically present, or else because they overcome the constraints by some form of anachronistic outburst. For all its obsessively researched dialogue and its dense agglomeration of Victorian bric-a-brac, *Topsy-Turvy* does its most convincing work of historical suggestion on the level of the acting. It is not a matter of faithfulness to the period—who would know?—but of a relaxation of manner that does not rely on contemporary modes of speech. The improvisational method—still applied here, but with the additional weight of historical data hemming it in—results in dialogue where, for once, witty remarks are not necessarily delivered with the aplomb of the perfectly rehearsed stage actor. Each of the principal speaking roles (there are at least twelve, each distinctly affecting the overall flavor) is defined with an exact feeling not just for a particular style of speech but for the character's sense of presentation and for the space separating each from the others. The rest—the clocks and cups and candlesticks scattered about in every shot, the deftly interwoven topical allusions, even Dick Pope's staggeringly fine photography—is built around those spaces. As superb as Jim Broadbent and Allan Corduner are as Gilbert and Sullivan, they in no way overshadow the rest of the cast, down to the servants, the members of the chorus, and the participants in the Japanese exhibit at Knightsbridge who get roped into the rehearsals.

The remarkably unstrained quality of the acting is doubly appropriate, since it was the stiffness of the acting style inherited from the original D'Oyly Carte productions, and maintained with puritanic rigidity over the decades, that did more than anything to turn the Savoy operas into theatrical antiques. Leigh shows us that style from the inside, as it gestates in rehearsal under Gilbert's exacting tutelage, just as every aspect of what eventually becomes *The Mikado* is shown as the result of major or minor decision-making. The film establishes a world in which there is only one problem of any significance: how to conceive, prepare, and present the next Gilbert and Sullivan opera. The personal travails of the creators and their troupe can never be more than marginal shadows, because everyone is too busy with the work at hand; any other sort of problem registers only to the extent that it threatens to impede the production. The company is so busy that there's scarcely time for anyone's ego to blossom in *All About Eve* fashion; at most there's room for brief eruptions over costuming or salary.

There is not even any room for sky. This is a film almost without natural light, taking place almost exclusively in interiors, each of which in the hands of Dick Pope has its own peculiar sheen and density. The lone foray outdoors is into the dark and fetid alley—really another kind of interior—in which Gilbert, escaping from first-night anxieties, is accosted by a raging beggar woman. Intellectually, the world beyond the theater leaks in only through a discussion of the death of Gordon in the Sudan (as if to salute obliquely such old-school British classics as Zoltan Korda's *Four Feathers* and Basil Dearden's *Khartoum*), although Gordon is upstaged in the end by some bad oysters. But if the sun and the outside world are removed from consideration, it is not in order to induce claustrophobia but rather to allow the inner light of theater to shine without competition.

For the Savoy troupe, reality tends to be a nightmare: not an especially Victorian nightmare (the film refrains mercifully from facile retroactive finger-pointing at ancestral sins of commission or omission), simply the usual share of human discomfort. They can awaken from it only into the closet world of performance. But if *Topsy-Turvy* inevitably evokes comparison with the sort of musical in which somebody is apt to say "Let's all of us kids get together and put on a show," it cannot allow itself the untrammeled theatrical apotheosis of *Summer Stock* or *The Band Wagon*. Those are movies where the show the characters mount becomes the solution to their problems, allowing them to partake of the same pleasure that they afford the audience. *The Mikado*'s small share of ecstasy—its capacity to send everyone out smiling—offers no redemption to those who concoct it in the first place. Leigh feels the need to underscore the point, even at the risk of undercutting the theatrical gaiety he so effectively summons up for the 1885 opening night, by having Gilbert remark afterward: "There's something inherently disappointing about success."

The Mikado itself is given to us only in fragments; wonderful as they are, they do not cohere enough to let us enter the theatrical illusion, nor are they meant to. Every scene or song from the opera is used to demonstrate one or another part of the production process. Leigh has judged, probably wisely, that unimpeded contact with the show's pleasures might swamp his hard-won sense of the bitterer reality offstage. Nor does the theater audience figure as anything but an abstraction, to be called into action for a culminating

shot — almost perfunctory in its inevitability — of the whole house applauding enthusiastically, the great yet finally inadequate payoff of everyone's labors. We remain on the other side of things with the actors, unable really to see the show because completely caught up in it, lost in a process of intricate collaboration and endless rehearsal.

That, in spite of everything, the ecstasy of performance does come across may be a demonstration that the paradoxical magic of theater is unkillable after all. In this film with no sky we end with a song about the sun and the moon — evoked only as metaphors for the beauty of the character who sings it — sung by the actress we have seen a moment earlier staring disconsolately into the mirror in her dressing room. A single image serves to fuse Gilbert with Sullivan, *Topsy-Turvy* with *The Mikado,* actress with role, and audience with the spectacle just preparing to recede into darkness.

The New York Review of Books, January 27, 2000

Groucho *and*
His Brothers

T HE THINGS ABOUT THE Marx Brothers that most
people remember — that they obsess over and memorize and if they are feel-
ing reckless even try to imitate — are found in seven films made between
1929 and 1937. The Brothers made another six movies after that, culminating
in the dreary and impoverished *Love Happy* in 1950, but the comic frenzy
subsided after *A Day at the Races.* While Groucho went on to a second
career as television's most (or perhaps only) memorable quizmaster in *You
Bet Your Life,* which ran from 1950 to 1961 and persisted long after in reruns,
Chico and Harpo found few performance opportunities after the movies
dried up. (Gummo and Zeppo, the younger brothers who had in earlier
phases been part of the act, had long since dropped out.)

Yet *The Cocoanuts,* the primordial talkie they filmed in Astoria in 1929,
represented a rather late milestone in their career. Chico, the oldest of the
brothers, was already forty-two, and had been playing piano in honky-tonks,
nickelodeons, and beer gardens since his mid-teens (he had already, accord-
ing to family lore, established his penchant for gambling and bad company
before the nineteenth century was out); Harpo had followed Chico into the
saloons and mastered his older brother's limited piano repertoire (which for
a long time apparently consisted of a single song, "Waltz Me Around Again,
Willie"). Groucho, born in 1890, had been performing professionally since
his fifteenth year: how far his roots go back can be measured by his appear-

ance in a benefit for victims of the San Francisco earthquake of 1906, on a bill featuring Yvette Guilbert and Lillian Russell.

In those days they were Leonard, Adolph, and Julius; the familiar nicknames were bestowed by a theatrical friend during a poker session around 1914. The personae that went with the nicknames evolved in hit-or-miss fashion through years of more or less improvised, more or less chaotic wanderings — as the Three Nightingales or the Six Mascots, with or without their mother Minnie or their aunt Hannah, with or without their failed tailor of a father planted in the audience to egg on the laughter — over most of the United States, mostly in the lower, small-time echelons of vaudeville. The chief fascination of both recent studies of Groucho and his brothers, Stefan Kanfer's *Groucho: The Life and Times of Julius Henry Marx* and Simon Louvish's *Monkey Business: The Lives and Legends of the Marx Brothers,* lies in what they can tell about these lost decades in which the Marxes invented their art. The frustration is that they can after all tell so little. A few fragments of script, some rare photos, some not very revealing contemporary reviews, and the unreliable anecdotes in memoirs written long after the fact: from such remnants a world must be imagined.

It is worth imagining, that domain (in Harpo's words) of "stale bread-pudding, bug-ridden hotels, crooked managers, and trudging from town to town like unwanted gypsies," into which Groucho was sent out at fifteen — his education halted permanently at his mother's insistence — to be robbed by his employers and given a dose of gonorrhea by the first woman he slept with, a domain whose Hobbesian realities were matched only by the desperate energy of its tattered amusements. "In a typical week," writes Stefan Kanfer of the life the brothers led around 1912, "they might play three days in Burlington, Iowa, catch the overnight train and play the following four days in Waterloo — four-a-day vaudeville for five days, five-a-day for two days, for a total of thirty shows per week. The process went on unvaryingly, in the cities around the Great Lakes, in Ohio, Illinois, Texas, Alabama."

Perhaps one would not really want to savor every phase of that long and miserable pilgrimage, to watch the young Julius making his 1905 debut in drag with the Leroy Trio before being stranded in Cripple Creek, Colorado, when Mr. Leroy absconded with all the money, and then setting out once

again, touring Texas with an English "coster singer and comedienne" named Lily Seville, a pair of clog dancers, and a seventy-four-year-old tenor. The *Dallas Morning News* for December 1905 remarked: "Master Marx is a boy tenor, who introduces bits of Jewish character from the East Side of New York."

He and his brothers weren't, of course, the only wild kids of the road. There was an army of them. The children who performed with Gus Edwards's famous troupe (Groucho did his bit with Edwards's "Postal Telegraph Boys" in 1906) included George Jessel, Eddie Cantor, Ray Bolger, Eleanor Powell, Ricardo Cortez, Mervyn LeRoy, and Walter Winchell: a successful handful among the vast and largely threadbare host of small-timers who sustained their internal migrations from the Gilded Age until the circuits began petering out in the twenties. An army of the lost: we must be content with what we can glimpse in S. J. Perelman's recollections of an early Marx Brothers appearance that also featured

> Fink's Trained Mules, Willie West & McGinty in their deathless house-building routine, Lieutenant Gitz-Rice declaiming "Mandalay" through a pharynx swollen with emotion and coryza, and that liveliest of nightingales, Grace Larue.

If the Marx Brothers' work is "about" anything, it is about survival in that world. Half-grown, without training or material, they were thrust into the business of entertainment, and it took them two decades to fight their way to the Broadway opening in 1924 of *I'll Say She Is!*, the show that finally sealed their fame. The legend of how their mother Minnie turned them into performers by main force has been well rehearsed, beginning with press releases overseen by the brothers and culminating in 1970 in the Broadway musical *Minnie's Boys* (cowritten by Groucho's son Arthur). Indeed, the whole early history of the Marx Brothers was carefully remade by them and their chosen publicists, and both Kanfer and Louvish become enmeshed in layers of deliberate myth-making and minute misrepresentation of such simple things as dates and locations. Even in their memoirs, Harpo and Groucho consistently took five years off their ages, and the internal contradictions in the various anecdotal histories of the family make any precise

account of their doings virtually impossible. The family's life in the three-room East Ninety-third Street apartment where they lived from 1895 to 1909, a life crowded with relatives and visiting show-business types, can only be envisioned as an unknowable but presumably chaotic corollary of the world of their films.

The centrality of their mother in their career resulted to some extent from the fecklessness of their father, an immigrant tailor from Alsace more devoted to cooking and pinochle than to his chosen profession. As the daughter of an itinerant Prussian ventriloquist and magician and the sister of the increasingly successful vaudevillian Al Shean (of Gallagher and Shean), Minnie had every reason to be drawn to show business. The alternatives were not many or appealing, and her sons — excepting the bookish Groucho — showed early tendencies to drift into the life of the street. So she sent her children on the road and eventually set about building her own show-business empire, moving the family from New York to Chicago, managing not only her sons but a string of other troupes with names like the Golden Gate Girls, Palmer's Cabaret Review, and the Six American Beauties. It may be, as Simon Louvish surmises, that "being Minnie's Boys was a bad career move" and that their mother's managerial flaws — her empire was short-lived — may have made the boys' progression toward stardom unduly slow, but what we appreciate in the Brothers' art has everything to do precisely with its slow and familial evolution.

THE MARX BROTHERS CREATE a world because they have no other choice. They start from no plan or idea but proceed by groping and trying out, grabbing at any material that offers itself. Everything takes shape through an accretion of bits. "I was just kidding around one day and started to walk funny," Groucho wrote. "The audience liked it, so I kept it in. I would try a line and leave it in too if it got a laugh. If it didn't, I'd take it out and put in another. Pretty soon I had a character." The phrase "pretty soon" covers years of experiment. For a long time Groucho's persona was a comic German, until the sinking of the *Lusitania* made Germans less than comic. The German bits became Yiddish bits, until these were sloughed off in turn and he made the crucial transition into a character not dependent on dialect.

(Chico, on the other hand, stuck with his Italian persona to the bitter end.) It took years, likewise, for Harpo to understand that he had no gift for verbal comedy and remake himself as a silent clown.

Their performances remain breathtaking because of a moment-by-moment control and rapport that distills years of trial and error. This was comedy as experimental science, and the experiment was conducted under the most prolonged and uncomfortable circumstances. Years later, when studio filmmaking threatened to dull their instincts, the Brothers attempted to regain intimacy with the audience by trying out the script for *A Day at the Races* on the road. One of the publicists recalled how Groucho's line "That's the most nauseating proposition I ever had" was arrived at:

> Among other words tried out were *obnoxious, revolting, disgusting, offensive, repulsive, disagreeable,* and *distasteful.* The last two of these words never got more than titters. The others elicited various degrees of ha-has. But *nauseating* drew roars. I asked Groucho why that was so. "I don't know. I don't really care. I only know the audiences told us it was funny."

It was an apprenticeship of a kind no one has time for anymore, nor indeed would one wish it on anyone. It only took them twenty years to become geniuses. "They had absolutely no marketable skill outside of comedy," writes Kanfer, "and they instinctively rode that skill as far as it would take them." Their finesse was acquired in the roughest of schools, where a pause, even the most momentary relinquishment of control, would be fatal. Even if they were brilliant in a field populated largely by the not so bright, witty in an area where wit came cut in broad slabs, imaginative where the custom was to grind out every last possible bit of juice from repeated and imitated and stolen routines, it was still not quite enough to guarantee success. The final ingredient was an unparalleled ferocity. The rule had to be: No mercy, no exceptions, no leeway for the audience to think or resist.

All vaudevillians practiced a certain savagery in their assault on the audience, but often the savagery came disguised in the form of heartwarming sentiment or reverential high-mindedness. The Marx Brothers were not interested in eliciting sympathy. Even the sentimental trappings of the later films—where the Brothers figure as benign eccentrics rescuing star-crossed lovers, and the infantile ecstasies of Harpo assume an ever more self-

consciously beatific aura—cannot altogether conceal a persistent kernel of exhilarating heartlessness. Not malice: simply comedy in its most cold-eyed state. In *The Cocoanuts* (1929) and *Animal Crackers* (1930), the violent energy of the stage performances is still palpable. Harpo's emergence into the frame, on the heels of a blonde parlor maid, registers as a chaotic intrusion the camera can barely capture. Groucho's verbal assaults are flanked by the downright menacing physical comedy of Chico and Harpo.

The roughness was as real offscreen as on. There were other worlds where the brothers might have flourished outside of show business. In his youth, Zeppo carried a gun and stole automobiles; Chico became a chronic gambler at an early age, around the same time he was beginning his career of relentless womanizing ("Chico's friends," according to Gummo, "were producers who gambled, actors who gambled, and women who screwed"); Harpo at one point fooled around with Legs Diamond's girlfriend. The ending of *Horse Feathers,* when the Brothers collectively marry Thelma Todd and then jump on her at the fade-out, was evidently mirrored when some of the Brothers felt obliged to proposition the bride of the newly married Chico. As Chico's daughter Maxine remarked in a memoir, "Years of touring the hinterlands, seeing the uglier side of people and life, made the boys callous and insensitive. In the world known to the Marx Brothers, only the fittest survived. . . . If Betty couldn't take care of herself, too bad."

THE MARX BROTHERS REPEATEDLY saved themselves by leaping from one declining medium to another. As vaudeville slowly expired, they switched to the Broadway musical; when lavish Broadway musicals went into decline after the crash of 1929, they escaped into the movies. Groucho at least was finally able to adapt his persona for television, exchanging his greasepaint mustache for a real one and toning down his verbal pyrotechnics into a more manageable blend of insult humor and mild double entendres. Always they seemed to belong more to the past than the future. Fugitives from a livelier and more elemental world, potentially dangerous primitives, they brought a demonic whiff of the comedic lower depths into the polite drawing rooms of Broadway comedy.

High culture was eager to make them its own. They symbolized authenticity to jaded theatrical types and New York intellectuals: the semiliterate

Harpo was inducted by Alexander Woollcott into the Algonquin circle, and fashionable revelers attended theme parties dressed as the Marx brother of their choice. After the movies, the admiration was global. Graham Greene felt that "like the Elizabethans, they need only a chair, a painted tree," while Antonin Artaud spoke of "essential liberation" and "destruction of all reality in the mind." Salvador Dalí incorporated Harpo into paintings and sent him a scenario for a Marx Brothers movie to be titled *Giraffes on Horseback Salad,* whose humorous potential can be gauged from the scene where Groucho tells Harpo: "Bring me the eighteen smallest dwarfs in the city."

Fortunately the Brothers' scripts were written not by Dalí but by George S. Kaufman and Morrie Ryskind and S. J. Perelman — not to mention Harry Ruby and Bert Kalmar, responsible not only for specialty songs like "Hurray for Captain Spalding" and "Whatever It Is, I'm Against It" but for the best script of all, *Duck Soup.* If their timing and personae were their own creations, the Marx Brothers owed much to the writers who expanded the scope of their material beyond such earlier hodgepodges as "Fun in Hi Skule" and "On the Mezzanine Floor." The Brothers may have chafed at opening up their closed world to a circle of collaborators — Perelman had a terrible experience and later described Groucho as "one of the most detestable people I ever met" — but it was a collective process that resulted in the comic density of the Paramount films.

Without some very lucky timing we wouldn't have anything like *Horse Feathers* and *Duck Soup,* and without these we probably wouldn't remember the Marx Brothers at all. It was only for a brief interval — from the advent of sound to around 1934 — that Hollywood, faced with a new market for talking pictures, allowed an assortment of hams, clowns, double-talkers, and carny spielers to cut loose onscreen with a freedom that would be curtailed soon enough. Order would be reimposed in the form of logically (if not plausibly) constructed screenplays, and decency reasserted by means of the Motion Picture Code, putting an end to lines like Groucho's "Signor Ravelli's first performance will be 'Somewhere My Love Lies Sleeping' with a male chorus."

When young cinephiles rediscovered the Marx Brothers in the 1960s, the haphazard structure of the Paramount movies seemed a prophetic radical-

ism, with Groucho as master saboteur of linear convention. It hardly mattered that one had to sit through interminable harp and piano interludes, or that *Horse Feathers,* for instance, ran out of steam well before the end of the last reel. To transform a lineup of college deans into a minstrel-show chorus, turn puns into blueprints for action (so that a deck of cards can only be cut with an ax), insult society matrons and randomly chase blondes down hotel corridors, cheerfully go to war because of the month's rent already paid on the battlefield: the anticipation of such moments encouraged endless repeat viewings of *Monkey Business* and *Horse Feathers* and *Duck Soup,* simply to soak up an atmosphere of total permission found nowhere else. Greed, lechery, the sheer desire to subvert every attempt at etiquette and rational conversation: no impulse went unindulged. Satire had almost nothing to do with it. The Marx Brothers provided a series of interruptions, the more brutal the better; any fixed image, any stable situation or relationship, had to be disrupted as soon as it began to solidify:

> GROUCHO: I suppose you'll think me a sentimental piece of fluff, but
> would you mind giving me a lock of your hair?
> MRS TEASDALE: *(Coy)* A lock of my hair? Why, I had no idea . . .
> GROUCHO: I'm letting you off easy. I was going to ask for the whole wig.

This was disruption as bliss, the paradise of impudence, and with Groucho as commander in chief there was the sense that a superior intelligence had decreed the dismantling of intelligence itself.

I do not know what one might hope to find in a biography of Groucho Marx, beyond the accumulation of small facts that both Stefan Kanfer and Simon Louvish supply in abundance. Louvish's book, useful as it often is, is marred almost fatally by a tic of nervous jokiness and rib-jabbing overemphasis that makes for tortuous reading. A pity, since Louvish has in many ways done a more thorough and sometimes more skeptical excavation of the historical record, offering a great deal of information missing in Kanfer. Kanfer's *Groucho,* on the other hand, is a firmly constructed, emotionally coherent study of a man who, by the time the end is reached, seems like an oddly inadequate subject for a biography. All that is most interesting about Groucho is either on the screen or lost to history.

Instead we find ourselves living, at what comes to seem like inordinate length, a slow and painful decline culminating in scenes of grotesque confrontation—the custody battle between Groucho's children and his last companion, Erin Fleming—scenes of which the ailing Groucho may not have been fully aware. The lacunae of the formative years give way to the excessive detail of our own era, offering more material than can be drawn on: letters and films, memoirs and magazine articles, radio and television transcriptions, and, not least, legal depositions. We move from an age of legend to an age of forensic scrutiny, and end up learning too much about what we might really not want to know, while remaining famished for what will always be beyond knowing.

The real history of Groucho Marx would be the story of how he assembled himself as a public character, but we cannot have that. There are fascinating if unsatisfying glimpses in some of the old newspaper reviews, as when *Variety* comments in 1919 that

> Julius Marx is developing into an actor. He shows flashes of Louis
> Mahn, at least a chemical trace of David Wakefield and at times reflects
> the canny technique of Barney Bernard. Julius has a strongly defined
> sense of humour. His asides are more funny than the set lines.

But we cannot trace in any detail the process by which Julius turned himself into the fully emerged creation we encounter in the opening monologue of *The Cocoanuts*. We know some of the things that happened to him early on: that he read Horatio Alger and Frank Merriwell; that he dreamed of becoming a doctor before his mother yanked him out of school to go on the road at fifteen; that she called him *der Eifersüchtige*, "the jealous one," an unusually telling detail rescued from the Marx family lore.

For the rest of it—the part not spent on stage or in front of cameras—there are the three failed marriages and, in his eighties, the disastrous final liaison ("women," wrote his niece, "were never his strong point"), the strained relations with his three children (he doted on them in childhood and appeared to lose interest when they reached adulthood), the chronic insomnia, the penny-pinching that became obsessive after he lost his fortune in the stock-market crash and persisted long after he recouped it, the resentful

sense of inadequacy in the company of literary contemporaries like Kaufman, Perelman, and Woollcott. He prided himself on his acquaintance with T. S. Eliot, who avowed himself a fanatic Groucho admirer, but close, extended friendships seem to have been rare in his life. He was closer to his brothers than to anyone else, but after the first few movies they kept their distance from one another; the years on the road had taken their toll on fraternal bonding. He seems to have been at his happiest at home alone with his guitar and his Gilbert and Sullivan records.

In one anecdote after another, Groucho is revealed as a disappointed and often disappointing man. Maureen O'Sullivan, with whom he became infatuated during the filming of *A Day at the Races,* described his courtship as an endless comic monologue: "After a while your face starts to crack. I was tired of it after the third day. I told him, 'Please, Groucho, stop! Let's have a nice quiet normal conversation.' Groucho never knew how to talk normally. His life was his jokes." In private life, we are told, he often employed his comic gifts to humiliate wives, waiters, and other hapless victims. Harpo's wife Susan remarked devastatingly: "He destroys people's ego. If you're vulnerable, you have absolutely no protection from Groucho. He can only be controlled if he has respect for you. But if he loses respect you're dead."

We already knew that it isn't easy being funny, especially if you're funnier than practically anyone else. If a whole body of literary speculation can evolve around the question of how it felt to be Marilyn Monroe, there is little likelihood of comparable investigations into the inner reality of being Groucho. Maybe we suspect that we already know the answer: that the real Groucho is indeed the one at whose routines we are laughing, and that all the rest was an unfortunate interlude or epilogue. The intimacy of Groucho's comedy—and it is as intimate as one's own thought rhythms, one's own responses that one finds already anticipated by him—at the same time precludes the very possibility of intimacy. Beyond the mask there is nothing. He endears himself by eschewing all endearment, with a brutal honesty that makes all the other comedians look like sentimental hypocrites.

There is none of that "But seriously, folks" reflex: he *is* serious when he kids most viciously. Charm is reserved for Chico, with his smile of instant seduction; the Saint Francis–like appreciation of children and nature for

Harpo. Groucho's lot is total intelligence without an ounce of charity. In *Horse Feathers,* there is a beguiling Kalmar and Ruby ballad, "Everyone Says I Love You," that each of the Brothers gets to sing (or play) in turn. When it's Groucho's round, the playful love lyrics turn to pure gall —

> Everyone says I love you
> But just what they say it for I never knew
> It's just inviting trouble for the poor sucker who
> Says I love you —

and you know he means it.

The Essential Groucho, Kanfer's companion compilation of bits and excerpts from movies, radio, TV, and Groucho's modest output of books and articles, demonstrates that in fact Groucho's essence lies elsewhere. What makes Groucho a supreme comic figure, certainly the most durable of the sound period, is not the words he speaks but how he speaks them. The words he wrote are something else again, a mostly disappointing mimicry of Perelman, Thurber, or Kaufman; as for the celebrated ad-libs from *You Bet Your Life,* at this point they come across as not so funny and not so ad-libbed.

If only the scripts survived, I doubt Groucho would concern us much. The handful of celebrated quips have little to do with his continuing fascination. The essential Groucho is not on the page but on the screen: the voice, the walk, the little jigs that over time have become as elegant as Astaire. We can even catch glimpses of the inner life elsewhere so elusive, in those moods of melancholic reverie that he sometimes adopts only to dissolve them into travesty. For a moment we might think we are seeing the face of the boy soprano who mimicked adult voices onstage before his voice broke, so that his adult voice when it emerged was imbued from the start with a long experience of parody and dissimulation.

His routines remain an unsurpassed compendium of parodistic possibilities, shifting as quickly as the inflections of Groucho's voice and body language: mock grief, mock terror, mock piety, mock sternness, mock bonhomie, the ten thousand shadings of unctuousness and inane good cheer. The speed of reception is taken for granted, since the original intended audience was presumed to have sat through years of stock comedy setups, tear-jerking ballads, rote melodrama, incompetent jugglery and acrobatics,

to have internalized the American repertoire of electioneering, sermonizing, and unrestrained huckstering. The inflections change, but the voice—the voice of the flimflam man so self-confident that he can afford to expose his own con even as he works it—remains curiously constant. It is a tone that can never quite come to rest, a voice that finally undermines its own authority as it does everything else. There is always some additional comment, some pun to cap the pun that came before, some further dissolution to which language can be subjected.

The work leaves an abiding impression of extraordinary richness, even if the life may have had its share of emotional barrenness. The latter part of Groucho's career was centered on what he lacked, on the depths he failed to sound. He faulted himself for not being the writer he felt he should have been, and probably failed to appreciate the singularity of what he had created. He had put the best of himself in full view, embodying a character of Shakespearean dimensions who only lacks a play to be part of. Instead of a play, he had brothers.

The New York Review of Books, July 20, 2000

All *the* Luck
in the World

IN THE POSTWAR WORLD I grew up in, Bing Crosby's presence was pervasive without ever quite being central. It was clear that he had been around for a long time, and was not in any apparent danger of displacement. Nobody I knew had ever seen him in the flesh—he pretty much gave up live performance after the mid-thirties—but pieces of him were scattered everywhere you looked or listened. Turn on the radio and you heard a steady rotation of his hits both new and old: "Easter Parade," "Mexicali Rose," "You Must Have Been a Beautiful Baby," "In the Cool, Cool, Cool of the Evening." Move over to the television and you saw him turning up as a guest on variety shows, joshing with Bob Hope, Louis Armstrong, the Andrews Sisters, and all his other legendary cronies. Go downtown to the movies and you saw him in a rerun of *Road to Morocco* if not in the trailer for the upcoming *High Society.* Duck into the diner and some half-crocked old-timer was dropping a quarter in the jukebox to hear "McNamara's Band" again. Open a magazine and there he was with his trademark paraphernalia —hat, pipe, Hawaiian shirt, golf clubs—posing with wife and children or promoting one product or another. Arrive at school the next morning and the teacher might be playing "White Christmas" on the battered portable phonograph so the kids could learn it for the holiday recital.

"White Christmas" was preeminently the recording of which every syllable, every intake of breath—the effortless modulation from comforting bass tones to affecting high notes, the deftness with which Crosby negotiated

the treacherous row of sibilants in the last line—was as familiar as the lay-out of the playground itself, as familiar as the living rooms with which he had been blending in since before any of us were born. We did fight back: no ele-mentary school playground was without its Crosby imitators, and in their efforts we began to discern that the effect of Crosby's singing was after all a matter of technique, which could be appropriated, rather than of the kind of raw emotional charge that can only be contemplated with awe. The emo-tions that Crosby elicited did not seem inherent so much in him as in his audience and their lives. He touched on the feeling latent in every common recurrence: Christmas, Easter, Saint Patrick's Day, each season in its turn.

No one thought to ask where he had come from. He was there, like Mount Rushmore. How much he was there I had not fully gauged until, for the whole time I spent reading Gary Giddins's biography, I was conscious of being wrapped in Bing's voice. As if from within an internalized echo cham-ber, that intimately known baritone sounded every refrain and every line of dialogue cited in the text. The button had been there, waiting only to be pushed to reveal a long-hidden disembodied Bing, a ghost continuing to melodize somewhere just below the level of conscious hearing. Yet what might that voice convey? It did not appear to dredge up either my own emo-tions or, indeed, those of the singer. More than anything, from this remote vantage point, Bing Crosby's voice seemed like the sonic balm that had held together some of the parts of a world. It had created an impression—an illu-sion, perhaps—of shared feeling, of relaxed good humor, of a benevolence and tolerance that could almost be taken for granted.

This wasn't music for serious solitary listening; there were no depths to plumb, no complexities to unravel, no private revelations. But it was fine for aunts and cousins and grandparents, for picnics and bus rides and church socials, for the undemonstrative interludes of good-natured calm that had once, in what seemed like another incarnation, actually seemed like the characteristic emotional climate of a certain backyard America. The admi-ration expressed for him by those who had been through a depression and a war with him was broad and deep. As Gary Giddins writes, "Bing's natural-ness made him credible to all. . . . He was discreet and steady. He was fam-ily." To be near the center of the phenomenon, like Crosby's troubled son Gary, was to experience steady streams of people "kneeling in front of me to

tell me what a wonderful man he was and what a thrill it must be to be his son, and how they loved him so much, and he had done so much for them, and his singing was so great, and it went on and on and on, the way people spoke about God."

In the course of time I encountered, with considerable surprise, earlier incarnations of Bing: the tricksterish self-mocking "Bing Crosby" he incarnated in the 1932 movie *The Big Broadcast,* the jaunty jazz singer jamming with Bix Beiderbecke or Joe Venuti on early recordings like "That's My Weakness Now" and "Some of These Days." At the time of these encounters — this was the sixties — it seemed a typical instance of an industrially confected image rubbing out all traces of a more youthful, more authentic performer. A cautionary tale might be made of it, showing how a temperament of carefree, almost insolent incandescence — a raffish talent at home in the worlds of jazz and vaudeville — could be transmuted over time, with a good deal of corporate support, into the blandly beneficent Father O'Malley of *Going My Way* and *The Bells of St. Mary's.*

But there was not much occasion to think about Bing Crosby in the sixties, and afterward there was scarcely any occasion at all. After his death on a golf course in Spain in 1977, after the expected flurry of record sales, Crosby faded with startling suddenness from a culture he had once dominated. The ease with which his image was tarnished by a couple of unsympathetic biographies (particularly the one by Gary Crosby, who described harsh corporal punishment and a glacial emotional distance between Bing and his children) illustrates how vulnerable that reputation had already become.

For one thing, pretty much all of Crosby's recorded output — the records with Paul Whiteman, the early movie songs like "Love Thy Neighbor" and "I'm an Old Cowhand," the lively cuts from the late thirties like "Bob White" and "Don't Be That Way" and "Small Fry" — had been drowned out by the perennials, from "White Christmas" and "Silver Bells" on down. The iconic Crosby had succeeded in hiding the range of his own work, and when that icon became suspect — when that singular combination of talents and virtues began to seem too good to be anything but a publicity job — any interest in exploring the work tended to evaporate. There was so much else to listen to, to focus on. What was the appeal of an artist neither rebellious nor self-destructive, but rather canny, pragmatic, conciliatory, a man who had

reaped the profits of consensus, the very incarnation of the middle of the road? He began to become invisible in somewhat the same way that Long-fellow—to whose once-universal acceptance Crosby's might be likened—became invisible after the triumph of modernist poetics. It should not have been surprising, when the moment of millennial assessments came around, to find Crosby largely missing from the roll call of twentieth-century pop music. A conclave of *New York Times* critics found room, in one such tabulation of the century's Top 25, for Caruso and Jolson at one end and the Ramones and Nirvana at the other, but could not even squeeze Bing—and here was real humiliation—into a list of twenty-five runners-up that included Kraftwerk, Nine Inch Nails, and the soundtrack of *Saturday Night Fever*.

AS A RESULT OF THIS period of cultural amnesia, Crosby's career is ripe for the reconsideration that Gary Giddins accords it in the first volume (*Bing Crosby: A Pocketful of Dreams, The Early Years 1903–1940*) of his extremely ambitious biography. He has set out not only to reconstruct Crosby's career in detail—a career that Giddins prizes above all for a musical achievement he considers more significant, and more modern, than usually acknowl-edged—but to use it as an occasion to map the emergence of that musical-industrial complex we now know as the modern entertainment business. Crosby is exactly the right protagonist for such an undertaking, in that he benefited more than anyone else from the convergence, in the late twenties, of electronic recording, radio, and talking pictures. What he made of his opportunities was extraordinary, as Giddins notes in a tallying of statistics designed to allay any skepticism about Crosby's stature: he was responsible for more studio recordings than any singer in history, the most popular record ever made, the most records charted (an astonishing 396, as com-pared with 209 for Sinatra and a mere 68 for the Beatles), of which 38 were number-one hits, another record; in addition, he was the top-ranking movie star every year from 1944 to 1948, and was a radio star from 1931 to 1962, appearing on roughly four thousand broadcasts.

The statistics set the tone for what is very much an outward study of Crosby's career: not a description of his inner life—that must be accounted among the unwritable books—but a graph of his doings and their intersec-

tion with a busy and rapidly evolving world of showbiz folk. It could hardly be otherwise. Crosby guarded his privacy so well that very little of it gets into Giddins's biography. That reserve—which was described by some as a form of self-protection, by others as icy detachment—establishes the mysterious bass pattern under the busy, disciplined, consistently successful melody line of a life that Crosby himself summed up in the title of his 1953 memoir: *Call Me Lucky*. For whatever reason, Crosby succeeded, once he had attained the stardom he never lost, in constructing a private world where he could hide in plain sight. He was at once the most publicized and, as he wanted it, the least known of individuals. The household Crosby of radio and fan magazine was a kind of decoy, distracting attention from the individual who remained a cipher even to most of the people he worked with. (Giddins suggests that his withdrawal may have been connected with the death of the guitarist Eddie Lang, his closest friend; Lang died in 1933 following a tonsillectomy that Crosby had recommended, and the trauma was compounded when Crosby was mobbed at the funeral by unruly fans who overturned pews to get close to him.)

His colleagues were in awe of his professionalism—his memory, his musical precision, his ability to learn a song after a couple of hearings—and yet puzzled by his persistent emotional distance. Few ventured to guess what really lay beneath that perfect surface: "He was a very private person, at least in the studio," according to his announcer Ken Roberts. "He would come in and do his job. He was not temperamental at all, easy to work with, but as soon as he was finished it was good-bye." It is astonishing to learn that he had no personal friendship whatever with the Andrews Sisters, for instance, with whom he made four dozen records brimming over with a convincing imitation of exuberant bonhomie. The more you learn about Crosby, the more you don't learn about the other side of that easygoing, open disposition.

THE ACCOUNT OF HIS early years is all the more fascinating as a result. Before the curtain falls on his private life, we are able to get a glimpse of the face before it settles into a mask. He was born Harry Lillis Crosby in Tacoma, Washington, in 1903, and grew up in Spokane, one of six children of a mandolin-playing spendthrift of a father and a musically gifted, sternly Catholic

mother. Taught by the Jesuits at Gonzaga High School, he was, as Giddins notes, perhaps the only major American pop star to receive a classical education. To the oratorical and poetical recitations of his school years he attributed a measure of his artistry: "If I am not a singer, I am a phraser. . . . I owe it all to elocution." Crosby was the kind of quick study who could do well in school—on top of participating in football, glee club, debating club—without ever displaying any particular intellectual ambition. "He had a vocabulary like a senator's," his father remarked, and in his youth he was apt for theatrical experiences ranging from *Julius Caesar* to some exercises in blackface minstrelsy. His ability to entertain people was manifest long before he had acquired any specific skill, and everything that happened to him subsequently can be traced to his intelligent management of that ability.

Music, modern music, came into the picture through records. If his father's Edison gramophone had already introduced him to "Irish tenors, Jewish vaudevillians, Sousa marching bands, barbershop quartets," the local record store in 1917 and after began to offer the Original Dixieland Jazz Band, the Six Brown Brothers playing "That Moaning Saxophone Rag," the Mound City Blue Blowers, the Original Memphis Five. Whole days spent at Bailey's Record Store with his pals, listening to all the new releases, formed the basis of a musical education, along with a Spokane appearance by Al Jolson: "I hung on every word and watched every move he made. . . . To me, he was the greatest entertainer who ever lived." In ad hoc fashion, teaming up with other local music fans, borrowing repertoire from records, improvising on a mail-order drum kit, Crosby fell into his career as if following the path of least resistance. With his friend Al Rinker he formed a piano-and-drums duo; they played at the local movie theater between films and became, in the recollection of a local observer, "great favorites—good looking, pleasant appearing chaps with ingratiating smiles and an original method of putting over their songs."

In 1925, a three-week motor trip down the road took them to Los Angeles to stay with Al's sister, the singer Mildred Bailey, who was married to a bootlegger and singing regularly at a Hollywood speakeasy. Liberated from Spokane and the Jesuits, Crosby seems to have taken without much difficulty to the world of speakeasies and vaudeville houses. Within a few months of his arrival in Los Angeles we find him touring with Al on the Orpheum circuit as

Two Boys and a Piano, partying at San Simeon with William Randolph Hearst Jr., and amusing Beatrice Lillie at a party in the Hollywood Hills with his rendition of "When the Red, Red Robin Comes Bob, Bob, Bobbin' Along." By the end of 1926 they had been hired by Paul Whiteman, the most famous bandleader in America. Joined by Harry Barris and billed as The Rhythm Boys, they would record the scores of records — among them "Muddy Water," "Mississippi Mud," and "'Taint So, Honey, 'Taint So," — in which Crosby forged a jazz-inflected male vocal style that made most of his competitors seem pinched, pompous, and artificial.

At this stage, the casualness that later became mythic seems to have been unfeigned; during and after this rapid ascent, he enjoyed by all accounts a life of carousing that somehow did not interfere either with his musical career or his regular attendance at Mass. In the Whiteman years, a friend recalled, "if they couldn't find Bing, they'd say, well, where was he last night, and they'd go and look for him under one of the tables." He also smoked his share of marijuana and in his later years called for its decriminalization. Glimmers of a feckless era come through in anecdotes about the weekend he unknowingly spent in the company of Al Capone's hit man Machine Gun Jack McGurn (the party was finally interrupted by gunfire from a rival gang) or the jail term for drunk driving that led to his missing his big solo number in the gaudy Paul Whiteman movie musical *King of Jazz*.

He did manage to show up for a few scenes in *King of Jazz* — notably its finale, "Happy Feet," a production number beyond parody: "Happy feet, / I've got those happy feet, / Give them a lowdown beat / And they begin dancing." Bing delivers himself of these lyrics with a grin of complicit hilarity, as if to say, "It's ridiculous, but we're all having fun, aren't we?" He enlists the audience in a shared pleasure rather than dazzling it from the glittering heights occupied by the rest of the production. The other Rhythm Boys are good, too — just not as good as Bing; Harry's a bit over the top in his comic stylings, Al doesn't quite have the personality of his colleagues. What they enact together amounts to a kind of rock and roll, an up-tempo entertainment designed to create a perfect illusion of spontaneous good times, a well-oiled simulacrum of rambunctiousness.

IT'S HARD TO IMAGINE that air of youthful revelry surviving into the thirties, and it didn't. In relatively short order Bing acquired a solo career, a radio show, a string of hit movies, a movie-star wife (although Dixie Lee's fame would soon be eclipsed by his own), a mansion, and a worldwide reputation that would make him, in the heart of the Depression, a kind of logo for the American version of the good life. He was the man for whom America's vacation spots were made, the fun-loving handsome cousin who sent postcards of his various incarnations—Dude Ranch Bing, Waikiki Bing, Golf Course Bing—as if he were enjoying himself on behalf of everybody else, as a designated vicarious success story. The concept of leisure was woven into every aspect of his public image: he was the guy who'd rather be fishing, rather be playing golf, anything but have to get up in the morning and go to work. Louis Armstrong, seeing him in his natty jacket ("a *hard* hitting blue with white buttons"), thought of him as "a young Captain on some high-powered yacht." The hats (which he wore to conceal his baldness) became a badge of laid-back eccentricity, likewise the pipe, likewise the tropical shirts and bright socks (whose gaudily mismatched hues were to some extent a by-product of his color blindness).

What he was really doing, from the moment he opened on his own at the Cocoanut Grove in 1930, was applying everything he had to becoming, as Duke Ellington put it, "the biggest thing, ever." Within a year his schedule went like this:

> In total, he commanded Paramount's two New York stages for five months without a break. During most of that time, Bing's daily grind consisted of four stage shows—at $2,500 a week—and two fifteen-minute daily broadcasts, plus variety charity shows, guest appearances, recording dates, and concerts.

The rest of the time he was making movies, ten features between 1931 and 1935.

As Giddins emphasizes, technological change always seemed to work in Crosby's favor. Electronic recording, microphones, and radio all favored the calm and intimate style for which he was perfectly suited, a style that soon made other entertainers sound antiquated: "Two years earlier Al Jolson had been at the peak of his popularity; now he would be recast as the beloved

reminder of old-fashioned show business." Crosby didn't need to bellow or
gesticulate, didn't need to plead hyperactively for the audience's attention;
he was just an average fellow who happened to have a golden voice, a price-
less sense of humor, and all the luck in the world.

The hipness of the humor—especially in the earlier years—kept the
sweetness of that baritone from cloying. He was the perfect guy to embody
Modern Romance, without all the absurd stickiness and florid caterwauling
that now seemed remnants of some mannered and stultifying age of point-
less decorum. Like the young sailor he plays in the 1932 movie *We're Not
Dressing,* who has to take charge when shipwrecked with a party of useless
and contemptuous aristocrats, he had arrived on the scene to bring tux-and-
tails pretensions down to street level. His 1935 recording of "Love Is Just
Around the Corner" gave the lively impression that it was being sung by
someone at home on the corner.

For all the luck, none of it seems the product of accident. As his radio
announcer observed, "We liked his easiness, the intelligence behind his
interpretation of the lyrics. Everything he did depended upon intelligence
and he certainly had that."

GIDDINS'S BOOK IS PUNCTUATED with lists that are often fascinating.
Musicians with whom Bing hung out at the Sunset Club in Chicago after
joining the Whiteman band: Bix Beiderbecke, Hoagy Carmichael, Tommy
Dorsey, Frankie Trumbauer. People who showed up on the 1926 opening
night of Paul Whiteman's short-lived Club Manhattan on Broadway and
West Forty-eighth Street: Al Smith, Jimmy Walker, Jimmy Durante, Texas
Guinan, Charlie Chaplin, Jeanne Eagels, Gloria Swanson, and Harry War-
ren. ("Evangelist Aimee Semple McPherson dropped by a few days later.")
Participants in Bing's 1932 roast at the Friars Club: Jack Benny, George
Burns, Irving Berlin, Rudy Vallee, William Paley, George Jessel, Damon Run-
yon, and George M. Cohan, who presented Crosby with a lifetime member-
ship card made of gold. Bing's guests (among many others) on the *Kraft
Music Hall* in 1936: Spencer Tracy, Lotte Lehmann, Edward Everett Horton,
Louis Armstrong, Fyodor Chaliapin, Alice Faye, Andrés Segovia, Iona's
Hawaiians, Art Tatum.

It was not a solitary world he lived in, to say the least, and the company

could hardly be described as bland, at least not at the outset. From a distance that era can seem like a carnival of unbridled personalities. In the fifties, when the era's survivors showed up on television, there was a wonderment at the sheer unlikelihood of those faces, those accents, those bizarre traits upon which they had founded their comedy, those cherished eccentricities. Once upon a time, it appeared, oddity and improvisation were not only honored but required.

Then came the stealthy encroachment of those publicizing and marketing forces that wanted to iron out the crags and protuberances in favor of a one-size-fits-all entertainment product. For Bing that encroachment took the form of Jack Kapp, the founder of Decca Records, who encouraged him —or, more precisely, ordered him—to lose his more outré vocal mannerisms: "Jack summed them up as the 'bu-bu-bu-boos,' by which he also meant scat singing and jazz." Kapp wanted to remake Bing as a universally acceptable figure, "the John McCormack of his generation," as he put it. The result ultimately was a more pietistic and paternally reassuring persona, expressed in records that, however expertly made, had a heavier aftertaste than his earlier buoyancies. Where he once was a pure entertainer, now he seemed to be selling something. What he was selling might be no more than his own personality, but it was a personality that had somehow been abstracted from him and remade into a plausible and yet finally unsettling doppelgänger.

The contemplation of Bing Crosby seems like an unlikely trigger for existential anxiety. In contrast to Cocteau's "difficulty of being," he offered an incomparable ease of being: carefree, graceful, virile, beneficent, self-deprecating, and, beneath and beyond all that, knowing. He had everything covered. He had sung

Life is a beautiful thing
As long as I hold the string

and made it believable, yet in the later years one wondered when he had stopped believing it himself. What remained was a perfect model of the adjusted human that didn't, somehow, fit in anywhere. Outside of a soundstage or a broadcasting studio, in what imaginable world could such a being exist? It was a paradise of personality to which, unfortunately, the rest of us could not gain access.

But all this is more than music—a voice, a tune, a tempo—could or should be expected to bear. Speaking of Louis Armstrong, whom he professed to admire more than any other singer, Crosby remarked: "When he sings a sad song you feel like crying, when he sings a happy song you feel like laughing. What the hell else is there with pop singing?" If for at least thirty years Bing Crosby's voice was a medium through which countless listeners encountered their own emotions, perhaps it is an irrelevance to wonder what his were.

The New York Review of Books, March 8, 2001

The Mechanical Child

T HE PERSISTENT THEME of Stanley Kubrick's movies
is the obsessiveness of the human attempt to control the future—one's own
or the world's—and the complicated ways in which that attempt fails. Fix-
ated lovers (*Lolita*), solitary rogue-adventurers (*Barry Lyndon*), grandiose
novelists (*The Shining*), nuclear strategists (*Dr. Strangelove*), military train-
ers (*Full Metal Jacket*), all the way down to the picture-perfect couple whose
model of domestic joy is oneirically dismantled in *Eyes Wide Shut*: they are
all there to enact some version of *The Control Freak Brought Under Control*,
the story of the inventor who invents his own doom, the entrapper who
maneuvers himself into someone else's trap.

That the obsessive patterns within his films were mirrored by Kubrick's
own slow and perfectionist filmmaking process is no secret. *A.I.* (or alterna-
tively, *Artificial Intelligence*), one of the most elaborately developed of his
unrealized projects, had been in the works since the early eighties; it was
announced as his next film after *Eyes Wide Shut*, but with Kubrick such
forecasts frequently went unfulfilled. One of his consultants on the project
was Steven Spielberg, whom he at one point proposed should direct the film
with Kubrick as producer. Following Kubrick's death, Spielberg took it upon
himself to bring the movie to fruition, rewriting the script but evidently pre-
serving the essential structure already laid down. The idea of Spielberg serv-
ing as a medium enabling Kubrick to make one last movie, or at least a sim-
ulacrum of a last movie, has a curious symmetry with the movie's notion of
artificial intelligence preserving humanity beyond its own extinction. Spiel-
berg's films have often been concerned with the idea of rescue, whether of

endangered people or of endangered childhood dreams. *Saving Stanley Kubrick* might be this movie's alternate title, raising again the question of what finally can be saved, and for whom.

The movie's source, a story by the science-fiction writer Brian Aldiss, hinged on the plight of an android endowed with the capacity to love but not the capacity to understand why his adoptive human mother fails to love him back. In *A.I.* the android is David, an experimental prototype who is given to a couple as a substitute for their own ailing, cryogenically frozen son. We are in a world transformed by global warming, where the surviving humans exercise strict population control and supplement their diminished numbers with a virtual slave class of intelligent "mechas," but the household where David comes to live scarcely differs from the suburbia of *E.T.*, except that everything is a bit more sour.

The domestication of the robot child serves as a demonstration—unsentimental, and without facile caricature—of the way in which adults can use children for their own emotional gratification. In culmination, the desperate mother takes the irreversible step of activating David's capacity for love. The ritualistic quality of the scene—she reads a prescribed list of random words while maintaining eye contact—recalls the drinking of the love potion in *Tristan and Isolde,* except that it's a one-way process: only the mecha child comes under the spell. The scene's real horror (it's worthy of Kubrick's *The Shining*) resides in the absence of magic. Love, for *A.I.*'s purposes, is an involuntary emotional imprinting, as cold as any other form of software programming. There is no suggestion that David's feelings will grow richer or deeper, merely that an unvarying fixation on his mother will henceforth be part of his makeup. He becomes a machine for unfulfilled longing.

All this is prelude. In short order the real son, defrosted and healed, is brought home, and proceeds with malevolent calculation to undermine the position of his mechanical sibling. Cast under suspicion, David is driven into the forest by his mother and abandoned with only a talking teddy bear —an earlier, more rudimentary form of artificial intelligence—for company. The Disneyish echoes are quite deliberate; the movie will soon become a series of variations on *Pinocchio,* with a full complement of violent misadventures and chaotic carnivals and comic relief provided by Jude Law as an

android gigolo with his own built-in soundtrack of Bing Crosby and Fred
Astaire recordings.

The emotional resonance is, however, constantly undercut. Every feeling
that we're tempted to invest in David's fate feels displaced; we follow the
adventure of an "I" that is not really an "I"; he's not a human but a digitalized
archive of human potentialities. If he seems better than the humans — whose
emotions are in varying degrees thwarted, conflicted, misguided, or down-
right malicious — it's in the same way that a work of art might be construed
as better than life. He's a product of design, nothing more. What, after all, is
David but a highly evolved special effect in a Steven Spielberg movie? The
fact that he's played by a human actor (Haley Joel Osment, the twelve-year-
old star of *The Sixth Sense*) is beside the point; in this movie, in the world of
digitalized filmmaking that this movie embodies, everything on the screen is
a special effect.

A.I. IS A MEDITATION ON its own components; the technical means that
make possible the mechanical child are as one with the means used to make
the film. (It was when Kubrick saw the seamless interaction of actors and
dinosaurs in *Jurassic Park* that he realized that *A.I.*, with its world of half-
demolished bodies and replaceable faces, could now be filmed as intended.)
Now that we have the technology, what are we going to use it for? Perhaps to
make — under the guise of children's adventure stories — allegories exploring
the philosophical dilemmas elicited by digital technology. The suggestion of
allegory pervades *A.I.*; we might be reverting to that fin de siècle symbolist
world of Maeterlinck's plays, Ibsen's *Peer Gynt,* Strauss's *Die Frau ohne
Schatten*—works in which the characters would be identified only as The
Father, The Mother, The Human Child, The Mechanical Child. It was only
a step from there to the early android fantasies of Karel Čapek's *R.U.R.*
(1920) and Fritz Lang's *Metropolis* (1926). What keeps *A.I.* from feeling like
an exercise in aesthetic retrospection is that, in the interim, the robots have
become real. They may not have feelings yet, but they have already been
entrusted with a good part of the running of the world.

It's another remake of *Frankenstein* or *The Golem,* but the man-monster
here is the embodiment of the golden child who has haunted the American

imagination in these latter decades: the inner child, the abandoned child, the illuminated child. Spielberg certainly grasps the implications of that fetish, since he has done more than his share to reinforce the myth of childhood as the privileged sphere of imaginative freedom, moral courage, uncorrupted emotion. The spectator prepares for another retelling of the myth of the little boy born to save the universe, unaware of his destiny until clued in by tutelary elders and fated to undergo the usual mythic journey through wilderness and man-made inferno. But the movie consistently goes against the grain of the emotional expectations that it invokes in Spielberg's expertly realized shorthand; David is neither star-child nor hidden savior but an industrial prototype persuaded by his programming that he exists. He can neither save the universe nor be saved by it.

It would be easy to attribute the rigor of A.I.'s structure—its inexorable denial of easy solutions—to Kubrick; in any event, the narrative's firm architecture restrains any sentimentalizing tendency. The Pinocchio motif (the robot child's journey in search of the Blue Fairy who will turn him into "a real boy"), which threatens at every moment to turn into a predictably wish-fulfilling extravaganza, is taken through ingenious variations all the way to the final demolition of the Blue Fairy two millennia hence in the ruins of Coney Island, in a Manhattan that has become Poe's City in the Sea. What is unexpected is how concise and detached the film is, how Spielberg avoids milking the emotional implications, or calling on special effects as deus ex machina as in most contemporary digital fantasies. There is enormous relief in realizing that for once a tragic ending—the only possible ending—is to be permitted.

There are in fact three tragic endings. First there is David's suicide after realizing that he is merely the prototype for an endless line of mass-produced replicas, and then his eternal solitude beneath the waters while the human race becomes extinct and the oceans freeze over. When he is retrieved two thousand years later by what appear to be sophisticated artificial beings of a later provenance, there is again the fear that some magical happy resolution is to be proffered. This coda turns out to be a false reprieve. In the digital afterlife, David gets to remake the world according to his desires. The inhabitants of the future, who value him as a last link to the long-vanished human world, enable him to inhabit a neverland constructed out of his own stored

memory, in which the emotionally deprived child finally has the mother all to himself.

The catch is that he isn't really a child but the artificial spectator of an artificial spectacle; and she isn't really his mother, or not for long (she's been cloned from a few strands of hair, and the resurrection will last only for a single day). In the meantime—and the movie ends right there—they are alone together at the bottom of the universe: an ideogram of grief, disguised as a Hallmark card. More precisely, intelligence is alone with itself and what it has wrought, surrounded by interstellar chill. In the face of that confrontation, David undergoes the only small miracle permitted him: for the first time in his existence, he achieves a blissful unconsciousness.

New York Review of Books, August 9, 2001

Hitchcock:
The Hidden Power

Hitchcock et l'Art, an exhibition devoted to teasing out connections between the films of Alfred Hitchcock and a wide range of art from the 1850s to the 1990s, has just closed at the Centre Pompidou in Paris, and it is a pity that there are apparently no plans to bring it to the United States. (It has been shown in North America, having originated in a more condensed form in Montreal.) Since Hitchcock is already everywhere in American culture — in video stores and on cable TV, in film courses and in a stream of critical studies and biographies that shows no sign of letting up, in remakes and reworkings and allusions that mine the oeuvre as a kind of folklore — it would have been fitting if more of us could have had a look at an assemblage that opens up the work in unpredictable and fascinating ways. Hitchcock et l'Art amounts to a form of film criticism relying not on verbal analysis but on the deployment of images and objects. It talks about Hitchcock by speaking in his own language, and in the process raises haunting questions about the potential of what that language might convey.

I saw the exhibit under circumstances that may have heightened its emotional effects in ways not foreseen by its creators. It was only a few days after the attacks of September 11, at a point when I didn't yet know the fate of friends and neighbors or indeed whether my home in the shadow of the twin towers was intact, an uncertainty that at least helped deflect attention from more horrible certainties. To attempt to escape for a few hours from the shock of real terror in a gallery devoted to imaginary terrors made as much

sense as anything in a Paris made unfamiliar precisely by its air of untroubled calm, by a sky where for the time being no airplanes flew. At that moment not only the pop-industrial facade of the Pompidou but the city around it seemed momentarily flat and insubstantial, like one of those rear projections of which Hitchcock was so inordinately fond: a movie set, that might be junked without warning.

If the purpose of the exhibit had been to impart a sense of timeless solidity to works that had once been perceived as ephemera of cinematic commerce, in this new context the materials on display seemed marked by a new kind of fragility. Rather than objects securely fixed in space — brought finally for safekeeping into an unbreachable museum — they seemed messages that had been transmitted, in a twentieth century now suddenly ancient, only as far as this point in time: messages whose purport would continue to be transfigured by unimaginable circumstances, and whose perpetuation could scarcely be guaranteed. It was open to question whether we would still want to look at them, and what they would convey to us.

An issue of *TV Guide* from the late fifties, a 1945 lobby card for *Spellbound*, a 1925 cover from *The Kinematograph Weekly* had abruptly acquired a pathos merely by continuing to exist. They implied a chain of connections unbroken by the vicissitudes of the previous century, and took on the tranquil charm of a family album, a charm reinforced by the home movies of Hitchcock clowning with his wife and daughter that were projected in one corner of the labyrinthine show. An exhibit that, to judge by recurring phrases in its catalog, was to be defined in terms of "fatality"and "fetishism," "malaise" and "culpability" and "the paranoia of the glance," now fairly radiated with the colors and expressive flourishes of a threatened life.

Hitchcock may have dwelled on themes of death and disquiet, but it was always — it now became obvious — the exhilarating vitality of his work, its constant urge to invent and construct even in an atmosphere charged with fear and self-doubt, that had drawn us to it. To speak, as one of the catalog's contributors does, of "the eruption of horror into the midst of everyday life" as a prime characteristic of his films was to overlook the fact that those films had long since become part and parcel of everyday life. Terror? Anxiety? Morbid obsession? Hitchcock didn't unleash them, he domesticated them. His films were by now almost as much a part of the culture of childhood as

The Wizard of Oz or *Peter Pan*. In the pleasurable unease that was his signature, it was the pleasure rather than the unease that represented the more difficult accomplishment.

Hitchcock et l'Art takes for its epigraph (I use the present tense in the hope that the Paris showing will not be its final incarnation) an encomium by Jean-Luc Godard worth quoting at length as an eloquent reminder that it was after all in Paris, in the 1950s, that attention was first paid to the uncanny artistic originality and density of films that until then had passed for more or less efficient entertainments:

> People forget why Joan Fontaine was leaning over the cliff . . . and what Joel McCrea was up to in Holland. They forget what Montgomery Clift was obliged to keep silent about and why Janet Leigh stops at the Bates Motel, and why Teresa Wright remains in love with Uncle Charlie. They forget what Henry Fonda was not altogether guilty of, and why exactly the American government employed the services of Ingrid Bergman. But they remember a car in the desert. They remember a glass of milk, the vanes of a windmill, a hairbrush. They remember a wine rack, a pair of glasses, a fragment of music, a set of keys. Because through them and with them, Alfred Hitchcock succeeded where Alexander the Great, Julius Caesar, Napoleon, and Hitler failed: in taking control of the universe. Perhaps ten thousand people have not forgotten Cézanne's apple, but a billion spectators will recall the cigarette lighter in *Strangers on a Train,* and if Alfred Hitchcock has been the only *poète maudit* to achieve success, it is because he was the greatest creator of forms of the twentieth century and that it is forms which tell us, finally, what there is at the bottom of things; and what is art except that by which forms become style.

Passing beyond the white wall where these words (extracted from Godard's multivolume *Histoire(s) du Cinéma*) are inscribed like a poem, the spectator is obliged to enter a dark room—like a latecomer at the movies trying to find a seat—to discover, laid out on satin under glass as in some very peculiar jeweler's shop, a series of props of the kind celebrated by Godard: the glass of milk from *Suspicion,* the necklace from *Vertigo,* the yellow hand-

bag from *Marnie*, the straight razor from *Spellbound*, the set of keys from *Notorious*, the broken eyeglasses from *The Birds*, the shrunken head from *Under Capricorn*, the rope from *Rope*. The effect is not so much to evoke the films as to subtly alter one's impression of them by breaking them down into their constituent elements, assembling the films for the first time from the fragments gathered here.

That effect—with its sense of addressing not finished works but the process by which they were made in the first place—is multiplied by the objects in the rooms that follow, storyboards and costume sketches, production photos and private snapshots, shooting scripts and original editions of books adapted by Hitchcock. The walls vibrate with movement: clips from Hitchcock's films flicker on all sides in the midst of paintings, posters, magazine covers. The show has the charm of an oddly tenebrous theme park. Spaces open up: a whole wall on which the panning shot of the rear-window view from *Rear Window* is endlessly projected, Salvador Dalí's backdrop of giant eyes for the dream sequence of *Spellbound*, a full-scale re-creation of Janet Leigh's motel room in *Psycho*. In this context many of these objects take on a singular beauty and power, none more than the prop crows arranged in battle formation on the monkey bars from *The Birds:* a sculptural work that acquires a disturbing monumentality, like the remnant of some wordless premonition of disaster.

Interspersed with these objects, and providing the exhibit's chief reason for being, is a dense assemblage of works by artists ranging from Edward Burne-Jones and Julia Margaret Cameron to Cindy Sherman and Tony Oursler, works chosen more for analogy than for traces of direct influence. Dominique Païni, one of the curators, explains the approach: "We have put our faith in intuitive *constellations* of images that stood out as we watched the films again." It is to be a game of resemblances, then, just like that favorite parlor game that seeks points of contact among different moments in Hitchcock's films, looking for a system among the motifs that repeat almost to infinity: women being dressed by others; lovers handcuffed together; painted portraits; varieties of masquerades (the costume ball in *To Catch a Thief*, the female impersonator in *Murder!*, the stand-in for the diplomat in *Foreign Correspondent*, the changes of hair color in *Marnie*);

criminals disguised as priests; the man of evil who offers a drink to the virtuous (*Shadow of a Doubt, Dial M for Murder, North by Northwest*); a cigarette stubbed out in cold cream (*Rebecca*) or a fried egg (*To Catch a Thief*).

Here the game consists in finding images from elsewhere that can mix seamlessly with images from Hitchcock's films, so that Kim Novak strewing flowers into San Francisco Bay before throwing herself into the water is mirrored by the Ophelias of Millais and Redon; the indefinitely prolonged kiss of Cary Grant and Ingrid Bergman in *Notorious* by Rodin's *Kiss*; the haunted houses of *Rebecca* and *Under Capricorn* and *Psycho* by analogously desolate settings from Arnold Böcklin and Fernand Khnopff and Alvin Langdon Coburn. Images may tally in the most literal fashion: Walter Sickert's portrait of Sir Thomas Beecham at the podium rhymes perfectly with a still of Bernard Herrmann conducting the "Stormcloud Cantata" in *The Man Who Knew Too Much,* and Saul Bass's spirals for the credits of *Vertigo* could almost be superimposed on Marcel Duchamp's "Rotoreliefs" of 1935. Hitchcock's sealed-off maze has been punctured at a thousand points to let the world in, to demonstrate connections that were already there although unseen. It hardly matters whether the relation between the images is a matter of influence or mystical correspondence. (As it happens, Hitchcock worked with Dalí, and in a small way collected Klee, Rouault, Sickert, and some of the other artists in the show, but the curators are not concerned to chart any direct line of transmission.) The pictures talk back and forth to each other in just the winding and arabesqued manner suggested by Hitchcock's endless stairways and tracking shots and encircling glances.

That the rooms are dimly lit adds to the impression of eavesdropping among the overlapping dialogues of a shadow world of images, a museum of the imagination where the distinction between austere abstraction and tawdry observation blurs into a common dialect. By following the path of mere resemblance, the most unlikely objects are brought into contact with one another. The sources of imagery range from a lithograph of one of Jack the Ripper's victims from an 1888 issue of *Famous Crimes* to a painting of birds by Georges Braque, and from Dante Gabriel Rossetti's painting of Proserpine to a Cecil Beaton photograph of Marlene Dietrich. High art is not walled off from magazine illustration or fashion design. The list of artists drawn upon makes a wonderfully eclectic band; side by side with Beardsley,

Munch, Vuillard, de Chirico, Klee, Ernst, Magritte, and Hopper are such relatively more elusive figures as Alberto Martini, Fernand Khnopff, Meredith Frampton, Carel Willink, Léon Spilliaert, Ralston Crawford, and many others.

As a concept it sounds impossibly broad—Hitchcock's visual art would by this reckoning have been a kind of indigestible potpourri of the Pre-Raphaelites, the Symbolists, the Blaue Reiter group, the Surrealists, and every variety of pop culture from London variety posters to the cover art of *Vogue* and *Harper's Bazaar*—but the show is about neither schools of art nor hierarchies of taste. The connections it looks for are almost familial: a matter of shared spaces, shared (if perhaps unspoken) desires, shared dreams, shared nightmares. A vocabulary takes shape: the drowned girl, the music hall, the crowd, the kiss, the shadower, the haunted staircase, the murder. Are these the real subjects of what is being said, or merely signs to represent something else? Are they strange to us or do we lie down with them every night? If they frighten us why do we keep looking? Moving through these rooms, we become more and more aware of being part of a vast and shifting audience, onlookers at the circus in *Murder!* or at the Bijou Cinema in *Sabotage*, part of the more or less anonymous crowd milling about restlessly, from one era to the next, in Piccadilly Circus or Grand Central Station.

Of course, by dismantling Hitchcock's films in order to come up with powerful isolated images—and it is striking how many of those images come from early and largely unsung movies like *The Ring, The Manxman, The Skin Game,* and *Number Seventeen*—the chief art of the films falls by the way. The music of narrative, the flavoring of humor and character, the structural mastery not only of individual shots but of the connections among all the shots: none of this can really be suggested in such a setting. Strangely, that makes the exhibition more rather than less interesting.

The theme of the double that weighs so heavily in Hitchcock's movies applies also to the spectator's experience of watching them. There is the film he is conscious of watching and in which he is effortlessly caught up, the film without slack or digression that leads him from one point to the next as if carried by a high-speed train; and there is the more abstract and dreamlike film, the subliminal film that has less to do with intrigue and story logic than with images and situations exerting a mysterious and enduring power. The

outer or conscious film can be seen as a framework enabling the other to do its darker and more pervasive work, almost unbeknowst to the watcher—or even at times to the filmmaker. In exposing some portion of that inner domain, *Hitchcock et l'Art* becomes something of an essay on hidden powers; that they are hidden in plain sight, in the visible, is a paradox appropriate to a work concerned equally with showing and concealing.

By an interesting coincidence, Peter Conrad's book *The Hitchcock Murders* represents a very similar mining of the films for correspondences that often go far beyond any intention of the director's. For example, a discussion of the role of art in such movies as *The Trouble with Harry* and *Rear Window* leads, by a rapid train of associations, to the "bloody lakes of congealed pigment" in the paintings of Mark Rothko and thence to Rothko's 1970 suicide by "opening his veins into a kitchen sink." The effect is often (as it is here) gratuitous, but just as often Conrad penetrates to highly suggestive layers of implication, precisely because of his book's jettisoning of systematic argument in favor of something like free association. As his title suggests, his vision of Hitchcock is more cannibalistic than romantic, and he is particularly attuned to the devouring aspects of even the most apparently idyllic or amusing moments in the films.

 Conrad has carefully studied the literary sources of Hitchcock's films, and some of his freshest passages have to do with the often much rougher, more sadistic, more sexually explicit content of such novels as *Rebecca, Jamaica Inn, The Paradine Case, The House of Dr. Edwardes* (source of *Spellbound*), or *Goodbye Piccadilly, Farewell Leicester Square* (on which *Frenzy* was based). The weight Conrad puts on material that neither appears in the finished films nor, usually, was ever intended to might appear questionable; but his discussions open up avenues on Hitchcock as reader and the crucial yet so often neglected portion of the creative process that has to do with the selection of material for adaptation. Just as the Pompidou show imagines a Hitchcock inflected by Munch and Klee and Max Ernst, Conrad insinuates himself into Hitchcock's readings of writers as disparate as John Buchan, Daphne du Maurier, Patricia Highsmith, Boileau-Narcejac, and Robert Bloch. He's equally lively on such motifs as food, scissors, bathrooms, teeth, and the recurring presence of *Tristan und Isolde*.

Reading Hitchcock, Conrad reads himself, as he candidly acknowledges throughout. The book's subjectivity is its strength; having steeped himself in Hitchcock (and the evidence of the steeping is on every page and in every arcane fact and overlooked visual detail), Conrad must write his way through the work to find out what it has made of him. If this involves a certain amount of overextension along the way — and if in search of extreme transgressiveness Conrad misses some of Hitchcock's more delicate balancing acts — there can be no question at the end that one has been through a stretch of territory. One might have taken a different route, but Conrad has covered the ground.

Conrad has written a history of walking through someone's head, and the Pompidou show likewise begins to feel like a literal promenade, in the dark, among sense impressions and nerve endings. Decades seem to have passed during the walk. In the beginning we were in a world of pianolas and Ivor Novello, the early English films' drab succession of rooming houses, police stations, dance halls, and crowded tube trains, their endless round of banal prurience indiscriminately mingling the erotic and the horrific. Then, from the apparently safe distance of America, we were living through the war, its inner home-front drama enacted by Hitchcock in *Shadow of a Doubt,* in which the external enemy was replaced by a homegrown psychopath of Hitlerian intelligence linked to the "good" people of Santa Rosa by the most intimate ties of family feeling and sublimated erotic attraction.

Through a deep-shadowed decor redolent of Surrealism and Freud as modified for the readers of *Vogue,* we entered the postwar world that would realize itself in poster-bright expanses of VistaVision and Technicolor. In that world Hitchcock could for a long stretch do pretty much as he wished, plot his ironic twists and make his little jokes about murder as a fine art, work out his elaborately conceived grids of visual and sonic relationships, his recurring spirals and vertiginous ramps, choose his actresses' clothes (a crucial part of the creative process, with special attention to color schemes and hairstyles), divert a vast audience with meticulous realizations of his most idiosyncratic fantasies and preoccupations. A golden age, culminating in the explosive success of *Psycho* (a pop-culture event as radical as, say, rock and roll) and followed by the slow decline of *Torn Curtain* and *Frenzy;* and then the museums with their retrospectives.

A lifetime in a dream, deliberately so: "I practice absurdity quite reli-
giously," he told François Truffaut. Elsewhere he remarked that he offered
not a slice of life but a slice of cake. He was in some sense our Lewis Car-
roll, populating his Wonderland with looking-glass inversions of the same
world we inhabit: a world of spies and murderers, lovers and tennis players,
actresses and jewel thieves. They exist, apparently, to make fascinating pat-
terns in which the spectator, like the director before him, can become lost.
"You could look at it forever," Hitchcock said about one of his own composi-
tions. That the global crisis foreshadowed in *The Lady Vanishes* and *Foreign
Correspondent* was real enough had not prevented him from weaving it
into graceful, often comic fantasies that established a quite separate and
extremely pleasurable alternate reality. Yet nothing about Hitchcock's work
finally seemed frivolous; too much attention had been paid to every piece
and every step of it. If stepping out of the Pompidou from that city of the
mind into the actual city of actual dangers was like waking from a dream, it
was not a dream one wanted to forget. There was, rather, a strange comfort
in feeling close for a while to that nether realm where we store our shadows,
as if for future use.

<div align="right">New York Review of Books, November 15, 2001</div>